Painting as a Language
Material, Technique, Form, Content

Painting as a Language
Material, Technique, Form, Content

Jean Robertson

Herron School of Art

INDIANA UNIVERSITY – PURDUE UNIVERSITY INDIANAPOLIS

Craig McDaniel

INDIANA STATE UNIVERSITY

WADSWORTH

THOMSON LEARNING ™

Australia • Canada • Mexico • Singapore • Spain • United Kingdom • United States

WADSWORTH

THOMSON LEARNING

Publisher: EARL McPEEK

Executive Editor: DAVID TATOM

Market Strategist: LAURA BRENNAN

Developmental Editor: STACY SIMS

Project Editor: LAURA J. HANNA

Art Director: BURL SLOAN

Production Manager: SERENA BARNET

Compositor: PROGRESSIVE INFORMATION TECHNOLOGIES

Cover Printer: PHOENIX COLOR

Printer: MALLOY LITHOGRAPHING

Cover Image: Peter Doig, *Night Fishing,* 1993. Oil on canvas, 200 × 250 cm. Courtesy: McGinnis Finch.

Printed in the United States of America
9 10 11 12 13 14 15 10 09 08 07 06

For more information about our products, contact us at:
Thomson Learning Academic Resource Center
1-800-423-0563
For permission to use material from this text, contact us by:
Phone: 1-800-730-2214
Fax: 1-800-730-2215
Web: http://www.thomsonrights.com

Library of Congress Catalog Card Number: 99-64890

ISBN 13: 978-0-15-505600-8
ISBN: 0-15-505600-x

Asia
Thomson Learning
60 Albert Street, #15-01
Albert Complex
Singapore 189969

Australia
Nelson Thomson Learning
102 Dodds Street
South Melbourne, Victoria 3205
Australia

Canada
Nelson Thomson Learning
1120 Birchmount Road
Toronto, Ontario M1K 5G4
Canada

Europe/Middle East/Africa
Thomson Learning
Berkshire House
168-173 High Holborn
London WC1 V7AA
United Kingdom

Latin America
Thomson Learning
Seneca, 53
Colonia Polanco
11560 Mexico D.F.
Mexico

Spain
Paraninfo Thomson Learning
Calle/Magallanes, 25
28015 Madrid, Spain

For our parents

Preface

The practice of painting has undergone startling changes in just the past two decades. The cultural landscape has altered in response to forces both within and outside the artworld — including the influx of voices from a diverse mixture of ethnicities and cultures, and the challenges and opportunities in all spheres of life brought on by rapid technological change. Anchored as it is in the world around it, the practice of painting, and the painters who make paintings, are also different. And yet, the art of painting remains steadfastly anchored to strands of tradition that extend back into the mists of history.

Painting as a Language: Material, Technique, Form, Content is designed to introduce developing painters to a range of basic painting techniques and painting materials, and to a systematic exploration of how materials, techniques, and formal elements combine with cognitive meaning. The book is designed for use by students working in a college classroom as well as painters working independently or in a less formal gathering of artists.

We wrote this book because, quite frankly, there was nothing even remotely like it available and the need for a compact resource of this type seems to us to be unquestionable. Throughout the process of its research and writing we frequently found ourselves facing challenging choices (such as, do we emphasize the Western tradition, or do we emphasize painting as a multicultural form of expression?). We believe that the developing painter's own learning is enriched exponentially by the availability of a structured introduction to the language of artistic form, technique, and content.

Distinctive Features and the Structure of the Book

Following a brief introductory chapter, *Painting as a Language* is divided into eleven chapters. The eleven chapters can be understood as falling informally into three sections:

Chapters 1 through 3 provide information to help the reader get started painting. Chapter 1 gives an overview of what a painting is; Chapter 2 provides a concise look at materials and techniques available to the contemporary painter; and Chapter 3 offers a special introduction to color as a defining element of painting.

Chapters 4 through 7 focus on an integrated approach to exploring both the material and the mental aspects of painting. Each chapter is organized around a coordinated exploration of formal concerns and subject matter, along with a study of specific approaches to materials and techniques. The practice subjects are ones which historically have provided painters around the world with content, and which have continuing relevance and renewed vigor today:

Chapter 4: The Picture Plane
 Practice subject: Still Lifes and Objects
Chapter 5: Shape, Plane, Volume, and Brushstroke
 Practice subject: The Self-Image
Chapter 6: Space
 Practice subject: Places
Chapter 7: Form and Light
 Practice subject: The Human Figure

Each chapter uses a similar approach. The chapter includes a focused presentation of the formal topics, a concise discussion of the subject matter, and an assessment of past and present painting practices relevant to the chapter's topics. The exercises involve studio techniques of increasingly greater sophistication in successive chapters. At appropriate points in each chapter, "Focus On" sections present exemplary paintings as a means to offer guidelines in the analysis of form, technical strategies, and interpretation of content. Drawing exercises are recommended as preliminary explorations, and related journal writing exercises guide thinking about approaches to meaning.

It is essential to note that the connecting of a chapter's practice subject with specific aspects of visual form, materials, and painting techniques is not exclusive or inevitable. For example, Chapter 6 focuses on "Places" as a subject, the articulation of space as a formal issue, and the study of techniques of direct painting and mixing additional materials into the paint. But direct painting techniques, additional ingredients, and ways to render space are not relevant *only* to paintings of landscapes and other settings. Having absorbed the experiences offered in each chapter, the artist should be prepared to apply this knowledge to any subject matter one may explore as a painter.

Chapters 8 through 11 ask the student of painting to become more aware of current theories and strategies that are influencing contemporary painting, and to think critically about how these might affect and empower an artist. Many approaches and ideas about painting are undergoing intense theoretical debate at present, and, as part of one's education, an artist needs to be aware of major issues. Chapter 8, "Expanded Forms and Ideas," challenges the reader to experiment with approaches which are not constrained by the familiar rectangular format and introduces several concepts that are central to current artistic theory. Chapters 9, 10, and 11 are structured in a manner similar to Chapters 4 through 7, offering a combination of painting, drawing, discussion, and journal writing exercises around focused topics along with in-depth studies of exemplary works by a variety of artists. We believe these final chapters will bring forward formal and intellectual approaches that go beyond those that are already familiar to many.

Alternate Routes through the Book

It is not absolutely necessary to follow the chapters and exercises in the order in which they appear in the book. When *Painting as a Language* is used as a text in conjunction with a course, the teacher will decide which exercises to emphasize. If used over a two-semester sequence, most likely the class will concentrate on Chapters 1 and 4 through 7 during the first semester, and Chapters 8 through 11 during the second semester. (Chapters 2 and 3 are intended as general references to be consulted repeatedly.) If the text is planned for use during one semester only, then the teacher will probably select chapters, or portions of chapters, from each part of the book. Using the book over three or more semesters would allow, of course, for a more in-depth study of the topics presented.

For artists working independently, we recommend initially going through the chapters in sequence. Even if you think a topic has no relevance to your art, keep an open mind. You may be surprised by how deeply you connect with a topic you have never before considered as artistic content. Of course, the exercises may also be dipped into intermittently — for fun, a new challenge, or to help you overcome a temporary block.

Acknowledgments

No book is conceived and written in a vacuum, certainly not a textbook in the studio arts intended to meet the needs of a diverse audience of students, teachers, and independent artists. We are happy to express our appreciation to the many institutions and people who have helped us significantly by their contributions of support and resources. Our efforts were aided by gifts of time and working space at the Millay Colony for the Arts, Austerlitz, New York, and the Mary Anderson Center, Mount St. Francis, Indiana.

Our writing was strengthened and our conception broadened thanks to the many valuable insights and suggestions we received at various stages from those who reviewed the manuscript: Gregory Amenoff, Columbia University; Janet Ballweg, Bowling Green State University; Ed Bereal, Western Washington University; Sarah Canright, University of Texas — Austin; Patrick Craig, University of Maryland; Darcy Huebler, California Institute of the Arts; Kay Miller, University of Colorado — Boulder; Barbara Nesin, Front Range Community College; Dan Smajo-Ramirez, University of Wisconsin — Madison; and Loyola Walter, College of Mount St. Joseph.

Our sincere thanks go to our colleagues at Herron School of Art, Indiana University-Purdue University Indianapolis and Indiana State University, Terre Haute. In particular, we wish to recognize the support and encouragement provided by Dean Valerie Eickmeier and former Dean Robert Shay at Herron School of Art, Adrian

Tió, Chair of the Department of Art, ISU, and Dean Joe Weixlmann, College of Arts and Sciences, ISU. We thank our students who cheerfully submitted to trying out our ideas for painting and writing exercises.

We are grateful for the excellent working relationships we have enjoyed throughout this project with the staff at Harcourt College Publishers. This book would not be a book at all without the careful guidance and thoughtful contributions of Stacey Sims, Developmental Editor, Laura Hanna, Project Editor, Serena Barnett, Production Manager, Burl Sloan, Project Designer, Barbara Rosenberg, former Acquisitions Editor, and Terry Johnson, her successor. We are happy to cite the important contributions made by Cheri Throop, our Photo Researcher, including her wit and good spirits. The efforts of Yanya Yang for special graphic design assistance and Doug Bolt for photography assistance are much appreciated. The illustrations were made possible with the help of the numerous artists, collectors, galleries, and museums identified in the captions and photo credits.

Finally, we thank our families and friends for their ongoing love and support; we cite the lasting influence Larry Shineman (a true painter's painter) has made on our thinking; and we acknowledge the inspiration of the myriad women and men, now and in the past, who have enriched this world with paintings!

J.R. and C.Mc.

Table of Contents

Painting as a Language

Material, Technique, Form, Content

Introduction

We have written this text, *Painting as a Language,* for you and anyone else engaged in the adventure of painting. Like a good map, we hope you will refer to it often and trust that with this guide you will find your way into uncharted territory, where your creative spirit will discover new sources of inspiration and new paths for expression.

Your adventure into painting will take you in three directions: inside yourself, outside into the world around you, and inside the process of painting itself. These three directions, the cardinal points on your compass, are mutually reinforcing.

Inside yourself. One of the bedrock themes of this book is that painting is a form of communication. In order to function as a painter, you must have something you want to communicate. That "something" might derive from your inner world, where you tap into a rich storehouse of feelings, memories, dreams, ideas, or even nightmares.

Outside into the world around you. Alternatively, that "something" the painting communicates might be anchored in the world (or worlds) that engulf us all. Your painting might be a record of the visual appearance of everyday objects, or a graphic communication of your personal reactions to a social issue, or a visual means of telling a story about your community.

Inside the process of painting itself. The something which forms the primary content of your painting might be the formal qualities of the painting itself — its color harmonies, paint texture, dark and light shapes, and so on.

In fact, a painting can be about virtually *anything,* with the qualification that it must be about *something.* Most likely the content of your painting will be about a combination of things, overlapping all three of the "directions" we just described. What the painting is about might be unnamable, but this elusiveness does not negate the existence of meaning.

THE CONCEPT AND APPROACH OF THE BOOK

Painting as a Language is an innovative text that will help you to discover content for your paintings — what you want to make art about — while you are acquiring basic painting skills and exploring techniques and materials. The book is designed for use by painting students working in a college classroom setting as well as painters working independently or in a less formal gathering of artists.

This book presents painting exercises along with related drawing, discussion, and journal writing exercises. Together they will help teach you not only how to paint, but how to decide what you want to say in a painting, and how to respond analytically to your work while it is being created. We are convinced that all four types of exercises are invaluable in making you a more effective artist. Simply allowing habit, tradition, and instinct to guide your selection and approach to subject matter and visual form will not make your paintings stand out no matter how technically skilled you become. At the same time, if your style and technique are undeveloped and uninspired, you will not make significant work even if your subject matter is of headline importance. Powerful content, a visual communication that sings, occurs when

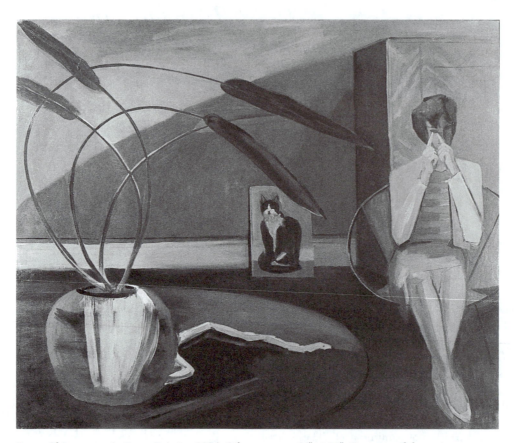

Larry Shineman, *An Eye on Painting,* 1984. Oil on canvas, 66″ × 80″. Courtesy of the artist.

an artist selects subject matter which is personally meaningful and becomes adept at shaping and interpreting that material through the visual (or plastic) language of painting.

The exercises in this book assume that *you* are an invaluable resource as you begin to discover what you want to paint and to analyze how effective your paintings are. Many exercises encourage you to look inside yourself and find experiences, memories, emotions, opinions, ideas, and fantasies that are already there, perhaps forgotten or half-buried, and bring them to light by writing them down or considering their potential with exploratory sketches. You will discover subject matter which is personally meaningful. Some exercises also ask you to look outside to the wider world, and think about how your interests may connect with the life experiences of other artists, whose paintings can teach you different approaches to expressing your ideas. Other exercises ask you to consider subject matter you may not already know a great deal about, but which is important for other painters.

Research outside the realm of painting is sometimes necessary to augment the painting process. Just as a writer whose goal is to produce an impassioned essay on the perils to peace in the Middle East would strengthen his thesis by research into his subject, similarly, a painter who plans to produce a canvas critiquing an aspect of the world's ecological crisis would reinforce the authenticity of her creative product by undertaking background research. Although most of the exercises in this book do not require outside research, there will be occasions when we will recommend consulting other sources.

Above all, you will learn to paint by painting. First and foremost, painting is a *visual* art; the developing painter gains facility with painting by experiencing directly its visual effects. Each artist's sensibility is developed by paying close attention to his or her own physical and psychological responses to possible arrangements and relationships of visual forms. Throughout this text we will guide your artistic development by offering information to help you gain command of strategies of composition. Likewise, the sequence of painting exercises is de-

signed to increase your knowledge of and experience in using various artistic conventions. This learning will always be tied to hands-on studio experiences. Your understanding of a painting's content will often be clarified, or even changed altogether, during the actual process of painting. Moreover, various studio exercises ask you to begin painting directly, from imagination or by responding to a subject before you, in order to experience these gateways to creativity.

THE DIVERSITY OF PAINTING

A walk through any of the encyclopedic museums of world art reveals the staggering diversity of painting as it has been practiced around the globe over the millennia of history. In no place has painting ever remained static; however compelling any way of painting may have seemed at one time in one culture, alternative approaches have always risen up to challenge and ultimately transform the "rules" of painting. The history of painting in all parts of the world is one of dynamic, ongoing change in preferred subject matters, techniques, tools, formal ideas, and even the physical mixture of paint itself. Today, as artists — like everyone else — increasingly participate in the developing "globalization" of planet Earth, the potential for painters to have their ideas formed by numerous cross-currents is more vast than ever before.

This book is concerned mostly with painting as it is practiced today within the United States. Even within that less-than-global field, we do not claim to be covering all the significant forces at work. Artists in the United States comprise a multi-ethnic, experientially diverse population. As students, many of you probably share some common ground (classes, television programs, music, fashions in clothing), but otherwise are pulled in different directions by other forces — economic, ethnic, religious, political, familial. The word *hybrid* is sometimes used to describe the notion that a person's ideas and be-

haviors derive from an intermingling of sources. The situation is dynamic and in rapid transition.

Our approach to teaching painting is also a hybrid. We acknowledge a starting place in the so-called "Western tradition," and recognize that some of the techniques and formal principles taught today in art departments in the United States (at least at the beginning levels) derive from the way painting was taught in the European academic system. Our program of study includes many of these academic techniques and principles, although we offer ways to update and move beyond those conventional uses. We also know that in the United States in particular, the "tradition" has always been one of exchange and intermixture of cultural influences. Our program of study incorporates many approaches developed outside the Western academic system, approaches which are doing so much to broaden and revitalize contemporary painting. Our illustrations recognize and honor the multifaceted approaches to painting as it is practiced by artists active in the United States. We also occasionally illustrate painters' achievements in non-Western cultures in order to hint at painting's vast history and global diversity.

There is no one right way to paint, no one technique or kind of paint, no single purpose or single subject matter for painting. Painting is about choices. We aim to show you some of the amazing variety of choices and to help you develop your critical faculties so that you are empowered to make decisions about how and what you want to paint. Above all, we urge you to be open to experimentation and your own potential for growth and change.

As society rushes headlong into the future, and the cultural landscape appears to be increasingly dominated by modes of electronic communication, the practice of painting remains a vital endeavor. As a painter, you are engaged in freedom of thought and bodily movement, a heightened awareness of sensory input and sensual textures, an unlimited opportunity for emotional expression, and the exploration of a captivating means of communication that stretches back to the dawn of human history.

1 *Getting Started*

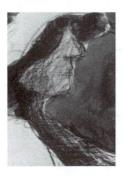

As a painter, you participate in an activity that humans have practiced for at least 15,000 years, since Paleolithic people at the end of the last Ice Age are known to have created images on cave walls in France and Spain (Figure 1.1). Prehistoric painted images also have been found on rock walls in Africa and Australia. Because of the fragility of paint materials and the ravages of time, there is no way of determining where and when the practice of painting initially began. In fact, as a way of image-making, painting may have developed independently in multiple social settings, at dispersed places around the globe. What we do know is that over the past one hundred and fifty centuries, the art of painting in its multiple guises has been actively pursued by people in many diverse societies.

WHAT IS A PAINTING?

What is a painting? The simple answer to this question is: a painting is any artwork which is painted. This definition, while having the advantage of being grounded in common sense, leaves the door open to such follow-up queries as, What is an artwork? Are all objects that are painted paintings? For example, is a painted fence or the painted wall of a house a "painting"?

As we shall see in later chapters, some painters make artworks that combine other materials and textures (such as photographs or sand) with paint. So we might say that a painting is whatever a painter makes. While the contemporary art world places great emphasis on just this aspect of our definition (to the degree that painters are often judged successful if they push the definition of painting beyond traditional notions), for our purposes this answer merely substitutes one unknown for another. If a painting is what a painter makes, then who is a painter? Unless we are careful, we soon find ourselves circling back into the endless loop of a tautology.

Answering the question, "What is a painting?", requires more careful thinking on our part. Perhaps we can slip free of what looks increasingly like a philosophical riddle by reframing our opening question as, "What is a painting made of?"

As we will explore in the chapters that follow, paintings consist of four interactive layers of meaning: physical materials, painting techniques, formal elements, and

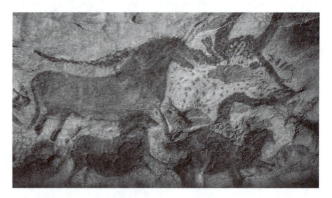

1.1 Anonymous artist/s, Cave paintings of horses, Lascaux, France, c. 15,000–9,000 B.C.E.

cognitive (intellectual) meaning. Each is integral to the impact a painting makes upon a viewer.

What is a Painting Made of? Physical Materials

A painting is an object, or, more precisely, it is the tangible painted image or design adhered to an object as well as the object itself. Like all objects, paintings are created out of physical materials. (Indeed, this statement remains true even with the so-called "paint" software programs designed for use with computer technology.)

The physical materials most paintings consist of include the paint itself and the surface upon which the paint is applied. The paint itself is composed of *pigments*, *medium*, and a *binder*. The surface to which paint is applied is called the *support*. We discuss these terms below. More extensive descriptions of various materials available for use by painters are provided in the next chapter.

Pigments

Pigments are the colored elements from which artists' paints and pastels are made. Pigments exist in a dry form as small, colored particles of fine powder. These particles of pigment are insoluble, but can be suspended in various oils, water, and other liquids. The result is the spreadable colored material known as paint. Pigments derive from a variety of sources, including plants, minerals, ores, and chemical compounds. They may be found naturally or made synthetically. Most likely you will not be working with pigments in dry form; instead, you will buy tubes of paint in which pigments are already combined with a liquid substance.

Medium and Binder

Definition #1: The term *medium* is used for the liquid within which pigment particles are suspended to form paint. The *binder* (or "vehicle") is the substance mixed into paint to make it adhere to a surface once it dries. Sometimes the medium and binder are the same substance. In oil paint, for example, the same drying oil serves as the medium and binder. In watercolor, by contrast, water is the medium while water soluble gum is the binder.

Types of paint are commonly named according to the type of medium. Oil paints are formed with a vegetable oil, most commonly linseed oil. In watercolors, the pigments are combined with water, which evaporates upon application, leaving the color as a dry residue on the surface of the paper or other support. Acrylic paints are made from an acrylic resin (a form of synthetic plastic) that is polymerized and dispersed in water.

Definition #2: In painting, the term *medium* also refers to the additional liquefied substances an artist can add to paint to alter its consistency. Although paint can be applied directly from the tube, paint used in this way is often thick and somewhat difficult to spread with a brush. Typically you will add extra liquid to thin the paint. The extra liquid may be more of the original medium; frequently, it is a mixture of several liquids. In addition to thinning paint, various recipes for mediums are designed to achieve certain special effects, such as increasing the relative transparency or gloss of the paint film. Susan Rothenberg's painting *Butterfly* (Figure 1.2), for example, combines acrylic paint and matte medium on canvas. (Matte medium is a polymer emulsion that dries to a nonglossy appearance.)

Further information about the ingredients and working properties of various mediums for oil painting and acrylic painting is provided in the next chapter. Throughout the book you will see examples and undertake various exercises exploring the use of specific painting mediums.

Definition #3: As if things weren't confusing enough, *medium* has a third meaning: it refers to the type of materials an artist uses to make an artwork. Defined this way, the medium might be bronze or wood (examples of materials a sculptor might use), or, for a painter, the medium might be oil on canvas, acrylic on paper, or some other combination of paint and the physical surface to which the paint is applied. To avoid uncertainty, throughout this text we will restrict our usage of medium to the first two definitions only: paint and the liquids you add to paint to alter its consistency.

Support

The *support* is the physical surface to which an artist applies paint. For the past four hundred years in the West, canvas fabric has served as the most common support for oil (and now acrylic) paintings. The canvas is usually stretched onto a wooden framework (called a *stretcher*) to make it taut enough to paint upon. Other materials have been favored as supports for other types of paint and in other periods and parts of the world. The support for a cave painting at Lascaux, for example, is the rock surface (Figure 1.1).

Paper is the preferred support for watercolor paintings as well as for paintings done in ink or *gouache* (an opaque version of watercolor mixed with extra gum arabic and an opaque substance, often chalk). There is a long tradition of painting on paper in many cultures of Asia and the Middle East.

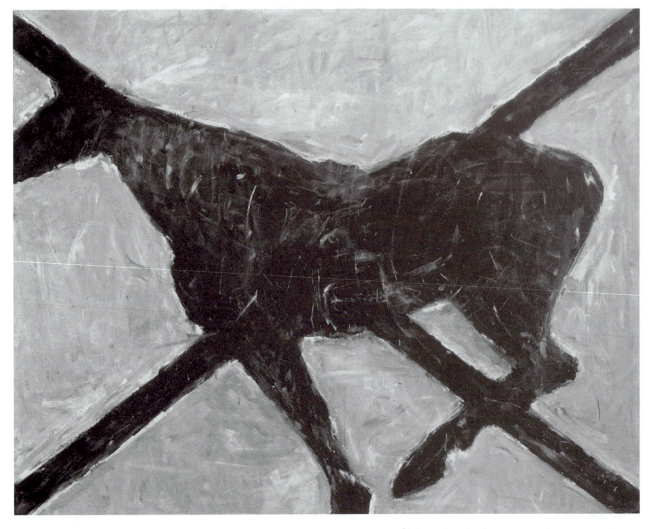

1.2 Susan Rothenberg, *Butterfly,* 1976. Acrylic and matte medium on canvas, 69 ½″ × 83″. Gift of Perry R. and Nancy Lee Bass. Copyright © 1998 Board of Trustees, National Gallery of Art, Washington.

Wooden panels were a common support in Europe in the Middle Ages. Even today, many oil and tempera painters who wish to produce highly detailed images select wood or masonite panels in order to take advantage of their extremely smooth, hard surfaces. Painting on wood is also prevalent in folk art traditions of Europe and North America. Moreover, the painted decoration of wooden objects has been practiced in cultures across the globe, including many in Africa and the Pacific Islands, and among many Native American cultures.

An array of other materials have served as supports for paintings in the past and today, including animal hides, cardboard, papyrus, silk, plaster, metal sheets, glass, Plexiglas, and found objects. Moreover, the support for a painting is not always portable. As we said at the start of this chapter, the oldest known paintings were created on rock walls. Throughout history there has been a vital practice of creating large-scale images on architectural walls, from the tomb paintings of ancient Egypt, to the fresco paintings of classical Greece and Rome, to the revival of fresco in the Italian Renaissance, to the twentieth-century murals made by painters in Mexico and the United States in the 1930s, to urban memorials painted on the sides of buildings today.

What is a Painting Made of? Techniques

Paint is applied to a support utilizing any one or a combination of techniques. For example, a painter may choose

to paint with opaque brushstrokes, intending each mark to cover that portion of the support to which it is applied. Alternatively, a painter may choose to apply paint in transparent or translucent layers, so that the final image is the result of a slow buildup of paint. Depending on their materials, various types of paint may require different techniques for their application (encaustic paint, for example, requires heating wax to a molten state). We discuss the primary characteristics and approaches of many basic painting techniques in Chapter 2.

The technique used by an artist contributes to a painting's visual appearance. For instance, applying paint in a technique utilizing smooth, blended brushstrokes may enhance an effect of photographic realism. Indeed, some artists and writers even utilize the term "technique" when naming the resulting visual style — "photorealistic technique," for example.

What is a Painting Made of? Form

By means of techniques, the physical materials of a painting are arranged into forms. While the term *form* is applied in several ways, in each case it refers to the specific and actual appearance of something.

First, the form is the overall physical structure of the artwork itself, a structure of specific dimensions and shape. For instance, the form of a painting might be a rectangle with outer dimensions of 48 inches in height by 36 inches in width by 3 inches in depth (from the front surface of the canvas to the back of the stretcher).

Second, a form is the specific representation of an object or figure within an artwork, such as the form of a male nude in a painting. (In a related usage, form is the appearance of an actual object in the real world, such as an object a painter observes when he paints from life.)

Third, the paint itself is given form as points, lines, shapes, colors, values, textures, and volumes. Together these are known as *formal elements* (they are also called *visual elements*).

Finally, the formal elements are grouped together in an overall arrangement called form (also called *composition*).

Within a composition, the formal elements interact with one another to create design and spatial relationships (including balance, stress, dimension, direction, movement, and scale). See, for example, how the various shapes in Rothenberg's painting (Figure 1.2) interact with one another within the overall composition. We analyze examples of these relationships in ensuing chapters.

While a painting's formal elements are customarily embodied in paint, painters have also experimented with the attachment of nonpaint materials (such as photographs or words cut from newspapers) as well as with the alteration of the overall shape of the support itself. Later in the book, you will try creating multi-part, non-rectangular, and even nonpaint paintings.

Each of the formal elements can be discussed independently, and this is often useful for instructional purposes. But you must also learn how these same formal elements operate within the context of the entire composition. We see a painting as a visual phenomenon in which the whole is more than the sum of the parts. From an overall perspective, we observe the broad characteristics of form known as *style* that recur in the paintings of an artist, group of artists, or even an entire culture or period of art. The style of Rosa Bonheur's painting (Figure 1.3), for instance, is more *naturalistic* (more natural looking) than the style employed by Catherine McCarthy in *Riding Through Streams* (Figure 1.4). Rather than creating one continuous space within which to embed her subject, McCarthy superimposes various whole and fragmented treatments of her subject across the picture plane.

Visual experience is dynamic. We do not perceive a painting as an undifferentiated mass of physical material nor as a static mosaic of lines, shapes, colors, and textures. Formal elements coexist in the painting's composition; their interaction creates a field of active forces. Colors may appear to vibrate; a shape may pulse with energy as it appears to be in perfect balance with other shapes and a corner of the canvas.

What is a Painting Made of? Cognitive Meaning

From our discussion so far, we know that a painting is composed of physical materials that an artist has shaped into a specific form through the use of one or more techniques. But things don't stop here. A painting also contains *cognitive meaning* (sometimes referred to as cognitive content). The cognitive meaning of a work of art includes its intellectual, symbolic, emotional, thematic, and narrative connotations. Cognitive meaning is interrelated with the other three components we have discussed: cognitive meaning derives directly from the materials and forms of the painting and the techniques the artist has employed. Cognitive meaning also derives from outside knowledge (such as familiarity with religious symbols, patterns of social behavior, and knowledge of other paintings by the same artist) which the viewer and artist utilize in the process of interpreting a specific painting's meaning.

Focus On

PAINTINGS OF HORSES
Figures 1.1, 1.2, 1.3, and 1.4

To illustrate the complexity and subtlety of how paintings communicate and are interpreted, we observe that paintings sharing the same subject matter may otherwise communicate vastly different messages. For example, you may have noticed that the four paintings illustrated so far in this chapter feature images of horses. But is their content identical?

Bonheur (Figure 1.3) gives a virtuoso demonstration of how closely a painter can replicate the appearance of a real horse. Indeed, the artist based her style on direct observation of live animals and firsthand study of anatomy through visiting slaughterhouses. Rothenberg (Figure 1.2) tests how a painted image of a horse can hover at the edge of abstraction. While Rothenberg appears to be using the horse shape mainly as a means to explore formal "painterly" issues of balance and composition, Bon-

heur takes us outside the painting to a consideration of aspects of the relationship of humans to animals. The prominence given to the magnificent horses through lighting and dynamic poses compared to the insignificant humans at their side communicates Bonheur's belief in the superiority of animals.

In her painting (Figure 1.4), McCarthy juxtaposes snippets of verbal text with images of horses. On closer inspection, we find the equine images change before our eyes—from ordinary animals to dreamlike beasts; some are even centaurs: half horse and half adolescent girl on the edge of sexual maturity. The total effect of the painting is a wonderfully engaging exploration of the process of growing up and a joyous celebration of giving free rein to one's imagination. We undertake a more extended examination of the possibilities of narrative painting in Chapter 10.

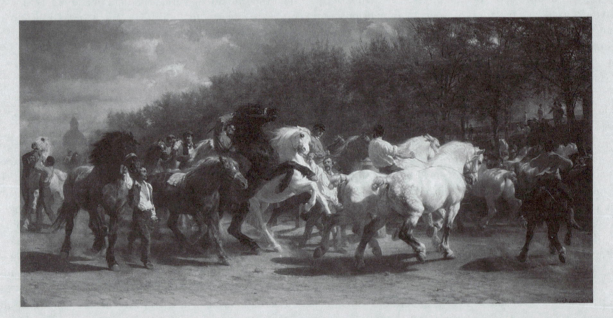

1.3 Rosa Bonheur, *The Horse Fair*, 1853. Oil on canvas, 94 $\frac{1}{4}$" × 16' 7 $\frac{1}{2}$". The Metropolitan Museum of Art, Gift of Cornelius Vanderbilt, 1887. (87.25)

(continued)

Finally, while we can only speculate as to what the Paleolithic artists who painted the horses on interior cave walls meant to communicate, to us the images stand in part as testimony to the persistent efforts by humans in all times and places to make sense of their surrounding world (Figure 1.1). In sum, despite sharing equestrian subjects, each of these artworks evokes a varied response from viewers.

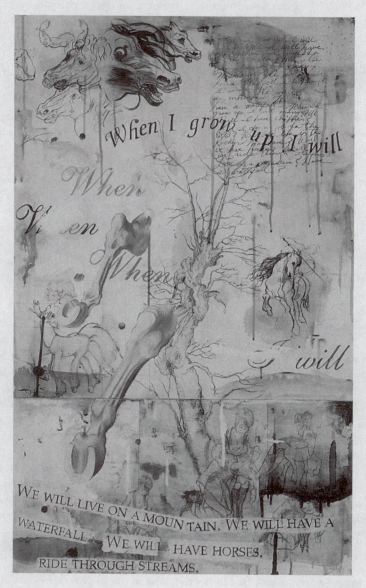

1.4 Catherine McCarthy, *Riding Through Streams,* c. 1990s. Oil on canvas, 38″ × 24″. Courtesy of the artist.

CONTENT

We use the term *content* to refer to the total meaning of a work of art. A change in any one of the four "active ingredients" necessarily alters the overall content of the painting. For each viewer, the content of a painting is the sum of how that viewer makes sense — makes meaning — out of the interaction of the materials, techniques, form, and cognitive meaning the painting is made out of.

Content is not identical with *subject matter*. Subject matter is whatever a painting depicts, that is, its imagery. Throughout history, in most cultures, the subject matter of paintings has usually been *representational* — imagery which a viewer can recognize and name, such as fruit, horses, trees, a person, a goddess, and so on. But subject matter may be *nonrepresentational* — imagery that does not refer to anything tangible that exists outside the painting. In the latter case, the subject matter might be a series of squares of various colors. Figure 1.2 combines representational subject matter — a horse — with nonrepresentational subject matter — an X shape.

Being able to identify the subject matter does not mean you know what a painting is about or all that it is about. The content of a painting is what we interpret as its overall meaning; this meaning derives from the subject matter as it is communicated through medium, form, and technique. As noted, the content is affected by additional cognitive information that is invested in the painting and influences the context within which it is understood, such as our knowledge of the artist's biography or the social conditions prevailing at the time the painting was created.

Like other forms of communication (such as spoken and written language, music, mathematics, and even what is popularly known as "body language"), painting has a special vocabulary along with guidelines for making effective use of that vocabulary. Because the vocabulary of painting is visual, for both artist and viewer a painting is first and foremost a visual experience. While this point may seem obvious even to the raw beginner, its implications are all too frequently overlooked or ignored. The content of a painting is never fully translatable into words; there can be no complete verbal reenactment of a painting since a painting's specificity of meaning and effect are borne, color by color and brushstroke by brushstroke, by its visual language.[1]

That a painting employs visual means, however, in no way necessarily limits the purpose of a painting to a description of what can be seen with the eyes. Indeed, paintings that ostensibly have similar subject matter may communicate vastly different meanings. One painter may intend to create a straightforward description of what fruit physically looks like; another may use fruit to symbolize other meanings, for example, depicting blemishes on pears to suggest the fragility of life. Paintings are conceived for many different reasons: to describe the physical world, tell a story, impart a moral lesson, express emotion, pay homage to a political leader, protest injustice, provoke social change, or simply provide a new look at the relationship between two colors. Many contemporary paintings are created, at least partially, for the purpose of challenging previous notions of what a painting is (i.e., what a painting is made of, to use our own terminology).

The fact that a painting employs visual means does not mean that we should judge its success strictly in terms of visual criteria. While we may be charmed by the subtle color scheme of one painting and the verisimilitude of another, our admiration sometimes stems primarily from the force of the artist's expression of emotion or from the intellectual challenge of the artist's ideas. Many of the most intriguing paintings seem to operate simultaneously on visual, emotional, and intellectual levels.

We perceive a painting via our senses and simultaneously become engaged in the process of making sense of the painting. This is the process of interpretation. We may interpret a painting in a highly conscious and carefully structured manner, or we may apply a more intuitive process.

We each come to a painting with a considerable range of knowledge about how to look at and interpret visual sensations, including whatever past learning we have had regarding pictorial images in general and paintings in particular. As viewers, we may bring to a painting an understanding of the social conditions under which the work was created, and knowledge of other paintings by the same artist. These color to some degree how we conceive meaning.

While some theorists believe that the content of a painting stems entirely from the painting itself (mostly produced by the painter's intentions), and others believe that the content is "authored" by the viewer (whose interpretation, in turn, is controlled by the indoctrinating influence of society), we believe that content is established by a combination of forces operating in both directions. This forms the basis of our approach to learning to paint with power and purpose: you learn to tap into that

which bears the strongest personal meaning for you; and you learn to express meaning by using the visual language of painting in ways that communicate effectively to a wide range of viewers.

PAINTING AS A LANGUAGE

The title of this book is *Painting as a Language: Material, Technique, Form, Content*. It might have been simpler (and intellectually less risky) to title the book, *Learning to Paint: Material, Technique, Form, Content*. But we elected to use *Painting as a Language . . .* because we wanted to emphasize, as a primary feature of our pedagogical point of view, that paintings have content and that the practice of painting is a form of communicative behavior. The title emphasizes that painting is a mode of producing and embodying symbolic meaning, and that this mode of producing and embodying meaning (the practice of painting) is like a language, at least metaphorically. Painting is a language with its own visual lexicon (forms, materials, and techniques that interact to embody meaning), and it incorporates conventional knowledge of "grammar" (how earlier artists arranged and related painting's visual qualities into meaningful constructs). Our approach asserts that painting is a language that possesses an inexhaustible capacity for constructing meaningfulness, including the constant potential for each painter to evolve new "dialects" involving his or her own idiosyncratic approach to form, materials, techniques, and cognitive meaning.

Furthermore, the title initiates a confrontation (a fruitful intellectual exchange, we trust) with those readers who may come to the study of painting with any number of received notions. By foregrounding the idea of painting as a language, we purposely challenge any notions that paintings are primarily made for decorative or strictly formal purposes (art for art's sake), or that the one and only proper goal for all paintings is to portray accurately the visual appearance of a specific real-life subject, or that the one and only proper goal for all paintings is to serve as a means for the individual artist's expression of emotion. While all these, and more, have undeniably been valued goals for painting at specific moments in the cultural history of various societies, we have aimed to write an introductory text that serves the wider needs of developing artists at the dawn of the twenty-first century.[2]

Modes of Pictorial Representation

Throughout history, the vast majority of paintings have incorporated images that function as representations of something else. All such images serve as signs for the represented subject matter. But the relationship of the image as a sign to what it signifies, what it represents, is often overlooked. We readily understand that although a square with two small triangles on top can serve as a sign for the head of a cat, the image itself is not really a cat. On the other hand, we may overlook or lose sight of the fact that a highly detailed, seemingly naturalistic representation of a cat is a sign as well, and differs significantly from any actual cat (the image is flat, the fur is only paint, and so forth). Bonheur's horses (Figure 1.3) are no more alive than McCarthy's (Figure 1.4).

In progressing through the chapters of this text and looking at the various examples of paintings that are illustrated, it is expectable that many readers will presume that some paintings are more accurate, more lifelike, more naturalistic in terms of their effectiveness in representing a subject. We wish at the outset to call into question such a presumption, for two main reasons. First, any presumption of what it means to be "accurate, lifelike, naturalistic" is, itself, the result of conventions, conventions which are artificial and culturally determined. Secondly, the presumption leads, too often and too swiftly, into another presumption: that any painting which is thought to be more "accurate, lifelike, naturalistic" is necessarily better than another which is deemed to measure less on this particular gradient. This presumption is also artificial and culturally determined; a goal of this text is to encourage you to become more fully aware of how the conception of painting as a language empowers you, as both a potential creator and viewer of other artworks, to explore painting broadly and to examine all rules and traditions with an open mind.

Research and Discussion Exercise

What Is Realism?

What does it mean to paint "realistically"? There may be as many answers as there are cultures with traditions and

Focus On

PAINTINGS OF ANIMALS
Figures 1.5, 1.6, and 1.7

Figures 1.5, 1.6, and 1.7, made by artists in very different cultures, show the use of different symbolic conventions to represent animals.

Figure 1.5, made by a Tlingit artist from the Northwest Coast of North America, is an image of a brown bear painted on a huge wooden screen. Tlingit painters frequently use animals as subject matter, and share highly conventionalized methods for rendering them, including the simplification and exaggeration of characteristic body parts, which serve as signs to identify the entire animal. Rounded upright ears and a wide head are signs for a bear, for example, as in Figure 1.5. Among other conventions of Northwest Coast art adhered to in this painting are the use of frontality and *split representation*: an approach in which the image of the animal is divided into two equal halves, and body parts are flattened and rearranged so that all parts are visible in a symmetrical design. Another convention is to fill empty spaces, such as ears, eyes, nostrils, and other body cavities with faces and in some cases complete animals. The image as a whole also functions as a sign: the brown bear is an emblem which signifies the clan of the Tlinglit chief for whom this screen was made.

Bruce Nabekeyo, an Aboriginal Australian artist, made Figure 1.6, painting in earth tones on a sheet of tree bark. Known to us as bark painting, this is an ancient method (although only recent examples exist since the medium is impermanent). The artist represents the serpent in an "X-ray" image showing both its outside and inside, a characteristic convention in Aboriginal art from northern Australia. The water lilies on the serpent's back symbolize the water where she lives. The Aboriginal audience for whom this bark painting was made would have immediately recognized the image as an episode from a creation myth about the serpent Yingarna, that swallows and regurgitates humans.

Finally, Figure 1.7 was painted by Giacomo Balla, who was a member of the movement known

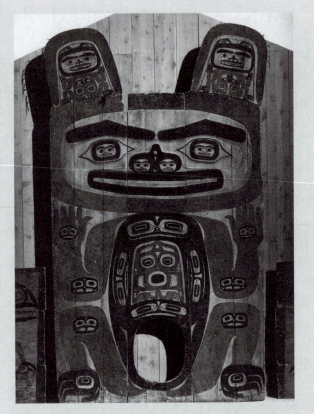

1.5 Tlingit bear screen, c. 1840. Wood and paint, 15′ × 9′. Native Arts, American Indian. Denver Art Museum.

as *Futurism*, launched in Italy in 1909. Futurists wanted to create a new art built on sensations of speed and dynamic movement. Balla's decision not to show the dog as a static form with a single fixed contour results in an eye-catching strategy for representing a moving subject in a painting. We easily understand the repetition of the forms of the feet, tail, and leash as signs for a person walking a dog. The convention is unusual but not arbitrary; by Balla's time, advances in stop-action photography had taught many people to understand movement as just such a closely repeated sequence.

(continued)

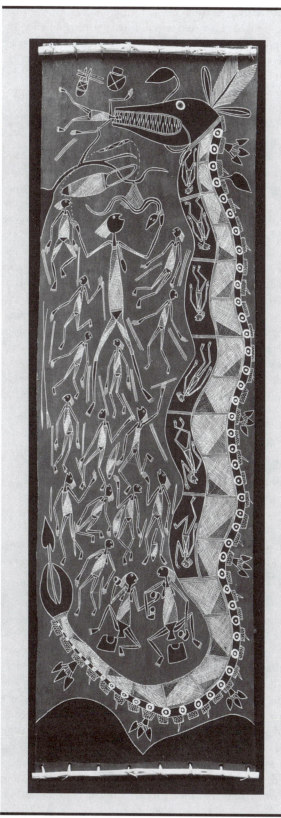

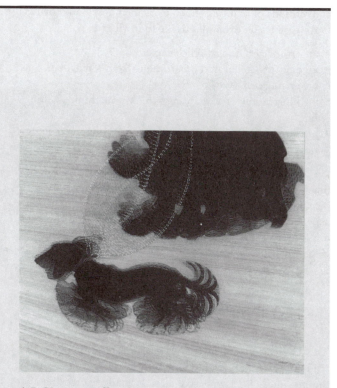

1.7 Giacomo Balla, *Dynamism of a Dog on a Leash*, 1912. Oil on canvas, 35 3/8″ × 43 1/4″. Albright-Knox Art Gallery, Buffalo, N.Y. Bequest of A. Conger Goodyear and Gift of George F. Goodyear, 1964.

1.6 Bruce Nabekeyo, *The Rainbow Serpent, Yingarna*, 1989. Natural pigments on eucalyptus bark, 150 × 404 cm. National Gallery of Australia, Canberra.

conventions of painting. Each class member should bring in for discussion examples of the following:

- an ordinary photographic snapshot;
- a computer-generated illustration (from a magazine or other source);
- an illustration of a painting which you think is "life-like";
- an illustration of a painting from a culture you have never researched before.

Discuss what you mean by "realism," attempting to find ways that each image you have brought in for discussion can be said to represent (at least partially) an aspect of visual or physical reality. In other words, strive for a more rather than less expansive understanding of visual realism.

KEEPING A STUDIO JOURNAL

This book uses informal writing as a tool to help you, a student of painting, unlock your creativity, understand the meaning of art you have already made, gauge the effectiveness of paintings you are working on, and explore new avenues for future images. The book is based on the premise that expressing yourself in a personal voice in writing will help you to discover your personal voice in painting; formulating into words your reaction to a painting (in progress or completed) will foster an increased awareness of how a painting functions as a complex, visual form of communication. While painting is anchored in the visual, its analysis for the artist and the viewer operates in both the visual and verbal realms. Articulating your thoughts about painting in words should be an invaluable and integral process in learning to paint.

Keeping a studio journal, in fact, has been an important practice for many artists. Such notable painters as Leonardo da Vinci and Max Beckmann (Figure 5.1) used journal writing as a way of working out their ideas, making sketches, recording information, and analyzing their progress on specific projects. Moreover, many painters have published their thoughts on studio techniques, artistic purposes, the creative process, and philosophical content in books and essays.

Using Writing to Explore Content

When and why should you, as a student of painting, use the process of writing?

- SOMETIMES: Early in the painting process, or even before you have started a painting, we recommend undertaking an occasional writing exercise to help you discover new, different, or deeper ideas for a painting. Journal writing can help unlock your creativity by pointing the way to topics and ideas of strong, personal interest, perhaps recovering memories of events and subjects that once held strong emotional attachments for you.
- OFTEN: During the late stages of the painting process, an informal, written analysis of your painting-in-progress can be an invaluable aid to discovering what you *now* think your painting means, and how effective you judge each part and the whole are in embodying and communicating this meaningfulness.
- ALWAYS: Write at the end of the painting process, when you are preparing to discuss and share your ideas about your painting's development and meaning to others, for example, in advance of a group critique. Articulating your thoughts into writing will make your own thinking clearer and will help you become more effective in articulating your thoughts to others. Gauging what we, as artists, think a painting means to us, and comparing its effect on others, is an invaluable step in developing our artistic vocabulary and skills.

Guidelines for Journal Writing

Supplies

The only supplies you need for the writing exercises in this book are a pen or pencil, paper, and a folder or notebook to collect your responses. Or you may choose to write on a computer (perhaps keeping all entries together under one file labeled "painting journal"). It is a good idea to keep all the responses in one place so you can refer back to them easily.

When and Where to Write

You should respond to journal exercises as soon as possible after they are assigned, and certainly before a class where responses will be discussed by the group. You will find that writing goes more smoothly when you do it frequently, just as a physical activity becomes easier as you practice it. You will reach deeper insights because today's writing will build on that of yesterday and the day before.

Your teacher may direct you to undertake a writing exercise during class time. Outside class, you should set aside at least twenty minutes when you won't be interrupted for each journal exercise. That is the minimum amount of time you need to let a train of thought run

freely as you write. Some exercises require more than twenty minutes.

When and where you write is not important as long as you can be alone with your thoughts. Experiment with different times and places to write, and discover what works best for you.

Who Will Read the Journal?

Your teacher may want to collect your journal from time to time to assess your development. Otherwise, you are the primary audience for your writing. While some of your writing will serve to clarify your own thinking before engaging in a group discussion, most often you are writing to inform yourself about the development of an individual artwork and to explore who you are as an artist and what experiences, ideas, feelings, and perceptions you want to express in your art. You should record insights about yourself openly and honestly.

If you are using this book for a classroom text, you may be discussing responses to the exercises as a group. You will quickly learn that many people want to share their writing. But no one should feel pressured to share private material who doesn't wish to. You may discuss your general reactions to an exercise in class if you don't want to talk about specific details of what you wrote. Hearing many painters' responses to the same journal exercise is an invaluable experience. You see your own perspective more vividly when it is put up against a broad curtain of other viewpoints. You may expand or change your perspective under the impact of different ways of thinking about an issue. Moreover, you gain a more complex awareness of diversity, which promotes tolerance.

How to Write

The journal exercises do not require you to use the formal language you would need for an academic research paper. Instead, use your personal voice, language that comes naturally to you. Don't struggle to sound witty or brilliant. Just write your thoughts in the same way you might say them aloud to a trusted friend. Using a natural voice in writing can be a means of finding your personal vision in painting.

Take risks and write freely. The exercises should be taken as suggestions for self-reflection and catalysts to inspire your painting, not as ironclad directives. Many exercises are in parts, and you may find that you only want to respond to one of the parts. You may also choose to complete longer exercises in stages, over more than one session of writing.

Deviate from the exercises whenever you wish. Follow a renegade train of thought if it calls you forward. A branching path might prove to be the right direction for you.

Think of your responses as opportunities to think out loud on paper, not as finished, polished documents. If you decide later that you want to use sections of your writing for an artist's statement or other public communication, you can always go back to revise and edit.

You should date each piece of writing and give it a brief title — probably the same title as the exercise — to help you sort through your writing later.

Directed Freewriting

When you freewrite you write for a specified period of time without stopping. Usually you begin with the first thought that pops into your mind and start to write spontaneously without worrying about what will come next, using a stream-of-consciousness technique. If you want a variation, begin with a certain question or idea, then write freely in response to that catalyst. The latter kind of *directed freewriting* is the approach we suggest in most exercises in this book.

For directed freewriting, read the exercise carefully, then spend at least twenty minutes writing down continuously every thought that comes into your mind in response to the issues and questions raised in the exercise. You do not have to write rapidly but you should write steadily without stopping and without going back to reread what you have written so far. Write phrases and words if complete sentences don't come to mind. When the twenty minutes are up, you may reread what you have written. Then, if you wish, add any other thoughts that occur to you.

Relaxation

Try to put yourself in a meditative state of mind before you begin to write. Turn off the television and radio. Sit in a comfortable chair. Stare at an object in front of you and empty your mind of distracting outside thoughts. Relax every part of your body. Close your eyes and slowly breathe in to a count of eight, then slowly exhale. When you feel ready, open your eyes. Pick up your pen and begin!

VISITING MUSEUMS AND LIBRARIES

We strongly advocate that you look at as many paintings as possible while you are learning to paint, from all

places and periods. At first the variety may seem overwhelming, but gradually you will become familiar with the conventions employed by certain cultures and individual artists and will be able to discern the subtle qualities that distinguish the most compelling paintings made by a particular culture or artist. Take from these paintings what you can: try out techniques, materials, compositional schemes, formal devices, subject matter, and cognitive ideas that intrigue you in the paintings of other artists. Learning by imitation is a time-honored practice and, indeed, in numerous societies recreating traditional styles and approaches has been considered the proper goal for mature artists.

The best way to see art is to see it firsthand, in museums, galleries, and other public collections, artists' studios, and private collections, if you are lucky enough to know someone who owns a lot of art. *There is no substitute for the real thing*. Reproductions of paintings in books, magazines, on the Internet, and elsewhere are convenient, but they give an incomplete and distorted view. An obvious distortion is *scale* (the size of a painting). With rare exceptions, the scale of a reproduction in a book is never the same as the actual painting, and the reproduction can be extremely misleading. Did you realize, for instance, that Bonheur's painting of horses is over 16 feet wide (Figure 1.3), eight times the size of the painting by McCarthy to which we compared it (Figure 1.4)? The grandeur of Bonheur's horses is unforgettable for a viewer in front of the actual painting. Reproductions of paintings also misrepresent surface textures by reducing variations in brushstrokes; with black-and-white illustrations, important color relationships are eliminated.

We urge you to visit local museums and art collections in your community, and visit them often. Great paintings are inexhaustible; there is always something else to be learned by seeing them again. Travel to cities in your region to see some of the great collections of paintings available to the public. Start saving your money and planning a trip to another country: the visual and intellectual charge of visiting a different culture is invaluable for an artist.

With all this said, we realize that if you were only to look at paintings in person, you would never know about most of the work that has been produced in history and the new paintings being created today. Thus we highly recommend looking at reproductions of paintings in any and all sources, as long as you keep in mind that you are seeing substitutes for actual paintings. There are many high quality art books in print. Increasingly the Internet gives you access to electronic simulations of museum exhibitions and collections. The more you see, the more

you will get ideas for your own paintings. Remember, a picture is worth a thousand words: open your eyes and look at what paintings have to teach you!

USING DRAWING TO PREPARE FOR PAINTING

In addition to undertaking the writing exercises outlined in this book, your approach to painting should be augmented by the regular use of a sketchbook. Using a sketchbook provides you with a convenient means of developing and recording visual ideas — possibly even ones that occur to you while doing one of the writing exercises or looking at paintings in museums or artworks reproduced in books. Some artists utilize the same studio journal for recording written thoughts and visual sketches. For larger sketches you can utilize additional sheets.

We strongly encourage the use of drawing as a way to try alternative approaches to a composition prior to starting the actual painting. If you have had previous training in drawing this should help you develop painting skills, because many of the same principles of composition apply to both. Moreover, while drawings are often finished artworks in themselves, artists also use drawings to plan paintings. For example, a study in black, white, and shades of gray may be done in order to plan the value relationships of a painting to be completed in full color.

Richard Diebenkorn's pencil and ink wash sketch, entitled *Seated Woman with a Hat* (Figure 1.8), is just such a study. Diebenkorn preferred to use drawing as a way to respond directly to the living model; typically his compositions for paintings were developed later in the studio.[3] Compare the drawing with Diebenkorn's oil painting, *Seated Figure with Hat* (Plate 1). While the positions of some body parts have been altered in the painting, many *value* relationships (relationships of darkness and lightness) remain the same. In both, the heightened contrast between light flesh tones on the near arm and the darker top of the figure's clothing help bring that arm closer. The shadowed face, in reduced contrast to the background, recedes in space. We examine Diebenkorn's use of color in this painting in the next chapter.

Tips for Using a Sketchbook

Draw a margin on all four sides of each sketchbook page prior to using it. Most artists are inhibited from drawing

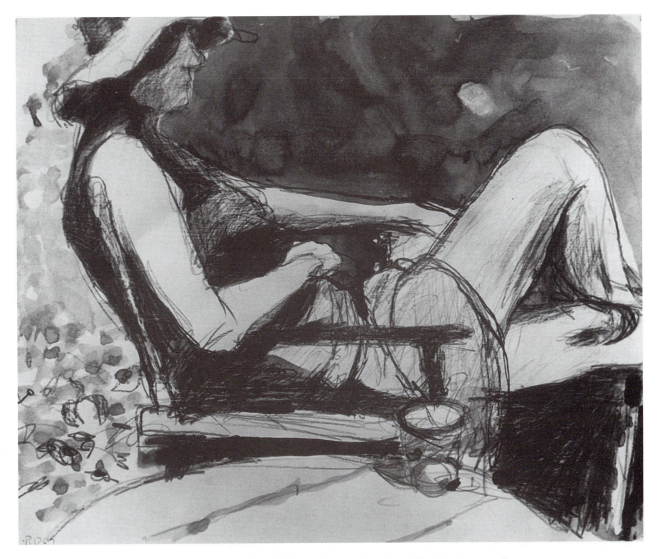

1.8 Richard Diebenkorn, *Seated Woman with a Hat*, 1967. Pencil and ink wash, 14″ × 17″. Private collection.

right to or intersecting the edge of a page, and without a margin your compositions will not utilize the full space. Drawn margins will encourage you to consider the entire picture plane as you develop a composition, allowing you to work to the edges and into the corners.

Sketch often!

DEVELOPING HAND AND EYE SKILLS

We do not advocate any attempt to confine painting to one tradition or "canon." Nevertheless we support the need for beginning painters to develop certain skills and certain knowledge: particularly hand skills at mixing and applying paint; perceptual skills at observing visual reality and translating perceptions into paint; conceptual knowledge of fundamental terms and strategies; and intuitive, nonverbal knowledge (what some writers call tacit knowledge) as you learn by doing how *your* paintings are made.

Many exercises in the early chapters of the text stress learning to paint in a representational mode (again, paintings which represent subject matter in an identifiable way). Learning to paint a subject so that it is identifiable challenges the beginning painter to coordinate the processes of looking, seeing, and mark making. No matter which style (or styles) of painting you may ultimately

develop, learning to respond to the visual qualities of a subject in front of you should enhance your development. Moreover, many historic cultures around the world developed varieties of realistic representation, and representational visual art remains a strong current within the practice of contemporary painting.

Research in Visual Perception

Research in the process of human vision has established that what we think we see often differs in significant ways from the image that actually falls on the retina. While even a modest summary of recent experimentation and theorization in human vision is beyond the scope of this text, we believe it is valuable for you, the developing painter, to recognize that you cannot rely strictly on painting things as you *think* you see them and expect to achieve an accurate naturalistic representation.[4] The human mind operates automatically in ways that often value identification more than perception. While we look with our eyes, we see with our mind. Perception and conception are intricately linked together in the process of human vision. Two examples: experimental evidence suggests that humans are prone to what psychologists call "size constancy" and "shape constancy." Our minds tend to make corrections so that in looking at distant identifiable things we "see" them as if they were closer to their known size, and in looking at identifiable shapes we "see" them corrected so that they aren't turned away from us at odd or acute angles. Such mental corrections are quite effective in helping us to identify the things we are looking at, but they also serve to thwart the artist who wishes to paint with perceptual accuracy.

Artists have developed strategies to overcome the conceptual nature of human vision. If the goal is to paint what your retina sees and not what your mind knows (i.e., your retina perceives an elongated parallelogram, but your mind knows the table has a rectangular top) one useful strategy is to concentrate on painting the *negative shapes* (the shapes formed by background areas lying between the outlines of painted objects and figures). Because you don't know the negative shapes conceptually, you will not be as prone to distortion of size or shape. Look at and paint the shape of the air under and over the table, rather than painting the table itself.

A WORD ABOUT THE CREATIVE PROCESS

This text emphasizes the planned exploration of a variety of painting techniques, approaches to the use of materials, strategies for the articulation of form, and exercises to enhance the development of cognitive meaning. A painter who possesses only limited and disorganized knowledge is in danger of being stuck in a rut he or she cannot see a way out of; knowledge empowers the painter to explore new directions for creating expressive meaning. By arming the developing painter with knowledge of fundamental approaches and concepts from a rich range of traditions, we ensure that the painter's efforts will, ultimately, be less likely to become formulaic. Equally important, while we believe that a developing artist can gain important conceptual insights and invaluable practical experiences while learning fundamental strategies in a systematic way, we hope that this textbook and its suggestions will also serve as springboards for one's own further unplanned and intuitive experimentation.

Experiment, explore, be creative!

1. In addition to effecting a visual experience, a painting also effects a tactile experience. The painter responds to the tangible qualities of paint as he or she works, and a viewer indirectly senses the textural qualities, whether the painting has a smooth, glossy finish or is a buildup of thick, peaked brushstrokes. In response to the malleability of painting's formal language, some artists and writers refer to the formal elements as plastic elements.
2. In Chapter 8 we look more specifically at the conception of painting as a language from a semiotic point of view. (Briefly put, semiotics is the study of signs, and a sign is, basically, something which stands for something else.)
3. Gerald Nordland, *Richard Diebenkorn* (New York: Rizzoli, 1987), p. 114.
4. Excellent discussions of some of the more important research efforts and theoretical developments focusing on perception and the interpretation of visual images can be found in Howard S. Hoffman, *Vision and the Art of Drawing* (Englewood Cliffs, NJ: Prentice-Hall, 1989) and Paul Messaris, *Visual Literacy: Image, Mind, and Reality* (Boulder, CO: Westview Press, 1994).

Materials and Techniques

<div style="text-align: right">2</div>

"I hope the layers of ideas are being built into the layers of paint."
—Ed Paschke

A painting's content is produced by the interaction of four major components—materials, techniques, form, and cognitive meaning. While all four combine to produce the meaning of a painting, our next step is to explore two of them (materials and techniques) independently.

We have written this book emphasizing the use of oil paints, a type of paint which emerged early in the fifteenth century when northern European painters such as Jan van Eyck (Figure 2.1) made technical advances with the medium. Oil paint has remained the dominant professional painter's medium in the West ever since, and is now popular in many other parts of the world as well. Your teacher, however, may ask you to substitute an alternative type of paint, or pastels or oil pastels, in order to broaden your learning experience as you undertake a particular exercise. In fact, the teacher (or you, if you are working with this book independently) may opt to use another type of paint throughout the entire course. Most exercises can be undertaken with any artist's paint or colored drawing media. For classes or individuals who can afford an inventory of oil and either acrylic or alkyd paints, we recommend exploring the properties of each.

MATERIALS

In terms of its physical components, a painting is made in layers. Paying attention to the order of the layers and using appropriate materials and application techniques for each should guarantee that the finished artwork will remain stable far into the future.

The layers of a completed oil painting may consist of the following, listed from the outermost layer down:

> varnish*
>
> upper layers of oil paint glazes*
>
> oil paint layer(s)
>
> underpainting*
>
> imprimatura or toned support*
>
> ground**
>
> size**
>
> support
>
> stretcher or strainer*

The specific approach an artist takes in preparing each physical layer is open to a range of options, and, as indicated in our list, many of these layers are optional. If

*These are optional layers, which may be created depending on the artist's technique, goals, and plans for the painting's care.
**The separate layers of ground and size (which together are called the primer or priming coat) are often combined into one layer by using acrylic gesso. We discuss this option later.

2.1 Jan van Eyck,
Arnolfini Wedding Portrait, 1434.
Oil on wood, $32\frac{1}{4}'' \times 23\frac{1}{2}''$.
National Gallery, London.

this introduction seems dauntingly complex to the novice painter, one should realize that many paintings are limited to the following layers:

 oil paint layer

 acrylic gesso

 support

 stretcher (if the support is canvas)

The Support

The support is the physical surface to which paint is applied. Until recently, oil paintings commonly utilized a limited range of materials as supports — primarily canvas, wood panels, and paper. The painting exercises in Chapters 4–7 mainly provide you with opportunities to use these familiar support materials. In Chapters 8–11, we discuss some of the alternative supports many

painters are also exploring, in addition to continuing the use of canvas, wood, and paper.

Canvas or Linen

For the past four centuries in the West, the most popular support has been a woven fabric, simply referred to as "canvas." Today the fabric is often cotton duck; linen is a higher grade option. The fibers of linen are longer so they hold up better under the stress of stretching. Many artists prefer cotton, which is less expensive, has a more regular weave, and is easier to stretch properly.

Canvas is a flexible, lightweight support. Choosing fabric with a tight weave results in a smoother surface to paint. Choosing canvas with a broad weave contributes to a textured appearance. (Some painters use burlap because of its thick texture.) Canvas is sold in rolls, or sections may be purchased in lengths by the yard. It is manufactured in varying thicknesses (medium or heavy weight canvas provides the necessary durability), and in varying widths (Figure 2.2).

To provide stability, canvas is mounted on a *stretcher* (discussed later), similar to the way the head of a drum is stretched. Another approach is to apply paint to unstretched canvas tacked up against a wall or laid directly on the floor. After the painting is completed, the canvas may then be stretched or left unstretched for exhibition.

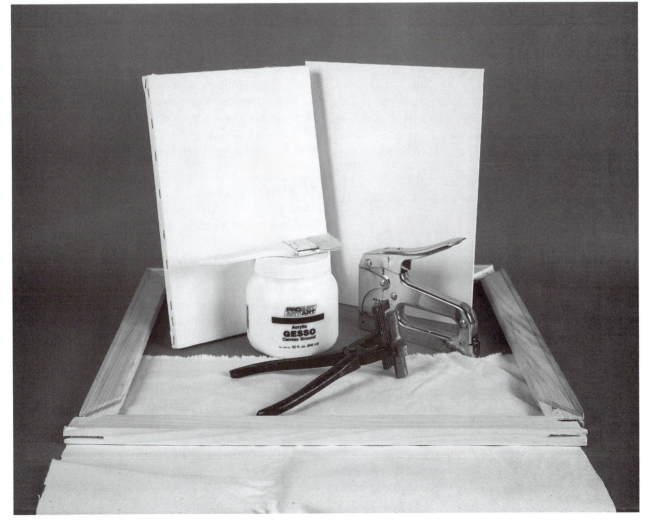

2.2 Sample painting supports and supplies for preparing a canvas. Clockwise from left: a stretched and primed canvas, a canvas board (also called canvas panel), stapler, canvas pliers, 32 oz. container of acrylic gesso, and 2″-wide utility brush (for applying gesso). Surrounding these are stretcher bars on top of unprimed cotton duck canvas.

Wood Panel or Masonite

A prepared hard surface provides a durable support for an oil painting. Artists may choose a hardwood panel, piece of plywood, or masonite. Masonite (also called hardboard) is painted on either the smooth or more textured side. Both sides of a wood, plywood, or masonite panel require sealing (discussed below) in order to prevent warping and to separate the surface from direct contact with the oil paint. Panels may be braced on the back as further prevention against warping. Many painters prefer to use soft brushes when working on a hard, smooth surface to create a highly detailed image. Van Eyck's meticulous oil painting of a marriage is supported on a wood panel (Figure 2.1). In contrast, using bristle brushes can create strong, textural effects.

Paper

Relatively inexpensive, paper is a common choice as the support for oil paintings, especially for small-scale work or quick studies. Paper can be a convenient, lightweight option for working outdoors. A drawback in using a paper support is that eventually oil penetrates its fibers, causing damage and discoloration. To reduce deterioration, always use high-quality, acid-free, heavy-duty art paper (90 lbs. should be the minimum weight). To eliminate oil penetration, paper may be sealed first with a thin application of acrylic gesso, acrylic medium, or rabbitskin glue; any of these strategies, however, masks the paper's original texture. When applying sealer, tape or tack the paper to a board to prevent buckling. For long-term care, both sides of the paper should be sealed.

Canvas Board

For practice sessions, painters may use a support consisting of a lightweight, pre-primed canvas that has been glued onto cardboard backing. Most store-bought canvas board is considered unsuitable for professional quality paintings that you expect to display or sell. Make your own inexpensive canvas board by adhering a piece of canvas to the face of cardboard.

Cardboard

Like canvas board, cardboard is best limited to practice paintings only. It produces an interesting paint texture because of its corrugated interior construction. For longer lasting results and to prevent the oil in the paint from soaking into the support, cardboard should be sealed with acrylic gesso before painting.

The Stretcher

Painters planning to work on canvas usually attach the fabric tightly across a framework. The typical framework is constructed out of four straight bars (usually wood, although more expensive metal bars are available). The bars have mitered ends, allowing them to be easily joined into a rectangular or square format. Ideally, the ends of the bars have mortise-and-tenoned corners. The latter allow the framework to be expanded and contracted by the insertion or deletion of "keys" in order to keep the canvas taut. Because of this function, such a framework is called a *stretcher*. (Note: an option is to construct a framework with mitered bars that are rigidly attached at the corners. Although much easier to construct than a true stretcher, such a rigid framework cannot be conveniently expanded or contracted to keep the canvas at the proper tautness.)

Many painters find it practical to purchase prefabricated stretcher bars. Purchase the bars in pairs at the lengths required to construct a stretcher of the proper size. Make sure you insert each end at a true 90-degree angle.

An option is to purchase preassembled stretchers, with canvas already stretched and primed. The canvas on prefabricated stretchers usually has a "portrait" smooth finish, not suitable for all styles and painting techniques.

Stretching a Canvas

Mounted upon a stretcher, a canvas should be evenly taut and free of wrinkles. Stretching unprimed canvas is generally easier. Be careful not to stretch too tightly any canvas that you plan to *size* (see below); a sizing agent is powerful in its capacity to shrink fabric, which may cause the framework to buckle. While working alone is possible, it is easiest to stretch a canvas if two people together follow these steps (Figure 2.3):

1. With scissors, cut a piece of canvas measuring approximately 3 inches larger on all sides than the size of the stretcher.

2. With a staple gun (or tack hammer and tacks), attach the canvas to the center of one of the two longer sides of the stretcher. Apply the staples diagonally to the bar. Stapling to the uppermost edge of the stretcher bar is easier; stapling to the back looks neater.

3. Turn the entire stretcher 180 degrees.

4. While one person pulls the canvas taut across the second of the longer sides from the back of the stretcher (using stretching pliers if necessary), the second person staples the canvas at the center.

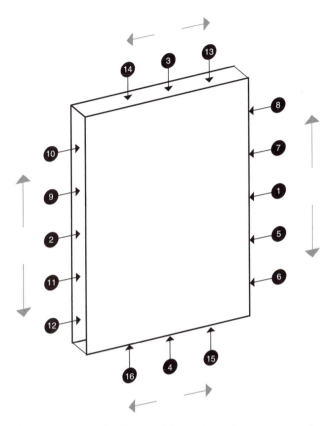

2.3 Suggested order for stretching and stapling a canvas to the stretcher.

5. In sequence, attach the canvas at the centers of the two shorter sides.

6. Now return to the first of the longer sides and begin attaching the canvas at points approximately three inches apart, working outward in both directions from the center. Maintain consistent tautness and keep the canvas smooth as you proceed. Work outward approximately 18 inches in both directions, or stopping about 6 inches from the corner, whichever comes first.

7. Turn the stretcher 180 degrees and do the same to the second longer side.

8. Turn and attach the canvas to the shorter sides, again working out from the center.

9. Return to the first of the longer sides and continue working outward, attaching the canvas.

10. Attach the canvas to the stretcher bars all the way to the corners. Tuck in the excess canvas at the corners and attach with staples on the back.

Preparing the Support: Priming

Most supports need to be prepared prior to painting. Traditionally this preparation occurs in two steps, which together are called *priming* the support. In the first step, a *size* is applied in order to seal the support and separate it from all subsequent layers of paint. Sealing prevents oil paint from causing deterioration of the support. (Oil paint dries by oxidation, a process that causes an acidic action harmful to the fibers in canvas, wood, and paper.) The traditional size is rabbitskin glue. Preparation of the size is done by heating rabbitskin glue in water in a double boiler (following the manufacturer's directions on the container), and then applying it to the support with a 2–3"-wide housepainter's brush (if the support is a wood panel, be sure to apply the size to all sides).

The second step in priming is the application of a *ground* on top of the size. The ground, which provides an absorbent and toothy surface for the oil paint to adhere to, is white lead or titanium paint specially prepared to function as an oil ground (sometimes called oil priming). Follow the manufacturer's specifications regarding application procedures and drying times (a minimum of several weeks is common). A white-colored ground provides a surface with maximum light reflection (other painters prefer to start with a colored ground — see "toned ground," discussed below). Light will pass through translucent layers of oil paint, reflect off the white ground, and then pass back through the oil paint layers a second time. This double passage of light through the paint layers allows the colors to achieve maximum luminosity.

In addition to priming with separate layers of size and oil primer as the ground, another traditional process uses gesso as the ground on wood panels (true gesso is a combination of rabbitskin glue, chalk or marble dust, and white pigment; not to be confused with acrylic emulsion "gesso" described below). See the manufacturer's directions for its use.

Priming with Acrylic "Gesso"

Today many oil painters simplify and speed up the work of preparing and applying the size and ground layers by combining both into one ingredient—an acrylic emulsion ground (commonly known as acrylic "gesso"). Always use a high quality brand. Because acrylic gesso will not harm the fibers of canvas, paper, or wood, no size layer is needed nor recommended.

Acrylic gesso can be applied with a 2–3"-wide gesso brush (or a soft housepainter's brush). Rather than applying one thick coat, it is better to apply two (or three)

coats and sand the first one (or two) lightly. For the first coat, some brands can be thinned with water (don't use more than one third water; an overdiluted film won't bind properly), or thin with a combination of water and acrylic medium. Keep the brush damp.

Acrylic gesso is popular with oil painters because it is applied easily, provides a light reflecting surface, contains no toxic ingredients, and the brush is quickly cleaned with soap and water. It should be noted, however, that some experts question its acceptability as the primer underneath oil paints applied to a large, flexible support, such as stretched canvas. The final verdict is still out, but critics point out that acrylic gesso remains flexible whereas oil paint becomes more brittle as it ages. Consequently, the two layers may ultimately be in danger of separating.

Acrylic gesso can be purchased in white, gray, black, and clear. Additional colors can be mixed easily by adding acrylic paints to clear or white acrylic gesso. (Or try grinding and adding dry pastels.) To create a more textured surface to paint, mix a small amount of fine-grained sand in with the gesso, or mix sand in with acrylic medium and apply a layer on top of the gesso.

Solvent, Thinner, Medium

Various materials, usually in liquid form, are used in conjunction with oil paints to serve specific purposes (Figure 2.4). These purposes include altering or adding properties to the oil paints (*medium*), thinning the viscosity of the oil paints and medium (*thinner*), and cleaning up (*solvent*). Sometimes the same material may function in more

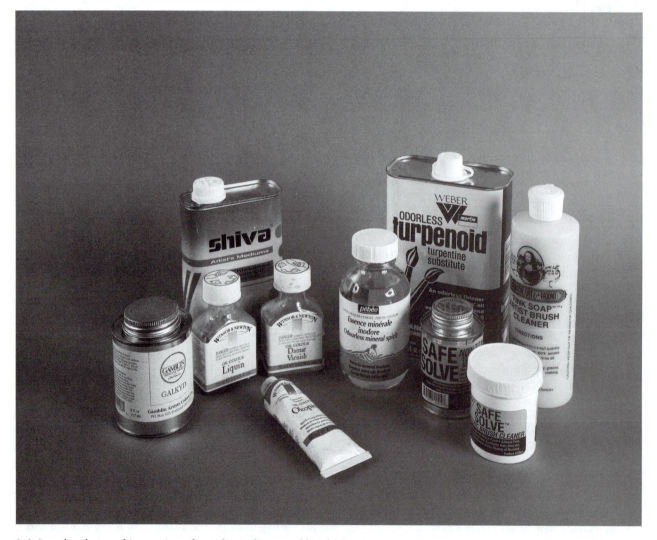

2.4 Sample solvents, thinners, ingredients for mediums, and brush-cleaning agents.

than one of these capacities: mineral spirits or distilled turpentine, for example, may be used as a solvent, a thinner, and as an ingredient in the paint medium. Appropriate metal or glass containers, with an airtight lid, are needed for the safe and efficient use of these additional materials. (Keep the container of a solvent sealed except when pouring out the small quantity you need.)

Solvent

A liquid solvent is useful for cleaning paintbrushes and work surfaces. Common solvent choices for oil painters are turpentine and mineral spirits. We recommend *odorless* mineral spirits (which some manufacturers label as an odorless turpentine substitute), because their vapors are less harmful than those of turpentine.

Thinner

A liquid thinner, also called a diluent, is used to dilute oil paints and oil paint mediums. The goal is usually twofold: to thin the paint or medium to a smoother, more liquid consistency; and to dilute the paint layer so that it contains less oil and dries more quickly. The same type of liquid used as a solvent often serves as the thinner.

Distilled (or rectified) turpentine (called "turps") was once the most favored choice as a thinner (and many artists still opt to use it). However, mounting evidence has shown that it is safer for artists to limit or avoid its use, except in special circumstances (such as using a medium containing Damar varnish, that requires it). Unless ventilation is superb, it should be avoided, especially in large classroom situations where the buildup of harmful vapors can be extreme. "Turpentine should be used with extra caution because of its fast evaporation rate and low permissible exposure level [the measurement of how much solvent is considered safe to work around]. Turpentine is absorbed through healthy, unbroken skin."[1] Using distilled turpentine alone with oil paint leaves a matte or dry-looking surface. Distilled (or rectified) turpentine evaporates completely; its use allows oil paints to dry more quickly. Even distilled turpentine deteriorates over time; once it turns dark it can't be used. (Note: nondistilled gum turpentine leaves a slight, sticky residue; it is not suitable for an artist's use.)

As a safer alternative, we recommend using odorless mineral spirits (unless the painting procedure involves Damar or another resin varnish). In comparison to turpentine, it has a slower evaporation rate, higher permissible exposure level, and is not absorbed through healthy, unbroken skin. (Note: some recommended choices for odorless mineral spirits, currently available, include "Turpenoid" and Gamblin's "Gamsol.") Odorless mineral spirits (also called "white spirits") is derived from petro-leum. It functions like distilled turpentine, although with several important differences: it does not deteriorate as it ages, and it does not cause the allergic reaction some people suffer due to turpentine. Mineral spirits evaporates completely. As noted under health precautions, mineral spirits is safer to use than turpentine, but good ventilation is still important.

Painting tip: Diluting paint with thinner alone, without oil, is common practice in a painting's early stages — because the thinner speeds up the drying process. But don't overdilute the paint to the consistency of a *very* thin watercolor wash. In that state, the paint's binding properties are compromised, endangering the paint film's permanency.

Medium

As we explained in Chapter 1, "medium" has three distinct meanings with respect to painting. Here we use the term to refer to a material or combination of materials, in liquid or jelly-like form, which an artist adds to paint to alter handling properties and physical characteristics. For example, the slow drying time of oils is useful for blending colors and producing a rich buildup of textures and surface effects. But if desired, speeding up the drying time can be accomplished with the addition of ingredients which naturally dry more quickly. Moreover, a medium can make spreading paint easier; it can make the paint layer more transparent; it can produce a glossier surface (thus enhancing the richness of colors); and it can make the paint surface harder and more resistant to decay and dirt. Different "recipes" of mediums will serve to accomplish one or more of these goals. There are numerous prepared mediums available that serve specific purposes; painters should also explore options for mixing your own.

Most oil painting mediums involve a mixture of an oil, a thinner, and (sometimes) a varnish. The proportions of each will vary to achieve desired results.

Drying oils To manufacture oil paints, pigments are suspended in a drying oil. Upon drying (oxidizing), the oil becomes a durable film that binds the pigment to the support. Additional quantities of drying oil also may be used as an ingredient in the medium that is added to oil paint to increase its flow, change its characteristics, or alter its drying time. The most common are:

Refined linseed oil is used as the binder in many brands of oil paints. It dries slowly, and has a tendency to yellow somewhat over time. (Sun-thickened linseed oil and stand oil, described below, are usually preferred as ingredients in painting mediums.)

Sun-thickened linseed oil is partly oxidized linseed oil. It dries faster than refined linseed oil, and holds brush-strokes better.

Stand oil is a weather-resistant, boiled, thickened oil. It leaves no brush marks and is excellent in glazing mediums; it dries slowly, yellows less, and with a more glossy and harder surface than refined linseed oil.

Poppyseed oil can be used in place of linseed oil. It dries slowly, not as hard and yellows less than linseed oil; it gives the paint a "buttery" consistency, better for holding brush marks. Purchase the pressed poppyseed oil, not boiled; poppyseed oil is available from some grocery stores as well as art supply dealers.

Thinners The use of a thinner in a paint medium dilutes the consistency of the paint. (As noted in the section discussed earlier, thinners may also serve for cleaning and dissolving, in which case they are also referred to as solvents.) Keep all thinners properly stored in a closed container, away from heat and light.

Varnishes A resin varnish is sometimes added to the paint medium to impart toughness to the paint film.

Damar is the natural resin most frequently used in painting mediums. It produces a hard, glossy surface and enhances the drying time of oil paints. Only distilled turpentine (not mineral spirits) should be used to thin a paint medium containing damar, or the medium will turn cloudy.

Already prepared alkyd resin paint mediums are becoming more popular because of their quick drying time (within twenty-four hours if the paint is not applied thickly) and because they produce a tough, elastic paint film. Use odorless mineral spirits to thin alkyd resin paint mediums.

Recipes for Oil Paint Mediums

There are numerous recipes for oil paint mediums. Many artists find one that serves their particular way of painting and stick with it; others experiment with the ratio of ingredients or use different formulas at different stages in a painting. Additional information regarding paint mediums is available from technical manuals aimed at professional artists (or obtain a catalogue from one of the large mail order art suppliers and explore the valuable product information it contains).

a. A small quantity of odorless mineral spirits (o.m.s.) may be used alone. By thinning the paint, o.m.s. helps the paint film to dry quicker, with a matte surface. (If you want a less matte surface, add in a small amount of linseed oil, approximately one eighth the total.) Thinning with o.m.s. alone is sometimes used for the early stages of a painting — for the block-in or underpainting (described shortly). Don't over-dilute the paint, however, because the thinner will break down the paint's binding properties.

b. 1 part odorless mineral spirits
 2 parts stand oil or sun-thickened linseed oil
This is a general, all-purpose medium formula. (Note: when using this medium, you can also use odorless mineral spirits for cleanup and for the "block-in" stage of painting; doing so will avoid the use of turpentine altogether.)

c. 1 part Damar varnish
 1 part sun-thickened linseed oil or stand oil
 1 part distilled turpentine
Although this remains a widely used paint medium formula, because using Damar varnish requires the use of turpentine (not mineral spirits), this formula should only be used with caution, and extra care taken for adequate ventilation. To create a faster drying formula, reduce the amount of oil in half (which is the slowest drying ingredient of the three); or add a small amount of Liquin, cobalt or japan drier to the medium.

d. Alkyd resin painting medium. This helps oil paint to dry quickly (in twenty-four hours if the paint is not too thick); thin as desired with odorless mineral spirits. (Note: some alkyd resin painting mediums, including Winsor and Newton's Liquin, can be thinned with mineral spirits or turpentine. Others should only be thinned with mineral spirits. Read the directions on the manufacturer's label.)

e. Don't use any medium. Work with the oil paints straight from the tube. (Note: some painters prefer oil colors thinned only with turpentine or mineral spirits (recipe a) for the early stages; then they use oil paint straight from the tube for the final stages.)

f. Wax or gel mediums can be added to help hold the texture of brushstrokes.

Mediums for Glazing
Use b, c, or d, above, as a glaze medium. With b and c, stand oil is preferred over linseed oil. For glazing, use more medium, enough to thin the paint to the consistency of soup. To be successful, it is important to use *transparent* oil paints for glazing; don't try to glaze with opaque colors. (See "Glazing" discussed further later.)

The Application of Mediums
If the support is bone-dry at the beginning of a painting session, moisten a clean cloth or wide, soft brush with

medium and use it to moisten lightly the entire surface. This will create a surface that is more receptive to the new layer of paint, allowing it to adhere better and to be applied with more control.

During painting, most artists place a small amount of medium and a small amount of thinner in separate containers by the palette. The brush is dipped into the container holding the medium or thinner, the "charged" brush is then worked into the required pigments on the palette. Unless you are glazing, avoid using too much medium to thin your paints or your colors will lose their covering capacity.

Brushes

Artists' paint brushes are available in a range of options, including choices of size, shape, and material (or texture). Even a beginning painter should have an assortment of brushes in order to be able to experiment with various techniques; purchasing a few good quality brushes is generally better than acquiring a lot of poor quality brushes. Many brushes are manufactured for use with either oil or acrylic paints.

Brush Sizes
The number found on the handle indicates the brush size. The size is determined by the diameter or width of the brush where the fibers meet the ferrule (the metal part which holds the fibers together at the end of the handle). The scale varies somewhat between manufacturers, but the numbering is usually from 00 (the smallest), 0, or 1 up to 12 (the largest).

A common rule of thumb is: work with the largest brush you can in a painting's early stages so you will concentrate on developing a composition with overall unity and strong structural relationships, rather than focusing first on finicky details.

Brush Shapes
The shape of a brush is defined by the shape of its fibers. Different shapes are designed for different types of paint application. There are five major brush shapes for use with oil paints (Figure 2.5):

Flats: Flats have fibers with a squared top. When turned on its side, a flat is effective for handling broad passages and larger quantities of paint; turned on its edge, a flat can make broad, rough lines. Flats are excellent for direct painting techniques (discussed later). Flats can be used to paint one area of color up to the edge of another, and then the two can be blended.

Brights: Brights have fibers with a squared top, like the flat, only the fibers are shorter in length. Holding less paint than the same size flat, a bright is also excellent for direct painting.

Rounds: Fibers are round at the ferrule and come to a sharp or dull point at the tip. Rounds are useful for making lines; rounds with a sharp point are excellent for painting details. Large-size rounds can hold a large quantity of paint. Rounds can be used for thin or wide strokes, as well as the dots used in a pointillist technique. Rounds can be used for blending; soft rounds can be used for applying glazes.

Filberts: Filberts are versatile brushes combining properties of round and flat brushes. They have a flattened arrangement of fibers at the heel of the brush, but the fibers are rounded at the top, curving upward towards the center from both sides. The center is flat across the top.

Fan blenders: Fan blenders have bristles that fan out from the ferrule. The fan blender is designed primarily for blending colors together, not for applying paint. Brush a clean fan blender lightly across adjacent colors in order to blend them together. A fan blender can also be used for applying paint in very delicate brushstrokes.

Other brushes used by painters: For priming a canvas, many painters utilize 1–3″-wide flat brushes commonly available in hardware stores (some artists use them for laying in a large wash with acrylic paint). Moreover, any large, round, soft brush (even an old shaving brush) may be used to smooth out a glaze.

Brush Materials
In addition to their various shaped fibers, brushes are available in different materials. The materials are commonly categorized as either bristle brushes or soft brushes. Each type is designed for different paint applications.

Bristle brushes: Bristle brushes are manufactured with hog's hair, usually from China. The bristles are sturdy and somewhat stiff, with a pronounced "spring." Flats and filberts in bristle brushes are an excellent choice for loading up with paint and working thickly in a direct painting technique; bristle brushes can be used to make dynamic brushstrokes that are visible and "textured." Avoid the cheaper synthetic bristle brushes.

Soft brushes: Soft brushes are made with soft animal hairs or with synthetic nylon fibers. Soft brushes deposit

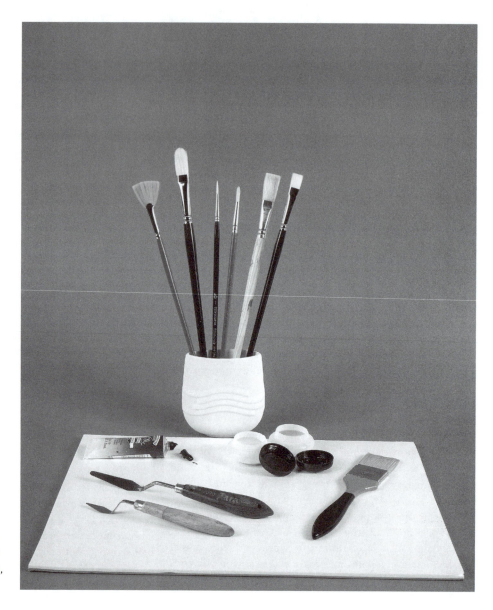

2.5 From left to right the brushes shown are: fan, filbert, two rounds, flat, and bright. In the front: two palette (or painting) knives, tube of paint, lidded cups for holding thinner and medium, a 1.5″ wash brush, all on a paper palette.

paint more smoothly and evenly than bristle brushes. Rounds as soft brushes are commonly used to create lines and finer details of a painting; soft brushes are preferred for glazing, when brushstroke texture is kept to a minimum or eliminated entirely. Flats as soft brushes are an excellent choice for blending colors, and for painting wet-on-wet (see later section) when the artist doesn't want to disturb the underneath layer of paint.

Cleaning Brushes

To clean a brush during a painting session, first wipe off as much excess paint from the fibers as possible on a newspaper, paper towel, or paint rag. Wiping alone may be sufficient if the next color you are using won't be harmed by a small trace of the previous color. But for a cleaner brush, after the initial wiping immerse the fibers into solvent, then wipe the fibers of the brush once again. Repeat until the brush appears clean. If the solvent container has a screened false bottom (or a plastic scouring pad that fills the bottom), dirty paint sediment will settle, leaving the solvent in the upper level clean.

At the end of a painting session all brushes should receive a thorough cleaning. Begin by wiping and then immersing the brushes in solvent (or try baby oil, for a safer substitute). Next, wash each brush in cold water with soap. (Artist's brush cleaning soap, Ivory soap, or dishwashing liquid soap are effective.) Remember to clean the brush down to where the fibers meet the

handle. Store the brushes resting up on the end of the handle or lying flat. Never store them resting face down on the fibers; this destroys their shape.

Other Painting Equipment

Easel

Easels come in many sizes and prices; all are designed to hold the support upright during the painting session. For best results, stand or sit on a tall stool at the easel while painting. Either facilitates broad arm movement, and allows you to back away to see the painting from a distance.

A sturdy easel can accommodate larger size paintings. Most lightweight portable easels (for working out-doors) cannot securely accommodate stretchers larger than 20″ × 15″.

To work on an extra long horizontal painting, try placing two easels side by side underneath the stretcher.

Palette

A palette is a smooth surface used during the painting session to hold small quantities of paint and to mix fresh colors. Common materials for a palette include a lightweight hardwood, piece of glass, and disposable paper palette.

A new wood palette should be tempered initially by rubbing the surface with linseed oil so that the wood won't later soak the oil from the paints you place on the palette.

2.6 Samples of oil paints in tubes, and left to right: 140 1b. watercolor paper (which can be primed and used for oil painting), painting gloves, a paper palette, and masonite panels (shown with primed and unprimed sides up).

Many artists find that using a disposable paper palette is particularly convenient; the top sheet is simply thrown away when the paint is no longer usable (Figure 2.6).

A plate glass palette should be at least 3/4" inch thick so that it won't break easily. Tape the edges with heavyweight tape to prevent being cut. As an aid in mixing colors and matching values of paint, tape a sheet of white paper to the underside of the glass. (Some painters prefer light gray or tan paper for this, because it is easier to see colors accurately against a neutral background.)

Other choices for a palette are various building materials, such as Formica or masonite. Even a sheet of wax paper works fine.

Palette Knives

There are two types of palette knives. One type, constructed with a flat spatula blade, is designed to mix paints on the palette. The other (sometimes called a painting knife), with a shorter, trowel-shaped blade, is designed for applying paint to the artwork and for carefully scraping off unwanted paint.

All palette knives should have flexible blades that taper towards the end. Painting with a palette knife can result in unexpected colors and textures; use the paint straight from the tube or mixed with only a small amount of medium.

Rags, Paper Towels, and/or Newspaper

Use these for wiping brushes while working. A rag moistened with solvent can also be used to wipe out an unwanted passage of paint.

Cleaning up

Plan to take sufficient time at the end of each painting session to clean up properly. A procedure for cleaning brushes is described in the section on brushes.

The palette itself should be cleaned, unless you plan another painting session tomorrow. Scrape excess mounds of paint off first with the palette knife (or use a razor blade for a glass palette), then wipe the palette off with a paper towel moistened with solvent (or use a non-solvent cleaner). An alternative is to store the palette in a plastic, airtight palette seal where oil paints should stay moist for several days.

The palette knife or knives should be wiped clean. (Be careful to avoid cutting yourself.) Wipe off the metal grooved neck of the paint tubes you used; doing this will ensure they will tighten properly and won't dry out.

Tighten the caps and lids on all jars and bottles for solvents and mediums. Properly dispose of all soiled rags, paper, and so forth.

Use soap or special artist's hand cleaners to clean your hands. Never immerse hands in turpentine or any strong solvent. While painting we recommend the use of lightweight rubber painting gloves; they are inexpensive and can dramatically reduce the amount of cleaning your hands will require.

Unplug studio lamps and other electrical appliances.

SAFETY AND HEALTH PRECAUTIONS

We follow our discussion of materials with a concise but all-important note of caution. ALWAYS take appropriate care: materials and studio techniques can be harmful to your health and to your property. Some health risks are slow to develop and harmful effects can accumulate over time; other dangers are immediate and can get out of hand with explosive quickness. As an artist, it is ALWAYS your individual responsibility to develop and maintain appropriate safety and health precautions. We offer the following as general guidelines only (and this list is certainly not exhaustive). Additional information about specific supplies can be obtained from the manufacturer or by consulting one of the more specialized reference manuals for art supplies and technical procedures.[2]

1. NEVER use turpentine or mineral spirits near an open flame. Never store any solvents near heat, nor store them in sunlight. Learn the flash points of all solvents you use. (The *flash point* is the lowest temperature at which a liquid's vapors can ignite.) NEVER light a match in a room where solvents are being stored or used.

2. NEVER smoke, eat, or drink while painting. (Many materials, including pigments and solvents, are toxic.) After working always thoroughly wash your hands.

3. ALWAYS have adequate ventilation. (As a general guideline, in a studio free of turpentine and using odorless mineral spirits as the thinner and solvent, the air in the studio should be changed "at least once a day."[3]) Air should be exhausted away from the face. Depending on what supplies and techniques you are using, an exhaust fan to the outside may be necessary. The use of toxic materials may require special additional ventilation. If you are using toxic solvents, there should be adequate cross-ventilation.

4. ALWAYS ensure the safe disposal of waste materials. On a university campus, this usually means pouring solvent wastes into an appropriate nonflammable metal container that is kept tightly sealed in between use. The university's waste management staff should be asked for advice about the type of container that should be used and then notified when the container is ready to be disposed of properly.

5. DO NOT pour hazardous waste liquids down the sink.

6. NEVER pile up rags or paper towels soiled with solvent; a fire can start through spontaneous combustion, even in a metal locker. Soiled rags should be removed from the studio and disposed of daily.

7. We RECOMMEND wearing thin rubber gloves while oil painting (Figure 2.6). They are inexpensive, you will soon grow accustomed to wearing them, and they help you avoid having strong chemicals (such as solvents) touching your skin.

8. ALWAYS carefully read and follow all safety precautions listed on manufacturers' labels.

9. ALWAYS keep large quantities of supplies, such as solvents, in their original containers. When mixing small quantities of mediums, use glass or metal containers; most solvents will eat through paper and plastic. Always label what you store in any container.

10. ALWAYS reseal containers as soon as possible. Don't leave a can of solvent or thinner open while you are working. This is especially important in a crowded studio classroom where fumes can build up quickly and someone can easily knock over a container.

11. ALWAYS receive and follow knowledgeable instructions about the use of power equipment (such as power saws used for the construction of such items as wooden stretchers). Always wear protective eye gear when using power equipment or a hammer.

12. ALWAYS wear a respirator mask when you are spraying or using dry pigments.

13. ALWAYS keep a first aid kit and a charged fire extinguisher in your studio area; post local telephone numbers for seeking emergency medical treatment or advice.

14. For the safety of your clothes, wear old ones.

PAINTING TECHNIQUES

Preliminary Stages

Once the support has been prepared, the painter can proceed in several ways. The following preliminary stages are optional and any or all can be skipped.

1. Add an imprimatura or tone the ground.
2. Make an underdrawing.
3. Develop an underpainting or block-in.

Imprimatura or Toned Ground

An *imprimatura* is a wash of paint — or a tinted size — that covers the white ground of the support. An imprimatura is translucent, allowing light to pass through and reflect back off the white ground, causing the color to glow. In order to keep the imprimatura translucent, no white paint should be added in mixing its color. An imprimatura is created by applying a wash of paint (we recommend diluting with odorless mineral spirits, or a fast-drying medium such as Liquin) over a prepared support. Apply the imprimatura evenly over the support with a large bristle brush. If a thinner is being used, allow it to evaporate for approximately twenty minutes, then remove excess paint by rubbing with a cloth.

In contrast to an imprimatura, which is translucent, a *toned ground* covers the white of the primed support with an opaque layer of paint. If the color to be applied is naturally transparent, adding some white to it will make it opaque. Thin the paint that is to be used for toning (we recommend odorless mineral spirits for this), but don't thin so much as to make the color transparent (which would create an imprimatura). A toned support dries more slowly than an imprimatura, usually in two to three days. Allow the layer to dry completely before proceeding.

It is easier to judge darks and lights accurately as you paint if you apply colors on a toned rather than a white background. For greatest accuracy, most artists select a tint in the middle value range when they apply an imprimatura or a toned ground to a support. Moreover, allowing some of the underlying color of an imprimatura or toned ground to show through subsequent layers of paint helps unify the color palette for the final painting.

Underdrawing

Some painters make a preliminary drawing of their subject directly on the canvas. This *underdrawing* is usually just a sketch showing the largest shapes and establishing the basic structure of the composition (Figure 2.7). Soft charcoal or diluted paint is commonly used for an underdrawing. If oil paint is used, thin with odorless mineral spirits only (for quicker drying); many artists apply one color of paint in lines with a soft round brush. If charcoal is used, lightly brush off the excess or use a fixative to seal the charcoal from the paint. Other drawing media that are appropriate to start an oil painting include pastels and oil sticks. (Most artists choose a neutral color.)

2.7 Example of underdrawing on a toned support. (Artwork by Jim Viewegh.)

Keep the drawing light in value. Graphite pencils and felt tip pens should be avoided because over time they show through dried layers of paint.

Block-in

A *block-in* (sometimes called a lay-in) elaborates an underdrawing, further developing the broad relationships of shapes and establishing the contrast of values that will be the foundation of your painting (Figure 2.8). (Some artists skip an underdrawing and begin immediately with a block-in.) Using paint thinned with odorless mineral spirits, block in the composition with a medium- or large-

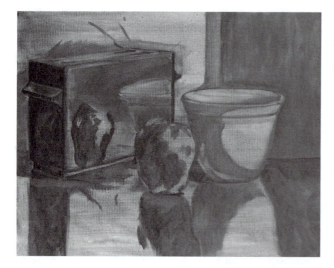

2.8 Example of a block-in. (Artwork by Jim Viewegh.)

sized bristle brush, concentrating on major shapes (thin the paint enough so you can lay in broad washes of color). Think about your composition as a whole, especially how the large shapes relate to one another both as geometric forms and as a pattern of lights and darks. Avoid the temptation to begin painting details or to completely develop just one part of the painting. An option for blocking in a composition on a toned canvas is to let the background tone represent areas of relatively lighter value while you add contrasting darks with washes of block-in color. In addition to organizing lights and darks, some artists also like to block in major areas of color.

Painting tip: If you aim to paint naturalistically from life, try looking at the subject with your eyes partially closed. Squinting diminishes distracting details, thus allowing you to see only the broad masses of darks and lights, and their relative value. Squinting also helps bypass your conceptual knowledge of the subject, and allows you to concentrate more easily on what you are directly perceiving.

Direct and Indirect Painting

To apply oil paint to a support the artist is faced with two basic choices: direct painting, where a composition is created directly and rapidly; and indirect painting, where the composition is developed slowly and deliberately in successive sessions. We look first at variations on direct painting.

Direct Painting/Alla Prima

Direct painting is defined by two characteristics. First, the artist intends to complete the painting in one session. This approach is referred to by the Italian term *alla prima*, meaning "at first" or "all at once." Secondly, the artist completes the painting in one layer rather than building the painting in layers that dry in succession. Ideally, the artist working directly intends each brushstroke as a final mark which will not be subject to further manipulation.

An artist may choose to paint alla prima on a canvas previously toned with an imprimatura or opaque color. Moreover, before proceeding to work alla prima, painters may first block in basic shapes and colors using paint diluted with thinner, thus establishing a general sense of the overall composition. After the block-in, an artist working in a direct painting technique is challenged to decide all other aspects of the final composition at the same time, during the one-step process of applying the paint (Figure 2.9).

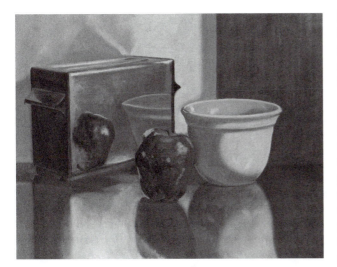

2.9 Example of direct (alla prima) painting. (Artwork by Jim Viewegh.)

Although the artist aims to apply the right color with every brushstroke, this may not always occur. If not, wipe or scrape off the unwanted paint (using a palette knife, or a rag dipped in solvent), or simply apply fresh color over the unwanted color if the new color is close in hue and value to the previous color.

Modified Direct Painting

In actual practice, painters frequently modify the direct painting approach by making later additions and revisions. After blocking in the general composition and working directly for several hours, a painter may allow the results of the first session to dry, then resume working on the canvas in one or more subsequent painting sessions. The artist may continue to work in a manner similar to the first session, attempting to refine the painting with additional opaque brushstrokes. In effect, the artist is adding to the complexity or subtlety of selected areas of the initial alla prima session, while possibly totally repainting other areas that upon evaluation appear to require changing (scraping off unwanted paint, if needed).

If the painting you are working on has already begun to "set up" (i.e., dry), it is best to wait until the painting surface is thoroughly dry before continuing. Once the painting's surface is dry, lightly brush or wipe a thin layer of medium or retouching varnish (available from art suppliers) across the entire surface of the painting. A fresh, moist layer of medium or retouch varnish helps new paint to adhere properly.

Indirect Painting

Indirect painting is a slower, more deliberate method than direct painting, involving the application of paint in several layers. Only with the final layering of paint does the artwork assume its final appearance.

In the history of painting in the West, indirect painting is considered the more traditional approach. The technique was well suited to the very slow drying times of the early oil paints developed in Europe in the fifteenth century (Figure 2.1). The results of indirect painting — with an emphasis on carefully planned and executed compositions — were consistent with the aesthetic goals of the Renaissance and subsequent cultural periods emphasizing classical values. In our own era, there has been a renewed interest in indirect painting methods among artists wishing to borrow stylistic tendencies from earlier periods in the service of contemporary content.

Indirect painting may utilize one or several options for the application of the successive layers of paint, including glazing and scumbling (see later sections).

Fat Over Lean

A useful rule of thumb advises that each successive layer of oil paint should contain slightly more oil content than the previous layer. This strategy helps prevent cracking of the paint layers, as the outermost layer will dry last.

The "fat over lean" rule may be followed by selecting paint colors with less oil (a low oil absorption rate) for the initial stages of a painting, while reserving paint colors with higher oil content for later stages. Because oil slows down the rate of drying, paints with higher oil content will dry more slowly. These should be used only during the later stages of a painting, while faster drying low-oil paints should be used first. Charts are available in specialized reference books on painting materials which indicate the oil absorption rate (or oil absorption index) for different paints or pigments.[4]

Painting tip: Two simple strategies can be combined to approximate the "fat over lean" rule. First, use flake white and mars black for mixing with colors in the initial stages of a painting, then switch to the more oily titanium white and ivory black for subsequent stages. Secondly, thin early layers of paint with thinner only (we recommend odorless mineral spirits), then add an extra drop or two of a medium containing oil to the paint for each successive layer. For the final stage of a complex painting, eliminate the use of any thinner.

Starting with thin paint and building to more opaque, thicker paint has additional advantages. It is easier to make corrections over thinly applied paint in the

crucial blocking-in stage, and the block-in dries fairly rapidly, enabling you to get on with your painting.

Paint Application Principles and Techniques

Oil paints are renowned for their versatility, allowing color to be applied in thin, transparent glazes or thick, opaque textures; permitting smooth finishes with blended brushstrokes or expressive surfaces with visible brush marks of great variety. The type and amount of medium you mix into oil paint will alter its consistency and affect how it is applied and how it looks. Brushes of different sizes, shapes, and hardness or softness will produce different effects. Moreover, the amount of paint you load on a brush and the pressure you apply as you move the brush across the surface influence the appearance of your marks. Many painters like to vary their brushstrokes so that the marks are lively in some areas and almost invisible in others; they also vary thickness, length, and direction of the strokes. Other painters prefer to make uniform brushstrokes throughout for a highly patterned, unified surface. A pointillist painting would be an example of the latter approach.

In traditional Chinese painting (as well as in the allied art of calligraphy) the development of refined skill and sensitivity in creating brushstrokes is central to an artist's achievement. Prized qualities such as apparent effortlessness and spontaneity are in fact the result of dedicated mental and physical training. "It is the rhythm and the quality of the stroke, the technique of the brush, which embodies the spirit of Tao."[5] The "first aim" of the artist is "to bring his own personality into keeping with the cosmic principle so that the Tao would be expressed through him, and thus in his painting he would act in unison with the natural order . . . "[6] Consistent with this aesthetic philosophy, Chinese artists developed an elaborate classification of styles of brushstrokes, such as *ho yeh ts'un*, brushstrokes like the veins of the lotus leaf.

In contrast to Chinese tradition, an emphasis on the outward appearance of a subject (reinforced in our society by the multitude of photographic images we see regularly) gives many students the mistaken impression that the development of sensitive handling of the brush is of little consequence. Nothing could be further from the truth. Although our aesthetic goals may be quite different, control over the visual quality of the brush mark continues to play a central role in the construction of a painting's meaning.

In this section we summarize some of the basic techniques for applying oil paint to a support. In later chapters we discuss other strategies for applying paint and using brushstrokes to impact content. Developing skill at handling paint takes concentration and practice. Be patient and experiment!

Wet-on-wet

"Wet-on-wet" is a variety of direct painting in which brushstrokes are applied on top and worked into paint beneath them while both layers are fresh and wet. The wet-on-wet technique allows you to mix colors directly on the canvas. The technique also enhances fluid, spontaneous brushstrokes since a wet layer underneath allows a newly loaded brush to flow easily across the surface. Use a soft hair brush and practice applying different amounts of pressure to the brush. More pressure will help blend colors; a light touch will deposit paint on top without lifting the underneath color up into the new stroke. Don't go over the brushstrokes again unless you want to blur them. Use a longhaired bristle brush to paint wet-on-wet with more pronounced brushstrokes and blending between colors.

Painting tip: To work wet-on-wet without blending the lower color into the new color being applied, use a soft brush and apply paint with a light touch. At the end of every stroke, look to see if any underlying color has been picked up by the brush; if so, wipe the brush free of the unwanted color, recharge the brush with the new color, and then make the next stroke.

Impasto

An extreme of "painterly" application is *impasto*, which is a buildup of thick paint. Some painters practice a technique in which impasto is built up everywhere across the painting. Others focus the impasto on areas of greatest illumination and other focal points. Because an area of impasto is actually a relief with volume, the paint catches light along its high ridges and casts shadows into the valleys of the paint.

To create impasto, you can mix your oil paint with heavy-bodied mediums such as Oleopasto or oil painting wax. Or you can apply oil paint straight from the tube, with no medium or thinner, in order to take advantage of the thick, buttery texture that is characteristic of oil paint in its normal tube consistency. Apply the paint with a stiff bristle brush or palette knife to add extra marks onto the thick paint. For a rich mixed color effect, try loading the brush with two colors at once. Thickly applied paint will hold its shape, so it is important to pay attention to the direction, width, and length of the marks you are making. If you don't succeed in creating the shape of brushstrokes that you want, use your knife to scrape the paint off and try again.

Painting tip: If you are interested in creating an illusion of depth, avoid impasto in the shadow areas. Impasto draws attention to the surface.

Blended Brushstrokes

Some painters prefer to eliminate evidence of brush marks. One strategy is to use a medium containing stand oil or to use copal varnish as a medium — these tend to level out all brushstrokes, thus enhancing a smooth final surface. Another strategy is to stroke lightly with a soft brush, such as a fan blender, back and forth across the borders of separate brushstrokes, thus creating a seamless surface without any impasto. This blending technique is effective when you want to model forms by creating a smooth transition between adjacent colors or tones. Beware of overblending, however, or the transitions may become too vaguely defined. You may want to blend only selected areas of your painting, seeking a more textured effect elsewhere.

Painting with a Palette Knife

In addition to using a palette knife to mix colors on the palette, you can use a knife instead of a brush to apply paint. Palette knife painting is a fast and direct application method, and can be used to create many textural effects. If you wish, use a brush to soften sharp edges left by the knife. In general, palette knife application looks loose and bold, although straight lines can be created by pressing down with the palette knife's edge loaded with paint. A palette knife can also be used for scraping paint off an area you want to repaint, and for scraping paint off in a technique called *grattage* (discussed in Chapter 6).

Sgraffito

Sgraffito involves scratching through an outer layer of wet paint to reveal a different color (applied in an earlier, now dry, layer) or the primed support underneath. The scratching may be done with a wide assortment of instruments, such as the blade of a palette knife or the end of a paint brush. Don't use an instrument that is too sharp, or you may damage the support.

Drybrush

Drybrush is a method for applying paint that creates an effect that looks like uneven flakes of color with another color showing underneath. Using a stiff bristle brush, lightly apply a small amount of "dry" paint across the surface of the painting. (Use opaque paint, no medium, and a brush that is beginning to "run out" of paint.) The drybrush technique works best across a textured surface. The dry paint attaches only to the upper ridges of paint, allowing the previously applied color to remain visible in the valleys. The result is a sparkling effect of diffuse, broken colors.

To obtain the necessary textured surface, use a canvas with a heavy weave (or add sand to the gesso); or wait until late in the painting process when underlying layers of paint have dried and built up a thick surface.

Painting tip: Don't discard your old flat bristle brushes which have lost most of their spring; they can be used for the drybrush technique.

Glazing

A traditional indirect method of oil painting is to execute an underpainting, then apply one or more transparent layers of color, called *glazes*, over the entire underpainting or selectively over sections of it. Successful glazing requires patience since you must wait for one layer to dry completely before you apply the next. The reward is that you get rich, deep colors which cannot be achieved by the application of paint in a direct approach. For example, a thin, transparent glaze of ultramarine blue paint and an underlying layer of cadmium yellow light will combine optically to produce a glowing green which is very different from the green which would be created by physically mixing the same color paints together on a palette and then applying the mixture in one direct layer. Because glazes are transparent, like colored glass, light can pass through and reflect back off the underneath layers of color. The viewer sees the subtle interactions of all the colors together.

Glazing serves to separate the process of form building and composition from that of adding color. In academic painting, a complete underpainting is created before any color is added. Glazes basically serve as a means of coloring the monochromatic underpainting. But this is not the only approach to glazing. You can glaze over all or part of a painting that is already colored, including one that was created by a direct technique. Moreover, after starting to glaze, artists may go back in and make changes to the composition by applying opaque areas of paint.

Used in a traditional manner, glazing produces a soft, atmospheric appearance and helps to unify the overall color composition. There is no correct number of glaze layers you should use. Some painters use only one or a few layers of glazes; some historical masters of glazing often used more than a dozen glaze layers.

You create a glaze by mixing any oil color which is already naturally transparent with extra oil or a glazing

medium. (Opaque colors should not be used for glazes.) Glazing mediums are available in premixed form. Some, such as alkyd glazing mediums, dry quicker than others. Or you can mix your own glazing medium, using one of the formulas provided in the earlier section on mediums above. If your goal is to apply glazes with smooth, invisible brushstrokes, a very tight weave canvas or other smooth-surfaced material, with a carefully blended underpainting, makes the best support. But some artists prefer to glaze over a roughly textured surface, such as over a drybrush painting.

TRADITIONAL STEPS FOR PRODUCING AN OIL PAINTING WITH GLAZES

1. Sketch the composition on the support.
2. Create an underpainting (see below) and allow it to dry completely.
3. Mix transparent oil color into a glazing medium. The consistency should be like soup or wine. Apply the glaze to the underpainting with a wide, soft brush, then wipe with a soft rag to distribute the paint evenly. Allow the glaze to dry.
4. If desired, glaze more layers, allowing each to dry completely before proceeding.
5. If desired, apply opaque paint (often done to establish the highlights and refine details).
6. Option: Varnish the completed painting after it is thoroughly dry.

Tips for glazing: Part of the glaze can be removed with a clean brush or rag dipped in the glazing medium (*not* dipped only in solvent). Wiping is done either to correct or diminish the amount of glazing, or if you want the glaze to remain only in the "valleys" (between the higher ridges of the support's texture).

Multiple layers work better than one thick layer of glaze.

Underpainting

Usually an underpainting intended for subsequent glazing is monochromatic (one color); if it is done in shades of gray, white, and black it is called a *grisaille*. The usual technique is to keep the underpainting somewhat higher in value contrast than you expect the finished painting to look like, because adding the colored glazes will darken the light areas and lighten the dark areas (thereby reducing the final, overall value contrast). Execute an underpainting with "lean" paint (use paint low in oil content, such as flake or underpainting white, and use a medium low in oil content).

Scumbling

While the term *scumbling* is used inconsistently by different artists and authors, we restrict ourselves to just one usage: for us, "scumbling" is the application of lighter colors (whether opaque, semi-transparent, or transparent) over a darker color. If the scumble contains white, add some extra oil before applying it over glazes.

Scumbling is useful in several ways. First, by applying an opaque or semi-transparent scumble thinly enough (or scrubbing the excess off), the underlying layer of color appears to show through a pearl-like sheen. Secondly, opaque scumbling can be used to make a glazed area of a painting lighter again — in order to create a highlight or to allow further glazing to proceed effectively.

Wiping-out

Areas of a composition may be painted with halftones (the middle tone of an object's color in between light and shadow), and then, while the paint is still wet, highlights are wiped out with a rag dipped in solvent (such as odorless mineral spirits). Other tools may also be used for removing paint (such as combs and sponges). Darker shadows and opaque details may be added later with a brush and paint.

Care of Completed Paintings

Varnishing

A completed oil painting may be varnished in order to provide a protective coating. The basic theory is that dirt will accumulate on the varnish while the surface of the paint remains clean. Old varnish can eventually be removed, and a layer of fresh varnish applied to continue the protection. A layer of varnish also contributes to the aesthetic appearance of the painting: it enriches and unifies the colors.

Damar varnish or mastic varnish are traditional choices. These varnishes are composed of resin dissolved in turpentine, plus a small amount of oil for elasticity. Upon application, the turpentine evaporates, leaving a thin coating of resin which protects the painting underneath.

Because natural resins yellow with age and become difficult to remove (due to a chemical change), new varnishes have been developed for artists' use. You want one that doesn't yellow and is easy to remove (such as Gamblin's Gamar Picture Varnish).

Make sure the painting is thoroughly dry before varnishing. (To see just how slowly thick oil paint dries, leave a glob of paint on a paper palette. Even after weeks, the tip of a palette knife can be used to puncture the glob's dry outer surface to reveal wet paint.) No oil

painting should be varnished before three months' drying time; depending on the thickness of paint application, some oil paintings should be allowed to dry for nine months or even longer.

Follow the manufacturer's instructions. Varnish only in a dry, warm room; the painting itself should be at room temperature before varnishing in order to prevent "blooming." Blooming is an unwanted cloudy condition due to moisture condensing inside the varnish.

Storage of Paintings

If stored in a dark place right after it is painted, an oil painting may yellow slightly. In this event, expose the painting to strong but not direct sunlight, and in a couple of days the painting's color should be restored, and the yellowing should not recur even after placing the painting back in the dark. (Consult a technical manual regarding the process of "bleaching" if you need further information.)

OPTIONAL MATERIALS AND TECHNIQUES

Water-Miscible Oil Paints

Manufacturers have developed what are called water-miscible oil paints such as "Grumbacher Max" and "Edvard Munch AquaOil" (Figure 2.10). These paints behave

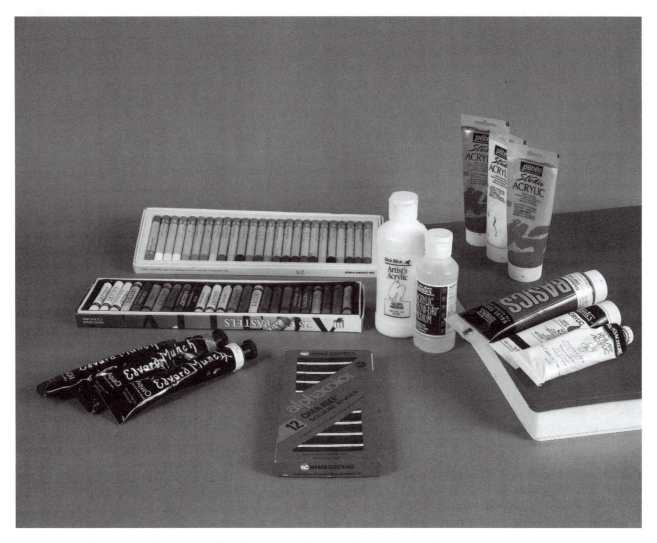

2.10 Left to right: samples of water-miscible oil paints, two boxes of oil pastels, charcoal, acrylic mediums, acrylic paint in tubes resting on a palette seal (a relatively airtight container for storing a palette with wet paints in between painting sessions).

much like traditional oil paints: they can be used for direct and indirect painting; and because they won't dry out in a several-hour painting session, they can be blended like traditional oils. In fact, Grumbacher Max can even be mixed with traditional oil paints and drying oils (as long as the Max paints remain at least 70 percent of the total), and the mixture will still remain water-miscible ("miscible" means mixable in any proportion). Because the handling of water-miscible oil paints is so close to that of traditional oil paints, their use can be substituted easily throughout this textbook.

The important advantage of using these paints for some artists and some situations is that the paints can be thinned and brushes cleaned with ordinary tap water. By using water-miscible oil paints, even a classroom crowded with artists can be kept free of solvent fumes.

Acrylic Paints

As noted in Chapter 1, artists' paints are similar in that all include pigments (which provide the color) mixed together with a binding agent. While the binding agent in oil paints is a naturally occuring drying oil (usually linseed), the binding agent in acrylic paints is a synthetic resin. Other ingredients are added to impart the proper paint thickness, prevent deterioration and freezing, and help "wet" the pigments. The resulting acrylic paints are quick to dry, extremely durable, weather-resistant, flexible, and virtually fade-proof.

An outgrowth of experimentation with synthetic polymers that started in the 1920s, acrylic paints are a form of plastic coating. It took a few decades to work out a paint formula that would satisfy the requirements of fine artists, but by the 1950s acrylic paints started to rise quickly in popularity in the United States, followed by their growing use in Europe and elsewhere.

While some artists think of acrylic paints as a safer, quicker-drying substitute for oil paints, we recommend that you approach each as a different paint medium. Acrylic paints offer properties that can provide distinct advantages: the paints are versatile in their handling capabilities; brushes are cleaned with water and soap; and acrylics do not require the use of strong solvents and thinners for manipulating their consistency. Acrylic paints can be applied to virtually any support that is acceptable for oil paints. In addition, acrylic paints can be applied on raw canvas, as stains of color, or directly onto paper since they will not rot the fibers (as oil paints would). Because of their exceptional durability, acrylic

paints are much preferred over oil paints for both indoor and outdoor mural painting projects.

Acrylics are available in both tubes and jars, in colors closely approximating the color range of oil paints. Acrylic paint in tubes is usually manufactured with a heavier body (similar to oil paint in tubes), while most acrylic paints sold in squeeze containers and jars are more fluid. Unlike oil paints (which dry the same color they appear straight from the tube) acrylic paints dry a bit darker. An exception to this are acrylics applied in thin washes which dry virtually the same color and value as they appear when wet.

Acrylics can be used straight from the tube or jar, thinned with water like a watercolor wash, or combined with special acrylic mediums. Among the available mediums, the most commonly used are matte and gloss mediums for dull or shiny surfaces respectively, and a gel medium for thicker paint body and adhering collage materials. Gloss medium may also be used to adhere lightweight collage materials.

Most acrylic paints are somewhat translucent, so they need to be applied in several layers to achieve a total opaque coverage (although some paint manufacturers make more opaque brands). Because of their rapid drying, acrylic paints are not easily suited for the slow blending that is possible with oil paints; some artists reduce this restriction with the addition of an acrylic "retarding" medium (which can approximately double the drying time) or by using a spray bottle with water to keep the paints moist.

Acrylics are excellent for building up a rich array of colors in layers. Because of their rapid drying, multiple glazes can be applied in one painting session. Acrylic paints can be mixed with gloss medium for thin glazes, or with gel medium for thicker glazes. All acrylic paints and mediums may be thinned with water, allowing for a full range of techniques quite similar to those used by watercolor painters. (Adding a small amount of medium into the water will help the paint flow and provide more body to washes.) A distinct advantage of acrylic paints over watercolors is that once dry, acrylic paints will not lift off with the application of another wash (paint diluted with water) or glaze. Specially formulated acrylics can be applied by airbrushing; and acrylics are excellent for use in reverse painting on Plexiglas.

Hard-edged geometric abstractions or crisp linear details in representational images are easy with acrylics: use masking tape to define the edge you want, then seal the edge first by brushing along it with gloss or matte medium. Once the medium has dried, paint over with the desired color. The medium creates a seal which prevents

paint from slipping under the tape line. Peel up the tape to reveal a perfectly straight edge. Results are best when painting on a fine-weave canvas or other smooth support.

Because of their different chemical compositions, acrylics and oils should not be blended directly together. Painters may use acrylics to create a quick-drying underpainting. After the underpainting is thoroughly dry (usually less than 30 minutes unless you have applied a thick layer), oil paints may be applied in subsequent layers. The reverse procedure is not recommended; acrylics should not be applied over oil paints because their quick drying may prevent oil paints from oxidizing properly.

Gloss medium can be used as a final protective layer, or use an acrylic varnish. (Look at the manufacturer's specifications for an acrylic varnish that filters for ultraviolet light and has a tough, impermeable surface for protecting murals.)

Cleanup for acrylic painting is relatively simple: wash brushes in water and soap (never turpentine or mineral spirits). Because acrylics dry so quickly, care must be taken to always *keep brushes moist when working* with acrylics. Avoid having paint harden on the brush; if it does, let it dissolve in alcohol. Wear old clothes.

Alkyds

Alkyd paints, invented in the 1930s, were originally developed as high-quality, durable house paints. Now they are marketed (by Winsor and Newton) as artists' paints. Alkyds are actually a form of acrylic paints, except they are thinned and cleanup is done with a thinner (such as odorless mineral spirits) rather than water.

The alkyd paint film remains flexible, and is stronger than that of oil paints. Some artists feel alkyds offer better handling properties than either oil or acrylic paints. Since they are slower to dry than acrylics (alkyds won't dry in a two- to three-hour painting session), they can be blended and worked wet-into-wet. But because they usually dry to the touch overnight, multiple layers and glazes can be applied on successive days. Unlike oil paints, all alkyd colors dry at the same speed. This allows a painter to use any color in any order, without fear of endangering the stability of the paint surface.

Because they dry rapidly and evenly, alkyds are excellent as a choice for the underpainting for a traditional oil painting. While some experts question the wisdom of using acrylic paints for the underpainting of an oil painting, there is virtually unanimous agreement that alkyds are safe for this purpose.

Alkyd and oil paints can actually be mixed together and applied simultaneously, but be careful to mix them thoroughly or their different drying speeds may cause them to crack or separate. You can also use alkyd mediums with oil paints, instead of the alkyd paints themselves. For example, Winsor and Newton's Liquin is useful for thinning and glazing; Oleopasto is useful for creating thick, fast-drying textures.

The same variety of supports we identified for use with oil paints can be used for acrylic and alkyd paintings.

Oil Pastels

Oil pastels are an excellent choice for a painter to use when doing preliminary work outdoors. Since they don't require drying and don't dust off or smear easily, they can be transported safely and used even on a windy day. Available in a range of rich colors, oil pastels allow an artist to capture quickly the impressions of the color of a landscape or other subject from life.

Oil pastels can be manipulated with many of the same techniques used with oil paints. Colors can be blended in their natural state or a little thinner can be brushed over them to make them flow. Sgraffito is easily accomplished: scratching through the upper layer will reveal the first layer of color laid down on a paper support. Broken color can be achieved by applying colors lightly across the upper ridges of the artwork-in-progress, allowing the underlying colors to show through in the valleys. This result is especially easy to achieve if the support (usually paper) is somewhat textured. If oil pastels are used for preliminary work, many effects achieved with them can be incorporated into the final workup of an oil painting in the studio.

Of course, an oil pastel painting on paper can be considered a finished work of art in its own right. (See the oil pastel paintings by Hollis Sigler, Figures 11.9 and 11.10). Oil pastels can be applied over acrylic or watercolor paints once they have dried. Because the oil in the oil pastels repels water, a wash of watercolor or diluted acrylic paint will adhere only to the paper support when brushed over a line drawing done with oil pastels.

Other Optional Supplies

Drawing supplies (such as pencils, charcoal, pen and ink) are all valuable. For those who are working through this book having already completed a course in drawing, you should feel especially comfortable continuing to use drawing skills and techniques learned earlier. We make recommendations throughout the text for ways for all painters to exercise their use of drawing as a means of developing, testing, and recording their visual ideas.

RECOMMENDED MATERIALS TO GET STARTED

Sketchbook (which can double as your writing journal if you wish)

Assorted drawing and writing implements: at a minimum a hard, medium, and soft drawing pencil

Brushes: over time you'll want to purchase bristle and soft brushes in a range of sizes. To start, get one small, medium, and large filbert (approximately nos. 2, 6, and 12). The filbert is a very versatile brush so if you can't afford a variety, this is the preferred choice for all-purpose painting. If you can't get filberts, get flats. Get a medium soft round (approximately no. 6) for glazing, and a 2″–3″ gesso or housepainter's brush for priming.

You'll need modest quantities of the following to start:

odorless mineral spirits

sun-thickened linseed oil

stand oil

an alkyd painting medium

soap

palette

canvas and paper for supports in a range of sizes

easel

acrylic emulsion "gesso"

palette knife

two small metal or glass containers (with lids if possible) for holding the medium and clean thinner; a larger container with lid for solvent (as the thinner gets dirty pour it into the solvent container)

Paint colors are discussed in the next chapter.

1. This information is contained in the "Oil Painting Solvent Comparison Chart" produced and distributed by Gamblin Artists Colors Company, Portland, Oregon (for additional information, see www.gamblincolors.com).
2. We recommend Mark David Gottsegen, *The Painter's Handbook* (New York: Watson Guptill, 1993), for general safety information about commonly used paint supplies. More detailed information can be found in references devoted specifically to artists' safety and health issues.
3. This recommendation is made by the Gamblin Artists Colors Company, 1998.
4. Oil absorption ratings (low, medium, and high) are given in the Pigment Tables in Mark David Gottsegen, *The Painter's Handbook* (New York: Watson Guptill, 1993), pp. 140–76.
5. Harold Osborne, *Aesthetics and Art Theory* (New York: E.P. Dutton, 1970), p. 109.
6. Ibid., p. 106.

Color
A Defining Element of Painting

3

"Color has to be experienced. It is a tremendous force."
— Fritz Scholder[1]

INTRODUCTION TO COLOR

Color is one of the visual elements artists take into account in creating art, along with line, shape, volume, texture, and space. Color is an incredibly exciting and versatile visual element. At the very least it adds to a painting's aesthetic appeal since most viewers are attracted spontaneously by color. In the hands of a capable painter color provides a basic means to construct relationships of form and structure: a change from pink to orange distinguishes one shape from another, while a spot of green attracts visual attention if situated in an otherwise uniform expanse of orange. The juxtaposition of dark and light colors adds a dramatically different impact than the subtle interplay of the palest pastels. Color relationships are often the heart of a painting's composition. Look, for example, at Figure 3.1, a black-and-white reproduction of Hector Hyppolite's *Pan de Fleur (Basket of Flowers — Voodoo)*. Now turn to Plate 3, an illustration in color of the same painting. It is obvious how vivid colors accentuate aspects of the painting's design that diminish in the black-and-white version.

Along with its role in creating form, color contributes in powerful ways to a painting's content, sometimes in several ways simultaneously. Color may be descriptive: an elongated pink shape, for instance, may represent the arm of a fair-skinned person. Color may be integral to formal coherence: a particular yellow might be selected because the painter thinks it harmonizes with a particular red. Color may be symbolic, with a coded meaning determined by cultural conditions: an artist who uses purple as the color for a king's robe, for example, may do so because in that artist's society purple connotes royalty. Color may be emotional, in a personal or even idiosyncratic way: for example, we can imagine someone saying, "I think violet blue is the saddest color; it reminds me of the bedroom where my mother died." Colors can signify danger or something good to eat; colors can camouflage for safety or attract sexual attention; colors can create harmony, or a sense of stridency, or an atmosphere of mystery and enchantment. Some painters explore color because of its potential to suggest associations or represent subject matter beyond the world of the painting; others explore how color itself can be imbued with emotional power, sensuality, and spiritual content.

While colors compel us in many ways, their meanings are hard to specify because colors are, at one and the same time, capable of bringing forth universally perceived effects (such as seeing on a white wall a green afterimage after staring at an intense red square) and effects which seem to vary from individual to individual (such as selecting one's favorite color). Many meanings attached to colors are culturally specific: for example, green means "go" only in certain countries. The meaning of a color is subject to wide variation: in the previous paragraph we cited the example of a person who associates violet blue with sadness; in contrast, many mystics are reported to believe violet blue enhances meditation.

A sensitive appreciation for the technical, formal, descriptive, expressive, and symbolic aspects of using color allows a visual artist to explore "color ideas" within

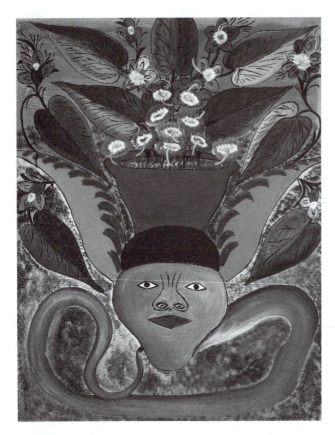

3.1 Hector Hyppolite, *Pan de Fleur (Basket of Flowers —*
Voodoo), 1947. Oil on cardboard, 30″ × 24″. Collection of Hally
K. Harrisburg and Michael Rosenfeld, New York.

a painting. Even if we cannot fully translate into verbal
language the effects of color relationships, one of our
goals in learning to paint is to gain greater awareness of
color's potential for meaning at the pictorial, formal, and
expressive levels.

THE DEVELOPMENT OF
NEW COLORS

Until the nineteenth century the range of colors available
to painters was severely limited compared to those avail-
able today. Judging from the known surviving examples,
Paleolithic cave paintings (Figure 1.1) were made with
a very limited palette, consisting of muted reddish and
yellowish earth colors, as well as chalk and charcoal for
whites and blacks respectively. Painters in subsequent

eras gradually developed additional pigments, thus ex-
tending the chromatic range of paint color. For example,
the ancient Egyptians introduced versions of blue and
green; artists of the European Renaissance produced ul-
tramarine blue from lapis lazuli, and also developed cad-
mium red and yellow, both made from minerals. Early in
the twentieth century, strong-tinting, transparent blue
and green hues called either "phthalo" or "thalo" (short
for phthalocyanine) were developed. The further devel-
opment of new pigments and colors, such as metallic and
iridescent oil and acrylic colors, has accelerated as color
scientists have taken advantage of ongoing advances in
chemistry, mining, and other fields. Who can imagine
what the exploration of space may provide someday in
the way of new pigments?

Today paint is commonly packaged in tubes and
labeled by color, such as "ultramarine blue," "yellow
ochre," and "cadmium red. " In Plate 4 we illustrate some
of the large range of oil colors commonly available.
Acrylic paints are available in a full range of colors that
closely approximate those of oil colors.

APPROACHES TO COLOR
IN PAINTING

The color choices a painter makes reflect many factors:
the pigments available to that artist; personal preference;
cultural understanding of color; the formal require-
ments of a specific painting; and the painter's intentions
regarding meaning. A few of the main ways of using
color are summarized below. These usages are not neces-
sarily mutually exclusive; an artist may combine more
than one approach in a painting, such as using mostly
local color with a few symbolic color choices for certain
motifs.

Local Color

Local color is the color we commonly associate with an ob-
ject as seen under even lighting without shadows or re-
flections — the orange of a pumpkin, the green of a leaf.
Some objects and surfaces have more than one local
color: a shirt with green and yellow stripes, for instance,
has two local colors. Some paintings focus on rendering
the local colors of each object, with little or no modula-
tion by light or shadow (see, for example, Plate 5 by
Philemona Williamson).

Optical Color

A painter working with *optical color* acknowledges that environmental conditions such as weather, time of day, and proximity to other colors alter the perception of local colors. Using optical color, the artist emphasizes color as a function of lighting conditions rather than as an unchanging attribute of an object. The green leaves of a tree, for example, may appear to include a variety of hues, tints, and shades due to the effects of sunlight on some leaves while others are in shadow. At sunset, even "green" leaves may appear tinged with violets and reds. Optical color choices are based on how the subject matter appears at a given moment from a certain distance, rather than what the artist knows is the local color. The French Impressionists were influential advocates of an approach to painting based on visual perception.

Arbitrary Color

Arbitrary color choices in a painting are colors which are not naturalistic. In abstract paintings, all color choices are in a sense arbitrary because the painter is not trying to describe recognizable subject matter. In contrast, in making a painting based on observation, the artist has a choice whether to restrict the selection of colors from among those that are visible or to invent arbitrary color relationships. Among the many reasons representational painters might use arbitrary color are: to separate the world of the painting from everyday reality; to explore powerfully expressive effects of color for their own sake; to create effects of movement or space; or to express emotions and evoke psychological states. Indeed, a freely expressive approach to color can induce strong, almost visceral reactions in viewers. (See paintings by Ed Paschke and Carole Caroompas [Plates 21 and 30] for examples of arbitrary color selected for their emotional and decorative effects.)

Symbolic Color

An artist making *symbolic color* choices intends selected colors to indicate specific meanings. Color symbolism is often widely recognized within a particular tradition. For example, in Indian painting Krishna is recognized by his blue skin; in Christian painting the Virgin Mary can be identified by her blue robe. Color may also be used in a general way to symbolize emotions and moods (such as the melancholy atmosphere of Picasso's "Blue Period" paintings), or to suggest associations with certain seasons, places, historical periods, holidays, or other events. Many painters also use colors with more private symbolic meanings.

Writing and Discussion Exercises

Color Symbolism

Exercise #1: Color Associations
Write the names of the following colors on a page: red, yellow, blue, green. Next to each color list at least ten attributes you associate with it. Look over your lists and think about how your symbolic associations with different colors were generated. Are the sources of the symbolism cultural, political, religious, commercial, psychological, personal, from the world of nature, or a combination of all these? The class as a whole should discuss their symbolic associations with various colors, and attempt to explain any differences in the interpretation of colors by individual students.

Exercise #2: Holidays and Color
Each student should select one of the major holidays celebrated by different cultures around the world. Possibilities include: Rosh Hashanah, Passover, Halloween, Christmas, the Day of the Dead, Ramadan, and the Chinese New Year. Research the holiday to learn what colors are associated with it, how those color choices originated, and what they symbolize. Return to class and report what you have learned about the color symbolism of your holiday topic.

BASIC VOCABULARY AND PROPERTIES OF COLOR

The study of color is complex, of interest to specialists in such diverse fields as optics, psychology, engineering, physics, biology, and chemistry as well as to creative artists working in the performing and visual arts. Our intention in this chapter is to introduce fundamental concepts, terminology, and a structured approach to thinking about color relevant to the practicing painter.

Some words of advice: DO NOT BE INTIMIDATED BY WHAT YOU DON'T KNOW ABOUT COLOR (or any other

aspect of painting, for that matter). You are learning, not attempting to paint a definitive masterpiece that will endure through the ages. As you undertake the painting exercises throughout this text, you will employ color, and in so doing you will gain increased knowledge of its working properties and potential for conveying meaning.

The study and use of color do not need to rely entirely on intuition or personal favorites; instead, painters can follow guidelines that have been developed over time. For example, experienced painters know that certain color combinations look harmonious when paired together (see "Color Scheme," following). As you develop as a painter, we urge you to consult some of the many books devoted to explaining principles and strategies for using color relevant to the visual and design arts. We caution, however, that guidelines for the use of color are only that — guidelines, not ironclad rules. As noted in Chapter 1, in discussing the creative process in general, gaining systematic knowledge should not inhibit or constrain the artist, but should empower her or him to explore beyond past achievements. Once a painter has gained experience in mixing and applying colors, she may prefer to rely on intuition to guide color selections. The mature artist develops her own special capacity to create expressive and meaningful color combinations. In any event, no guidelines can fully predict or explain the myriad ways artists use color and how even slight changes can sometimes dramatically alter the effect of a specific color combination.

Color and Light

Many people think of objects as having color: that blue chair, this red bowl. Contrary to this conception, however, color is not a physical part of an object but is actually in the light rays that illuminate the object. Without light there is no color to be seen. When light falls on it, an object's surface absorbs some of the colors from the light and reflects other colors. We see those which are reflected. If all colors are absorbed except blue, the object appears blue; if no colors are reflected, the object appears black; if all colors are reflected, the object appears white.

The color that results from light reflected off a surface is called *subtractive* color. (Color created by mixtures of light alone, rather than by reflected light, is called *additive* color.) Subtractive color is the type with which we are most commonly concerned as painters. In applying paint to a surface (such as a canvas), we alter

that surface's ability to absorb (subtract) specific colors of light, thus changing what we view as its reflected color. Although the colors we perceive are contained in the light rays reflected from an object's surface, the colors that are reflected are determined by physical properties of that object (think, for example, of a red apple rotting and turning brown).

Many of the effects of color remain outside the boundaries of current scientific understanding. Some people report experiencing color sensations in conjunction with sounds, and experiments have established that color changes in a room may even affect the mood of people who are blind.

Hue, Value, and Saturation

The basic properties of color are *hue*, *value*, and *saturation*. These terms should be part of your painting vocabulary. Understanding these properties will help you learn how to mix or match any color you want, as well as help you foresee the effects colors have on one another when they are used together in an artwork.

Hue is the name of a color of the spectrum ("red," "blue," and so on). *Value* (sometimes called *tone*) is the darkness or lightness of a color. Saturation (sometimes called *intensity* or *chroma*) is the amount of pure hue in a color, its vividness. Colors that are unsaturated are grayer than pure hues. While these properties are defined separately, they exist interdependently. For example, at its most saturated — when it is pure hue — purple is naturally a dark color. A light purple can never be very saturated. The term *brilliance* is sometimes used to identify the quality of colors that are both light in value and saturated.

Strategies for controlling degrees of value and saturation, and for mixing different hues are discussed in the section "Mixing Oil Colors," on pages 52–53. Exercises at the end of this chapter provide you with opportunities for gaining experience in controlling these qualities of color when you paint.

The Color Wheel

When a beam of sunlight is directed to pass through a prism, it separates, by refraction, into the full spectrum of visible hues — from red to violet. By taking a diagram of the spectrum and looping it around to form a circle, the seventeenth-century English physicist Sir Isaac Newton developed the first *color wheel*. The resulting

wheel hypothetically joins red (from one end of the spectrum) with violet (from the other). The color wheel has endured as a useful device for helping to visualize specific color relationships.

There are numerous versions of a color wheel; the one we illustrate is similar to the design of Johannes Itten, a design that divides the wheel into twelve pie-shaped segments (Plate 6). Some versions of the color wheel divide the spectrum into a larger number of hues, but a twelve-hue wheel provides enough information for painters to explore basic color relationships without being overwhelmed by detail.

Moving around the circumference, each segment represents a different hue. Three hues — red, yellow, and blue — are *primary* within the painter's spectrum, and are spaced at equal distances apart on the circle. In theory, the primary hues cannot be mixed from other hues but form the basis of all other hues. (As we discuss later, in artists' paints it is not actually possible to mix all the other colors from only three primaries; therefore, most painters start with additional colors on their palette.[2]) Between each of the three primary hues lie intermediate hues. The three *secondary* hues — orange, green, and purple — are located midway between each primary hue, and are made by mixing two primaries in equal visual proportions. Orange, for example, is the mixture of yellow and red. The six *tertiary* hues — yellow-green, blue-green, and so on — are each a mixture of a primary and one of its closest secondaries, moving around the color wheel.

On our color wheel, the center band of each pie-shaped segment illustrates a hue at its maximum saturation, where no black, white, or gray has been added. Moving inward from the center band, the hue is lightened in value by mixing white with the hue (these are called *tints*); moving outward shows the hue darkened (these are called *shades*).

Looking at the color wheel, it is apparent that pure, saturated hues are related to one another in terms of value: starting with yellow as the lightest hue, the hues become increasingly darker moving in both directions around the color wheel until we reach purple, the darkest hue. Red and green are equal in intensity. Figure 3.2 shows the color wheel translated into tones of gray.

Because it diagrams relationships among colors, the color wheel is an invaluable reference for mixing colors and determining color schemes and compositions.

Saturation Scales

In the saturation (or tonal) scale (Plate 7a) red is shown in five gradations from fullest saturation to achromatic

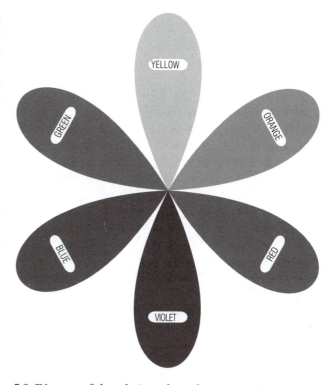

3.2 Diagram of the relative values of primary and secondary colors.

(colorless) gray. Each step of the scale is called a *tone* — a color created by combining pure hue with gray (white and black). Plate 7b shows the complements red and green mixing in five steps, with chromatic gray as the middle of their mixture.

Temperature: Warm and Cool Colors

Physiological and psychological responses to various colors result in a distinction between *warm* and *cool* colors (see Plate 6). We tend to associate warm colors, which include those in the red-to-yellow range, with hot or warm things such as fire and sunlight. We tend to associate cool colors, which are those in the blue-to-green range, with cool things such as ice and leafy trees. Psychological tests indicate that in controlled situations of limited duration, warmer colors tend to promote increased levels of activity while cooler colors calm people. Many painters find that their compositions appear more unified if they select colors that are predominantly either warm or cool, with a smaller amount of the other for contrast. For example, Williamson's *Pumpkin Girls* (Plate 5) is predominantly warm in its colors.

Advancing and Retreating Colors

The human eye focuses on the color red as if it were closer than it actually is. (This results from red being the visible color with the longest wavelength). The eye focuses on blue as if it were farther away. Consequently, we refer to reddish colors as *advancing* colors, while we call blues *retreating* colors. When placed next to each other in approximately equal intensities, advancing and retreating colors will appear to "dance" or vibrate, because the eye involuntarily shifts back and forth in attempting to focus on the different colors.

The use of warm colors to advance and cool colors to retreat, however, is an effective strategy for defining pictorial space only when used in combination with other strategies. A more consistent guideline for the painter to follow is that any salient feature tends to advance, so a single blue shape in a field of red will tend to pop forward.

Color in Context

The perception of a color may change depending on the context in which it is seen. *Simultaneous contrast* refers to a condition in which colors adjacent to one another or where one is surrounded by another appear to shift in terms of hue, value, saturation, or temperature. Whatever contrast exists between the two colors will tend to be exaggerated by the juxtaposition. Stated another way, the perceived hue/value/saturation/or temperature of a color changes in an inverse relationship to changes in its surrounding context. For instance, a color of middle value appears darker against a background color of lighter value, whereas that same color of middle value appears lighter against a color of darker value. To test this important effect for yourself, cut out two small squares of the same middle gray color. Turning to Plate 2, place one gray square on one of the darker portions of the grid and place the other gray square on one of the lighter portions of the grid. Observe how the two gray squares don't seem to be the same color anymore.

Complementary hues tend to create strong effects of simultaneous contrast. A gray surrounded by red will appear slightly greenish, whereas a gray surrounded by green appears reddish. For simultaneous contrast to occur, the color areas must be sufficiently large. Very small marks or strokes of color tend to mute each other's qualities mutually.[3]

CHOOSING COLORS IN A COMPOSITION

One of the chief challenges (and joys!) facing any painter is to decide what colors to use in a painting. Knowing basic principles of combining colors should not thwart creativity. On the contrary, more knowledge helps a painter avoid the rut of relying exclusively on the same colors or relationships employed before, or seen in the paintings of others. Of equal importance, you develop a more distinctive use of color if you avoid working haphazardly. To expand your range, be both systematic and bold in experimenting with new color combinations and mixtures.

To better understand the process of choosing and working with color, we distinguish between what we call the *color key*, *color scheme*, and *color palette*. Each of these terms refers to an approach for identifying the use of colors systematically. The actual effects of color in a composition, however, are almost always complex and difficult to foresee with total accuracy. While knowledge of these concepts will aid your progress, hands-on experience painting is essential. These approaches to composing with color are only suggested beginnings; they should not serve as limitations on your experimentation with color. In the ensuing chapters, we offer various exercises which challenge you to explore how color functions as an integral aspect of the overall thematic content of a painting.

Color Key

A *color key* organizes the selection of colors based on value or saturation.

> *Color key by value*: A normal color key includes a selection of colors representing the full range of values—from high (light) to low (dark). A high color key is a selection of colors restricted primarily to values in the high (or light) end of the value range. A low color key is restricted primarily to colors with values in the low (or dark) end of the value range. A high contrast key includes colors of both high and low values, with few if any areas showing values in the middle. Usually it is best to avoid using colors that are only in the middle of the value scale, for such paintings often seem dull.
>
> Just as a musician may transpose an entire melody to a higher or lower key (while keeping the

notes consistent in their relationship to one another), painters sometimes transpose the values of a subject to a higher or lower key. This can be a useful strategy, for instance, for a painter working outdoors because paint itself has a much more limited value range than the values found in nature.

Color key by saturation: A high saturation key features vivid, unmixed colors (see Plate 30 by Caroompas). A high key saturated painting is often started on a white ground, which serves to reflect the saturated colors that are initially applied thinly and transparently. A low saturation key features neutral browns, grays, and other subdued color mixtures (see Plate 22, by Emma McCagg).

Tonal unity: With *tonal unity*, colors of all hues are consistent in value (tone) depending on whether they are in shadow or in illumination. For example, blues and yellows in shadow are equally dark, while blues and yellows in a brightly lit area are equally light. Tonal unity is an effective strategy for emphasizing the illusion of light and shadow, and for creating a composition in which all the darks and lights in the painting are organized within an overall scheme. For these reasons, many realist painters have incorporated this approach, or a modification of it, in their work.

Color Scheme

A *color scheme* organizes colors based on logical relationships among hues. Color schemes are commonly used in conjunction with the color wheel to identify groupings of hues that relate to one another in harmonious ways. While each color scheme is defined by a relationship of only two, three, or four hues, in practice each scheme can also include any of the various tints and shades of these hues, as well as white, black, and tones of gray. Additionally, a single painting may combine two or more color schemes in its composition. The following are well-established color schemes (see Figure 3.3):

Monochromatic: All colors are selected from one hue. An example is a painting made from various tints and shades of red (see Plate 28, by Sabina Ott).

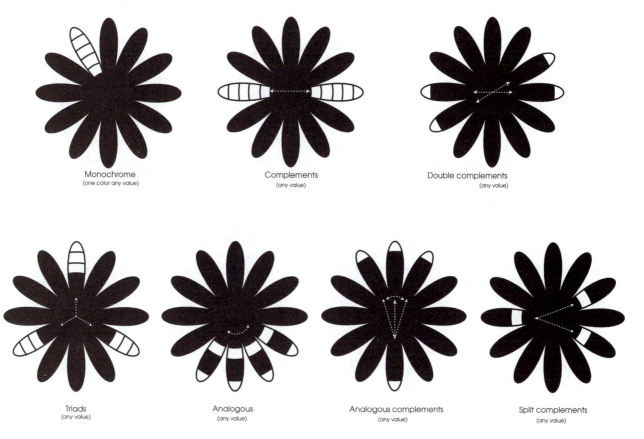

3.3 Diagrams of well-established color schemes.

Analogous: All colors are selected from two, three or four hues that are next to each other on the color wheel. For example, yellow-green, green, blue-green, and blue are analogous colors. (See Plate 23, by Colette Calascione, which is primarily a color scheme of various tints and shades of reds, red-oranges, and oranges, along with shades of warm gray.)

Complementary: Two hues directly opposite each other on the color wheel are selected. Examples of complementary pairs include red and green, orange and blue, and purple and yellow. (Plate 13, by Frida Kahlo, features a red and green complementary color scheme.)

Triadic: Three hues that are equally spaced around the color wheel are selected. The primary triad consists of red, yellow, and blue (Plate 16, by Ernest Pepion, is an example of such a triad); the secondary triad consists of orange, green, and purple. There are also two possible triads consisting of three of the six tertiary colors.

Split complementary: One hue plus the two hues adjacent to the complementary hue are selected. An example is red, yellow-green, and blue-green. The latter two are adjacent, in either direction, to green, the exact complement of red.

Analogous/complementary: One hue plus its complement and the two hues adjacent on either side of the complement are selected. This scheme combines the complementary and split complementary schemes. An example is red, yellow-green, green, and blue-green.

Double split complementary: Each of a pair of complementary hues is replaced by the two hues adjacent to it on the color wheel. An example is red-violet, red-orange, yellow-green, and blue-green.

Tetrad: A four-color scheme consisting of two pairs of complements is selected. Plate 32, by Kerry James Marshall, incorporates the complements blue and orange, and red and green.

Color discord: In general, discordant hues are located far apart on the color wheel (three to five steps on a wheel with twelve steps), without being complementary. The effect of discordancy is hard to predict consistently, but in addition to being distinct in terms of hue, combinations of colors that are very close in value tend to clash. Color discord can be a visually powerful and expressive effect.

Color Palette

As if trying to identify a painting's color key and color scheme weren't complicated enough, in actuality the number of colors used in any specific painting is often much larger than these terms suggest. Because painters constantly mix paints as they work, adding a little more of one color into another here and a little less there, a finished painting might have hundreds, if not thousands, of subtle distinctions of color. For this text, we are adopting the term *color palette* to refer to the complete array of all colors that are visible in a finished painting. Of course, in some paintings the transition from one color to another may be so subtle that it is impossible to define where one color leaves off and another begins.

Painting Tip: When you are painting a scene from life which has an overwhelming variety of colors, including a multitude of hues, values, and levels of saturation, you are not obligated to "match" them all. Attempting to copy nature will seldom result in a cohesive, effective visual statement. Instead, choose colors to replicate or enhance only selected aspects of the color relationships visible in your subject matter.

Analyzing Color Palettes by a Grid System

We use the term color palette to refer to all the colors that are visible in a painting. Because the number of colors can be vast it is useful to abstract from this complexity a reduced color palette that summarizes the most noticeable or important colors. We have designed what we call a *color palette grid* as a means to display and analyze this abstracted color palette. This analysis can be used as a planning strategy prior to undertaking a new painting; alternatively, this analysis can be used as a strategy for discovering significant underlying color relationships in a finished composition (which, in turn, can be modified and used as a springboard for a new painting).

To construct a color palette grid, identify nine colors in the painting. The goal is to select those colors that are most important in defining the overall effect of color in the entire composition. Create equal-sized squares of these nine colors and arrange them into a grid. Through this process you limit your analysis of colors and color relationships to a manageable level of information, with sufficient specificity to be practical for future applications.

Constructing the color palette grid is not an exact science, and there are usually several — even a great many — viable ways the palette could be analyzed and

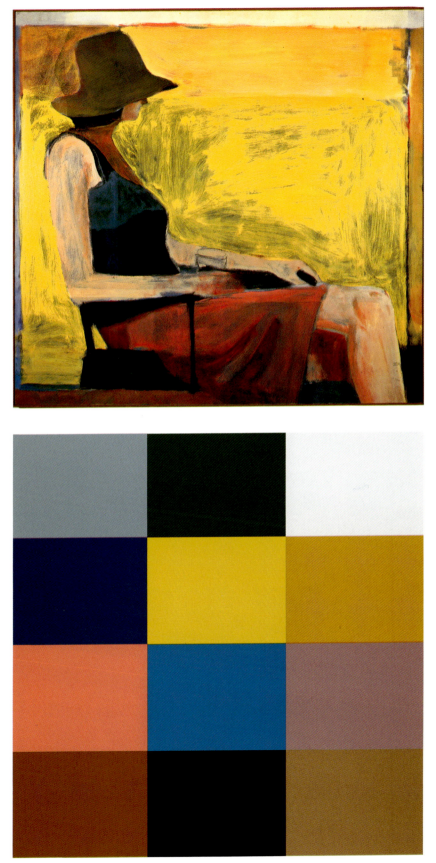

Plate 1 Richard Diebenkorn, *Seated Figure with Hat*, 1967. Gift of the Collectors Committee and Mr. and Mrs. Lawrence Rubin. Copyright © 1998 Board of Trustees, National Gallery of Art, Washington. Oil on canvas. 1.524 cm. × 1.524 cm. (60″ × 60″).

Plate 2 Color palette grid for Diebenkorn's *Seated Figure with Hat* (Plate 1).

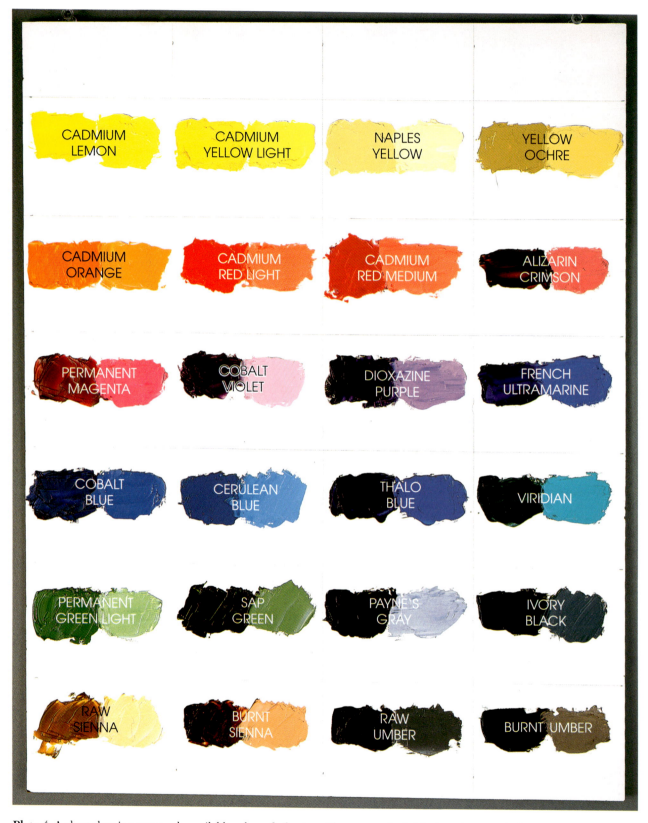

Plate 4 A chart showing commonly available colors of oil paints. The area on the left is the color straight from the tube; the area on the right is the color mixed with an approximately equal amount of titanium white.

Plate 3 Hector Hyppolite, *Pan de Fleur (Basket of Flowers—Voodoo)*. 1947. Oil on cardboard, 30″ × 24″, signed. Collection of hally k. harrisburg and Michael Rosenfeld Gallery, New York.

Plate 5 Philemona Williamson, *Pumpkin Girls*, 1989. Oil on linen, 48″ × 60″. Byron Atkinson Collection.

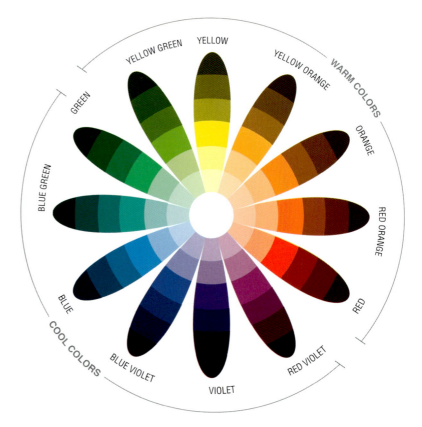

Plate 6 A color wheel showing each hue at full saturation in the middle band. Moving outward, each spoke shows a hue changing from light (with the addition of white) to dark (with the addition of black).

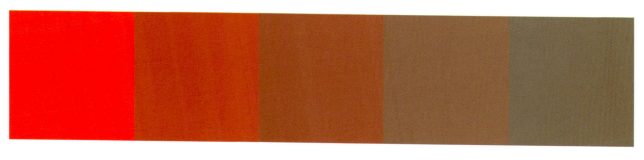

 RED

GRAY

Plate 7a Saturation scale showing the color red in five gradations (all of equal value) from fullest saturation to gray.

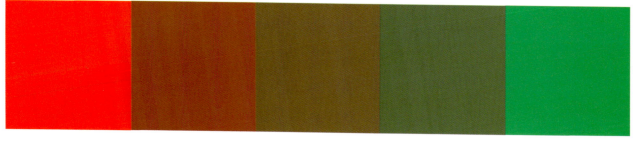

 RED

GREEN

Plate 7b A scale showing the complementary colors red and green mixing in five equal steps, with chromatic gray in the middle.

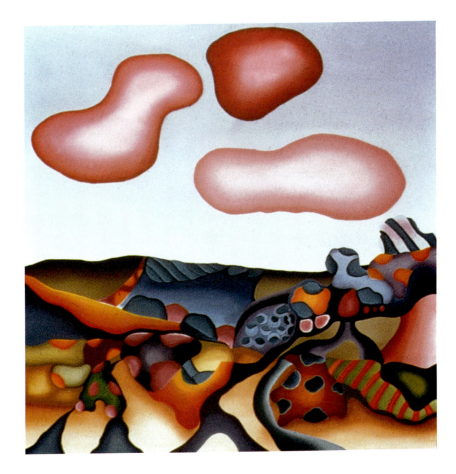

Plate 8 Linda Lomahaftewa,
Pink Clouds and Desert, 1970. Oil on
canvas, 60″ × 60″. Courtesy of the
artist.

Plate 9 Color palette grid for *Pink Clouds and
Desert* (Plate 8).

Plate 10 Philip Guston, *Talking*, 1979. Oil on canvas, 68½″ × 78″. Collection: The Edward R. Broida Trust, Palm Beach, FL.

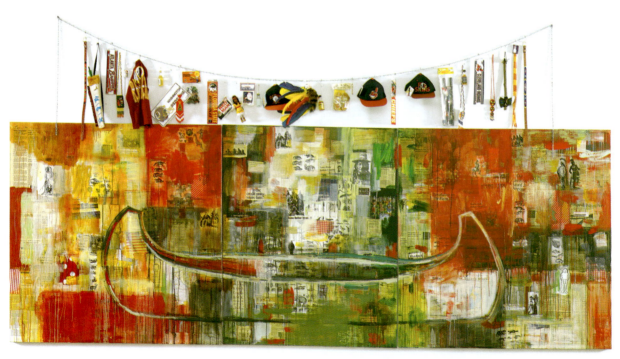

Plate 11 Jaune Quick-to-See Smith, *Trade (gifts for trading land with white people)*, 1992. Oil, collage, mixed media on canvas with objects, triptych, 60″ × 170″. Collection: Chrysler Museum of Art, Norfolk, VA. Museum purchase.

Plate 12 Vija Celmins, *Heater*, 1964. Oil on canvas, 48″ × 48″. Collection: Whitney Museum of American Art, New York, purchased with funds of the Contemporary Painting and Sculpture Committee.

Plate 13 Frida Kahlo, *Thinking about Death*, 1943. Oil on canvas mounted on masonite, $17\frac{1}{2}$″ × $14\frac{1}{4}$″. Private collection, Mexico.

Plate 14 Chuck Close, *Self-Portrait, 1986*, 1986. Oil on canvas, $54\frac{1}{2}$″ × $42\frac{1}{4}$″. Courtesy of Pace Wildenstein, New York.

Plate 15 Detail of Chuck Close, *Self-Portrait*, 1986 (Plate 14).

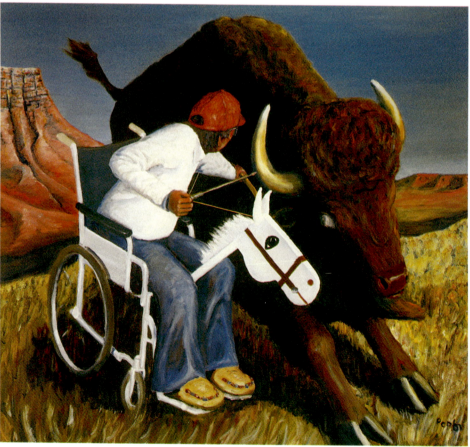

Plate 16 Ernest Pepion, *Buffalo Hunter*, 1994. Oil on canvas, 47″ × 49″. Courtesy of the artist.

diagrammed in the grid. Any one grid, however, if done effectively, should identify important colors and show something of the relationships among them that define the overall impact of the composition.

In a nine-color grid, the central square in the grid becomes the key color: four other colors touch it directly along one edge. We recommend placing the next most important colors in the palette as the squares at top center and bottom center. If possible, relative importance and actual physical location in the artwork should both be shown abstracted in the grid. Obviously, choices and simplifications must be made. (We recommend a nine-color grid, but to provide more choices of colors we also suggest a twelve-color grid. With twelve colors, there are two squares in the center of a grid with three rows and four columns.)

A color palette grid can be constructed using collage or paint:

Method #1: Use an assortment of colored paper, or paint chips. Our own favorite method is to use *Color Aid* paper, which is sold in sets of 314 colors.[4] As you search for the color to place in each square of the grid, you will be further challenged to make decisions regarding the most effective choice for hue, value, saturation, and temperature in each color selected. Depending on the artwork you analyze, you may find that the artist used a more subtle range of tints, shades, pastels, or neutrals than are available in the *Color Aid* pack. This is okay; you will learn by experience to abstract the essence of a color palette from the colors you have available.

Method #2: Use paint to mix colors and paint the squares of the palette grid.

WORKING WITH OIL COLORS

In the preceding sections, we discussed how a painting's composition may be organized or analyzed in terms of color key, color scheme, and color palette. To make a painting, however, the painter most likely does not begin with actual oil colors that coincide exactly with all the colors seen in the finished artwork. The *working palette* is our term for the colors of paint that the artist lays out on the palette to commence the process of painting. The colors shown in the painting (its color palette) result from the colors of the working palette being used both straight from the tube and in various mixtures.

What oil colors, for instance, did Richard Diebenkorn have on hand as he began the painting illustrated in Plate 1? Although we cannot be sure — because various brands of paint have differences in coloration — we believe that a blend of cerulean blue oil paint (a warm blue) was mixed with cobalt blue for the blue of the woman's top. That same blue was mixed in varying amounts with alizarin crimson to yield the colors of the skirt. Cadmium yellow was mixed with yellow ochre and brushed over an underlying layer of blue for the large rectangular shape that dominates the background of the painting. Diebenkorn's working palette, then, probably included cerulean blue, cobalt blue, alizarin crimson, and yellow ochre. The color palette of his painting consists of various mixtures of these colors, and we have illustrated the dominant ones in our color palette grid (Plate 2).

Properties of Oil Paints

In addition to learning the basic properties of color (hue, value, saturation, temperature), through experience a painter gradually develops an awareness of properties specific to oil paint colors. (Other types of paint, of course, have their own properties, some of which coincide closely to those of oil paints.) You will not have an immediate need to apply all this knowledge in your initial painting exercises, but we provide this overview so you will have a structured way of thinking about color and the properties of oil paints.

Opacity

Some oil colors are *opaque*, or nearly opaque. A layer of opaque color tends to completely cover any color below it, so that none of the underlying color shows through or affects the surface coloration.

Importantly, white tends to be an opaque color. Titanium and lead (or flake) whites are very opaque. Combining any other color — even a transparent color — with one of these whites will produce an opaque tint.

A list of opaque oil colors includes:

Cadmium reds: deep, medium, and light

Vermilion

Venetian red

Indian red

Cadmium yellows: deep, medium, and light

Yellow ochre

Naples yellow

Cadmium orange

Lemon yellow

Focus On

RICHARD DIEBENKORN AND LINDA LOMAHAFTEWA
Plates 1, 2, 8, and 9

To illustrate our concept, we have constructed color palette grids (Plates 2 and 9) for oil paintings by Richard Diebenkorn and Linda Lomahaftewa. Coincidentally, both artworks are identical in size (60 inches square), and both artists had important ties to the San Francisco Bay area. Diebenkorn was a prominent member of the Bay Area Figurative Art movement of the 1950s and 1960s; Lomahaftewa (of Hopi and Choctaw ancestry) was enrolled at the San Francisco Art Institute at the time her painting was completed.

Lomahaftewa's painting, *Pink Clouds and Desert* (Plate 8), features a split complementary color scheme. Various tints and shades of blue in the center of the composition are contrasted with tints and shades of red-orange in the clouds and earth, and yellow-orange in the foreground. More is going on in this painting, however, than is implied by simply identifying a "split complementary color scheme." Pale pastel tints of blue-violet infuse the sky, and dark blue-greens are imprinted on the abstracted land forms.

The immediate impact of Lomahaftewa's painting is one of complexity in terms of the colors she uses and the pattern of shapes these colors make. In constructing a color palette grid, we sought to select nine of the most important colors and place them together on the grid to show key color relationships, while being consistent, as much as possible, with the actual arrangement of colors in the artwork.

In contrast to Lomahaftewa's, Diebenkorn's painting (Plate 1) represents monumental simplicity. The painting is composed basically of a triadic color scheme, which may initially be identified as yellow, blue, and red. More careful inspection, however, reveals that Diebenkorn's color scheme is actually a triad in which each primary has been shifted half a turn around the color wheel: the yellow is between yellow and yellow-orange; the blue is between blue and blue-green; and the red is between red and red-violet.

Constructing a color grid of Diebenkorn's palette challenges us to realize how much wealth the painting shows in its subtle overlaying and mixing of colors. We have used a grid with twelve squares. Stacking the squares three across allows us to accentuate the horizontal bands that structure the composition.

The color palette grid abstracts several key color relationships that contribute to the overall effect of the painting but may easily be overlooked in a cursory description: the upper band contains a pale blue-gray that fades to almost white; just below this the dark yellow-green hat is juxtaposed to yellow-orange. We find, then, that the yellow of the triad has been extended in both directions into the analogous yellow-green and orange-yellow hues. The cool red is tinted to create the flesh tones; the black of the chair and hair complete the colors selected for the palette grid.

Cerulean blue

Titanium white

Flake white

Mars black

Lamp black

Note: In acrylic paints, these same colors are usually more opaque than others, but they may be slightly translucent.

Transparency

In contrast to opaque colors, *transparent* colors allow some light to pass through them. A transparent color will not block out the colors beneath it but instead will transform the appearance of underlying colors similarly to the way a transparent piece of colored cellophane alters any colors underneath. Transparent colors are utilized in the technique of glazing. (Paschke's painting, Plate 21, is a good example of the use of transparent colors in glazing.)

Because our perception of color depends on light, any change in the condition of lighting or how light strikes, passes through, or reflects off a painted surface will alter the quality of color we see. Simply stated, the technique of glazing allows paint colors to glow, looking stronger and richer than the same colors appear in opaque applications. (Adding a gloss varnish to a painting will also punch up the appearance of color.) The effect is similar to the way a wood or metal surface looks richer when it is wet than when it is dry.

Because of the considerably higher tinting strength and intensity of modern organic colors (which makes them particularly powerful as glazing colors) we have placed an asterisk (*) following the modern colors in the list.

In oil paints, transparent colors include:

Indian yellow

Transparent orange

Alizarin crimson

Quinadridone red *

Acra red *

Viridian (green)

Phthalo blue *

Phthalo green *

Prussian blue

Ultramarine blue

Dioxazine purple *

Cobalt violet

Burnt sienna

Raw umber

Semi-transparent

Semi-transparent colors are not opaque but slightly translucent (allowing some light to pass through).

Zinc white

Ivory black

Burnt umber

Whether pigments are opaque, transparent, or semi-transparent, they all tend to have the same "body" (thickness) when they come out of the tube. This consistency of body was not always the case, but it is something modern manufacturers of tube paints strive for.

Tinting Strength

Some colors of paints are more powerful than others in their capacity to dominate a mixture. While one may ini-

tially suspect that tinting strength would vary with transparency, this is not always the case. Some transparent colors are relatively strong in terms of tinting strength (e.g., the phthalo colors), while others are relatively weak. Similarly, some opaque colors tend to dominate mixtures; others are relatively weak.

It is easy to determine the tinting strength of paint colors. Simply mix controlled test amounts together with the same amount of another color and compare the results.

When in doubt about relative tinting strengths of colors you wish to mix, start with the lighter color and add small amounts of the darker color to it. This will help avoid mixing a large amount of an unwanted color.

Lightfastness or Permanence

You will notice on the sides or labels of high quality brands of oil paints that the manufacturer has provided a rating for the lightfastness or permanence of that color. The rating will consist of a number or a number of stars (usually from 1 to 4, with 4 being the most permanent). Some oil colors are composed of pigments which fade over time, especially when exposed to sunlight. Obviously your best strategy is to avoid those that are not permanent. You can test the lightfastness of a paint color yourself by painting two test patches and leaving one exposed to light coming in a window. After a few weeks, compare the two test patches for fading.

Drying and Drying Time

Oil colors keep their same coloration upon drying; acrylic colors, on the other hand, dry a bit darker than they appear when wet (except when used in a thin wash).

Oil colors dry at different rates. The drying time is contingent primarily on the amount of oil binding the pigment particles. Paints with low oil content dry faster than paints with increasingly higher levels of oil content. The "fat over lean" rule (see Chapter 2, p. 33) states that a more oily color should be placed over a less oily color. Because the former dries more slowly, following this rule helps to avoid any cracking of the paint surface which could occur if the outer layer dries more quickly than the underneath layers.

It is safest to start with colors low in oil content, and use colors with high oil content for later stages of a work. Because it is low in oil content, using flake white by itself and in mixtures with other oil colors during the early stages of a painting is usually a sound strategy that is not overly complicated to follow. Also, use more thinner and less oil in the medium for a painting's early stages. In the later stages, don't use any thinner.

Tinting with White

Adding white to any paint will increase its value (white being lighter than any other color), but with certain paint colors the addition of even a small quantity of white also alters its coloration. The change may result in a paint color that is more saturated, and often cooler in temperature. (To see this for yourself, add a touch of white paint to phthalo blue or phthalo green.) Similar effects occur when paints are spread in thin glazes over a white ground.

By experimenting systematically, a painter can gain experience as to which paints change coloration or intensity when white is added to them (for example, most blues become cooler).

Quality of Paint

Oil paints should contain pigment and linseed oil (or another natural oil) as the binding oil, and ideally nothing else. Some manufacturers add other ingredients in order to produce drying times that are more consistent for all colors. Professional-grade artists' paints usually contain less "filler" and more tinting strength for the same volume. Student-grade paints have more filler and less tinting strength. Nevertheless, many brands of student-grade paints are fine to use, especially when you are learning. Avoid oil paints that show a separation of the oil binder from the pigment when you twist off the cap. It is possible to combine colors from various brands of high quality oil paints. You will discover if you use different brands that specific colors may vary; one manufacturer's cadmium red medium may not look exactly like another's.

Mixing Oil Colors

As we noted above, all the shades, tints, and tones of the various hues present in a painting (what we identify as its color palette) were most likely mixed from a much fewer number of actual tubes of paint. Even a painter who begins with virtually the same tube colors (possibly as few as six or eight) for all her paintings may create finished artworks which differ markedly in their coloration. This variation is the result of color mixing. There is no adequate substitute for hands-on experience in gaining knowledge of color mixing. Many artists mix paints spontaneously rather than follow strict formulas, but even a spontaneous approach is usually more effective for those who possess a working knowledge of color relationships. Such knowledge saves time as well as paint.

Altering a Color's Value

To darken a color A simple way to darken any color (to create a shade) is to add a touch of black to it. The more black added, the darker the color becomes (see Plate 6). In addition to becoming darker, some colors show a dramatic change in hue when black is added (for example, yellow quickly turns greenish).

An alternative way to darken any color is to mix in (or use by itself) a darker color that is adjacent to it on the color wheel. By taking advantage of the fact that pure hues become darker as they move around the color wheel from yellow to purple, this strategy allows a painter to darken color while maintaining high color saturation. This strategy can be used to "cool" local colors as they become more shaded. For example, if the color you wish to darken is yellow-green, mix in green; if the color you wish to darken is green, mix in blue-green; and so forth. Two special cases with this strategy are: to darken purple (which is already the darkest hue on the color wheel), just add black; to darken yellow (which is the lightest hue), choose either yellow-green or yellow-orange.

In addition to becoming less saturated, adding the complement to a color also serves to darken it (with the exception of adding yellow to purple).

To lighten a color A simple way to lighten any color is to add white to it. Increasing the amount of white results in increasingly lighter tints (see Plate 6). Lightening a color by simply adding white, however, also cools most colors.

An alternative way to lighten any color is to mix in (or use by itself) a lighter color that is adjacent to it on the color wheel. Lighter colors move around the color wheel towards yellow. Using this strategy enhances the illusion that objects are being illuminated by warm light (light with a yellowish glow).

Reducing a Color's Saturation

One strategy is to add some of the color's complement to it (see Plate 7b). In using oil paint, some exact complementaries may be available with the tube colors on your palette. For example, red-orange and blue-green (complementary colors on the color wheel) are matched by cadmium red light and viridian (oil paint colors). Depending on the selection of tube colors you have available for your working palette, you may need to mix other complementaries as you need them. Unless you are determined to mix a true gray, however, it isn't necessary to work with perfectly matched complementaries.

Another strategy is to mix a neutral gray (white combined with black) of the same value as the color and add this (see plate 7a).

Darkening or Lightening a Color While Maintaining Uniform Saturation

The painter faces a special challenge if he wishes to create gradations of color that move from dark to light while maintaining uniform saturation (i.e., the proportion of hue appears to remain constant as the color changes in value). Such gradations, which are very harmonious, are appropriate, for instance, in a realistic painting in which the subject matter is shown under lighting conditions which vary from illumination to shadow. To keep saturation uniform, the painter cannot simply add black or white to a color. A tint is darkened by adding black plus some of the original hue. A shade is lightened by adding white plus more of the original hue. To darken or lighten a tone, add more of the hue plus black or white respectively.[5]

"Matching" a Color (or Mixing a New Color)

Frequently a painter needs to find a way to "match" a color (X) he doesn't have on his palette:

- First, select the two colors (A and B) you have available which are closest to the desired color going around the color wheel in both directions. Start with the color that is closest to the "target" color in terms of hue, then add small amounts of the other to it.
- Second, once the hue of X is matched, then adjust as necessary for the value of X by adding small quantities of white or black.
- Third, reduce saturation, if needed, by adding small quantities of the complement (or gray).
- Finally, if adjustments for value or saturation have shifted the color away from the desired hue, add in a small amount of the corresponding color (A or B) to correct.

TIPS REGARDING COLOR MIXING

Note: These are tips, not rigid rules; exciting exceptions are certainly possible.

1. *Avoid only using colors "straight from the tube."* Don't limit yourself to the colors you can squeeze from the tube. Use mixing to extend your available range of colors beyond the tube colors. Some of the most interesting visual surprises are the result of thoughtful color mixing.
2. *Keep the colors on your working palette clean.* Squeeze out a short cylinder of color from the tube, similar to the way toothpaste is squeezed. When mixing colors, it is easier to keep the colors clean if you get in the habit of picking up the amount of color you want from one end of the cylinder with a palette knife. Clean off the palette knife with newspaper or paper towel after each use.
3. *Too many colors in a mixture often result in "muddy" color.* In trying to achieve the color you want, restrict your mixing to only two or three colors, plus white and black.
4. *Avoid overmixing your colors.* Select the ingredient colors, and allow them to remain visible in the mixture which you put down on the painting. By not blending so thoroughly that you lose all sight of the "parent" colors, the mixture will look more dynamic. This is an especially useful tip for direct painting.
5. *For higher saturation, use colors that are close together on the color wheel in your mixtures.* If you want lower saturation but don't want to change the hue, mix the color with its complementary. Note: saturation in a mixture can never be higher than the saturation of the colors you used initially, and the farther apart the "parent" colors are from each other on the color wheel, the lower in saturation their mixture will tend to be.
6. *In a mixture, place the paint color that has the lower tinting power down first*, then start by adding a very small amount of the stronger tinting color to it. Add more until you get the color you want. If you are unsure of the tinting powers, start with the lighter color first.

Choosing Your Working Palette

The working palette consists of the colors arranged on the palette at the beginning of the painting session. Most artists use a working palette of colors squeezed directly from tubes of paint. While many use one working palette consistently, others will regularly change or alter their palettes in order to achieve different effects. We offer the following as ideas for possible working palettes:

All-purpose Working Palette

This working palette includes enough colors to allow for a very wide range of mixed colors while maintaining saturation. Additionally, the all-purpose working palette includes both opaque and transparent colors so that a range of direct and indirect painting techniques (including glazing) can be employed.

Flake white, opaque (Optional: if you can afford two whites, use flake white in the early stages of a paint-

ing and the slower-drying titanium white in the later stages.)

Hansa yellow, transparent (If necessary, substitute cadmium yellow light, which is opaque. Hansa yellow can be made opaque by mixing in a little white.)

Cadmium red light, opaque

Alizarin crimson, transparent

Ultramarine blue, transparent

Viridian green, transparent

Ivory black, semi-transparent

Yellow ochre, opaque (optional)

Raw umber, transparent (Optional: this is a useful neutral color that can be used to reduce the saturation of the other colors on your palette.)

Our suggestions for more limited or specialized working palettes are:

Triadic Paint Palette
Some painters choose a working palette that includes only the three primaries (red, yellow, and blue), plus white and black. The three primaries form a triadic color scheme. For the primary triad, the most common choices of tube colors are: ultramarine blue, cadmium red medium (or light), and cadmium yellow medium (or light).

Besides saving money on beginning supplies, working with a limited palette has the added benefit of challenging the painter to learn more fully the possibilities of mixing color. Different triadic palettes are created by starting with alternative choices for the primaries; for example, a palette might consist of alizarin crimson for the red, yellow ochre for the yellow, and cerulean blue for the blue.

A grayed-down triadic palette can be created by mixing primary colors with a small amount of each one's complement and then placing these colors on the palette. Mixed colors are then produced from these "grayed" primaries.

Double-Primaries Paint Palette
It is often said that all colors can be mixed from the three primary hues: red, yellow, and blue. In actuality, the range of colors that can be mixed from three primaries of paint is more limited, and depends on the exact colors selected as the primaries.

Why aren't the three primaries sufficient? For one thing, paint colors are not as pure and saturated as the spectral colors of light. And, unlike colors of light, mixing paint colors tends to result in a darker, less saturated

mixture. To produce a vibrant (saturated) green, the blue needs to be a warm blue (a blue that is relatively close to green on the color wheel); whereas to produce a strong or vibrant purple, the best blue to use is a cool blue (closer to purple on the color wheel). The same blue is not equally effective in both mixtures.

To produce paintings in a very broad range of colors, a working palette that includes two variations of each of the primaries yields more satisfactory results. For all-purpose painting, the painter might purchase the following tube colors:

a warm and cool red: cadmium red light and alizarin crimson

a warm and cool yellow: cadmium yellow light and lemon yellow

a warm and cool blue: cerulean (or cobalt) blue and ultramarine

flake white or titanium white

ivory black

burnt umber (optional)

yellow ochre (optional)

An alternative is to substitute a green, such as viridian, and eliminate the cool yellow and warm blue from the palette.

Glazing Paint Palette
When planning to glaze, select only transparent colors for the paint palette. (See the colors listed under *Transparency*.) Transparent colors made with modern organic pigments have more tinting power, more saturation, and greater transparency than mineral colors.

Mixed Paint Palettes
Instead of starting with colors squeezed directly from tubes, try premixing colors from tube paints and using *these* mixed colors as the working palette. This strategy helps free the artist from habitually starting with the same paint palette (an especially valuable strategy if you are working with a limited range of tube colors).

One option is to premix the nine colors you located by making a color palette grid of a painting by another artist you admire. (See Studio Exercise 6, following.) Start with these nine colors as the working palette for your own new painting.

Acrylic Primaries Paint Palette
If you are working with acrylic paints, try a palette limited to the mixing primaries: magenta, yellow, and cyan, along with white and black.

Working Palette Layout

Artists use a variety of arrangements when placing colors on their palettes: some arrange paint colors like a color wheel, in the order of the spectrum; some separate warm and cool colors; others keep saturated colors separate from earth colors. Whichever you prefer to use, make your palette arrangement an orderly one, and then be consistent until you purposefully plan to try a new arrangement.

Studio Exercises

Color Mixing

Mixing colors in a variety of combinations is invaluable experience for any painter. Below are some suggestions for experimenting with how to mix and handle paints.

1. Experiment with your colors. Try using them straight from the tube. Next thin them out to the consistency of a watercolor wash with odorless mineral spirits. Observe how, when thinned, some colors appear to change more than others.

 Experiment with mixtures of colors — dark colors over light, light colors over dark, and so forth. Try to create a smooth transition from one color to another. (One method is to paint both colors down next to each other, then with a clean dry soft brush moving along the border attempt to meld the two colors together smoothly.)

 Explore simple compositions in which you try to balance two or three colors in visually appealing arrangements. Try invented arrangements of interlocking imaginary shapes (both geometric and organic) in which one color dominates the painting, while the other color or colors occupy much smaller areas. Try other arrangements in which all colors occupy roughly equivalent total areas.

2. Adding just white or black, mix a seven-step value scale of tints and shades for each of your tubes of color. Try to make the steps appear even visually. Inherently darker colors (such as purple) will have more tints and less shades; inherently lighter colors (such as yellow) will have more shades and less tints.

3. Paint a twelve-step color wheel using the tube colors and mixtures of tube colors. Doing this, you will realize how close some tube colors are to the hues identified on the color wheel — cobalt blue, for example, is close to primary blue — while other hues will need to be mixed.

4. Practice mixing together pairs of complementary (and near complementary) colors. When combined in the proper quantities, true complements will mix together to form a gray.

5. Select any painting illustrated in this text and create a color palette grid for it. Use either colored paper (such as *Color Aid*) or paint to construct the grid.

6. Premix paints that match the color palette grid created in Exercise 5. Use these nine colors, plus white and black, as a working palette.

 With this working palette, create another composition that is totally abstract, i.e., create colored shapes with no attempt to create images of recognizable things. Try to use the same colors analyzed in the original grid to create a composition emphasizing different relationships among the colors.

7. Create a range of neutral grays (grays without hue) working with just white and black. Then create grays by mixing together complementary colors. These grays — called *chromatic grays* — will retain a rich, but subtle coloration. Observe the differences between the results you obtain in mixing grays these two ways.

8. Paint four quick studies each with the same composition. Working from a simple arrangement of objects, create the first painting by employing a color key that shows a full range of values (from very dark to very light, with most values in the middle range). After completing the first study, transpose the finished painting as follows: for the second study use a color key that is high in value, for the third use a color key that is low in value, and for the fourth use a color key that shows high contrast (by "pushing" the values in the middle of the value range to one extreme or the other, the painting will only contain darks and lights).

9. Develop three paintings with the same abstract composition (the composition should look something like a very simple jigsaw puzzle, with each part interlocking with the other parts surrounding it). Complete the first painting so it consists of all saturated colors; for the second painting create less saturated versions of all the colors (all the colors tend to be more "neutral" or grayer). And, in the third painting, explore keeping some colors at full saturation while others become more neutral.

 In your journal, write an analysis of what has changed in each painting. Pay particular attention to

how the relationship between colors differs when comparing the first and third paintings. In which painting do the saturated colors appear at their maximum saturation?

10. Develop a series of three paintings, working from a simple arrangement of objects. The arrangement should be illuminated with strong lighting from one side. Select objects in a range of hues (at least six). In the compositions employ the following:

 a. a composition featuring tonal unity

 b. a composition in which colors are shown at fullest saturation in the highlights

 c. a composition in which colors are shown at fullest saturation in the shadows

 d. a composition showing gradations of uniform saturation

1. Quoted in Vera John-Steiner, *Notebooks of the Mind: Explorations of Thinking* (New York: Harper & Row, 1985), p. 97.

2. Our color wheel is structured with three primaries: yellow, red, and blue. These are the elemental hues of human vision — each appears to us as a single pure color, not as a mixture of any others. The printing industry commonly uses a color wheel featuring primaries of magenta (a cool red), yellow, and cyan (or turquoise — a warm blue). In combinations with black and the white of the support, these are the most effective trio of primaries in terms of mixing printer's inks to form close approximations of all colors. Painters may also work with these as primaries.

An additive color wheel is based on the primaries of green, red, and blue-violet (the primaries of light).

3. Additional information about how context influences color perception can be found in Joseph Albers' classic text, *The Interaction of Color* (New Haven, CT: Yale University Press, 1975).

4. Contact Color Aid Corporation, 37 East 18th Street, New York, NY 10003.

5. The noted color authority Faber Birren discusses how harmonies are created by gradations of uniform chroma in *Creative Color* (West Chester, PA: Schiffer Publishing, Ltd, 1987), pp. 27–29.

The Picture Plane
Practice Subject: Still Lifes and Objects

" . . . in a [successful] painting everything is integral — all the parts belong to the whole. If you remove an aspect or element you are removing its wholeness."
— Richard Diebenkorn[1]

As introduced in Chapter 1, the overall form (the composition) of a painting is created by an interlocking combination of colors, shapes, lines, points, volumes, and textures. These are called *visual elements* (or *formal elements*), and — from a formal point of view — they are the building blocks of painting. In Chapter 3 we gave special attention to the visual element of color. In this chapter we examine how all the visual elements work together to articulate the *picture plane*, the upper flat surface of the support to which paint is applied.

In this chapter our practice subject will be paintings of objects — both inanimate objects and organic items such as fruit, vegetables, and flowers. In the Western tradition this kind of painting is known as *still life*. But bear in mind that the formal elements, techniques, materials, and cognitive meanings we discuss can be used to render and interpret any kind of subject matter.

STARTING WITH THE WHOLE

When painting an arrangement of objects observed in real life, a beginning artist may be tempted to concentrate on fully capturing the likeness of one object before turning her attention to painting the next object. The painter who follows this procedure assumes that if each object (and each part of each object) is accurately portrayed, then the whole painting will turn out well.

In actual practice, by paying attention to only one object (or part of an object) at a time, in all likelihood the complete painting will suffer. Without the construction of compelling relationships among all the parts, the finished painting will lack that emphasis on the whole which is what visually matters most in the final analysis. Rather than focusing your primary attention on making the various parts and details "correct," you should aim to have the whole painting be *more than* the sum of its parts. (This same advice applies to all paintings regardless of type of subject matter, including paintings of figures and landscape scenes as well as abstract arrangements of painted shapes, lines, and textures.)

Composition and Picture Plane

To establish an emphasis on the whole painting at once, many painters concentrate their initial focus on the picture plane. Paintings typically are painted on a flat support such as a wall or stretched canvas, and the *picture plane* is the upper flat surface of the support to which paint is applied. While some painters concentrate primarily on creating strong surface patterns directly on the picture plane, other painters strive also to create an illusion of depth and space behind the picture plane, as if viewers were looking at real, solid forms instead of flat designs of paint. Even the most illusionistic painters, though, know that each painting must also hold together as a flat design on the picture plane, and if they lose sight of the surface design, their painting will be less effective.

When focusing on the picture plane, you concentrate on the *visual elements* (lines, shapes, colors, values, and textures) that you make with paint. (As painter Maurice Denis said, "Remember that a picture — before being a battle horse, a nude woman, or some anecdote — is essentially a plane surface covered with colors assembled in a certain order.") No matter what subject matter you depict and what style you use, the process of painting involves manipulating visual elements on the picture plane. As you orchestrate these elements into relationships, you emphasize how the artwork is seen all at once in its entirety as an integrated arrangement. Even paintings with inherently "interesting" subject matter require effective relationships of visual elements to hold a viewer's interest.

And what exactly do we mean when we speak of visual relationships (also called design or plastic relationships) among the visual elements? Relationships are created when elements are seen not individually or in isolation but in relationship to each other. Relationships are primarily created by either pronounced similarity, contrast, position, or alignment. For example, interspersing triangular and circular shapes throughout a painting establishes a relationship of contrasting shapes.

Composition is a painting's overall visual organization. Composition refers to the specific manner in which the visual elements are arranged across the picture plane as well as how the visual elements may create forms in pictorial depth. In this chapter we focus initially on compositions in two dimensions — especially the arrangement of shapes across the picture plane. In the Western painting tradition, composition is usually based on the harmonious distribution of many separate forms. In contrast, a Japanese system of composition, called Notan, emphasizes "the opposition of light and dark." The American painter Georgia O'Keeffe (Figure. 4.1), who was influenced by the Japanese aesthetic, defined composition as the challenge of "how to fill a space beautifully."[2]

attentive, detailed looking that people in our analytic, sequentially logical society are trained to undertake. Most likely this is how you are reading now — word for word. Looking at a painting in this manner, you observe just one (or a few) details at a time. It is difficult to see relationships of the whole in this mode of looking.

Now look at an entire hand, and watch at once as you wiggle all five fingers. While this is broader vision, even it is insufficient for our purposes in analyzing the overall composition.

Finally, hold up both hands close together. Look first at one hand, then at the other. Now look at *both hands simultaneously.* Turn both hands, bending or wiggling various fingers. Slowly move your hands two feet apart while continuing to watch both of them at once. It may help to keep your eyes set on a point in between the hands, allowing your peripheral vision to observe the wide panorama of movement. Observe the simultaneous movements of all the fingers, hands, wrists, and arms; perceive any changes in the relative size, shape, clarity, and darkness of the hands and fingers as they move in and out of the light; watch also as the spaces *between* the hands and fingers vary in size and shape. You are now engaged in seeing the whole. This is all-over looking, the kind that is crucial for seeing, judging, and adjusting a painting's composition, a composition that contains colors and shapes in place of wriggling fingers!

Painters rely on various strategies to provide a fresh look at their compositions. Most painters occasionally back away so that they can see paintings more easily in their entirety; some turn paintings upside down; others look at paintings in a mirror; others (if they are nearsighted) may even take off their glasses. Any of these practices can help an artist see the overall structure of a painting at once, allowing him to see how effectively (or weakly) the various elements function in relationship to each other.

PAINTING THE LARGEST SHAPES FIRST
(Positive and Negative Shapes)

A painter divides, embellishes, and enlivens the picture plane by combining a variety of shapes, colors, values, textures, volumes, and lines in any way he chooses. (Only in rare instances have artists experimented with painting a canvas all one color.) In order to make the picture plane an integrated whole, many painters first create a simplified composition, then add complexity and

Studio Exercise

Seeing the Whole Composition

To analyze relationships of visual elements to one another and to the whole, a painter learns to look at "the big picture" all at once. The following exercise may enhance your ability to see and paint holistically:

Holding up one hand with the fingers spread, look at each fingertip one after another. This is the kind of

4.1 Georgia O'Keeffe, *Jack-in-the-Pulpit, No. II,* 1930. Oil on canvas, 40″ × 30″. Alfred Stieglitz Collection. Bequest of Georgia O'Keeffe. Copyright © 1998 Board of Trustees, National Gallery of Art, Washington, D.C.

Focus On

RICHARD DIEBENKORN, ED BAYNARD, AND HECTOR HYPPOLITE
Figures 4.2 and 4.3 and Plate 3

A trio of paintings by U.S. artists Richard Diebenkorn (Figure 4.2) and Ed Baynard (Figure 4.3) and Haitian artist Hector Hyppolite (Plate 3) reveals a range of approaches to emphasizing the picture plane and the composition seen as a whole. Each painting employs a simplified treatment of the shapes of inanimate objects. In Baynard's painting, a row of vases creates a rhythmic sequence of flattened silhouettes; in Diebenkorn's composition, an ashtray, cup, inkwell and looseleaf notebook are shown as sculptural masses, devoid of surface decoration and unnecessary detail, dispersed across a desktop; in Hyppolite's artwork, the repetition of forms on the left and right sides, with slight variations, creates an image of compelling intensity.

(continued)

4.2 Richard Diebenkorn, *Still Life with Letter,* 1961. Oil on canvas, 20⅝″ × 25⅝″. Collection: Art Commission of San Francisco.

In composing his image, Baynard not only paid attention to the painting of each individual vase, he also thought carefully about the position of each vase in relationship to the pattern made by the group. The artist deliberately varied the spacing between neighboring vases and contrasted their shapes so that the visual impact of the entire composition appears balanced yet not boring. Moreover, by eliminating all details from the background and reducing each vase and the shelf to a silhouette, Baynard severely restricted the sense of depth in his painting. The resulting composition appears as a flat pattern set flush against the picture plane. In Hyppolite's painting, while the forms of the subject matter (the vase, flowers, and so on) are emphasized as flat patterns pressed up against the picture plane, the background appears to be farther away,

an effect caused primarily by the lack of crisp details and more muted colors.

In creating *Still Life with Letter*, Diebenkorn produced something of a visual paradox. The paint is emphatically evident, swirling across the picture plane. Notice, for example, the brushstrokes cascading in loops just left of center. At the same time, the objects depicted in paint seem to exist at varying depths in the illusionistic space inside the painting (as if behind the picture plane there is a cockeyed third dimension). The tabletop itself seems to be tilted up at an angle so that it is no longer parallel to the floor, thus partially realigning the objects with the picture plane. In creating this painting, the artist simultaneously asserted the illusion of three-dimensional space and the reality of the two-dimensional picture plane.

4.3 Ed Baynard, *An American Painting — For Rose Paul*, 1979. Alkyd on canvas, $48^{3}/_{4}$" × $60 \ ^{1}/_{4}$". Courtesy of the artist and the Metropolitan Museum of Art. Gift of Mr. & Mrs. Eugene M. Schwartz, 1980. (1980.84)

refinement in later stages. Some artists even employ a style of image-making in which the final product retains this effect of simplicity. An example of the latter is *Desk Top III* (Figure 4.4), a monotype by Wendy Gedanken.

In organizing the picture plane, many painters find it is most effective to begin each composition by concentrating on the largest shapes first. The process of starting with large shapes first is known as *blocking-in*. At this stage, the painter develops an overall structure for the composition, usually emphasizing the basic contrast of lights and darks by massing them together as prominent shapes that interlock to fill the entire picture plane. After blocking these shapes in, further refinement proceeds: shapes gain more detail, the larger shapes are broken up into smaller components as necessary to define the subject fully, edges are refined, more color distinctions are created, and the shapes are defined with positions in space.

Even at the blocking-in stage, the artist has begun to articulate how the shapes of the painting behave in two specific ways on the picture plane:

First, shapes may function as flat areas of value, texture, and color on the picture plane, and, simultaneously, the same shapes may "read" as subject matter or parts of subject matter seen in depth from specific angles.

To see this simultaneous effect, look closely at Gedanken's monotype. (Although Gedanken's is a finished artwork, the artist has chosen to leave it at a stage similar to what many artists would consider the "blocking-in" stage.) Notice how the artist translated each object from a volume in three-dimensional reality to a distinctive flat shape on the two-dimensional picture plane. Some shapes — such as those of the salt and pepper shakers — don't seem

4.4 Wendy Gedanken, *Desk Top III*, 1983. Monotype on paper, 19″ × 24″.

surprising since they show the objects from a "normal" side view. But what is that pale shape just left of center in the painting? On the picture plane this shape forms a diamond, but this diamond shape "reads" as a square message pad resting at an angle on the desktop. Similarly, the dark shape in the upper left corner of the picture plane represents a telephone seen from above and to the side.

Secondly, the negative shapes should be as distinctive and as important to the visual organization of the picture plane as the positive shapes.

Positive shapes are those flat shapes on the picture plane which are intended to represent something in a painting. The spaces in between the positive shapes are called *negative shapes* (some artists and writers refer to them as *negative spaces*). In Gedanken's monotype, the entire picture plane is divided into positive and negative shapes, similar to the way a jigsaw puzzle is formed by interlocking shapes (a similar emphasis on positive and negative shapes can be seen in Hyppolite's painting). Recall our discussion of Baynard's deliberate variation of the spacing between vases: the "negative" areas between vases are as carefully calibrated as the "positive" shapes made by the vases themselves (Figure 4.3).

When shapes overlap on the picture plane — such as when objects in the foreground block part of the view of other objects — the foreground shapes are positive shapes. The background shapes are negative shapes when viewed in comparison to the nearer shapes which overlap them. These same background shapes may also function as positive shapes if they, in turn, overlap other, more distant shapes.

Preliminary Drawing Exercise

Exploring Positive and Negative Shapes

Do a series of sketches which explore the effects of emphasizing both positive and negative shapes simultaneously. Select a range of subject matter: make some drawings focus on cluttered concentrations of many objects (perhaps the things around a studio sink, or the arrangement of lights and ductwork hanging from the ceiling); other drawings should focus on more orderly arrangements of widely spaced individual objects (such as a few chairs, stools, and ladder placed on a platform).

Each sketch should be a contour line drawing (a drawing of the outer as well as the inner contour lines of all the shapes which make up each volume). Alternate your focus so that sometimes you are drawing the contours of positive shapes, at other times concentrate on drawing the shapes of the spaces between and within objects.

Make sketches in which you manipulate the contours of the shapes (both positive and negative) in order to create stronger visual relationships. For example, make alterations in the direction of contours so that important lines in the composition are brought into alignment. Make other alterations so that the similarity of shapes becomes apparent (such as emphasizing triangular shapes that you "discover" throughout the composition).

Studio Exercise

Making a Monotype

Create a monotype of an arrangement of simple objects. Emphasize a strong interplay between positive and negative shapes, and dark and light values.

Directions: Making a monotype involves a process that is somewhat between painting and printmaking. (A monotype is a unique work of art. An example illustrated in the text is Figure 4.4 by Gedanken.) The design for the image is created in oil paint or printer's ink, usually on a copper plate, but sometimes on an alternative hard, flat surface, such as a thick sheet of glass. Once completed, and while still moist, the design is then printed on a sheet of paper which has been laid across the design. The printing — the transference of the design to the paper — is accomplished either by sending the paper and design through a press, or simply by rubbing with the palm of the hand the back of the paper laid across the design. Doing this, the paint (or ink) is transferred to the paper.

Painting Exercise

Defining Objects as Shapes

Directions for painting: Set up an arrangement of seven or eight objects. Choose objects of varying sizes. If possible, use objects of one color (or neutral colors) with little surface decoration so that you can concentrate easily on the overall shape of each volume. Arrange the objects so there are some visible spaces between objects as you view them from various angles.

Begin with a block-in. Paint first the large positive shapes of the objects and the negative shapes (or spaces) between objects.

Use only black and white oil paint. Use thinner (we recommend mineral spirits) as needed to improve the flow and increase the drying time of the paint (using more thinner at the start of the painting).

Work on paper or canvas panels primed with gesso, approximately 15″ × 20″. To paint, use a relatively large brush (such as a 1/2″ wide flat or filbert). A large brush helps you to emphasize the general shapes first.

Painting 1: Simplify each object in the real-life arrangement into one flat shape. Make each shape the value you observe as the average darkness or lightness for the volume in general. (In similar fashion, Gedanken and Baynard limit themselves to one value for each shape in their paintings, Figures 4.3 and 4.4.) If you wish, add a few linear details in order to give specific character to the objects you portray (as Gedanken does in showing the dial on the telephone). Allow some of the texture of your brushstrokes to remain evident; this will help draw attention to the surface of the picture plane.

Painting 2: Move your easel to another position so that you have a different view of the same still-life arrangement. Instead of limiting yourself to only one shape and one value per volume — as you did in Painting 1 of this exercise — now translate each volume into two shapes: a lighter one and a darker one. (In Figure 4.2, Diebenkorn has translated objects into two shapes with different values.)

Looking carefully at the actual arrangement of objects, you should notice that each object contains darker and lighter areas. This may occur for any of the following reasons: where one side of an object is turned farther from the light than another side; where the same surface curves away from the light; where the same surface is simply farther away from the light source; and where the local color of one area of the object is darker than another area. In fact, a combination of all these factors may be operating in complex ways throughout the arrangement before you.

No painting can possibly replicate every nuance of visual reality. As a painter, you must simplify and make choices about what to emphasize in your painting. In doing this exercise, you are asked to select how best to simplify each object into just two shapes, one darker than the other. This process is necessarily open to interpretation. Being limited to two shapes per object, you will not be able to distinguish every side that you see of every object; and with only two values of dark and light you cannot show the nuances of every transition from shadow to highlight. In the process of painting, you must make choices: What pair of dark and light shapes (per object) will create the strongest visual impact? What will

be most effective in identifying the subject matter you depict? How will your choices influence the overall mood of your painting? Which selection of shapes will create the strongest overall composition by visually activating the whole picture plane?

Option: Try a third painting in which you use up to three shapes, each with a different value, to define any volume.

Discussion Exercise

Emphasis on the Picture Plane, Developing Shape Awareness

After completing the paintings in the exercise described above, examine each in order to determine which painting you believe to be more effective in terms of emphasizing the picture plane, and drawing attention to a relationship among the positive and negative shapes contained in each composition.

How hard was it for you to think about articulating the picture plane as a whole rather than painting each object one at a time?

What influence(s) on the overall content do you see occurring when there is an increased emphasis on the negative shapes in a painting?

The class as a whole should discuss these questions, looking at all the paintings completed for the exercise.

ESTABLISHING VISUAL RHYTHM

Looking at Figure 4.3, we sense a rhythm established by the sequence of vases. How does the rhythm occur when the spacing between vases keeps changing and the vases are of different sizes and shapes? The answer stems from a realization that, while different, both the spacing and shapes are sufficiently similar so that a relationship is apparent. In general, a visual *rhythm* is established in any artwork by the repetition of related formal elements. The repetition may be actual or implied, and it may occur at consistent or varied intervals. (An analogous sense of rhythm is established in music by individual notes or chords occurring in an arranged, although possibly varying, sequence.) A rhythm can be strictly repetitive (as in a sequence of identical shapes with identical spacing between them), or there can be some type of progression

4.5 David Bates,
Sheepsheads and Shrimp,
1983. Oil on canvas,
36″ × 48″. Courtesy of
the artist and Charles
Cowles Gallery,
New York.

(as in a sequence of shapes that gradually change — for instance, by becoming larger or darker or more transparent). A rhythm might alternate between visual qualities (e.g., dark/light/dark/light/dark). The flow of the rhythm might curve across a composition. Finally, we note that any of these ways to establish rhythm can be combined in any desired degree of complexity.

In *Sheepsheads and Shrimp* (Figure 4.5), a still-life painting by David Bates, five fish are related visually by virtue of their similar shape and pattern. Reading from left to right, and starting with the fish in a vertical position, each successive fish is oriented in an increasingly more horizontal direction. This sequenced repetition of the shape, design, and orientation of the fish establishes a visual rhythm.

However casual the composition may initially appear, in Bates's painting everything plays a part. Even the portion of a sneaker which is partially visible in the upper left corner of the painting echoes the overall shape of the fish, while the holes for the laces wittily mimic the round eyes of the sheepsheads.

Visual rhythm need not be as informal as shown in this particular example by Bates. The same artist uses a different approach in *Sheepsheads* (Figure 4.6), where his overlapping of the fish in a cluster of leaves and lemon slices appears highly purposeful. A visual rhythm occurs by the repetition of the distinctive interlocking dark and light wedge shapes of the fish bodies, while the bodies themselves face in alternating directions. In Plate 3, Hyppolite sets up an equally purposeful, consistent rhythm by pairing leaves of similar size and shape on each side of the basket.

Besides strictly visual differences, most viewers would discern expressive and intellectual differences stemming from the changes in Bates's two paintings: the more highly patterned rhythm seems to imply a sense of symbolic ritual in the arrangement of the fish, while the more informal rhythm in the other implies something of the transitory nature of everyday life.

ARTICULATING THE PICTURE PLANE: Balance

Most painters strive for a unified *balance*, the condition when the visual weights of all elements in a composition are equally distributed. (This is a generalized principle,

4.6 David Bates,
Sheepsheads, 1986. Oil on
canvas, 78″ × 96″.
Collection of Charles
and Jessie Pierce.

not an ironclad rule.) Balance is customarily achieved when the total visual weight is equal on both sides of a hypothetical vertical line that bisects the middle of the picture plane. While balance around a vertical is the most common approach in painting in the West, compositions may also balance in other ways, such as radiating out from a central area (as in Sara Bates's *Honoring Our Sacred Earth*, Figure 4.14), or mirroring across a horizontal division.

The balance that results may be either symmetrical or asymmetrical. *Symmetry* (or *symmetrical balance*) is achieved when the forms on the left and right halves are exact, or nearly exact, mirror images of each other. We see a nearly symmetrical balance in a still life by Catherine Murphy (Figure 4.8).

Asymmetry (or *asymmetrical balance*) consists of a balanced distribution of visual weight throughout a composition, without an exact mirroring of forms between the left and right halves of a painting. Asymmetrical balance is often subtle and difficult to produce. Asymmetry, like symmetry, implies equilibrium. Neither one lacks balance. A seventeenth-century still life by Juan Sánchez Cotán (Figure 4.7) is a superb example of asymmetrical balance. Because of our cultural predisposition to read a painting from left to right — the same way written text and numerical equations are read — forms on the left side of a composition normally assert less visual weight than forms on the extreme right. To see this, look at the illustration of Sánchez Cotán's painting in a mirror. It will seem unbalanced towards the right.

Like symmetrical balance, asymmetrical balance is achieved when the opposite sides of a composition each contain the same *total visual* weight. In a symmetrical composition, since both halves contain identical forms (or forms that are mirror reversals), the visual weight is necessarily equivalent. With an asymmetrical composition, where each side contains different forms, achieving balance is a more indirect process. Two basic principles should be kept in mind:

First, an increase in visual weight is usually produced by any feature which is conspicuous compared to its surroundings, and the more salient the feature the more weight that is produced. (For example, although we commonly think of bright red as a color which draws a lot of attention, in Philomena Williamson's painting

4.7 **Juan Sánchez Cotán**, *Quince, Cabbage, Melon, and Cucumber*, c. 1602. Oil on canvas, 27$\frac{1}{8}$″ × 33$\frac{1}{4}$″. San Diego Museum of Art, San Diego, CA. Gift of Anne R. and Amy Putnam.

Pumpkin Girls [Plate 5], the white dress of one girl and the white doll carry more visual weight than any individual pumpkin — because within that particular composition, white is more conspicuous.)

Secondly, visual weight is usually increased in proportion to how far a feature is located away from the center line of the composition. To understand this, it may help to think of children of different sizes and numbers balancing themselves on a playground teeter-totter. Smaller children sitting far to one side can provide a counterweight to a heavier bunch sitting closer to the fulcrum. (Note the relative weight of the ashtray on the far left of Figure 4.2.)

Discussion Exercise

Diagramming Examples of Visual Balance

Try making a simple diagram of the visual balance in other paintings illustrated in the text. In creating each diagram, depict important visual elements (shapes, lines, areas of color, value, and texture) in proportion to the size they actually occupy in the painting. Define each shape, line, and area as a pattern that becomes increasingly more bold in proportion to how much visual weight you feel it

Focus On

CATHERINE MURPHY AND PHILIP GUSTON
Figure 4.8 and Plate 10

To become more familiar with the concept of balance, we examine still-life paintings by Catherine Murphy (Fig. 4.8) and Philip Guston (Plate 10). Murphy's painting depicts a sink in carefully rendered detail. A convincing illusion of depth reveals the sink as well as its reflection in a mirror receding from the bottom edge of the painting. Almost everything in Murphy's painting is positioned in a symmetrical composition—what is shown on the left half is duplicated on the right half. To complicate matters, Murphy includes a mirror in the scene so that some forms from the bottom half are also echoed at the top.

The underlying symmetry in Murphy's painting is in contrast to the strands of curling brown hair that fall across the sink from the lower left corner on an upward diagonal. This trail of shorn hair is reflected again across the top of the painting. Seen as a pattern of rivulets, the hair establishes a strong visual rhythm running across the picture plane.

Guston's *Talking* is an example of asymmetry: the right half of the painting is altogether different from the left half, yet both halves appear to balance one another visually. Our analysis of this balance is aided by the fact that a string of orange beads divides the composition down the middle, aiding us as we gauge the left/right equilibrium.

In Guston's painting, a complex group of visual weights is positioned quite close to the central vertical. (In the world of this painting, red smoke packs a lot of weight!) The combined visual weight of the thumb, fingers, cigarette butts and smoke on the right is counterbalanced by the arm, wristwatch, and rolled-up sleeve on the left. The sleeve gains extra visual weight because of its position against the far left edge. Guston has carefully balanced every aspect. Even the smoke from the cigarette flowing over to the left side of the painting, at the bottom, is counterbalanced by the orange beads that swing off to the right as they descend.

4.8 Catherine Murphy,
Bathroom Sink, 1994. Oil on canvas, 51½″ × 44″. Private collection.

contributes to the overall balance of the composition. In other words, in your final diagram, the elements you think have the greatest visual weight should be defined with the densest patterns. For diagramming, select some paintings that exemplify symmetry and others that are asymmetrical. Be prepared to explain why you have emphasized certain elements in your diagrams.

Drawing Exercise

Exploring Asymmetry

In your sketchbook, make a series of quick drawings exploring compositional options for a still-life setup. Use a soft pencil, charcoal pencil, or conté crayon so that you can create a quick indication of the darkness and lightness of the shapes as you study them. The arrangement should consist of simple objects of various sizes and shapes, arranged as follows:

- across a tabletop or other flat surface
- on shelves or by using some other method of placing the objects at various heights (try hanging objects by wire or string from above)

Draw for one hour. Do as many variations as possible, creating compositions which explore a wide range of approaches to asymmetry and symmetry. Some possibilities: position yourself so that you see one object on the far right with a much larger number of objects on the left side of the composition. Switch the arrangement (or your viewing position) so that a single object is on the far left. Experiment with your use of value, line, and the amount of detail you include, so that a small object carries as much visual weight as larger objects. Create a composition that exhibits radial symmetry. Create a composition in which negative shapes carry more visual weight than positive shapes. (Suggestion: one way to achieve this is by using your drawing instrument to make more emphatic, bolder marks that give texture to the negative shapes.)

Painting Exercise

Simplified Shapes in Asymmetrical Balance

Working with a palette knife, create a series of quick paintings (preferably at least four) of simplified shapes in asymmetrical balance. The subject matter for the series should consist of objects with flat surfaces (such as card-board boxes, paper bags, wooden boards, and so on). For each painting in this exercise, limit your palette to white, black, and two earth colors. Use the paints without any medium or thinner. Apply the paint directly to sections of cardboard; being pale brown, the cardboard will serve as a toned support.

Working boldly, use the palette knife to apply a layer of paint (like smearing butter across the surface). Each stroke of the palette knife should define the approximate size, shape, value, and color of one of the flat surfaces that you observe in the subject. Keep your analysis of the number and shapes of the surfaces that define each object simplified. (In the next chapter we will take a closer look at these surfaces, called *planes*, which combine to make up each volume.) Also treat all the negative shapes between objects with appropriately sized and colored swipes of paint.

If available, change the two earth colors used for the palette for each painting in the series. These changes will allow you to become familiar with the color and temperature variation between raw and burnt sienna, and raw and burnt umber. (The burnt version is warmer in each.) Furthermore, the relative coolness and warmth of your choice of blacks will become evident if you can try varying from mars to ivory black.

THE IDEA OF CONTENT

As we noted in Chapter 1 of our text, a painting is composed of four interrelated levels of content: physical materials, technique, form, and cognitive meaning. Our discussion so far in this chapter has focused primarily on materials, technique, and form. But all the paintings we have looked at also contain cognitive meaning, including both intellectual and emotional content. In fact, all the paintings in this chapter are similar to one another on one level of cognitive content: each painting shares similar subject matter, incorporating a study of objects. In sharing objects as their subject, the paintings in the chapter also partake in the historical painting tradition known in Western art as *still-life* painting.

Otherwise the paintings we have studied so far in this chapter vary considerably in terms of their cognitive meanings. For example, we might ask ourselves: How do we interpret the emotional relationship between the use of bold colors in Guston's image (Plate 10) and what feelings and ideas are associated with late night chain smoking? Or, how do we unravel the mystery implied by

the shorn hair in Murphy's still-life painting: Who cut her hair? and under what conditions? Likewise, the fish in Figures 4.5 and 4.6 by Bates are not arbitrary selections of subject matter. Fishing plays a prominent role in the cultural life of places in eastern Texas and western Arkansas where the artist has spent much time and formed deeply personal relationships. We could interpret the sheepsheads in these paintings as symbols for that region, including the natural ecology and the culture and customs of people Bates cares deeply about.

History and Meaning of Objects and Still Lifes as Subject Matter

At the end of the last chapter, we presented a studio exercise involving simple objects. Our concern focused on examining and responding to their color relationships. But what about the objects as objects: What do we think about when we think about objects? And, in turn, what meanings are invested in paintings in which objects are used as the primary subject matter? By focusing on a specific category of subject matter, and the theme or themes that earlier artists have connected with a particular type of subject, artists engage the meaning of their paintings on a broad cognitive level: the traditions of art practices which come down to the present era from previous cultures and historical periods. In this chapter, we combine our study of the articulation of the picture plane with a concentrated examination of how painters have developed images of objects.

Has there ever been a society that has not been fascinated by objects? A large part of the attraction is visual: the variations among objects in color, shape, texture, size, and weight are endlessly interesting. In addition to their inherent visual attraction, objects potentially have appeal as items rich with personal and cultural meanings. Since before the dawn of civilizations, people have surrounded themselves with inanimate objects. The appearance of an object is partly the result of technical conditions (the materials, tools, and craft knowledge available to its maker); an object also reflects needs, beliefs, preferences, and social conditions of the time and place in which it was made. Humans often attribute value to a particular object through association. The scarf of a movie star or fountain pen of a world leader may be treasured as if it has trapped some glamour or power; likewise many of us save otherwise insignificant objects because they hold private associations for us. Artists can tell hidden stories of social relationships, cultural values,

and personal history by the objects they choose to include in their art.

Many societies worldwide have produced magnificent objects, many of them embellished with painted designs. Spectacular examples include carved and painted totem poles made by Native Americans of the Northwest Coast, shields painted by the Maori of New Zealand with arcane symbols intended to provide protection and power, and ceramic vessels in China and Turkey painted and glazed with stylized natural forms. In some (but not all) societies, objects also have been central to the practice of painting as subject matter to be depicted on a flat support. In this chapter we are especially concerned with the genre of painting known as *still life* as it has developed in the West and is practiced today in the United States.

A simple definition of still life is that it is a painting depicting an arrangement of immobile objects. In the Western tradition the objects have included fruits and flowers, dead game such as birds and fish, musical in-

4.9 Rachel Ruysch, *Flower Still Life*, after 1700. Oil on canvas, 29³/₄″ × 23⁷/₈″. The Toledo Museum of Art.

struments, and tableware, vessels, and other items of domestic use. An advantage of painting such objects is that the "models" can be moved about by the artist, and will not move by themselves once placed in an arrangement. Thus still life provides a convenient subject for artists to work out how to juxtapose and then paint different shapes, volumes, textures, colors, and conditions of light. Many college painting classes for first-year students in the United States return repeatedly to still-life setups.

Although few still-life paintings from ancient times remain, apparently they were not uncommon in northern Africa and Europe. Depictions by artists of food, vessels, plates, and other inanimate objects are found in ancient Egyptian tombs, Greek paintings, and later Roman mosaics and wall paintings. In contrast, in Europe during the Middle Ages still life did not exist as an independent type of painting. Artists painted objects, but only as accessories within paintings devoted to other themes, typically portraiture or the visual recounting of history, legends, and religious stories. Objects often helped to identify the humans in paintings, or served as symbols whose references were recognized by the initiated.

Gradually European painters became interested in depicting objects for their own sake, and in the sixteenth century occasional still lifes were painted in Italy, Spain, and northern Europe. The concept was refined in the seventeenth century, and still life attracted many painters and a popular audience. Many still-life painters concentrated on a particular subject such as elaborate flower arrangements or lavish table settings. Rachel Ruysch, one among numerous women artists of the era who excelled at still life, specialized in complex, botanically accurate paintings of flowers, fruits, and fauna (Figure 4.9). Many still-life paintings were intended simply to appeal to a sensual love for the variety of shapes, textures, and colors embodied in natural and human-made objects. Frequently, however, especially in northern European countries, still life was a vehicle for conveying moral and allegorical messages, as in the *vanitas* ("vanity") still life, in which the painter would include skulls, hourglasses, rotting fruit, or other items intended to remind viewers that material life is fleeting and death is inevitable. In terms of their compositions, still lifes ranged from the apparently casual — an uncleared table at the end of a meal — to the obviously contrived. A memorable example of the latter is the descending arc of vegetables in *Quince, Cabbage, Melon, and Cucumber* (Figure 4.7), by the Spanish monk Sánchez Cotán.

In other parts of the world in this same period, painters did not depict inanimate objects as in European still lifes. But in some places, including China and Mughal India, close-up paintings of small-scale living subjects such as birds and flowers flourished and, in fact, were held in higher esteem than their counterparts in the West. Figure 4.10 shows a section of a handscroll painted with butterflies clustered around flowers by the eighteenth-century Chinese painter, Ma Quan, renowned for her delicate outline technique. (Ma Quan is one among numerous well-recognized women artists in the history of Chinese painting.)

The diversity of European still-life painting continued in the eighteenth century, with styles ranging from

4.10 Ma Quan, *Flowers and Butterflies,* first half of the eighteenth century. Ink and color on paper, 27.9 cm. × 248.9 cm. The Metropolitan Museum of Art, New York, Ex. Coll. A. W. Bahr, Purchase, Fletcher Fund, 1947. (47.18.116).

Focus On

LISA MILROY, MIRIAM SCHAPIRO, AND JAUNE QUICK-TO-SEE SMITH
Figures 4.11 and 4.12 and Plate 11

To continue with this idea of content and cognitive meaning, let us examine paintings by Lisa Milroy (Figure 4.11), Miriam Schapiro (Figure 4.12), and Jaune Quick-to-See Smith (Plate 11). We note first that Milroy infuses her composition with visual rhythm created through the repetition of shoes. The effect is surprisingly engaging because the shoes, while very similar in shape, have been tilted in a rhythmically varying pattern. (Ma Quan creates a similar effect in Figure 4.10 by tilting the similarly shaped butterflies at different angles.) Miriam

Schapiro creates an emphatic rhythm by alternating two types of patterned bands across the semicircular support in *Mexican Memory*: a band with dark and light geometric shapes is followed by a more uniformly dark band, followed by another geometrically patterned band, and so on. The alternating bands evoke the form of an unfolded fan, so that the whole painting presents itself as a gigantic representation of a familiar object.

It is important in analyzing paintings to distinguish between subject matter and content. The sub-

(continued)

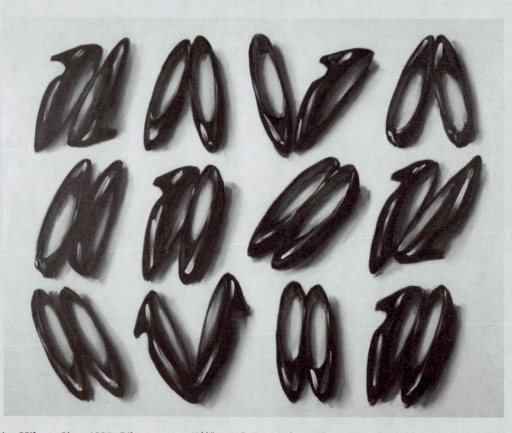

4.11 Lisa Milroy, *Shoes,* 1985. Oil on canvas, 69½″ × 89″. Copyright © The artist and Waddington Galleries, London. Collection, Tate Gallery, London.

4.12 Miriam Schapiro, *Mexican Memory*, 1981. Acrylic and fabric on canvas, 48″ × 96″. Collection of Lynn and Jeffery Slutsky.

ject matter of Milroy's painting consists of three rows of pairs of women's shoes. The content, however, depends on the interaction of all aspects of the painting: the subject matter (the shoes); our reaction to the physical materials (in this case, oil paint, a medium with a long, grand history); the direct technique the artist has employed in creating her naturalistic image; the visual elements and their relationships defined on the picture plane; and any interpretation we give to Milroy's choice of subject matter as a reference to wider issues and themes. The quantity of similar shoes, for instance, may poke fun at the consumer values of contemporary society, where people often buy more of something than they could possibly need.

Mexican Memory is an example of a "femmage," Schapiro's word for a work that combines fabric collage and painting. The use of fabric in itself has feminist overtones: Schapiro intends her introduction of patterned fabric into the "high" art medium of painting to evoke women's domestic crafts. She is paying homage to neglected women artists of the past. The reference to a fan likewise is suffused with content relevant to women's experiences. In art historian Wendy Slatkin's opinion, the "form of the fan metaphorically reveals the unfolding of woman's consciousness."[3]

Milroy's suggestion of consumerism and Schapiro's interest in female symbols relate to the content expressed in *Trade (gifts for trading land with white people)* (Plate 11) by Quick-to-See Smith. In this large mixed-media painting, Quick-to-See Smith critiques the exploitation of Native American identities in order to sell commercial products. The actual consumer objects strung above the top of the painting (hats, bumper stickers, a toy tomahawk) are embellished with kitsch slogans and stereotypes of Indianness, such as "Redskins." In an ironic twist, the artist is offering the cheap trinkets back to white people, perhaps in exchange for the accurate recognition of historical Native-American identities symbolized by the large canoe form painted on the canvas below. She uses actual objects as metaphors for larger concepts.

Our speculations about the meaning of these three paintings are not meant to imply that all paintings contain specific autobiographical or socially critical messages. We use these as examples to emphasize that all paintings have content, and that this content results from the interplay of physical materials, painting technique, visual forms, and cognitive meaning (including, in representational paintings, the interpretation of recognizable subject matter).

sharply focused realism to broader, more painterly approaches and with purposes ranging from naturalistic description to a concern for message and narrative. In the nineteenth century, interest in still life spread to the United States, where hundreds of painters specialized in the genre, including many who focused on *trompe l'oeil* ("fool-the-eye") illusions by painting in meticulous detail such flat objects as envelopes and playing cards at life-size scale.

Although one might think modern artists in the West would turn away from still life as too traditional, the reverse is true. Many of the artists who challenged Western painting conventions over the past century found that painting a display of objects was an enormously useful strategy for their visual experiments with form, color, and composition. Henri Matisse painted still lifes with new, unnaturalistic color relationships and dynamic compositions. Pablo Picasso and Georges Braque, co-inventors of Cubism, used traditional subject matter such as fruit and musical instruments as the basis for novel investigations of space and structure in mosaic-like arrangements. In this country, Georgia O'Keeffe produced still lifes with large, simple shapes and colors, emphasizing the abstract qualities of objects. A close-up view of a flower, at a greatly exaggerated scale, was one of her favorite motifs (Figure 4.1). Inspired by dreams and psychology, Surrealist artists introduced unconventional still-life subjects and put objects into new roles. Pop artists of the 1960s and 1970s brought in decidedly lowbrow subject matter — items drawn from the contemporary abundance of cheap consumer products and mass media images — reduced into stylized shapes.

Today objects as subject matter continue to attract talented painters. As in the past, some artists depict tangible things in order to display their ability to paint from life and their technical skill in painting convincing illusions of naturalistic textures, colors, and light. Many others expand the painting of objects in new directions, including combining actual objects with painted elements. An artistic exploration of consumerism — the media-driven demand for material goods — and the cultural meanings of mass-produced objects are important themes in a number of contemporary artists' work. Opportunities for using objects to tell stories, reveal social values, or symbolize cultural and personal experiences have never been greater. At the dawn of the twenty-first century our lives are increasingly filled with human-made things. (Indeed, one gauge of success in contemporary society is the quantity of "goods" one has managed to acquire.) How to select among the available objects, how to assess value and interpret meaning, and how to communicate the values embodied in objects can provide a wealth of ideas for painting.

Journal Exercise

Consumer Goods (or Not-So Good?)

Most of us regularly buy various consumer products. These products might be staples such as milk, soap, socks, and lightbulbs. Or they might be products we choose to indulge in more than is strictly necessary, such as gourmet chocolates, T-shirts, CDs, or hats. For this exercise, make a list of consumer goods which hold a special fascination for you — items you regularly buy, or want to buy as well as objects which you simply enjoy looking at.

After you have finished the list, circle two products which hold an especially strong attraction for you. For each, write a paragraph (or two) exploring what the product means to you and why you like to buy examples. Does the item appeal to you visually, emotionally, intellectually, or sensually, or in some combination of these and other ways? What do you think your interest in the product says about you?

Painting Exercise

Consumer Goods Still Life: Establishing Visual Rhythm and a Limited Sense of Depth

Make two paintings featuring multiple examples of one type of consumer product, like the shoes in Milroy's painting (Figure 4.11). The product may be one you wrote about in the preceding journal exercise. Both paintings can be made on gessoed paper or canvas panels, approximately 20″ × 15″. Use a large or medium-size flat brush to establish the general shapes first. Work from the general to the specific.

Colors: Work with a limited paint palette — black, white, and two colors (one warm and one cool). Choose colors that are different in value. Using these four colors alone and in combination, simplify the darks and lights and the warmth and coolness of the actual colors you see.

(Because you are simplifying, you shouldn't expect to match the actual hues of the objects as you see them.) Paint flat shapes one consistent hue and value; on rounded shapes paint a simplifed version of the changes of value you observe.

Changing values: Lighten and darken the warm and cool colors by adding white and black, respectively. Alternatively, you can lighten the darker of the two colors by adding some of the lighter color to it, and vice versa. (Or use a combination of these two methods for changing value.)

Painting 1 (exploring rhythm): Depict objects in a plane parallel to the picture plane (similar to the compositions in the paintings by Ma Quan, Baynard, and Milroy). Start by placing the objects on a shelf or shelves, or attaching the objects to a wall. As you arrange the objects prior to painting them, experiment with various ways of spacing and orienting them in order to enhance a sense of visual rhythm. Try moving the objects into highly ordered regular arrangements as well as relatively informal and irregular arrangements. Try arranging the objects based on patterns of darks and lights, or by size and shape. Make a series of thumbnail sketches, then, from these choices, paint the composition that most effectively establishes a sense of visual rhythm.

Painting 2 (a first look at creating depth): Arrange and then depict the objects so that they appear to recede back from the picture plane. Portray depth in two ways. First, *where they are aligned, opaque objects in front will shield the view of objects deeper in space.* And, secondly, *the contrast of values will be reduced in the distance.* (The reduction of contrast means that darks appear less dark while lights appear less light.)

Both of these methods of establishing pictorial depth are seen in *California Cakes* (Figure 4.13) by Wayne Thiebaud. Each cake partially eclipses the one behind it; and, moving into the distance, the shadows cast by the cakes become increasingly less dark.

4.13 Wayne Thiebaud, *California Cakes,* 1979. Oil on linen, 48″ × 36″. Private collection.

ICONOGRAPHY

Sometimes artists represent aspects of reality directly, using a subject's colors and shapes without intending any hidden meanings. A bare tree is simply a tree without leaves. Red is just one color of the spectrum. At other times artists aim to suggest ideas beyond surface appearances by their choice of subject matter and visual elements. The mind's tendency to make analogies often invests a class of forms with symbolic meaning. A bare tree may imply death, a simple cross shape symbolizes the Crucifixion to Christian believers, a red rose means passion and love to contemporary Americans.

Art historians use the term *iconography* to refer to the systematic investigation of the subjective, symbolic meanings of subject matter. The mirror with no one in it, in Murphy's *Bathroom Sink* (Figure 4.8), and the wristwatch with only one hand, in Guston's *Talking* (Plate 10), are examples of subjects that seem to be freighted with coded significance. In Chinese paintings beautiful women are sometimes shown surrounded by butterflies; the flowers attracting butterflies in Ma Quan's painted handscroll (Figure 4.10) probably symbolize feminine allure.

Some of the most powerful iconography is cryptic, suggesting several interpretations at once. For example, Hyppolite's painting of the basket of flowers (Plate 3) has symbolic meaning within *Vodun*, a religious cult with African roots which is practiced in Haiti, and which includes a belief in the power of sorcery. Usually artists themselves do not recognize all that their subject matter could mean, especially when they use symbols to represent heightened states of awareness and strong emotions which elude literal description. A painting by Vija Celmins shows a solitary heater aglow in a featureless grayish-green space (Plate 12). While the image may be explained, in part, by the specifics of the artist's autobiography (the choice of a *portable* heater may refer to the fact that as a child Celmins fled with her family from the onslaught of World War II), the painting conveys something of the fragility of civilization and the brave spirit of a solitary individual.

The selection and placement of objects in a work of art sometimes has a spiritual significance, as in the Dutch *vanitas* paintings discussed earlier. Contemporary artist Sara Bates, of Cherokee ancestry, arranges organic materials — such as flower petals, seeds, shells, bones, sand, stones, and corn — into floor-bound artworks which she calls *Honorings* and which possess spiritual connotations (Figure 4.14). The materials have been gathered by Bates as tokens of valued places, "such as a seed pod from the cemetery where she attended the funeral of a revered Cherokee medicine man, and feathers from birds who have appeared at significant moments in her life."[4] Working from the center out, the artist creates an Honoring as a circular design, usually organized around an equal-arm cross, representing the four cardinal directions. The design incorporates a worldview which is fundamentally Cherokee, even though the circular form is not traditional in Cherokee art. Still, the radial composition reflects Cherokee concepts of harmony, and in her selection of materials, Bates emphasizes the capacity for natural objects such as shells and feathers to contain sacred significance. Not a still-life painting in the European sense, because Bates arranges actual objects rather than painting an illusion of objects, the design nevertheless has strong pictorial qualities. The picture plane is horizontal, coinciding with the floor itself.

4.14 Sara Bates, *Honoring Our Sacred Earth,* 1997. Natural materials, including pine cones, kernels of corn, shells, leaves, and feathers, approximately 10′ in diameter.

Journal Exercise

A Symbolic Still Life

In this exercise you will work with objects which already have strong symbolic associations for you. To begin, go into a room where you keep many personal possessions, for example, your bedroom, living room, office, or studio. Walk around the room looking closely at your things. Look inside drawers and boxes as well as at objects in open view. As you look, make a list of items with which you feel a strong, intimate connection. Think: which objects would you miss most if you lost them?

Next look at your list and select four objects which belong to separate parts of your life — to different ages or places or personal relationships. Gather the four special objects and arrange them around you on the floor, as if they were the four points of a compass with you at the center. Draw a circle on a sheet of paper and divide it into four quadrants with a point for you in the center. Label each quadrant with the name of one object.

Pick up an object and examine it, letting your feelings of attachment envelop you. Fill in one quadrant with words and phrases saying what concepts and emotions the object represents for you. Why do you cherish this object? What aspects of your personality does it symbolize? What does it signify about your relationships with other people, either with specific individuals or with types of people? Does the object have any special power for you, like a good luck charm? Continue your examination by assessing any visual qualities which make each object special or identifiable.

Repeat, picking up objects one-by-one and writing notes until you have filled in a quadrant for each of the four objects. Don't worry if your interpretation of your attachment to an object is inconsistent. Include whatever ideas occur to you.

Can you imagine incorporating any or all of these four objects as iconography in a still-life painting? Would you need to embellish, exaggerate, or alter aspects of any of the four objects in order to make their symbolic meaning more apparent to viewers? Does it matter if viewers understand that the objects are symbols, or is it enough that you know? Are the forms of the objects interesting or beautiful in themselves, or would you want to alter the forms to make them more visually appealing? Would you include other objects in addition to the four?

Write down some of your ideas and reactions to the notion of creating a symbolic still life using objects of personal significance. Make sketches of possible compositions for your painting. Include changes you might make to the objects you envision.

Preliminary Drawing Exercise

Prior to completing the following painting exercise, make a series of preliminary drawings of still-life arrangements in which you explore dramatic changes in viewpoint. Alternate your viewpoint so that you draw the same composition from different heights above the surface on which the objects rest; in other drawings, position yourself so that you draw with your eye level below the level of the objects' base. In one drawing, position yourself very close to the nearest object, so that the nearest object is no farther than two feet from you. In another drawing, position yourself so that the entire arrangement starts approximately 6–8 feet from you.

Note how any of these changes affects the visual relationships created in the drawing. Utilize a dramatic choice for your viewpoint as you undertake the painting exercise below.

In these drawings, use changes in value contrast to define spatial positions. Increases in value contrast will serve to bring the objects closer to the picture plane; decreased value contrast will push objects deeper into the space behind the picture plane.

Painting Exercise

Personal Symbolism

Painting #1: Create a symmetrical still-life composition. Use black and white and three analogous colors. (Analogous colors are defined in Chapter 3, "Color.") To start the painting, use oil paint diluted by mineral spirits. Later, in some selected passages, use thick paint straight from the tube.

Painting #2: Create an asymmetrical still-life composition. Use black and white and three different analogous colors. Again, paint with oil colors diluted only with mineral spirits, or, in places, use paint straight from the tube. (Observe in Figure 4.15 how Donald Sultan contrasts a smooth application of paint on two white eggs and a black lemon, with a textured application of paint on the lime.)

4.15 Donald Sultan,
Two Eggs, a Lime and a Lemon,
June 3, 1985, 1985. Oil, plaster,
and tar on vinyl composite tile
on wood, 12″ × 12″. Collection of
Mr. and Mrs. Carl D. Lobell,
New York.

Directions: Select and bring to the studio or class-room several objects that bear personal significance for you; these may be ones you thought about in the journal exercise above, or choose different ones. As you arrange these objects and plan each painting's composition, think about how you can convey emotion and cognitive mean-ing by where you choose to have the boldest changes of dark and light contrasts occur, where you apply the thickest paint, and how realistically you depict each object.

Using the limited palette you have available, try to come as close as you can to matching the hue, value, sat-uration, and warmth or coolness of the local color of each object. (But don't expect to match them perfectly.) The saturation of a color should be altered by adding gray (formed by a combination of black and white paint). Warmth can be controlled, within limits, by using or mixing together the analogous colors you have selected (one should be warmer than the others).

Painting Exercise

Luminosity

Create a painting of an object or group of objects which appear luminous. Luminosity occurs when a glow seems to be generated from *within* an object or surface; in con-trast, a nonluminous surface appears lit from outside, by light falling on it from an external source.

To create a luminous effect, the artist must control the contrast of saturation (or chroma). Luminous colors appear more pure in terms of hue and generally lighter in value than their surroundings. It is easiest to achieve the effect of luminosity if the area of glow is kept relatively small compared to the overall size of the artwork. An ex-ample of luminosity can be seen in Plate 12, in which the orange glow of the heater is more saturated and lighter in value than the surrounding grayish blue-green of the

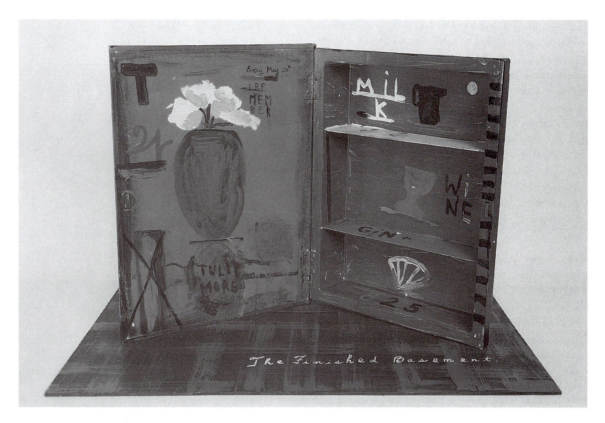

4.16 Stephanie Brody Lederman, *Cold Meal for Love,* 1994. Acrylic paint on medicine chest, 20″ × 15½″ (closed), 23″ × 32″ (wooden base).

metal and background space. Another example of luminous colors can be seen by looking ahead to Plate 19, a magical painting of a landscape at twilight by Peter Doig.

Painting Exercise

Expanded Picture Plane

Although the picture plane for a painting often is a flat rectangular surface, this is not a requirement. Increasingly, contemporary painters are exploring unusual materials and nonrectangular shapes as alternative supports for their artworks (and, as we shall explore in Chapter 8, these practices have important theoretical implications as well as historic and multicultural references). Like Sara Bates (Figure 4.14), some artists are even using actual objects directly to make pictorial compositions, without any paint at all.

For the final exercise in this chapter, paint a composition on a support that is an object itself. The subject matter of the painting should relate in some fashion with the support. As an example, see the approach artist Stephanie Brody Lederman has taken in creating *Cold Meal for Love* (Figure 4.16), one of a series the artist refers to as "Medicine Cabinet Books." Lederman's artwork emphasizes the shapes of various objects that are painted as if they rest on the shelves of the actual medicine cabinet used as the painting's support.

GROUP CRITIQUE

The group critique should be an exciting, vital part of the experience of learning to paint more effectively. By sharing ideas with others about materials, technical matters, formal relationships, and the interpretation of cognitive meaning, artists gain valuable insights into how paintings are made and how they mean what they mean. Hearing others talk about our own work provides important feedback; if paintings are forms of communication (and this

book begins with the assumption that they are), then we need to pay close attention to what others identify as the effects our paintings are having on them.

For this first group critique, we suggest the following in-class exercise: everyone in the group should select for display two or three paintings from those each person completed during this chapter. When the paintings are arranged for all to see, each participant should spend approximately fifteen minutes analyzing the paintings on his or her own. (Advance thinking will contribute to the effectiveness of the critique.)

Jot down notes with the following questions in mind; be prepared to discuss your ideas with the group as a whole.

1. Select the two paintings which you feel are most effective in articulating the picture plane. Write down a few ways in which each artwork has achieved this.
2. Identify one painting which has effective symmetrical balance and one painting with effective asymmetrical balance. (Remember: a painting with asymmetrical balance still must achieve balance!) Do you think you usually prefer one type of balance more than the other? Write down some reactions.
3. Which painting has the most interesting iconography? How do you interpret the cognitive meaning of that painting? What formal aspects of the painting support your interpretation?

Recommended Artists to Explore

Juan Sánchez Cotán (1561–1627)

Francisco de Zurbarán (1598–1664)

Johannes de Heem (1606–1684)

Rachel Ruysch (1666–1750)

Jean-Baptiste-Siméon Chardin (1699–1779)

Anne Vallayer-Coster (1774–1818)

Paul Cézanne (1839–1906)

William Harnett (1848–1892)

Vincent van Gogh (1853–1890)

Henri Matisse (1869–1954)

Georges Braque (1882–1963)

Juan Gris (1887–1927)

Georgia O'Keeffe (1887–1986)

Giorgio Morandi (1890–1964)

Hector Hyppolite (1894–1948)

René Magritte (1898–1967)

Morris Graves (b. 1910)

Philip Guston (1913–1980)

Wayne Thiebaud (b. 1920)

Richard Diebenkorn (1922–1993)

Roy Lichtenstein (1923–1997)

Miriam Schapiro (b. 1923)

William Bailey (b. 1930)

Audrey Flack (b. 1931)

Gregory Gillespie (b. 1936)

Janet Fish (b. 1938)

Ed Baynard (b. 1940)

Catherine Murphy (b. 1946)

Donald Baechler (b. 1956)

Lisa Milroy (b. 1959)

1. Richard Diebenkorn, quoted in Gerald Nordland, *Richard Diebenkorn* (New York: Rizzoli, 1987), p. 112.

2. Barbara Rose, "Georgia O'Keeffe's Universal Spiritual Vision," in *Georgia O'Keeffe* (Tokyo: The Seibu Museum of Art, 1988), p. 98.

3. Wendy Slatkin, *Women Artists in History*, third edition (Upper Saddle River, NJ: Prentice-Hall, 1997), p. 209.

4. Jean Robertson, "Sara Bates: Honoring Connections with the Natural World," in *Surface Design Journal*, Vol. 21, No. 4 (Oakland, CA: Surface Design Association, 1997), p. 10.

Shape, Plane, Volume, and Brushstroke

Practice Subject: The Self-Image

In Chapter 4 we studied how all the visual (formal) elements work together to articulate the picture plane. In studying the picture plane, we gave particular attention to how shapes may be arranged in order to create an overall pattern which activates both the positive and negative areas. In this chapter, we continue our study of the formal aspects of a painting with an in-depth analysis of the articulation of shapes, planes, volumes, and brushstrokes. In this chapter, our practice subject involves images of the self. Such paintings are frequently referred to as *self-portraits* (images made by artists to represent themselves).

SHAPES, PLANES, AND VOLUMES

In a painting, a *shape* is any defined area of the picture plane. Like the picture plane as a whole, shapes are flat areas. (When shapes are tilted into space, they become planes, a term which we discuss later.) To become a shape, an area of the picture plane must be distinguished from its surrounding areas. This can be done in one — or a combination — of several ways. A shape may be defined by a change in color (such as a change in hue, saturation, and/or value), thus differentiating it from its neighboring areas. A shape may be defined by a change in texture (such as a thick buildup of paint in one area, compared to a smoother application of paint in all surrounding areas). A shape may even be defined by very subtle changes, such as the use of a glossier paint medium in one area. In addition to defining a shape by any of the changes cited, a shape can be defined simply by the creation of an outer boundary which separates it from the surrounding areas. The boundary or border may be defined by any change, most often a change in hue, value, or texture.

As noted, in order to function as shapes, areas of the picture plane must be differentiated from their surrounding areas. In creating his dramatic painting, *Self-Portrait in Tuxedo* (Figure 5.1), Max Beckmann covered his canvas with an interlocking pattern of dark and light shapes. Sometimes the same shape is both lighter and darker than areas which adjoin it. For example, the illuminated portion of the left shoulder is darker than the background but lighter than the lower portion of the jacket. Sometimes the shapes of the shapes rhyme with one another and sometimes they contrast sharply. The rounded shapes of the nostrils, for instance, echo on a smaller scale the dark circular eyes and the massive globe of the head.

In a painting, a shape may function simply as a shape (a flat area distinguished from its surroundings), or a shape may also represent something else (i.e., a shape may represent a portion of a subject matter). In

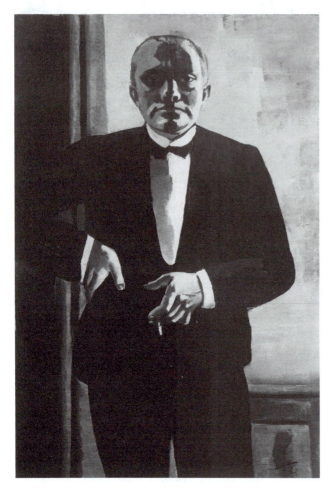

5.1 Max Beckmann, *Self-Portrait in Tuxedo*, 1927. Oil on canvas, 141 cm. × 96 cm. Busch-Reisinger Museum, Harvard Museum.

sides of the nose flare backwards from the bridge, and, doing so, build the nose as a pyramid-like volume projecting out from the cheeks.

Figure 5.1 is a *representational* painting: it shows aspects of the way things look, or could look, in the physical world. For purposes of instruction, we have turned our attention to the shapes, planes, and volumes of Beckmann's painting. Restricting our view to these formal elements ignores other factors that would contribute to a more complete interpretation. The alert facial expression and relaxed pose of the arms with the artist's casual grasp of his cigarette, for instance — what do they mean? In 1927, the year Beckmann created this painting, the horrors of World War I were fading from memory and the horrors of the Nazis had not yet taken hold. Beckmann had received a prestigious teaching position two years earlier and was enjoying considerable acclaim as an artist. At this moment of professional achievement and relative societal calm, Beckmann could afford to feel confident in his command of his own destiny.

Preliminary Drawing Exercise

Self-Portrait in Planes

Looking in a mirror (or at yourself from the neck down) create several drawings of yourself in which you analyze all volumes in terms of planes.

Drawing #1: Draw all visible body parts, clothing, and objects as a complex arrangement of flat planes. Make each plane whatever shape you think is most appropriate to define each facet. Start by drawing larger planes first over the entire surface of the drawing. Then work back into the large planes, adding smaller planes to further define and refine the shape of the volumes.

Drawing #2: Work similarly to drawing #1, except restrict the planes themselves only to flat circular, triangular, and rectangular shapes.

Drawing #3: Work similarly to drawing #2, except allow some planes to be curved, while others remain flat. (Keep all planes circular, triangular, or rectangular.)

Drawing #4: Work similarly to drawing #3, except simplify the volumes being created so that each volume is composed of parts which are basically pyramids, spheres, or cubes.

Beckmann's painting, so convincing is the portrayal of the artist's appearance that it may come as a surprise to realize how indecipherable the individual painted shapes would be as fingers, hands, forehead, and chin if studied out of context. How do the shapes in the painting create the representation of body parts and clothing? They do this by functioning as planes, which in turn create the representation or illusion of volumes.

Planes are surfaces with positions in space, which can combine together to create volumes; *volumes* are forms occupying three-dimensional space. In Beckmann's painting some planes are flat (such as the bridge of the nose), while other planes are curved (such as the brightly illuminated left side of the forehead and the curved half-cylinder of the wainscoting). Beckmann carefully composed the volumes by articulating the angles where planes meet. For example, the planes of the

General directions: the planes in each drawing should be distinguished in terms of changes in value (lightness and darkness). Make the contrast between neighboring planes more intense for planes nearest your viewpoint.

Painting Exercise

Self-Portrait in Planes

Portray your own physical likeness by focusing on a planar analysis of your features and clothing.

As shown in Figure 5.1, shapes may function as flat and curved planes that construct dramatically simplified volumes when hinged together. The painting depicts its subject as a convincing illusion of three-dimensionality, and, simultaneously, the painting asserts itself as a pictorial invention made by the hand of the artist.

Preliminary drawings: Make two preliminary sketches, working quickly while you look at yourself in a large mirror. Each sketch should differentiate the planes you observe in your own physical appearance. In the first sketch, emphasize the major planes by representing value differences. Each plane should be different in its lightness and darkness, depending on how directly it faces the light. Work with the broad side of a stick of charcoal to complete each plane in as few strokes as possible.

For the second sketch, use a soft pencil to draw in only the borders of the planes. By using the point, this sketch will allow you to create a more detailed analysis of the contours of smaller planes than was made in the first sketch.

The palette: Once you start painting, work with a color palette of limited hues, but within those hues mix a wide range of darks and lights, i.e., a high contrast value key. (For his self-portrait, Beckmann basically restricted himself to black, white, and orange; the orange defines the wainscoting which frames his figure and adds warmth to his flesh tones.)

Think: How would you appear if you were chiseled from a monumental block of the appropriate flesh and clothing materials? Such an exaggerated analysis of planes is shown in *After Dürer* (Figure 5.2), by Rimma Gerlovina and Valeriy Gerlovin. The artwork is a photograph created by painting directly on Rimma's face, then photographing the result.

5.2 Rimma Gerlovina and Valeriy Gerlovin, *After Dürer*, 1990. Ektacolor print, 48″ × 48″ framed.

Technique: When you begin painting, work with relatively large brushes and paint boldly. Work in two stages. Start by blocking in the general shapes of the largest planes in your composition, diluting the paint with thinner. Avoid giving too much attention to minute details and minor nuances. Let this blocking-in stage of the painting dry before continuing. For the second stage, work in the *direct* manner. (Review the discussion of "Direct Painting" in Chapter 2, pp. 32–33). Aim to have each brushstroke create the final color and shape of each individual plane on a volume. Some of the larger planes from the first stage will now be broken into smaller facets. For this final layer, sparingly use a thicker medium (for example, $2/3$ mineral spirits, and $1/3$ linseed oil). Work on a support no smaller than 18″ × 24″.

Subject matter: Your painting should include at least half your figure, from your head to your waist. Plan your wardrobe (and even your hairstyle) to signify a key aspect of your personality, real or imagined. For example, Beckmann portrays himself as a debonair man of the world wearing elegant evening clothes. In *Self-Portrait with Fish* (Figure 5.3), Joan Brown emphasizes her identity as a dedicated artist by depicting herself in paint-splattered clothes with a brush in hand, ready to work. (The fish she embraces in one arm is a personal symbol, referring in part to the artist's interest in long-distance swimming.)

DYNAMIC BRUSHSTROKES

Some painters blend their brushmarks carefully, so that the final surface has a smooth appearance. Others preserve the integrity of the marks. For convenience, we refer to the former as *blended brushstrokes* and the latter as *dynamic brushstrokes*.

Blended brushstrokes tend to enhance a sense of distance and impart a more "photographic" quality to an image. (Frida Kahlo in Plate 13 and Catherine Murphy in Figure 4.8 used blended brushstrokes.) While some highly skilled painters who strive for a total commitment to illusionism restrict themselves to smoothly blended brushstrokes, in less experienced hands this technique all too frequently results in imagery which is lifeless or overly finicky.

Using dynamic brushstrokes is an effective way for beginning painters to learn more about the tactile and gestural qualities of paint — how to use visible marks to activate the surface of a painting. Dynamic brushstrokes

5.3 Joan Brown, *Self-Portrait with Fish,* 1970. Enamel on masonite, 96″ × 48″.

tend to reinforce the viewer's attention onto the picture plane where the trace of the artist's hand remains visible. Look at the self-portraits by Chatchai Puipia (Figures 5.6 and 5.9), Vincent van Gogh (Figure 5.7), and Beckmann (Fig. 5.1), as well as Richard Diebenkorn's figure painting (Plate 1), for examples of various approaches to painting with dynamic brushstrokes.

One method for creating dynamic brushstrokes is to make the strokes consistent in size throughout the composition. The consistency will tend to flatten the appearance of the painting — emphasizing the picture plane — even when the brushstrokes themselves record spatial relationships. Van Gogh's self-portrait contains thick strokes of paint quite uniform in size. By following the planes of the face and clothing, the strokes effectively define volumes in depth. Chuck Close's self-portrait (Plate 14) is a kind of updated version of van Gogh's approach. Close paints more-or-less uniform circular daubs within the squares of an overall background grid; the total effect recalls the pixels of a computer image while retaining a "handmade" quality. While calling attention to the painting's surface (especially evident in the detail shown in Plate 15), dynamic brushstrokes can still be effective in articulating forms and communicating a sense of depth.

Painting Exercise

Practicing Brushstrokes

Experiment with how your various brushes (flat, filbert, round, bright, and fan) release paint. With practice, you should be able to vary the amount of paint that comes off in a brushstroke by controlling the pressure.

Practice direct painting with as few brushstrokes as possible, aiming to make each stroke count in defining your subject's forms. Try to anticipate the exact hue, value, saturation, shape, and thickness that every stroke of paint should be to achieve maximum visual impact. As an example, look again at Figure 5.1. Note how few strokes Beckmann used to define the nose, lips, cheeks, and fingers. Bold marks create the impression of a person brimming with vitality.

Painting tips:
1. Avoid scrubbing on paint with a brush. For direct painting, have sufficient paint on the brush to lay down a film of paint with every stroke. If your aim is to paint thinly, use more medium; avoid scrubbing with an empty brush.
2. If your aim is for a drybrush effect, use a bristle brush and apply the paint with a light touch. To do this effectively, practice applying as little paint as possible with a stroke of a brush. Applying the paint lightly, with a drybrush effect, over a dried layer of paint will allow some of the underneath color to show through. This effect is called *broken color*. (Note: Using a light

touch with the brush is also effective when painting wet-into-wet if you don't want to disturb the underneath layer.)
3. When using the drybrush technique, a subtle increase or decrease of pressure on the brush can control the amount of paint released. The painter can control value: when using paint color that is lighter than the surface to which it is being applied, an increase in pressure will lighten the effect of the brushstroke; when painting with a color that is darker than the surface being painted, an increase in pressure will darken the effect of the brushstroke. Why? Because the increase in pressure serves to fill in a greater proportion of the valleys of the surface with the new paint color, leaving less of the earlier paint color exposed.

Journal Exercise

Strong Emotions

Empty your mind of outside distractions and turn your attention inward. Think back to a period in your life when you felt one or more of the following emotions intensely. The period could be any length from a few hours to several months to many years as long as a powerful emotional mood predominated. It is okay if the emotional period is ongoing right now.

loss and grief	compassion	hurt feelings
love	loneliness	ecstasy
envy and jealousy	anger	happiness
fear	joy	commitment
depression	frustration	anxiety
playful mirth	passion	guilt

Close your eyes and meditate on your memories of this period of vivid emotions. Visualize yourself: how old you were and what you looked like; where you were; who the other people were around you. If one particular incident from that period flashes into your mind, stay with it and keep visualizing it. How were you behaving in the scene or time period you are remembering? What was going on around you? How were you feeling? Did you openly express your feelings in any way, either verbally or nonverbally? What colors, shapes, sounds, and other sensory details do you remember?

Open your eyes. At the top of a page write a title for the period or event you are recalling and your age. Tell the story of what was happening with you at that time in

your life. Pay particular attention to the dominant feelings you had. Describe any vivid visual and other sensory details you recall. Take your time with this. Whenever you have trouble recalling information as you write, close your eyes and return to the memory for a minute.

Ask yourself why this memory is important to you. Do any of the feelings still linger? Write a paragraph analyzing how this memory has meaning in your life now.

Painting Exercise

Strong Emotions

Plan a composition in which the image expresses yourself caught up in a strong tide of emotion. You may wish to develop your painting around your response to the journal exercise "Strong Emotions," above. Your subject may be based on a memory, an imaginary appearance, or it might focus on how you feel about a topic of ongoing concern.

For this painting, strive to integrate form and cognitive meaning as fully as possible. We offer two different approaches to accomplish this with an example for each. First, strong emotions may be expressed in a painting by the organization of formal elements in a carefully planned composition. In *Fear of Real Estate*, (Figure 5.4), Cynthia Evans depicts herself weighed down by the overwhelming burden of owning a home. The ropes used to hold the house are converging lines pointing dramatically to the figure hunched over at the bottom of the picture. The downward thrust of the largest shapes (those that comprise the house) are all pressing down on the figure's back. The weight of the house becomes literal, a symbol for the emotional burden caused by fear.

A second approach to creating a strong sense of emotion relies more on expressionistic paint textures and intense colors, and is exemplified by an ongoing series of self-portraits by Luis Cruz Azaceta, who emigrated to the United States from Cuba at the age of eighteen. In self-portraits such as *Homo-Fly* (Figure 5.5), Azaceta injects raw feelings of anguish and exposes his phobias by

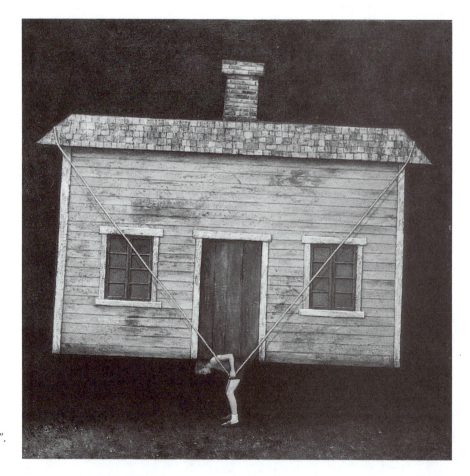

5.4 Cynthia Evans,
Fear of Real Estate, c. 1994.
Mixed media on wood, 17" × 17".
Copyright © 1995.

5.5 Luis Cruz Azaceta, *Homo-Fly*, 1984. Acrylic on canvas. 66″ × 60″. Collection of Richard Brown Baker, New York. Courtesy of George Adams Gallery, New York.

the handling of the paint itself. With its emphasis on rough-hewn, bold shapes and a thick, urgent application of dynamic brushstrokes, the artist's approach is related to the Neo-Expressionist style that reached a peak of critical recognition in the 1980s. The visual power of *Homo-Fly* results from strong colors as well as the dramatically interlocking positive and negative shapes created by the many indentations of the central figure.

As a learning experience, make two versions of your painting of "Strong Emotions." In the first, use a red, yellow, and blue triadic color scheme in which yellow is the most saturated color. For the second, following the same basic composition, employ a similar color scheme but make blue the most intense, dominant hue. What emotional effect does this change have on your painting?

How does color contribute to the overall expression of content?

For your pair of paintings you can opt to use a relatively controlled style in which compositional elements direct the attention of a viewer to important details in "the message" of your painting, as in Evans's painting. Or, alternatively, try creating a sense of turbulent emotion by aggressively applying thick strokes of paint, in an expressionistic style similar to that used by Azaceta in *Homo-Fly*. (Note: This exercise has concentrated on two strategies for generating strong emotional content in a painting. There are also other strategies for conveying strong emotion, such as the depiction of a gesture and/or facial expression [see Figure 5.9]; of course, the same painting may incorporate more than one strategy.)

Painting Exercise

Modified Pointillism

Working from a color snapshot, create a self-portrait in a style related to pointillism.

Developed in the 1880s in France, *pointillism* is a method for applying paint in small dabs ("points") of pure color. Placed on the canvas in close proximity, the dabs of paint can create optical mixtures in the eye when seen from several feet away. (For example, small dabs of red and yellow create an optical mixture of orange.) The first pointillists worked methodically to create paintings that captured the impression of natural illumination; later pointillists used small dabs more for a decorative effect to create a strong surface texture.

Option 1: In order to "scale up" the image in the photo, mark a grid on a sheet of acetate hinged to overlap the photo. With a charcoal pencil, lightly mark a grid with the same number of rows and columns across the surface of a gessoed, fine-weave canvas. For instance, a 4″ × 6″ photo would be enlarged six times to fill a 24″ × 36″ canvas; if the squares of the grid on the photo measure $\frac{1}{4}$″ across, then the squares on the canvas will measure $1\frac{1}{2}$″ across. Lightly indicate on the canvas the position of key features of the face as shown in the photo. Apply fixative so the charcoal won't smear.

Restrict your working palette to only four colors: the primaries (red, yellow, and blue) and black.

Apply the paint in small dabs of pure unmixed color, trying to achieve optical mixtures that recreate the actual colors seen in the photograph. For higher valued tints, apply smaller dots of color, allowing more of the white of the canvas to show. Areas of strong color are produced with a dense application of dabs; for darker shades add black dabs along with dabs of color.

On a practice sheet, experiment using the oil paints straight from the tube (here the paint will be at its most opaque), or diluted slightly with a glazing medium (such as Liquin). Note the different effect of overlaying translucent dabs of color versus opaque dabs.

As a faster-drying alternative, use acrylic paints and work with the four colors used by the printing industry for four-color process reproduction —magenta, yellow, cyan (use any warm blue, close to turquoise), and black.

Option 2: Work in a manner similar to that developed by Close. Begin by making a much tighter grid on the acetate over the photo — a grid with squares $\frac{1}{8}$″ across on a 4″ × 6″ photo would be magnified to squares $\frac{3}{4}$″ across

for a 24″ × 36″ canvas. Apply color to each square in circular dabs of diminishing size. For the working palette, use the three primary and three secondary colors — red, orange, yellow, green, blue, and purple. The artist describes the process he used to create his self-portrait (Plates 14 and 15):

> I began by blocking in whole areas of underpainting color in tones that were completely inappropriate. . . . And in painting the face, rather than arriving at a color in one way, I built the color in several ways. For example, I found that I could arrive at a brown by putting down strokes of orange and blue, or red, green and yellow, or purple and orange. . . . I know what the resultant color has to be, but there is no set way to arrive at it.[1]

Discussing an earlier portrait done in a similar technique, Close equated his painting approach to the game of golf:

> I thought of the gridded canvas as a golf course, and each square of the grid as a par-four hole. Then just to complicate things and make the game more interesting, I teed off in the opposite direction of the pin. For example, I knew that the color of the skin was going to be in the orange family, so I started out by putting down a thin wash of blue, green or purple — something very different from what the final color would be. The second color then had to go miles to alter the first one. So for this big correcting stroke, I chose a hue that moved me into the generic family I should have been aiming for. Now I had moved into orange, but it was too yellow, so in the middle of that stroke, I put down a gob of red to move into a reddish orange. Then I was at the equivalent of being 'on the green' and hopefully quite close to the cup. But the color was still much too bright. So the final stroke was a little dot of blue, the complementary color, which optically mixed with the orange and lowered its intensity, dropping it down to an orangish brown. I was in the cup.[2]

STUDYING SELF-PORTRAITS AND THE THEME OF PERSONAL IDENTITY

Who is portrayed in the painting illustrated in Figure 5.6? Entitled *Siamese Smile*, the painting depicts the

5.6 Chatchai Puipia, *Siamese Smile,* 1995. Oil on canvas, $94\frac{1}{2}'' \times 86\frac{5}{8}''$. Private collection.

artist — Chatchai Puipia — grinning broadly. In fact, the grin is *too* broad; the artist has portrayed himself ironically mimicking the wide smile that is promoted as a national emblem of friendliness in Thailand, the artist's home country. The curator Apinan Poshyananda explained Puipia's artwork in these words: "Thais have always put on a false smile to perpetuate the image of a nation of beautiful, Buddhist inhabitants. Only recently, with a loss of faith in the government, the economy, and even Buddhism itself, have many Thais openly expressed a lack of confidence and self-esteem."[3]

Our practice subject matter in this chapter involves the use of the artist's self-image as subject matter. Artists can and have made self-images in which they represent themselves symbolically, for example, using an article of clothing or a nonhuman animal or an arrangement of objects as a stand-in for the human body. But in this chapter we look at paintings in which artists represent themselves with a figurative image. Such images may be a naturalistic likeness, but frequently artists distort personal features or change their appearance. As we see in our example by Puipia (Figure 5.6), the painting of one's self may engage meaning beyond the level of mere physical appearance. In terms of cognitive content, we are concerned in this chapter with how artists use self-images as a means to represent their personal identity — who they are. In expressing aspects of their personal identity, artists may also address or reflect their view of the larger world.

The History of Self-Portraits

Paintings in which artists represent themselves belong in the West to the genre known as *self-portraits*. Self-portraits are a fairly recent phenomenon in the West, coinciding with the early Renaissance in Europe. The first self-portraits art historians have identified are carved busts on cathedrals and churches made by artists working on important commissions. In contrast, portraits of *other* people have been an important genre of art in many places around the world since the dawn of civilization. Artists in ancient Egypt, Greece, China, and other societies attempted to immortalize their rulers and religious leaders by preserving their "likeness" in art (often a highly idealized version of the person's actual appearance). We give further study to portraits when we take a broader look at the theme of the human figure in Chapter 7.

Painted self-portraits appeared during the first half of the fifteenth century in northern Europe and Italy when painters began occasionally using themselves as models, sometimes reproducing their likeness for one figure in a large composition. The emergence of self-portraiture coincided with the emphasis in Western civilization at large on individualism and personal achievement. No longer viewing themselves as mere artisans, artists began to define themselves as members of the intellectual elite working with their head as well as their hands, and to claim individual authorship for their works of art.

European self-portraits increased in number in the sixteenth and seventeenth centuries, reflecting the public's greater interest in artists as individuals and artists' increased self-assurance about their social position. Baroque artists often painted themselves wearing the rich costumes of aristocrats; some even placed themselves in scenes as the companions of kings. For the first time, women painters made self-portraits, including Artemisia Gentileschi in Italy and Judith Leyster in the Netherlands. The greatest Baroque exemplar of the self-portrait was Rembrandt van Rijn, who painted himself about sixty times, from his early twenties until the last year of his life. Rembrandt used the genre not merely to record his likeness at different ages but to interpret changes in his economic circumstances and his profound awareness of the emotional and spiritual dimensions of life.

By the early nineteenth century in the West the Romantic movement had given birth to the popular conception of the artist as an expressive, temperamental, highly individualistic personality, a stereotype which persists to the present day. Throughout the nineteenth century many artists painted personalized and psychologically revealing self-portraits. The most famous of the century's practitioners of the self-portrait was Vincent van Gogh (Figure 5.7), who, like Rembrandt, reproduced his own features again and again.

The twentieth century was one of the most varied in the history of art, and those artists who created self-portraits did so for a range of reasons and employed many different styles. Self-portraiture also was a significant genre in many non-Western societies in the modern era. Modern self-portraits provided opportunities for formal experimentation, role-playing, introspection, emotional expression, psychological insight, and social comment, in any and all combinations. Pablo Picasso, Max Beckmann (Figure 5.1), and Frida Kahlo (Plate 13) are but a few of the modern artists who returned repeatedly to the portrayal of their own features.

Contemporary artists continue to make self-portraits for all the previous reasons: to record their own likeness, project a social persona, probe their temperament, and

5.7 Vincent van Gogh, *Self-Portrait with Grey Felt Hat*, 1887. Oil on canvas, 44 cm. × 37.5 cm. Van Gogh Museum, Amsterdam.

communicate self-awareness. Today there is also a surge of interest in self-images as part of a wider engagement with issues of personal and cultural identity. Many people today believe that, rather than a fixed single "self," each of us has multiple identities formed in response to the different groups to which we "belong" — family, ethnic/racial groups, gender, economic class, and so on. The terms *multiculturalism* and *diversity* frequently are used to refer to the double awareness that many different kinds of people coexist in the world and that each individual is a complex mixture of attributes, beliefs, interests, and behaviors derived from numerous sources, some of which even compete with one another. In *A Walk through New York with a Headache and Lotería Cards* (Figure 5.8), Julio Galán portrays himself embedded simultaneously in two worlds: as an artist living in New York City

5.8 Julio Galán, *A Walk through New York with a Headache and Lotería Cards*, 1984. Oil, acrylic and montage on canvas. Collection: Nicole Miller, New York.

while still vitally connected to the images and symbols he remembers of his life in Mexico. The awareness of multiculturalism has made depicting "oneself" in painting more complicated but potentially very rich.

To produce a self-portrait the artist holds a mirror up to herself, literally or figuratively. To produce a superb self-portrait she must dig below the surface and reveal something compelling about her personality or life history or her understanding of the world around her or her complex identity as a person living in the multicultural world of the twenty-first century, and she must do so in a way that reverberates as significant visual form in her viewers' eyes. The journal exercises in this chapter are intended to help you explore different aspects of your identity. The painting and preliminary drawing exercises should help you translate your insights into visually effective self-portraits as you also acquire additional studio skills. Some of your paintings will resemble familiar versions of self-portraits; others will experiment with wider definitions of painting about personal identity. But all the painting exercises in this chapter will direct you to begin with your own human form as the vehicle for exploring your identity. In Chapter 11 we revisit the theme of identity, turning to paintings that use less literal images of an individual person and instead represent identity through objects, symbols, and multi-figure narratives.

GESTURE, POSE, AND FACIAL EXPRESSION

In representational figurative painting, including self-portraits, many artists pay special attention to the overall *gesture* of the figure(s). To accomplish this, the painting should focus on the gesture of the *pose* (the arrangement of the entire body) as an event in progress. Think of the pose as a verb, not as a static noun. This is especially important when you are painting someone who is actually "holding" a pose: a model in a painting class or a "sitter" for a portrait, including yourself seen in a mirror. Being sensitive to a person's overall posture may be necessary to convey a convincing message about identity. Look, for example, at *Mae Chow Woi!* (Figure 5.9), another painting by Puipia using himself as the model. The crouching pose with arms hugging one another and head tilted back with mouth open in a silent cry expresses extreme anguish.

Inexperienced painters often succumb to a strong tendency to align a figure's gesture with either a true horizontal or vertical. But by habitually "correcting" the

5.9 Chatchai Puipia, *Mae Chow Woi!,* 1994. Oil on canvas, 59″ × 43¼″. Private collection.

alignment, a painter may eliminate or reduce the tilt which animates a pose, makes a gesture unique, or reveals the telltale effects of gravity. The forward bend and twisted neck and head of the figure looking in a mirror in Anita Chiantello's *Big Butt* (Figure 5.10) is a compelling representation of the artist's critical concern with the size and shape of her body. In Su-En Wong's self-portrait, *(white) Dress* (Figure 5.11), the figure is shown with subtle shifts (note the slight tilt of the shoulders) which serve to animate the pose. How lackluster both of these paintings would appear if the artists had eliminated the special nuances that define these gestures.

One reason why visual art can seem so magical is that its "rules" are never ironclad. Even though individualized gestures can enhance the effect of many paintings — as in the examples just discussed — other paintings may gain strength by the strict alignment of the

subject's gesture with the major horizontal and vertical axes. Looking back at Richard Diebenkorn's drawing (Figure 1.8) versus the completed painting (Plate 1) we see that the original pose has been straightened up, an alteration that contributes an enduring, even monumental quality to the painted pose.

While sometimes a self-portrait portrays a complete figure, others crop the figure and focus only on the face and upper torso. For such a representation, the compositional possibilities are more limited: the head can be in profile, full-faced, or half-turned; it can be tilted to one side or another, up or down, or held level. Gesture is at a minimum; sometimes not even the hands are evident. In order to make your portrayal of yourself special, you may need to pay attention to subtleties of facial expression. We typically view the face as a person's primary identifying feature, as if character and personality reside there; moreover, we are accustomed to "reading" facial expressions for telltale clues as to what people are think-

5.11 Su-En Wong, *(white) Dress,* c. 1996. Oil on canvas, 72″ × 48″. Courtesy of the artist.

ing and feeling. Indeed, a face has great liveliness, and the smallest change — a slight upturn of the lips or widening of the eyes — alters the expression of the whole. The wide-open eyes and toothy grin of Puipia's *Siamese Smile* (Figure 5.6) convey an impression of manic feelings barely contained; in contrast, the pursed lips in van Gogh's self-portrait (Figure 5.7) give an impression of self-control in direct contrast to the exuberance of the artist's emphatic brushstrokes.

Discussion Exercise

Body Language

5.10 Anita Chiantello, *Big Butt,* 1996. Oil on panel, 13″ × 10″. Courtesy of the artist.

Discuss the effect the figure's pose makes on the overall content of a self-portrait. For example, can you make

any observations about how a figurative form which has been aligned vertically differs in meaning from a figurative form which has been portrayed with a shift influenced by gravity or feeling? Compare the figures in Beckmann's (Figure 5.1) and Galán's (Figure 5.8) self-portraits with those by Wong (Fig. 5.11) and Chiantello (Fig. 5.10).

Preliminary Drawing and Painting Exercises

Gesture Drawings and Paintings

Producing *gesture drawings* and *gesture paintings* are time-honored approaches used by artists to practice responding to the whole sweep of a figure's pose or action (see the example of a gesture painting by Jim Viewegh, Figure 5.12). The artist's marks or brushstrokes are put down spontaneously as the arm follows the eye in responding to the dynamic qualities of the subject's form and movement.

Working with charcoal on large sheets of paper (at least 18″ × 24″), and working with paint on sheets of gessoed paper or cardboard, do a series of gesture studies. Draw and paint yourself (looking as you take quick animated poses in a mirror); alternate your pose often. Superimpose one drawing or painting on top of earlier ones, to represent how the earlier pose has transformed into the next. (For variety, do some gesture studies of another person. Two artists working in tandem can each do a series of the other simultaneously. Because each "model" is also working as an artist, there is no chance that any pose will remain static for long!)

A drawn or painted gesture study emphasizes an intuitive, calligraphic response to the thrust of the masses seen in the subject. React boldly and quickly to what you see and feel are the major directions and tensions of the body as it exists dynamically in space.

Right from the start, create strokes in charcoal or paint which run the entire length of the picture plane. Begin by creating a response to the volumes as you work from the inside out, only gradually defining the specific contours of outer surfaces and edges.

Painting Exercise

Sustained Gestures and Expressions

Do a series of paintings of yourself, spending approximately thirty minutes on each. For an unusual challenge, work on very small surfaces (such as small pieces of gessoed masonite, approximately 6″ × 9″). Or grid off appropriate areas on one larger surface, to complete the paintings as a single, multi-part artwork. Working on such an intimate scale will enhance your use of dynamic brushstokes because the brushstrokes will appear larger relative to the size of the picture plane. Inevitably the scale itself will have an impact on the overall content of each image.

Complete the paintings in the following order:

1. a painting of yourself — approximately waist up — looking in a mirror. Sit upright, as straight as you can, and turn your head so you are facing directly into the mirror;

2. a painting of yourself — showing your full length — looking in a mirror. For this painting, slouch your body and tilt your head at an exaggerated angle;

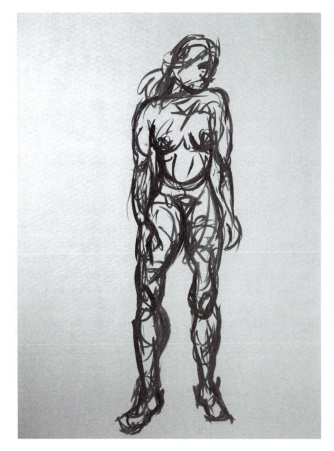

5.12 Gesture painting of figure. (Artwork by Jim Viewegh.)

FRIDA KAHLO
Plate 13

Frida Kahlo lived a short but highly memorable life. Her art, like Beckmann's, reflects the intertwining of social, political, and personal events as well as her formal interests. Born near Mexico City, Kahlo began painting at the age of eighteen while convalescing from a nearly fatal accident that resulted in a severe spinal injury, leaving her partially crippled and in frequent pain. In self-portraits created throughout her life, the artist portrays her physical condition as a metaphor for psychological suffering.

Today Kahlo is cited as an influential pioneer of art centered on issues of identity. Through the many startling self-portraits in her *oeuvre* (an artist's entire output), the artist expresses her deepest feelings about such themes as sexuality, love, pain, and birth, as well as her dual ethnic identity. (Her father was a German Jew; her mother was Mexican.)

A full examination of Kahlo's self-portrait, *Thinking about Death* (Plate 13), would weave together observations based on the artist's technique and the artwork's physical materials, formal means, and cognitive meaning. While focusing on one of the most compelling mysteries of existence—the contemplation of one's own death—Kahlo builds her image through the simplest of formal constructs. Her color scheme relies on the use of complementary reds and greens, which vary from warm to cool versions of each. A strong emphasis on the linear edges of shapes—particularly in the neck, chin, and neckline of her dress—ties the figure into the strong pattern of linear elements that define the leaves and branches. The figure is revealed as a creature bound to the earth, an observation which subtly echoes the message of death itself—the inevitable return to nature.

Kahlo combines her use of formal elements into what we call design relationships. The use of lines and edges, for example, creates a visual rhythm; the various curves of leaf stems, chin, neck, and dress repeat one another in an organized cadence. Even the pronounced curve of the arched eyebrows builds upon this consistent pattern that relates all the rounded elements, reaching a climax in the death's head embedded like a third eye in the artist's forehead.

Equally important to the painting's impact is the visual balance achieved by the central placement of the simplified figure set against the lush botanical background. As a result, the painting displays what is called a *figure-ground shift*: the negative shapes in the background vie with the figure in the foreground (a positive shape) for the viewer's attention. Background and foreground appear to alternate functions, each demanding equal attention and thereby making the entire picture plane visually active.

position something (such as a small table or chair) between you and the mirror, so that your view of yourself is partially interrupted (use this arrangement to establish more dynamic positive and negative shapes in the composition);

3. a painting of your face looking in a mirror. Paint so that just a portion of your face overflows the picture plane on three sides. Paint yourself holding an unusual expression — with your mouth open;

4. paint yourself with a different facial expression (now with one hand covering part of your face). Paint so that your face overflows the picture plane on all four sides.

Guidelines: Even as you work quickly to complete each painting, incorporate ideas that have been presented earlier in the text. Plan the series so that each of the following concepts and strategies is incorporated into at least one of the paintings: very pronounced asymmetry, an emphatic visual rhythm, a pattern of bold brushmarks emphasizing the picture plane, a pattern created by strong value contrast, a figure/ground shift.

Painting Exercise

Imaginary Self-Portraits

Create a self-portrait of yourself engaged in some imagined activity which holds special personal meaning.

Option 1: Paint your imagined self in a dynamic pose. As an example of this approach, see Yolanda M. Lopez's treatment in *Portrait of the Artist as the Virgin of Guadalupe* (Figure 5.13). Lopez incorporates her own image —

running straight forward into the viewer's space — in contemporary clothing emerging from the cloak of stars and sun-ray body halo that identifies the Virgin of Guadalupe, an important religious icon in the artist's Mexican heritage. Lopez shows herself as someone influenced by a tradition while striding confidently forward.

Option 2: Paint your imagined self in a static pose, with a limited facial expression, aligned with the major axes of the picture plane. See Figure 5.1, Beckmann's self-portrait, for an example of such a pose.

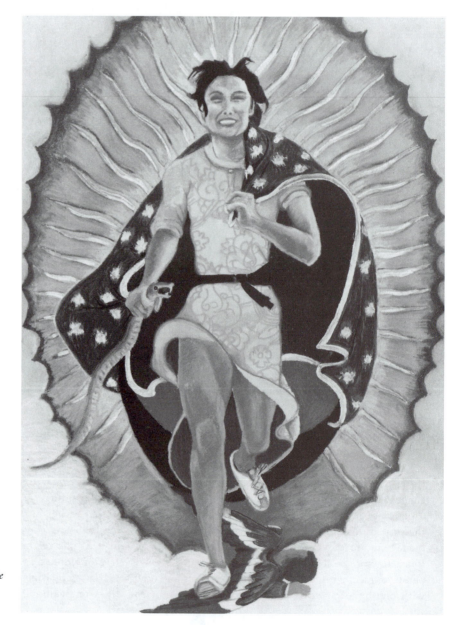

5.13 Yolanda M. Lopez, *Portrait of the Artist as the Virgin of Guadalupe,* 1978. Oil pastel on paper, 28″ × 32″.

After completing the paintings, the class should compare them as a group. Write some thoughts in your journal on what qualities are expressed by each approach. For instance, ask yourself: Does one painting make the figure appear more timeless? more dynamic and alive in the here and now? Which paintings are more active as visual images? Which create a stronger relationship between the positive and negative shapes?

Journal Exercise

The Body

This exercise considers the body as a basic carrier of human identity. It works with the body you know most intimately — your own. Our sense of identity is connected to our awareness of our self as a physical presence in the world — to how we feel about our body and how we think others react to our appearance. This exercise asks you to examine your sense of bodily identity, concentrating mostly on one body part or attribute.

1. Sit upright in a chair, with your back away from the back of the chair. Close your eyes and concentrate on your physical body. Begin at the top of your head and slowly move your awareness down and around every part of your body. Imagine you are carefully drawing a contour line tracing all your limbs and muscles from head to toe. If you wish, you can try actually to draw your contour, without looking at the paper as you draw. Take plenty of time to complete your imaginary or actual drawing.

 After you have traced your entire body, open your eyes. Make two columns on a page of your journal. Head one, "My favorite body parts and attributes." Head the other, "My least favorite body parts and attributes." Fill in the first column with the features of your body that you claim readily as part of your being. Fill in the second column with physical features you feel alienated from.

2. Next select one body part or attribute which is crucial to your image of yourself for better or worse — one you might inspect first if you were studying yourself in a full-length mirror as in Chiantello's painting (Figure 5.10). Cast your mind back to your earliest memories of this physical attribute and remember how it looked then and your emotional reactions to it. Slowly proceed forward in your imagination, calling forth memories of this attribute at different ages. Ask yourself what role the physical

feature has played in your self-image. Has the feature been with you from childhood or did it appear later? Has its appearance changed over time? How often? Were you responsible for changes (for example, trying out a new hairstyle), or were changes the result of illness, accident, or aging? Have your own reactions to the physical feature changed? How do you think the feature influences the way other people react to you?

In your journal record some of your thoughts about the feature. You might begin by writing about why the feature is important to your self-image, then proceed from there.

Further writing on the body: How often in your life have you deliberately altered your appearance by radically changing your hair, style of clothes, makeup, posture, weight, or some form of body adornment such as a tattoo or body piercing? Pick one aspect and explain in your journal how and why you altered it. What part of your appearance were you remaking? What public messages about your identity did you want the change to express? Did people react to the change as you expected?

Drawing Exercise

Body Parts

Looking in a mirror (or down at your body), do a series of thumbnail sketches in which various parts of your body are distorted or exaggerated in appearance. Distort such physical features as the size of your hands, the size of your jaw and mouth, the overall size of your head.

Painting Exercise

The Body

Option 1: Do a painting based on the journal exercise, "The Body." As examples, look again at *Big Butt* (Figure 5.10), one of a series of self-portraits in which the artist makes a witty yet poignant scrutiny of various aspects of her own body; and *(white) Dress* (Figure 5.11), in which Wong asserts her awareness of her sexuality (by focusing attention on her breasts) and also reveals cultural changes the artist has undergone emigrating to America from Singapore (changes which are symbolized by the

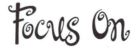

ERNEST PEPION
Plate 16

Buffalo Hunter (Plate 16), a witty oil painting by Ernest Pepion, reveals a wealth of information about the artist's own hybrid identity. The figure's placement in a combination wheelchair/hobby horse reveals the artist's disability as well as his upbringing on a Blackfeet Indian Reservation in Montana. Ironically, after safely surviving military service during the Vietnam War, Pepion became a quadriplegic following an automobile accident in 1971. Like Kahlo, the accident precipitated a twist of events that provided the opportunity for Pepion to become an artist.

By depicting himself hunting a buffalo while riding his wheelchair, Pepion expresses multiple facets of his identity in a humorous yet poignant way. The hunting act itself serves double symbolic duty: the artist is a military veteran as well as the inheritor of a Plains Indian hunting tradition. Hunting from a wheelchair suggests the will to prevail against all odds. The buffalo itself can be seen as a symbol of cross-cultural differences. Indians hunted the buffalo for survival and recognized it as a spiritual symbol; whites hunted buffalo for sport and profit.

In Pepion's self-portrait, the artist constructs his image with a triadic color scheme by using three colors (in this case, red, yellow, and blue) that are equidistant on the color wheel (Plate 6). Like Beckmann (Figure 5.1), Pepion simplifies his treatment of volumes. Note how the planes of the buffalo's face and front legs are emphasized.

In creating *Buffalo Hunter*, Pepion aligned the edges of shapes and important lines throughout the composition. For instance, the downward sloping rim of the mountain seems to flow in the direction of the figure's left arm. This same direction continues on the right side of the painting along the distant ridge of mountains. Together these elements create an *implied line*, a line that is not fully present but is completed in the viewer's mind.

Significantly, the tip of the arrow, one of the most dramatic details in the painting, is positioned along this implied line. In fact, the entire composition is structured so that the viewer's eye is guided along paths of vision pointing to key details (known as *focal points*) found throughout the picture. Such an organized structure makes the overall pattern of the painting more visually memorable. It is interesting to compare Pepion's painting with Evans's *Fear of Real Estate* (Figure 5.4). Both compositions utilize similar V-shapes to draw attention to important focal points. Furthermore, although not seen in the black-and-white illustration in our text, Evans's painting, like Pepion's, utilizes a red, blue, and yellow triadic color scheme. In both paintings, the reds and blues are more saturated colors than the yellows.

PAINTING TIPS:
Pay close attention to the overall pattern created by the formal elements. A distinctive pattern helps make a painting eye-catching. Look again at Figure 5.1 and Plate 13. The visual impact in each is enhanced by the order imposed on the formal elements (primarily shape and value in the Beckmann; line and color in the Kahlo).

Plan your composition to enhance the cognitive meaning of your painting. Your goal is not merely to create a visually effective composition; you want to use composition to communicate content. The planned orchestration of focal points in a painting can enhance both the visual and the cognitive aspects of a painting simultaneously.

bleaching of her dark hair). In creating your painting, emphasize a simplified treatment of the rounded and flat planes which connect to create the volumes of your subject.

Option 2: If you have the opportunity to paint from a live model, either in class or by asking a friend to pose, concentrate on a body part or attribute of the model which is significant to your own self-image. Obviously

the model's version of the part or attribute may contrast with yours. Make a series of small quick paintings — one where you render the attribute as accurately as possible, then one where you distort or exaggerate its appearance, and finally one where you change the attribute into the most ideal form you can envision. At the end write down your reactions to your three paintings.

Journal Exercise

Age

Some identity attributes are more or less fixed, such as your adult height, the color of your skin, and your ethnic origin (although reactions to these attributes are culturally variable). Other attributes have the potential of changing, for example, your occupation and nationality. You can control some but not all of the mutable attributes. This writing exercise deals with age, a feature of identity which in fact is constantly changing.

The secular society of the United States has broad age categories, sometimes referred to as "infancy," "childhood," "adolescence," "youth," "middle age," and "old age." People tend to blur the boundaries between categories, unlike cultural and religious groups that have formal rituals fixed at specified chronological ages to mark the passage from one stage of life to the next. Without specific "rites of passage," age group is largely a matter of self-definition, which in a youth-privileged culture means that many adults are reluctant to let go of calling themselves "young." Yet aging can be an opportunity for self-discovery, and some older artists rivet us with their work about the effects of growing older on their body, social status, self-image, and other aspects of their identity. See, for example, Alice Neel's uncompromising *Nude Self-Portrait* (Figure 5.14), completed in 1980 when the artist was eighty years old.

1. For this exercise you will think about the age group you presently belong to as well as the one you will enter next. To begin, draw a "lifepath" across a blank page. The line can be straight or it can twist, turn, and even circle back on itself. Write "birth" at one end. Study the lifepath, then make an arrow pointing to where you place yourself now. Next make vertical slashes dividing the line into sections corresponding to the age groups you expect to pass through during your lifetime. Label the sections according to the categories described above, or give them other labels which you prefer.

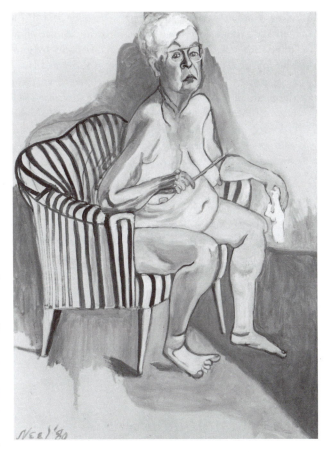

5.14 Alice Neel, *Nude Self-Portrait*, 1980. Oil on canvas, 4'6" × 3'4", National Portrait Gallery, Washington, DC.

2. Write the label of your present age group at the top of a page. Underneath list characteristics associated with people your age. The characteristics may be physical, mental, or emotional. They may be positive, negative, or neutral. They may be charateristics you have observed or ones you have heard other people or the media use to describe people your age. (To come up with your list of charateristics it may help to think of people you consider positive and negative role models for your age group.)

At the top of another page write the label you gave the age group you will enter next. Underneath list age-related characteristics which you or others associate with people in that age group.

When you have finished, circle characteristics on both pages that you think you exhibit — ones you share with others of your present age group and ones that put you ahead of your time because you believe them to be more typical at the next stage of life.

3. Next compare the characteristics you listed for the two age groups. Are you surprised by any of the characteristics you listed? How do you respond to your identity as a person within the age group you belong to at present? When you look ahead toward entering the next stage of life, how do you react — with excitement, indifference, fear, curiosity, or other emotions?

Write for at least twenty minutes about some of your reactions to making the lists and thinking about the questions in the previous paragraph. Write spontaneously, recording whatever comes to mind. Don't worry if your ideas don't sound completely connected and logical.

4. What impact has aging had on your identity — either on how you see yourself or on how others perceive you? Do you believe some aspects of your being have remained constant throughout your life, even though other aspects of your identity, such as religion, occupation, where you live, and economic status, may have changed? What facets of your being are the same now as they were when you were a child? Make a list in your journal of your unchanging qualities. Write for another ten minutes reacting to these issues.

Painting Exercise

Aging Self-Portrait

Painting #1: Create a self-portrait which captures not only your physical likeness at a particular period in your life, but additionally communicates something of your ideas about the aging process.

Effects of aging are examined in the self-portrait by Neel (Figure 5.14) and to some extent by Kahlo (Plate 13). Neel devotes her painting to a frank appraisal of her sagging nude body; Kahlo ponders death.

You might elect to do a painting in which your ideas are visualized in a symbolic fashion, as Kahlo shows the thought of death as a skull and crossbone embedded in her forehead. (Symbolic objects — a fish and a rope — also play important roles in Figures 5.3 and 5.4, Brown's and Evans's paintings.) Or consider other options, such as envisioning how you will look at a much later time in your life. (What will you be wearing? Where will you be? What will you be feeling about your quality of life? What changes will your body undergo as you age?)

Build your painting around a complementary color scheme. Generate visual interest in the negative space/s of your composition in order to achieve a pronounced figure-ground shift in your completed canvas. Establish one or more focal points, but, for a more interesting challenge, *don't* make your eyes the focal points. Create a strong sense of rhythm that links together specific formal elements (such as a rhythmic sequence of lines or shapes). The emphasis should be on the creation of an image which activates the entire picture plane. Your success in accomplishing this goal is more important — and, ultimately, more challenging — than merely capturing "a likeness." Do a few sketches to work out your compositional ideas before you begin the actual painting.

Work "fat over lean" on gessoed paper. For the first stage (using oil paint diluted only with thinner), block in stains of color that relate broadly to your basic composition. For the second stage, further define the volumes and shapes of your composition (for this stage use a medium with more oil). Allow the initial underpainting to remain visible in some areas of the composition, thus creating contrast between the thin luminous underpainting and opaque thicker passages. For the final stage, wetting your brush in a "fatter" medium (add in a few more drops of oil), concentrate on the highlights and give additional definition to the background shapes in order to exaggerate the figure-ground shift you should establish in this painting.

Painting #2: For an intimate-sized artwork, paint on a photo of yourself to make you look like a member of an ethnic or national group some of your ancestors belonged to. Or find an image of a member of your ancestral culture from any source and superimpose your features on top of that. With this artwork, utilize strong invented shapes in the negative spaces to add visual interest and enhance the unification of the entire pictorial surface.

Recommended Artists to Explore

Albrecht Dürer (1478–1521)

Artemisia Gentileschi (1593–c. 1653)

Rembrandt van Rijn (1606–1669)

Paul Cézanne (1839–1906)

Vincent van Gogh (1853–1890)

Käthe Kollwitz (1867–1945)

Paula Modersohn-Becker (1876–1907)

Pablo Picasso (1881–1972)

Max Beckmann (1884–1950)

Egon Schiele (1890–1918)

Frida Kahlo (1907–1954)

Arnulf Rainer (b. 1929)

Gregory Gillespie (b. 1936)

David Hockney (b. 1937)

Joan Brown (1938–1990)

Chuck Close (b. 1940)

Luis Cruz Azaceta (b. 1942)

Yolanda M. Lopez (1942–1996)

Ernest Pepion (b. 1943)

Howardena Pindell (b. 1943)

Cindy Sherman (b. 1954)

Chéri Samba (b. 1956)

Julio Galán (b. 1958)

Chatchai Puipia (b. 1964)

1. Chuck Close quoted in Lisa Lyons, "Expanding the Limits of Portraiture," in Lisa Lyons and Robert Storr, *Chuck Close* (New York: Rizzoli, 1987), p. 39.
2. Ibid., pp. 36–37.
3. Apinan Poshyananda, "Roaring Tigers, Desperate Dragons in Transition," in *Contemporary Art in Asia: Traditions/Tensions* (New York: Asia Society Galleries and Harry N. Abrams, Inc., 1996), p. 48.

6

Space
Practice Subject: Places

"I am interested in both the inscrutability and essential abstractness of landscape and in the very simple, direct fact of place it represents."
—April Gornik[1]

" . . . every corner in a house, every angle in a room, every inch of secluded space in which we like to hide, or withdraw into ourselves, is a symbol of solitude for the imagination; that is to say, it is the germ of a room, or of a house."
—Gaston Bachelard[2]

Chapters 4 and 5 start with discussions of formal concerns, and then integrate these concerns into an examination of subject matter. In this chapter, we shift the order of discussion, starting with a consideration of our practice subject — which in this chapter is *place* — and then proceeding to a discussion of this chapter's primary formal concern — *space*. What a place looks like and in turn how it is represented in art is anchored in a culture's and artist's understanding of what space is or can be. We employ our focus on place as an opportunity to explore various strategies painters use to articulate a sense of space. Additionally, we consider what cognitive meanings might be invested in the various approaches to a sense of place and the articulation of space we find in a painting.

INTRODUCTION TO PLACE AS SUBJECT MATTER

All societies have a view of reality that incorporates concepts of place and location, whether their members are nomadic and regularly change the location of their exis-

tence, or whether members remain firmly grounded in the same site for generations. As Patricia Malarcher puts it, "Place is integral to human existence — there is a 'where' for every event and experience."[3] Not surprisingly, because of its centrality to human experience, place has been a subject incorporated into many artistic expressions.

A painting of a place is usually concerned with the visual qualities of a specific location or geographic area (whether real or imagined). For example, in an image from fifteenth-century Iran (formerly Persia) (Figure 6.1), observe how this place is characterized by a walled-in courtyard and ornate doors and windows. In addition to showing actual physical attributes, paintings of places encapsulate individual artists' responses to the world around them and cultural attitudes and values toward nature. Observe how the nature of the depiction in Figure 6.1 is influenced by the culture which produced it. As an example of what is called a Persian miniature, this image reveals a highly organized complexity created at an intimate scale.

Outdoor Scenes: Landscapes

A landscape is a familiar genre of paintings in many cultures in the West and East. We use the term *landscape* to refer to any painting of an outdoor scene. Although we often associate landscape with scenes of nature — mountains, oceans, rivers, forests — a landscape painting may include the "built environment" (buildings, bridges, streets, and so on), other human-made objects, and even people. Among the exciting choices facing a painter of landscapes are whether to paint an actual landscape or

achieved excellence by the tenth century. An emphasis on landscape in Chinese painting was a result of a philosophical emphasis in Chinese society on contemplating the cosmic order of the universe. The painting of a landscape could function as a means for even the city dweller who worked indoors to visualize the order of nature. The example shown in Figure 6.2 exemplifies an approach taken by many Chinese artists showing the relatively small scale of human culture embedded within the grand scale of the natural world.

Given the popularity of landscapes among today's museum visitors in the United States, it may be surprising to realize that landscape painting has not always been widely practiced or appreciated in the West. Scenes inspired by the natural world appeared two thousand years ago in wall paintings in Roman villas, then disappeared except as occasional backdrops in narrative paintings of human and divine events. In Europe, landscape as an independent genre only gradually emerged in the sixteenth century, and even then ranked well below figure painting in importance.

In the nineteenth century, in response to the pressures of urbanization and industrialization, many European and U.S. artists took a great interest in landscape painting as a way to reconnect to nature. Painters associated with Romanticism, a movement which aimed to establish an introspective, often passionate contact with nature, were as interested in conveying drama and influencing mood as in depicting the external appearance of nature, and they tended to depict nature at its most awesome (what they termed the "sublime"): cascading water, jagged rocks, towering cliffs, and extremes of weather. Many painters in the United States used landscape as a vehicle for expressions of national pride, viewing the natural wonders of North America as manifestations of divine creation. Thomas Moran's *Grand Canyon of the Yellowstone* (Figure 6.3) is a vast panorama showing a waterfall, erupting geysers, and the Rocky Mountains.

Realism was another important trend in nineteenth-century landscape painting in both the United States and Europe, culminating in Impressionism. Artists began regularly painting *en plein air* (outdoors) with oils, in the search for greater optical accuracy in depicting nature. At first they used the results as studies, producing their final versions of an outdoor scene in the studio. Finally in the 1870s, the Impressionists learned to see their landscape "sketches" as finished paintings. Wanting to convey a momentary impression, the Impressionists often selected outdoor scenes to paint because they were interested in depicting the transient effects of light and

6.1 Nizami, "The Eavesdropper," from *Haft Paykar* (Seven Portraits), Iranian, Herat, Timurid period, c. 1430. Colors and gilt on paper, 11″ × 7″. Collection: The Metropolitan Museum of Art, New York. Gift of Alexander Smith Cochran, 1913.

an imaginary one; whether to paint outdoors "from life" (with all its challenges of changing light and distracting movement) or to compose a landscape in the studio from memory, photographs, or sketches; whether to paint a scene up close or from a distance; and what angle of vision to use in rendering a scene.

In China, monumental landscape painting (which the Chinese call *shanshui*, a "mountain-water" picture)

6.2 Chinese landscape painting. Private collection.

weather, painting in the full spectrum of colors applied with visible brushmarks.

In the twentieth century, although there were many excellent artists painting landscapes in a naturalistic manner, landscapes by avant-garde painters were more

often about pictorial technique, formal ideas, and self-expression than about physical reality, departing in radical ways from the illusionism of previous landscape paintings in the West. For example, an abstracted landscape by Linda Lomahaftewa (Plate 8), bursting with vitality, is as much a superimposition of the artist's mind on nature as a reflection of the outer world.

In the past few decades, some artists have realized anew that representations of place can be fraught with social meaning and symbolic messages. In addition to recording present-day outdoor scenes and exploring formal ideas, various artists today have taken up painting landscapes and cityscapes as a means to respond to issues such as national identity, territorial claims, attitudes toward the environment, and the values of human civilizations. (We look more closely at artistic treatments of ecological issues in Chapter 11.)

Indoor Scenes: Interiors

Being *inside* somewhere is different from being *outside* somewhere. Almost always, an interior differs from an exterior — psychologically and physically. An interior surrounds, it is primarily concave; an exterior excludes, it is primarily convex. Important differences between inner and outer places may also occur on the planes of spiritual, social, and historic meaning. Of course, the boundary separating an interior and an exterior is not always definite and static: the permeability of these two concepts is subject to wide cultural variation, and the distinction can shift back and forth depending on one's mental framework (for example, while a forest is outdoors, one can be *in* the forest). We explore a range of paintings of interior places in our look at the artistic treatment of places in this chapter. By distinguishing these spatial concepts — interior and exterior — our wish is not to limit thinking into specific categories but to stimulate your consideration of the possible deeper meanings of the places you inhabit. Of course, some paintings combine or meld together an inner and an outer view. See, for example, Kathryn Freeman's *The Weather Channel* (Figure 6.11).

Paintings of interior places may show the inside of rooms, buildings, or other enclosures. Often we associate an interior with a domestic scene, but artists have also painted grand public interiors such as cathedrals and opera houses, and (especially in the past century) workplaces such as factories and office buildings — for example, Sue Coe's horrifying interior of a slaughterhouse, shown in Chapter 11 (Figure 11.2). Until recently a

6.3 Thomas Moran, *Grand Canyon of the Yellowstone,* 1872. Oil on canvas, 84″ × 144 ¼″. National Museum of American Art, Washington, DC.

painting of an interior without any figures was highly unusual; even the vast church interiors that were the province of specialist painters in seventeenth-century Holland include small figures who help establish the scale of the architecture. Today some artists paint unpopulated interiors — and we illustrate examples in this chapter — although interiors with figures continue to be much more common.

In the history of art, paintings of interiors cut across other categories of subject matter. For example, the events of history paintings have often been set indoors, and sitters for portraits have regularly been posed in interiors. Interiors have been a recurring setting for paintings of scenes from everyday life, that is, for portrayals of the manners and customs of ordinary people. Artists today who paint interiors may be depicting the public or intimate settings for other people's lives or they may paint personal settings which figure in their own activities. The purposes of interior paintings have ranged from a romantic idealization of the pleasures of leisure pursuits, to an absorption in describing in paint the carefully observed details of domestic life, to an interest in using an interior place as a metaphor for a concept such as "confinement" or "shelter."

THE ARTICULATION OF SPACE

The attempt to control pictorial space and to render an effect of depth is fundamental to many paintings of places (as it is to many paintings in general). A scene is usually shown from a specific distance, angle, and height. Together these establish the artist's *viewpoint*. The possibilities are varied: in one painting the viewpoint might be looking up, while in another painting we might be looking down at something near at hand. Compare, for example, the far-off vista looking straight across in Moran's landscape (Figure 6.3) with the close-up view looking down in Carolyn Blakeslee's *Potomac River* (Figure 6.18). In addition to variations in the viewpoint, the panorama of space represented in a painting can vary enormously — from a broad sweep to a narrow view.

No matter what the viewpoint or how wide the view, an artist typically tries to convince viewers that some parts of a painted scene are farther back in space than others. Artists in different cultures through history have had various strategies and goals for showing space, ranging from the desire to convey a convincing illusion

of depth to a much less naturalistic interest in spatial effects. An important choice you have in creating any painting is how deep or shallow a sense of space you want to convey. This is a matter of artistic preference as much as of the actual distances you are painting. One painter might choose to make far-off mountains look like a flat pattern against the surface of the canvas; another might make plants in a small garden appear to recede dramatically into the distance away from the viewer.

In this chapter we discuss some of the key strategies painters have developed to create the illusion of three-dimensional space, and invite you to practice several of them, using a variety of kinds of places as your subject matter. (Of course, these same strategies for creating space can be employed in paintings with subjects other than places, as well as in paintings with no representational subject matter.) You will practice ways to create convincing illusionistic views, and you also will work with more flattened or patterned treatments of space.

Developing effectiveness in controlling the illusion of three-dimensional depth should not come at the expense of overall compositional unity. The sensitive interplay of forms on the picture plane remains the basic compositional structure upon which overall unity is commonly built. The illusion of depth complicates the challenge: now you must strive to create a successful integration of all the parts of a painting as they simultaneously appear in both two and three dimensions!

As you learn about space as a formal element of painting you also will consider the kind of cognitive content you might want to express. Ultimately as a painter you should use whatever spatial effects most attract you visually and also enable you to convey your intentions about content.

Strategies for the Articulation of Space

The following are some important strategies that painters employ to define and control pictorial space. These strategies can be incorporated into a painting either alone or in combination.[4]

Overlapping of Forms

In our first look at creating depth in a painting, in Chapter 4, we introduced the familiar notion that a nearer, opaque form will block the view of any farther forms positioned behind it. Thus you can create a representation of depth by "hiding" portions of forms that are supposed to be farther away behind forms that are supposed to be closer. The sense of depth created by overlapping of forms will be shallow unless this device is combined with

other spatial devices, such as diminishing the size of forms in the distance.

Vertical Position

As humans, we usually experience the world such that the closest objects and areas are lower (at our feet) while more distant objects are successively higher. We commonly look up to see things in the distance. These tendencies have become codified in the practices of visual artists in many societies. Forms closest to us are usually positioned lowest in a painting; forms farther away are usually placed higher. A clear example of this strategy is shown in the Persian miniature in Figure 6.1, where the higher figures in the dark square of the pool are understood to be farther away than the lower figures.

This "rule" is reversed, however, for objects situated above the viewer's *eye level*, where eye level is defined as looking straight out horizontally. For example, an overhanging tree branch which zigzags in from a painting's upper edge is correctly read as the closest feature of a landscape, while clouds high in the sky appear closer than those seen lower along the horizon. This spatial effect of forms moving down into the distance from above is exaggerated when the horizon line is low on the picture plane.

Diminishing Size

In our everyday world, objects appear progressively smaller as they recede from a viewer's location. A basic way to indicate distance in a painting is to make forms relatively larger in the foreground, medium-scale in the middleground, and small-scale in the background. The contrast in scale can be dramatic; in Paul Inglis's *4 O'Clock* (Figure 6.4), the nearest pedestrians are painted at a scale that rivals a distant steeple.

The idea of distance can be conveyed simply by the devices of overlapping, vertical position, and diminishing size. In *E.F.C.B. (Estrada de Ferro Central Brasil)* (Figure 6.5), Brazilian modernist painter Tarsila do Amaral has made close-up objects larger and closer to the bottom of the composition, more distant objects smaller and higher up.

Aerial Perspective

In our everyday world, generally those objects which are closer to us appear to have stronger colors and sharper outlines while those in the distance appear less distinct. Vapor and particles of dust in the atmosphere contribute to this optical effect by filtering light. You can fool the eye into seeing depth on the flat surface of a painting by "graying" hues (making them less saturated) as well as reducing value contrast and softening the edges for objects you wish to appear farther away. This combined

6.4 Paul Inglis, *4 O'Clock*, 1993. Oil on canvas, 10″ × 8″. Courtesy of the artist.

fading of value and color in the distance is known as *aerial* or *atmospheric* perspective. The effect is accomplished by the progressive reduction of strong tones and value contrasts to represent greater distance. (As examples, note the use of atmospheric perspective in the paintings in Figures 6.3 and 6.4.) The common strategy is to paint the darkest darks in the foreground, middle-tone darks in the middleground, and the lightest darks in the background; at the same time dark-light (value) contrasts are gradually reduced as the eye moves back into the scene. Color recession operates in a similar manner. Colors in the distance are less saturated, so painters enhance the illusion of depth by using vivid colors in the foreground and gradually muting them for forms receding into depth. All colors become progressively less saturated and warm colors become cooler.

PAINTING TIPS

1. To position something close in your painting use more saturated color, stronger value contrast, and sharper edges.

2. To create a deeper sense of space minimize value contrast in the background, reduce color intensity, and paint forms with softer edges, using a soft brush to lightly blend edges with background colors.

Using Advancing and Retreating Colors to Define Space

As discussed in Chapter 3 (see section on "Advancing and Retreating Colors"), warm colors tend to appear closer visually, with red (the hottest hue) coming forward the most. Cool colors tend to recede, with blue (the coldest color) dropping back the most. Notice in Lomahaftewa's painting (Plate 8), how the sense of depth is controlled almost exclusively by the interplay of warm and cool colors. The clouds appear to float nearby, painted in warm pinks, while the shapes on the horizon seem miles away due to their cool blue and green coloration.

The tendency for warm colors in a painting to advance and cool colors to retreat derives from how colors of different wavelengths focus on the eye's retina. In any particular painting, a combination of other competing factors may override this perception. For example, a chair painted a saturated blue color will appear closer

6.5 Tarsila do Amaral, *E.F.C.B. (Estrada de Ferro Central Brasil)*, 1924. Oil on canvas, 55 $^7/_8$″ × 50″. Collection: Museu de Arte Contemporânea da Universidade de São Paulo, Brazil.

MARK TANSEY
Figure 6.6

Mark Tansey uses a representational style of painting to create visual paradoxes and pose philosophical riddles. At first glance, *Robbe-Grillet Cleansing Every Object in Sight* (Figure 6.6) looks like a straightforward rendering of a landscape extending back into deep space—albeit a rather unappealing landscape, devoid of trees and strewn with rocks, the foreground dominated by a kneeling man with brush in hand, scrubbing one of the rocks. Tansey appears to have created an illusion of deep space by conventional means, including diminishing size and aerial perspective: the rock shapes get progressively smaller as the eye travels back in the scene, becoming specks on the far horizon; and the background has the evenness of value and blurring of details associated with aerial perspective.

On closer inspection, the "truth" of the illusion is undermined by illogical components. Many of the "rocks" are not rocks at all; we can discern monuments such as the Sphinx and Stonehenge, various animals, architectural fragments, kitchen utensils, and human figures, including soldiers hiding behind a rock in the middleground and, in the lower right corner, a tiny duplicate of the crouching man. The illusion is visually convincing but conceptually impossible. Two belief systems—visual realism and mental logic—collide: it is impossible to imagine that these items from different civilizations and histories could really occupy the same landscape at once, no matter how unified the whole looks as a result of Tansey's mastery of spatial devices. Moreover, the scales are out of whack, posing relationships that are incredible in the world outside the picture, such as a cow the size of the large man's scrub brush!

Tansey's painting is a witty demonstration of the underlying premise of this book: that a painting functions simultaneously on formal, technical, physical, and cognitive levels. However much we may admire formal qualities such as the illusion of depth and technical qualities such as an artist's skill with a brush, a painting is more than a visual experience. Moreover, "truth" and "realism" are loaded concepts, which do not necessarily correspond to the artist's creation of a visual illusion. We cannot divorce what we know from what we see. Tellingly, Tansey's title refers to Robbe-Grillet, a twentieth-century French author who wrote experimental novels in which he tried to describe the world as if he had no preconceptions about the meanings and relationships of one object or event to another.

than red shapes if it overlaps them in a scene. Consequently, many painters operate under the philosophy that where color is concerned, context is everything, with the most salient features tending to push forward.

Painting Exercise

The View from a Window

Paint a series of two or three views out a window. For each painting, utilize a different combination of the strategies for articulating space that have been discussed so far: diminishing size, overlapping of forms, vertical positioning, aerial perspective, and advancing and retreating colors.

For this series of paintings, work *alla prima*, attempting to finish each painting in one sitting, working rapidly and spontaneously. Paint with as few brushstrokes as possible, aiming to make each stroke count in defining your subject's forms. As an example, look again at Inglis's small painting of an urban landscape in Boston (Figure 6.4). Inglis painted quickly, wet-into-wet, relying on aerial perspective, diminishing size, and overlapping to convey a sense of spatial recession. Note how few strokes Inglis used to define each form, and how his decisive, unblended brushmarks help create the impres-

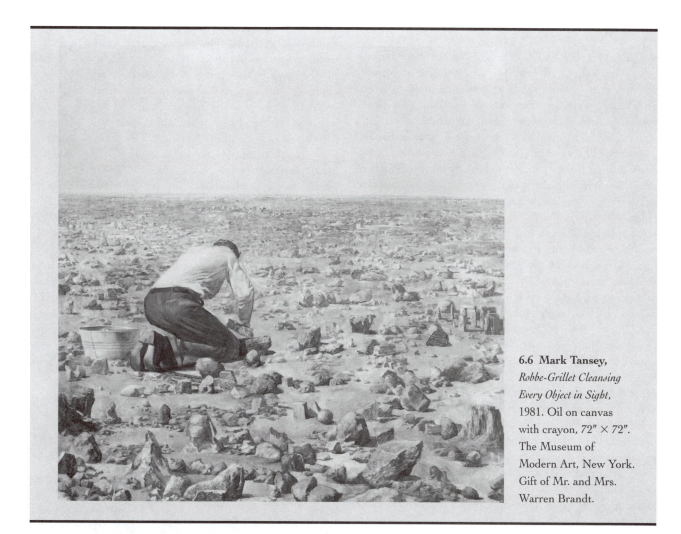

6.6 **Mark Tansey,**
Robbe-Grillet Cleansing
Every Object in Sight,
1981. Oil on canvas
with crayon, 72″ × 72″.
The Museum of
Modern Art, New York.
Gift of Mr. and Mrs.
Warren Brandt.

sion of an urban environment where people are on the move.

As you begin your paintings in this exercise, ask yourself: What is it about this scene that I find most compelling? What color and value relationships are central to how I seek to develop my painting? What viewpoint shows this subject advantageously in terms of representing the spatial qualities I wish to paint? In answering these questions eliminate irrelevant detail and organize your selection of colors and values to enhance your visual statement.

Option: For one of the paintings in this exercise, focus only on what you see looking *up* through the window. This painting will include whatever aspects of the landscape or cityscape are visible above your eye level; the horizon line will not be shown because it will be located below the bottom of the picture plane. Paint the objects you see (such as treetops or the upper stories of buildings) framed only by the sky. Establish the sense of distance separating the nearer and farther elements by exaggerating the sense of aerial perspective. Because your vantage point is looking up at these forms, the usual strategy of placing more distant forms higher in the composition (vertical positioning) is now reversed. With forms that are above the horizon line — those that we must look up to see — increased depth results in a lower location on the picture plane.

THE MEANING OF SPACE AND PLACE

We all have subjective reactions to places we see for ourselves, hear about, or imagine. Likewise, the societies in which we are raised teach us attitudes toward natural and human settings. For example, a basic decision a painter makes is the viewpoint from which to render a landscape. In traditional Chinese (and later Japanese) landscapes, the vantage point is often a suspended, imaginary one, as if the spectator is hovering in space. Moreover, the viewpoint shifts as the spectator looks at different parts of the landscape. In the traditional Chinese landscape painting in Figure 6.2, the various elements of the landscape appear to be stacked vertically, and our own viewpoint seems to ascend as we scan up the surface of the landscape. In contrast, the viewpoint in representational European and U.S. landscapes is generally lower and closer, as if the spectator is standing on the ground at a fixed position (such as the viewpoint in Tansey's painting, Figure 6.6, or Freeman's painting, Figure 6.11). Following the conventions of *linear perspective* (discussed later), the latter reveal only what a stationary spectator would see if her gaze were fixed in one direction. Among other differences, traditional Eastern and Western landscape paintings imply contrasting conceptions of the relationship of humans to the environment. The Western conception is (often) human-centered, with all the space in the scene organized from a singular human point of view; traditional Asian landscape paintings suggest a more humble view of the human relationship to nature, showing or implying a setting too vast for a human gaze to dominate. The experience of time also differs: in the West, what is thought of as a "realistic" portrayal commonly represents a fixed temporal moment, as in a snapshot; the Eastern landscape incorporates a sequence of scenes through which the spectator visually travels over time (an effect enhanced in the many landscapes painted on scrolls that were designed to be unrolled and viewed as a sequence of scenes).

We cannot pretend to be exhaustive here about all the different ways humans have thought about place and represented space. But we emphasize that no one "correct" or universal way exists to interpret, and hence to paint, outdoor or indoor scenes.

Place as Metaphor

The scene represented in a painting may be simply the portrayal of how a place looks. But often a place represents something other than or more than its visual appearance. Steve Paddack's *Summer of Grief* (Figure 6.7) implies a metaphorical relationship between the painted architectural setting and the experience of death and grieving. The painting is a response to the death from complications related to AIDS of a friend of the artist. The foreground interior, with burning cigarette butt and tipped-over ashtray, functions like a "waiting room" for the terminally ill; while the narrow doorway centered vertically in the painting is a symbol for the passage from life to death. The process of grieving is spelled out literally: the letter "I" identifies the artist, and by its position in the painting the "I" also points to the artist's own inevitable passage through death's door.

Spiritual or Sacred Places

The investment of a place with spiritual meaning can be of central importance to artists. As an example, we illustrate *Serpent Landscape II* by Mario Martinez (Plate 17). Martinez's ancestry is Yaqui, a group of Native Americans who came to the United States from Mexico as political refugees at the turn of the twentieth century. According to Martinez, "the Yaquis' religion is a synthesis

6.7 Steve Paddack, *Summer of Grief*, 1990. Oil, enamel, and latex on board, 96″ × 84″. Courtesy of the artist.

of Catholicism and their primordial veneration of all that makes up the natural universe. For the Yaqui, the natural world consists not only of the actual or the real, but of a magical, supernatural counterpart, as well."[5] Martinez does not show the landscape from one single human viewpoint; the abstracted treatment of the land seems to emphasize the fact of its sacred quality, irrespective of any viewpoint.

Place as Social Commentary

The scene in a painting may serve as a setting for the interplay of social or political forces and for the display of psychological states that result from these forces. Roger Shimomura's painting *Diary: December 12, 1941* (Figure 6.8) features a kimonoed Japanese female figure in an interior framed by shoji screens. The screens, with their regulated gridlike pattern, serve both to protect and imprison the woman. This painting is one in a series inspired by events recorded in diaries that Shimomura's grandmother kept while involuntarily interred with other Japanese-Americans during World War II in a guarded compound maintained by the U.S. government. The distinction between "private" and "public" space is a key issue here.

In Kerry James Marshall's *Our Town* (Figure 6.9), the small-town setting with well-maintained, expensive homes, a clean, gently curving street, and a bucolic vision of nature stands in ironic contrast to the actuality of many children's (including many urban U.S. minority children's) lives. The thought bubble emerging toward one building from the young girl's head suggests that "our town" is only a fantasy.

Unexpected Places

A painting may allow viewers access into another mental dimension: one of intimacy, immensity, or psychological strangeness (sometimes called "the uncanny"). We encounter this strategy in paintings in which our sense of logic or scale becomes unmoored from its harbor in everyday expectations. An example is provided by the Surrealist Max Ernst's *La Ville Petrifée (The Petrified City): Le Puy, near Auch, Gers* (Figure 6.10), in which the geography appears created out of a texture that seems like a strange combination of the natural and the human-made.

An unexpected cognitive shift may occur in viewing any painting of a space containing unfamiliar content, as in an attic or workplace full of unusual equipment. Moreover, paintings can provide unexpected views of

6.8 Roger Shimomura, *Diary: December 12, 1941,* 1980. Acrylic on canvas, $50\frac{1}{4}'' \times 60''$. Smithsonian Institution, Washington, DC.

6.9 Kerry James Marshall, *Our Town,* 1995. Acrylic and collage on canvas, 100″ × 144″. Courtesy of the artist.

normally hidden interiors of all sizes and shapes, such as the insides of bureau drawers, the inner chambers of seashells, the underground burrow of an animal, or the interior of a mouth. (Obviously, at such an intimate scale, there is no clear division between what we might call a painting of a place and a painting of an object.)

Drawing Exercise

Keeping a Visual Diary

Take a small sketchbook with you *everywhere* you go for a week. Make a concerted effort to record with a quick sketch the most distinctive and memorable aspects of every interior location in which you find yourself. In making each sketch, pay particular attention to how your selection of what visual qualities to emphasize (including key details and visual relationships) may simultaneously serve to communicate your emotional impressions. Experiment with ways to represent how the architectural elements surround you — make sketches that signify that your view is *inside* a space, a space that surrounds you. Develop quickly recorded but nuanced responses to the

changing quality of light you encounter in the various spaces you sketch. (Note: in the next chapter we focus on specific strategies for the articulation of light.)

Every second or third night, select one of your sketches and make a larger version of just one portion of the whole. Enlarge and enhance that portion of the whole sketch which strikes you as the most compelling both visually and cognitively. Allow new visual relationships to gain precedence as you eliminate much of the original and develop your composition on one focused area.

Painting Exercise

Painting the Unexpected

Create a painting of a place which contains content which is somehow unexpected or thought-provoking. The "unexpected" quality might be something physical or something mental (or both). Possibilities might include thinking about the strangest space or the most extreme weather you have ever encountered.

In order to emphasize the cognitive content in a painting of a place, one strategy some artists employ

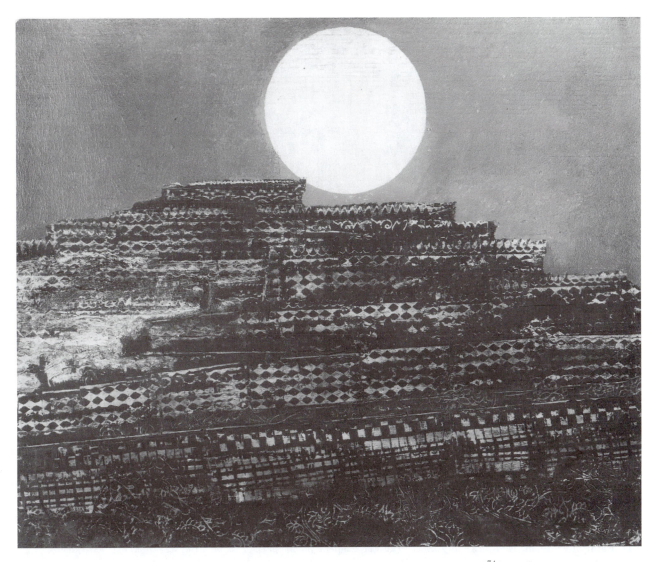

6.10 Max Ernst, *La Ville Petrifée (The Petrified City): Le Puy, near Auch, Gers,* 1933. Oil on paper, 19 $\frac{7}{8}$" × 24".

is to create an image of a place in which something out of the ordinary is occurring. For example, in Figure 6.11, the artist imparts both a visual and mental jolt by depicting odd weather — the trees seen through the windows are slanting and the trees in the painting *within* the painting are also blowing over! The few topsy-turvy elements inside the room (flying book and paper, girl's hair blown into the shape of the funnel cloud) contrast bizarrely with the locked-in geometry of the floor pattern and other architectural elements.

In creating your painting, utilize the devices we have introduced in order to create and control a sense of space — including overlapping, vertical position, aerial perspective, and the diminishing scale of objects in the background.

Options: Paint two versions of the same scene. While the subject matter remains constant, vary the viewpoint in each. Most scenes look dramatically different when seen from unusual viewpoints. In one version use warm colors in the foreground and cool colors in the background; in the other version, use cool colors in the foreground and warm colors in the background. Observe for yourself the impact these color choices make on the sense of depth you achieve.

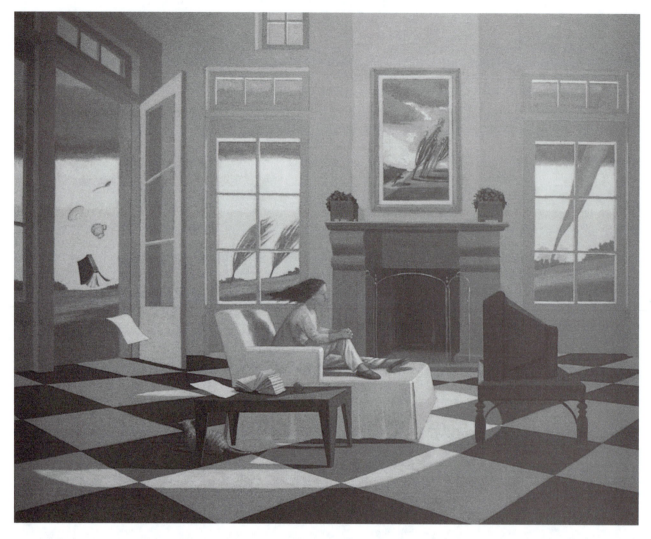

6.11 Kathryn Freeman, *The Weather Channel,* c. 1998. Egg tempera, oil on panel, 24″ × 30″. Courtesy of Tatistcheff Gallery, New York.

Journal Exercise

A Sense of Place

Paintings based on actual places are especially effective when they evoke a powerful sense of place. The artist may show local effects of light and weather and select a view with details that distinguish a particular setting. For example, Larry Morace's painting, *Seacliff Afternoon* (Figure 6.12), is a quintessential California townscape: sun-drenched houses on hills, an ocean backdrop, palm trees.

Imagine that you have been asked to designate eight outdoor views for a magazine article representing "characteristic views" of the community where you live now. List what places you would select, writing a sentence or two explaining how each represents your community. Next pick two of the locations on your list and consider what distance and viewpoint would be effective for visually conveying the meaning you attach to the place (close-up, panoramic, high view looking down, straight-on view, tilted view, and so on). Briefly describe how you would want each of the two locations represented and what the viewpoint would contribute to expressing your interpretation of the place. Make thumbnail sketches.

6.12 Larry Morace, *Seacliff Afternoon,* c. 1995. Oil on canvas, 48″ × 66″. Courtesy of the artist.

PAINTING OUTDOORS

A wonderful learning opportunity awaits any painter willing to accept the challenge of painting outdoors, whether from nature or in an urban environment. An outdoor scene is constantly dynamic because of shifts of light, weather, and subject. Direct observation allows you to see the sparkling brilliance of colors in sunlight, the rich colors in shadows, and changing relationships of form and color from different viewpoints and under different conditions of light and weather.

In attempting to paint a scene directly from nature, an artist may be tempted to copy the scene as fully as possible, putting in every detail, color, and modulation of value that is visible. To make an effective painting, however, fidelity to nature is less important than clarifying an overall visual statement by reducing the variety of nature to a controlled scheme. In Figure 6.12, Morace has eliminated a great many details. For example, he depicts lawns as sloping planes instead of painting individual blades of grass. He controls his color key by reducing the full value range of nature's colors to seven distinct gradations: very dark, dark, middle dark, middle, middle light, light, and very light. As evident in our black-and-white reproduction, the painting is organized into a pattern of separate color patches, each painted flatly in one of these seven distinct values, with none of the gradual modulations the artist must have encountered at the actual scene.

Some artists painting outdoors work *alla prima*, trying to capture a whole scene in one burst of rapid painting; others return to the scene on successive days when the light is once again the same. Another choice is

to begin a painting outdoors and finish it in the studio, in which case you will certainly have to rely on your visual memory (or such possibilities as a photograph or supplementary sketches with color notations) if your goal is to be true to your original observations.

One approach to painting outdoors is to begin with a toned support or colored imprimatura. A *toned support* (in which the initial layer of paint is opaque) should be prepared a few days prior to going outside to paint so that it will have time to dry. On the other hand, an *imprimatura* of transparent paint, thinned considerably with mineral spirits, can be prepared on location since it will dry sufficiently in fifteen to twenty minutes. The color of the toned support or imprimatura should be selected to enhance the painting's overall effect. A warm, mid-value earth color, for example, is a logical choice for painting a natural scene on a sunlit day. Some painters prefer to select multiple colors for the toning or imprimatura; one strategy is to use colors for different zones of the composition that are complements of what you anticipate the final colors in each zone will be.

Drawing Exercise

Sketching Outdoors

Take your sketchbook on hikes through natural settings as well as on walks and drives through urban areas. Use quick sketches to capture the spirit of such places as riverbanks, the parking lot of shopping malls, paths through forested areas, deserted beaches, and views of an entire city from a hillside. (We know an artist who often makes sketches from inside a parked car, with a drawing board propped against the dashboard or steering wheel. The car becomes a mobile "studio," safe from the weather and the eyes of curious strangers!)

In your drawings, employ a variety of the concepts that have been presented so far: seek unusual viewpoints, chart rhythmic relationships in natural motifs, discover geometric patterns in both positive and negative shapes (allowing a drawing to reorder reality in order to enhance whatever patterns you find).

Using your drawing medium, explore how to vary the sense of depth in the scene. Try for a strong sense of deep space in some sketches, while in others focus primarily on an intense articulation of the two-dimensional pattern on the surface of the picture plane. (After reading the discussion of linear perspective later

in this chapter, apply those concepts to sketches of outdoor scenes, even ones that contain no straight lines.) Continue regularly charting your visual impressions of outdoor scenes in your sketchbook even after you have moved into later chapters of the book. The process of sketching "from life" will be an invaluable stimulus to all your work as a painter.

While sketching, pay particular attention to what the visual qualities of the scene "tell" you as you develop an image. Maybe when seen from just the right angle, the space underneath a bridge echoes the shape of a distant building, thus providing a visual link between negative and positive shapes. If so, perhaps there are other areas in the drawing that can be nudged to rhyme with these shapes.

In addition to sketching with pencils, charcoal, and conté crayon, practice using a drawing medium — such as oil pastels — that will allow you to record color relationships. For practice, reduce the complexity of colors you see in a scene so that the drawing emphasizes an identifiable color scheme (permitting only small variations for visual interest). Such sketches can be invaluable sources for ideas for future paintings.

Painting Exercise

Painting Outdoors

For this painting, select an outdoor scene with a strong sense of place. You might pick a place that causes a powerful emotional reaction in you, such as a desolate place, or one that you find beautiful in an uncommon way. For ideas, refer back to the journal exercise, "A Sense of Place," in which you analyzed places that are somehow characteristic of your community, and look through your sketchbook to find possible places that might be worth revisiting.

Select with care the supplies you bring. Many artists find that a fisherman's tackle box with its numerous compartments is ideal for carrying paints, containers, and brushes. If you have one, bring a lightweight, portable easel for working on stretched gessoed canvases, or you can use a canvas pad or gessoed paper taped to a drawing board.

Working at a small scale, paint the scene from life two or three times using different viewpoints. From each viewpoint, carefully select an effective way to frame your subject, so that each composition concentrates on a visu-

ally cohesive aspect of the scene before you. To analyze options for framing your landscape subject and for gauging proportions, it may be helpful to utilize a *viewfinder* (any device that allows only a limited view, similar to the way looking through a camera "frames" the subject). Looking at the scene with one eye through a viewfinder, you can easily envision what details will be included in possible compositions. Hold the viewfinder closer to frame a wider view.

A simple, flexible viewfinder can be constructed by cutting two L-shapes out of cardboard. Overlap them to make a rectangular opening that is in relative proportion to the outside dimensions of your intended painting. A more crude but "handy" viewfinder is created by forming a rectangular opening out of the first two fingers of each hand, held at right angles to each other.

For each painting, limit yourself to a specific color scheme — for example, many outdoor scenes are effectively captured by a scheme of analogous complements or split complements (see Figure 3.3). Concentrate on capturing the effects you want quickly: the weather may change, and a particular lighting effect may last from just a few minutes (think about a sunset!) to perhaps two hours. You can provide only a suggestion of the range of colors and values seen outdoors. Paints have a more limited range of values than what is actually seen under sunlight. No paint color is as light as a sunny sky itself.

When you are ready, do a quick underdrawing on a neutrally toned support, using a soft round brush and thinned paint in an earth color to establish the size and location of major compositional elements. Then proceed to paint directly, allowing the texture and direction of your brushstrokes to remain evident. Use the concepts of aerial perspective to create a strong distinction between foreground and background spaces.

Option: If you are painting an effect which will be over quickly, concentrate on making only the quickest notations "on the spot," then complete the painting back in the studio. Strive to keep the feeling of spontaneity in the finished work. For example, no matter what strategy was actually used to complete it, a wonderful quality of freshness animates Jennifer Baker's *Warehouse Burning, American Street* (Figure 6.13).

Painting tip: Artists often select an earth color (such as burnt umber) for a landscape's underdrawing because the color is neutral and because earth colors are fast drying; while working outdoors, thin the paint with turpentine or mineral spirits, then the underdrawing should be dry in about fifteen minutes.

PUBLIC VERSUS PRIVATE SPACE

A recurring theme in many commentaries about the quality of life in contemporary society is the changing nature of what is considered private and what is considered public. (The blending or ambiguity of the public and private is by no means only a contemporary issue. Figure 6.1 shows a scene over 500 years ago in which the privacy of the nude bathers is intruded on by two onlookers peering from behind the courtyard wall.) One aspect of this trend is that places which were once overwhelmingly private (such as the car or one's home) are increasingly accessible to the influx of outside information, due to technological developments such as cellular phones and the Internet. Even the limited privacy that one may expect to maintain in public areas such as stores and the workplace are increasingly monitored by surveillance devices and other forms of monitoring. Boundaries that once separated public and private spheres of activities are becoming blurred. For many, the home doubles as the electronic workplace as computer links multiply; and the home becomes a marketplace as purchases and solicitations for purchases are made over the phone and computer. A constant diet of television, radio, and other media creates a lifestyle in which many people are almost never alone with their own thoughts. Even the most interior space of all — one's own mind — becomes a public arena, open to constant manipulation by outside influences and high-tech stimuli.

Journal and Discussion Exercise

Public versus Private Space

Explore in your journal your thoughts regarding the changing nature of public versus private spaces — comparing and contrasting the quality of interior spaces in the year 2000 with what you imagine everyday life was like in the year 1800, and what you think it will be like in 2050. Discuss with the class your ideas, and explore how you might incorporate some of these thoughts in a painting that portrays or responds to the altered sense of privacy in our everyday living spaces.

6.13 Jennifer Baker, *Warehouse Burning, American Street*, 1996. Oil on mylar, 39″ × 26″. Courtesy of the artist.

Painting Exercises

Interiors

For these exercises, you are asked to think about the function of a specific interior, the people who most often occupy it, and what they do there. For example, how is the character of a dental office different from that of a college dorm room? Think about the message — the cognitive meaning — you want to convey. What does the interior mean to you and its occupants in a personal, social, political, literary, or psychological sense? Is the interior you are painting a public or a private space, or some hybrid?

Whether you are working from observation, memory, or imagination, be selective as to which architectural elements, furniture, ornaments, patterns, colors, and lighting effects to include. Your selection should take into consideration how each contributes to the overall composition of your painting, and how the composition helps to define the character of the interior and to convey a psychological mood or social message.

Painting 1: Paint an actual interior (working from life or from memory), emphasizing spatial and color relationships in order to utilize the interior as a symbol or example of social commentary.

Painting 2: Paint an invented interior from your imagination. Attempt to create spatial and color relationships that enhance a connection between the physical and psychic structure of the interior. Use the painting as an opportunity to express or explore some of your thoughts about the issue of public versus private space.

MORE STRATEGIES FOR THE ARTICULATION OF SPACE

Linear Perspective

Linear perspective is a renowned method for creating a convincing illusion of depth on a flat surface. (As a strategy for depicting depth, it has been adopted and adapted by many artists working in societies around the world.)

For many artists it is also the most intimidating method. It may help to realize that the strategy is based on common observations: the principle of diminishing size (that objects of similar size appear to get smaller as they get farther away from a viewer); and the illusion that parallel lines (and parallel planes) converge as they recede in space toward the horizon.

Elaborating on these fundamental observations, artists during the Italian Renaissance codified linear perspective as a complex geometric system.[6] The system dictates that from the viewpoint of a stationary observer all lines parallel to each other — and not parallel to the picture plane itself — appear to converge at the same place on the *horizon line* (or would converge were they sufficiently extended). This convergence occurs at what is known as a *vanishing point*.[7]

The illusion of converging parallel lines is shown in Marc Jacobson's *Coasting East* (Figure 6.14). In the scene depicted, the sidewalks and storefronts on the left and right sides of the street are presumably parallel, but the artist has painted them as if they all converge at the same point in the center of the image at the *horizon line*, that line where eye level and the earth appear to intersect when nothing interrupts the view. (The horizon line is partially visible in the center of Jacobson's painting. In some paintings the horizon line remains hidden, existing only hypothetically.) Similarly, the buildings appear progressively smaller relative to their distance along the street. Figure 6.14 is an example of what is called *one-point perspective*. The planes of the storefronts lining the central street converge to the same single vanishing point, while the planes of the other buildings, which are

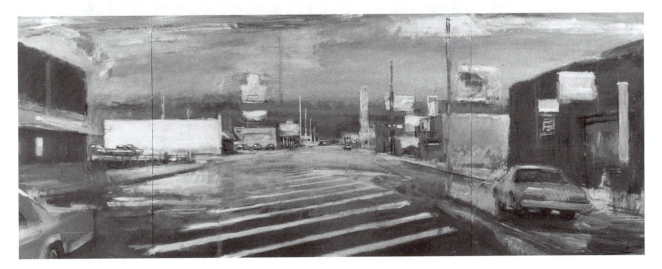

6.14 Marc Jacobson, *Coasting East*. Pastel and gesso on paper, 30″ × 80″. Collection of Peter and Susan Miller-Hall.

parallel to the picture plane, don't converge. (See the diagram in Figure 6.16a.)

In James Doolin's painting *Bridges* (Figure 6.15), we see a more complicated geometry. The left and right edges of individual roadways and bridges are presumably parallel, but all the roadways and bridges are not parallel to one another. The roadways are painted as if each converges to its own separate vanishing point, all of which are located along the horizon line.

Furthermore, the volumes in Doolin's painting are positioned so that *two* planes of each structure are visible, angling away from the picture plane. (Remember: in Jacobson's painting only one plane of each structure angles away from the picture plane.) The condition represented in Doolin's painting is called *two-point perspective*. The receding parallels from each angled face on each structure converge to separate vanishing points on the horizon line; thus, there are two vanishing points *per volume* (see Figure 6.16b).

Note how the parallel vertical edges of structures do not converge in either Jacobson's or Doolin's painting. By convention, verticals do not converge except in the special case of *three-point perspective* (Figure 6.16c), in which a dramatic sense of size or closeness is created by showing verticals converging to a third vanishing point located above the horizon line (or below for a downward view).

If the form or forms being depicted overlap the horizon line, painters may utilize *four-point perspective* (Figure 6.16d). In this case, two vanishing points are created, one below and one above the horizon line, to which the verticals converge. Four-point perspective can be thought of as an extension of three-point perspective both upwards and downwards.

Linear perspective is designed to unify the space in a picture by determining a consistent rate and direction for the convergence of parallel lines and planes. In turn, the

6.15 James Doolin, *Bridges*, 1989. Oil on canvas, 72″ × 102″. Courtesy of Koplin Gallery, Los Angeles.

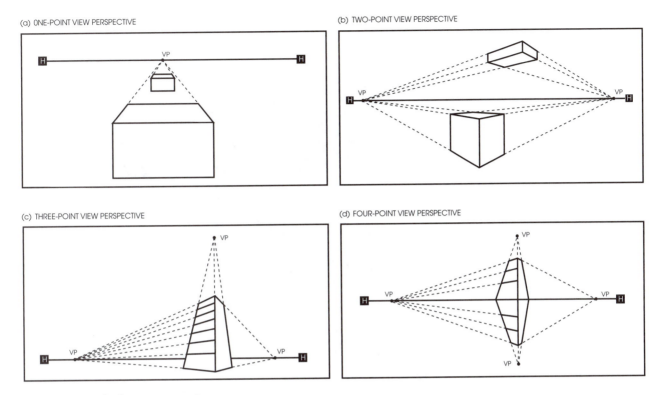

6.16 Diagrams for linear perspective

size of every object is regulated in a logical manner depending on its position in depth compared to the vanishing point(s) at the horizon line. Although perceiving such consistent convergence of parallel lines is unlikely in daily living (when the viewer is constantly shifting viewpoints), in a painted composition the effect of converging diagonals creates an impressive illusion of deep space.

While a basic understanding of linear perspective is valuable, we caution you about compulsively seeking exact measurements in its use, because the result tends to look mechanical. One contributing factor to the sometimes rigid effect of linear perspective is that it assumes that the view is seen through only one, unmoving eye, somewhat akin to the static view of a camera on a tripod. As you develop your painting skills, be sensitive to your own vision. You can approximate the effects of linear perspective by spontaneously painting the angles of diagonals and relative sizes of landscape features as you observe them naturally for yourself. (Of course, as you further develop your skills, you may wish to engage in an in-depth study and practice of linear perspective and its more complex conventions. For example, if your aim is to develop competence as a photorealist painter of downtown cityscapes, mastery of linear perspective will become a necessity.)

Diagonals

A diagonal in a composition can enhance the sense of depth. In contrast to the stability of horizontals and verticals, diagonals usually imply movement. In conjunction with any of the other strategies for articulating space, the movement of a diagonal is interpreted as a movement into or out of the space of the painting. For example, the diagonal of the upper edge of the figure scrubbing rocks in Tansey's landscape (Figure 6.6) contributes to our understanding of the figure's position, leaning forward and into depth.

Isometric Perspective

Another system for representing depth on a flat surface, called *isometric perspective*, is traditional in much Asian painting. In artworks done in isometric perspective, forms in the distance are represented as smaller in scale, but parallel lines do not converge. A comparison of Shimomura's painting (Figure 6.8) with *The Giant Snowball* (Figure 6.17), attributed to the eighteenth-century Japanese artist Tosa Mitsutada, shows the key difference. In Shimomura's painting, the parallel lines of the

6.17 Attributed to Tosa Mitsutada (Japanese, eighteenth century), "The Giant Snowball" from *The Tale of Genji* by Lady Murasaki. Ink and color on paper, 10 ³/₄" × 11 ³/₄". Metropolitan Museum of Art, Gift of Mrs. Mary L. Cassily, 1894. (94.18.1ff).

architectural structures are painted as if they converge (as dictated by linear perspective); in Mitsutada's painting the parallel lines remain parallel in the painting (an example of isometric perspective).

Framing

In *framing* a subject, the painter is involved in deciding what aspects of the scene will be included within the painting's borders. (The process of framing is influenced by, although not totally dictated by, the decision of what viewpoint to use.) Attention to framing is critical when you paint outdoors because a scene in nature is not self-contained; it has no preordained boundaries. Prospects extend on all sides as far as the eye can see. You decide where to set the boundaries of your painted scene. (Blakeslee could have framed another section of the water in Figure 6.18.) As noted in our earlier discussion of painting outdoors, landscape artists may use a viewfinder as an aid in determing how to frame a subject.

Shifting Perspective

Linear perspective is effective for registering a consistent sense of measurable distance. But the use of linear perspective keeps the world in the painting locked inside a rigid framework, and displayed as if seen by an unmoving, singular eye. Linear perspective has been criticized on the grounds that in everyday life "the eye does not keep the world at a distance."[8] Sensing this limitation, painters in the twentieth century developed approaches that break free of a static approach to perspective and viewpoint. And, as noted, painters in many societies have historically emphasized alternative approaches to representing depth. (We further discuss in Chapter 8 how the stipulation of a fixed viewpoint is one reason many artists today do not use linear perspective; these artists embrace a conception of space which is not unified and implies multiple points of view and shifting spatial relationships.)

David Hockney's *A Visit with Christopher and Don, Santa Monica Canyon* (Plate 18) is an inventive example of a dynamic conception of space. Scanning the full

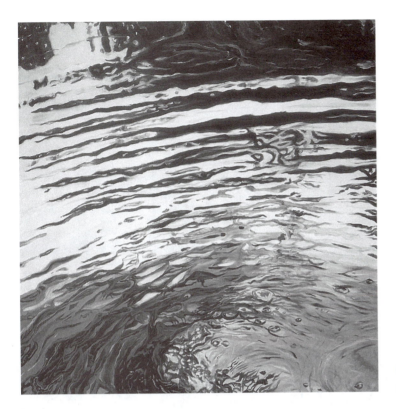

6.18 Carolyn Blakeslee, *Potomac River*, c. 1995. Oil on panel, 24″ × 24″. Courtesy of the artist.

width of Hockney's immense two-part painting (it is 20 feet wide), we experience various interior spaces of a house overlooking the ocean as if we were walking among the rooms, peering now into a bedroom, now looking out a window, and so forth. Hockney's canvas seems to incorporate the passage of time by documenting a succession of viewpoints.

Another approach to painting multiple interior views in a single artwork is seen in Lincoln Perry's *Picturing Will* (Figure 6.19). We can look into each of many rooms as if all the front walls were transparent or peeled off, similar to the way a dollhouse is constructed. We witness events occuring in separate rooms on four stories.

Mapping and Other Ways to Represent Space

Contemporary artists are utilizing a wide assortment of conceptual strategies to explore how humans understand and fit into the universe. Of particular importance to depictions of place, we find that many artists are turning to the field of cartography to "borrow" map imagery and techniques employed in creating maps. For example, starting in 1987 the Argentine artist Guillermo Kuitca has incorporated maps, charts, and floorplans of build-

ings in numerous drawings and paintings (including a well-known series of maps painted directly on full-size mattresses which are hung on the wall). In Figure 6.20, we illustrate *Marienplatz*. In choosing to use a map as his image, and often a map of a place with no special autobiographical association, Kuitca evokes "fluid notions of origin and place in a transient, global society."[9] Maps are aloof — they can provide abstract representations of the spatial relationship of locations; simultaneously, maps are dreamlike, allowing us to imaginatively visit places teeming with life.

Research and Discussion Exercise

Different Spatial Systems

Option 1: Discuss how different strategies for representing space impact the cognitive meaning of an image. For example, do you sense a greater feeling of anxiety or disorientation in Doolin's cityscape (Figure 6.15) or Freeman's interior (Figure 6.11)?

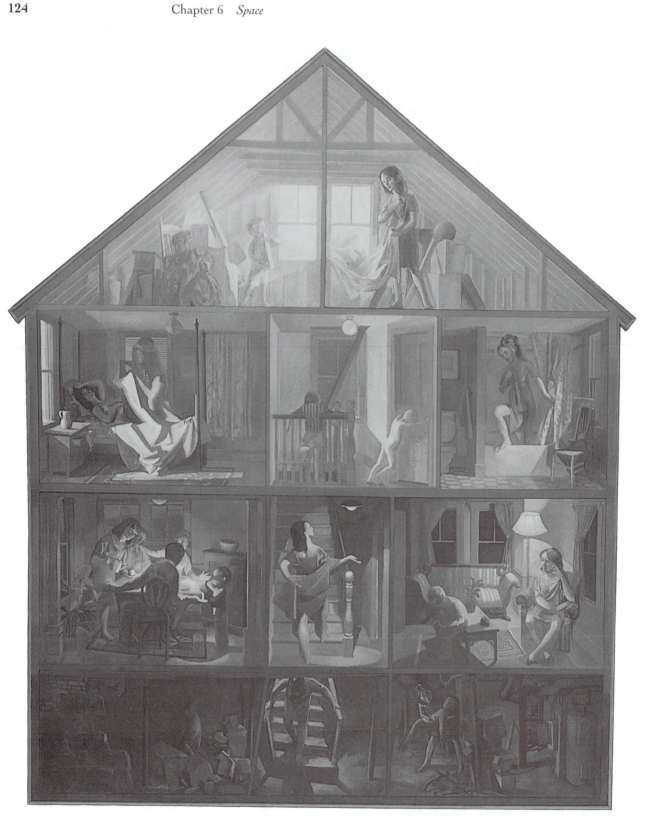

6.19 Lincoln Perry, *Picturing Will*, 1992-1993. Oil on canvas, 96″ × 82″. Courtesy of the artist.

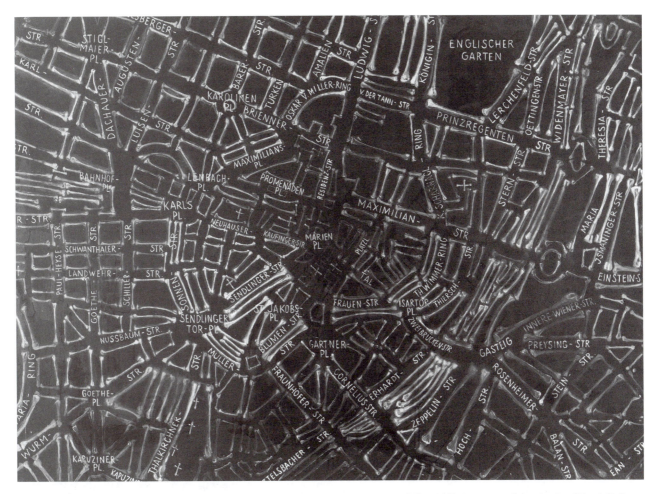

6.20 Guillermo Kuitca, *Marienplatz*, 1991. Synthetic polymer paint on canvas, 6′8″ × 9′4″. Courtesy of the Annina Nosei Gallery, New York.

Option 2: Research how unusual senses of space have been represented in paintings of landscapes and interiors by twentieth-century European and South American surrealists. Bring in examples of images to discuss as a group.

Option 3: Research how space is represented in maps from different cultures and time periods; research how maps differ from landscape paintings. Discuss as a group.

Painting Exercise

Linear Perspective

Select a cityscape or landscape subject which includes an assortment of parallel lines and planes, e.g., roadways,

buildings, relatively straight rows of trees or corn, and so forth. Do a series of charcoal sketches of the site, exploring various viewpoints and options for framing the subject. In three sketches try for a consistent application of the conventions of one-, two-, and three-point perspective, as outlined in this chapter. In other sketches, don't worry about exact measurements but allow yourself to bend the rules in order to represent a more casual scanning of the scene. Incorporate other spatial devices (such as overlapping, aerial perspective, and diminishing size) to enhance the representation of depth.

From the series, select one sketch to develop into a painting. Recreate the charcoal sketch on canvas, enlarging the size to approximately 2 feet by 3 feet. Make changes as necessary to further refine a cohesive visual statement. Do not apply fixative. Begin painting directly

into the charcoal sketch with acrylic gesso, using the charcoal to tone the white gesso to various darknesses and lightnesses. Allow this underpainting to dry thoroughly. (The gesso and charcoal mixture should dry in a half hour.) Proceed to paint over the charcoal/gesso underpainting with oils, further defining the representation of depth and adding color to the composition.

Option: Use pastels instead of charcoal for the initial sketch. Blend acrylic gesso into the pastels to complete the artwork, taking care not to overblend; alternatively, add oil paints once the pastel/gesso layer has dried. The pastels function like pure pigment that is mixed with gesso directly on the support to create blended colors. (Note: For Figure 6.14, Jacobson used only a combination of pastels and gesso.)

Sketching Exercise

Imaginary Cityscape

Create two sketches of an imaginary cityscape.

Sketch #1: Follow the conventions of four-point perspective; each plane is shown converging to two vanishing points (see Figure 6.16d). Imagine that you are painting the scene from a window situated on approximately the middle floor of a tall building. In the painting, the upper stories of other tall buildings will extend high above your eye level (remember, the horizon line is at eye level); the lower stories of buildings will extend below eye level.

Sketch #2: Create a modified version of four-point perspective. Allow the vertical edges of the planes to bow outward, so that a gentle curve is created where forms appear to overlap the horizon line. (The effect should resemble how the scene would appear through the fish-eye lens of a camera.)

Painting Exercises

The Painter's Studio — Exploring Perspective

Create two paintings of your painting studio or the painting classroom:

1. In the first painting, create a view of the studio using the conventions of isometric perspective (for an example, see the Persian miniature, Figure 6.1), in which parallel lines do not converge, and vertical positioning is used to demarcate the positions of objects in depth.

2. In the second painting, represent the studio from multiple positions or viewpoints. The single composition should incorporate changing properties of the interior as perceived by a roving viewer, or a viewer whose head turns. The complex painting by Hockney (Plate 18) features a dynamic sense of space as seen from changing viewpoints. Changing viewpoints are also represented in the three-part painting by Bartlett (Figure 6.21).

COMBINING THE ARTICULATION OF SPACE AND THE ARTICULATION OF THE PICTURE PLANE

From the time of the Renaissance until the latter part of the nineteenth century, the majority of painters in Europe and the United States were beguiled by the challenges of embodying three-dimensionality on a two-dimensional surface. They conceived of the picture plane as a "window" opening onto a scene, with the outer edges of the composition functioning like a window frame. For these artists, paintings were pictures synonymous with their subject matter, and the picture plane itself seemed transparent, like a windowpane — to the degree that viewers were primarily interested in *what* a painting depicted, and tended to overlook the means of the depiction.

Towards the end of the nineteenth century a radical shift in emphasis occurred as avant-garde painters in the West challenged the notion that the picture plane should be an illusionistic window onto the world. Among other influences, Japanese prints, which were newly available in the West, stimulated a passion for flatter perspectives, asymmetrical compositions, and (for the West) unusual vantage points. The picture plane itself became the focus of attention as the physical surface upon which a painter creates a design with colors and shapes (analogous to a fogged-up windowpane that one draws upon with a finger). Since then, painters with many different intentions have explored the demands and potentialities of a picture plane that is noticed rather than ignored.

JENNIFER BARTLETT
Figure 6.21

Jennifer Bartlett is known for working in a range of styles (from realism to abstraction) and various painting, drawing, and sculptural mediums. Often she mixes styles and materials within a single work, for instance, juxtaposing paintings on enamel-coated steel plates with ones on canvas, and putting perspective renderings next to schematic images. *Pool* (Figure 6.21) is not entirely typical of Bartlett's work because here she uses just one medium and style: oil on canvas and a realism which depends on linear and aerial perspective for its spatial illusion.

The lush scene of a pool with a statue of a small boy and a dark row of cypress trees behind is taken from the unkempt garden in a villa in France where Bartlett spent one winter. Obsessed with the location, she made nearly 200 drawings of the garden from a variety of vantage points in a parade of styles and mediums. *Pool* is one of a series of multi-panel paintings of the garden she made several years later, working from photographs and memory. Each of the three panels shows a successively higher viewpoint. In each, the grid painted on the bottom of the pool provides an almost mathematical account of her use of linear perspective. Seen together, a passage of time seems to have occurred: for example, the level of water in the pool changes in each view.

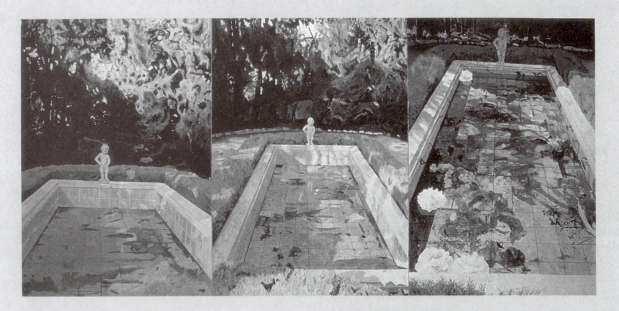

6.21 Jennifer Bartlett, *Pool*, 1983. Oil on three canvases, 7′ × 15′ overall. Collection: Mr. and Mrs. Aron B. Katz.

In this section we look at examples and practice making paintings which combine a place as subject matter with a strong emphasis on making a two-dimensional design on the picture plane. In some instances painters combine painting strategies which articulate a sense of spatial recession with others which call attention to the paint surface; in others their emphasis is more on a powerful surface design with little illusion of depth.

Strategies for the Articulation of the Picture Plane

Strong Sense of Pattern

A strongly patterned relationship of visual elements can be an effective means of drawing attention back to the flat surface of the picture plane and away from an illusion of depth. In Figure 6.22, April Gornik has created strong patterns based on relationships of values, interlocking large areas of lights and darks into bold patterns that both enhance and then reverse our reading of the illusion of depth.

Another technique for creating a strong surface pattern is to align or synchronize formal elements such as lines and shapes. Lomahaftewa accomplishes this in Plate 8 by utilizing a strong pattern of round and striped shapes. In his self-portrait (Plate 14), Chuck Close represents his facial features as a composite of thousands of colored circles inside the equal-sized squares of a grid. Standing back, the image registers as a recognizable image of Close's face; up close, the image dissolves into an insistent pattern on the surface of the canvas. The isometric perspective system employed in Figures 6.1 and 6.17 emphasizes the picture plane, while simultaneously providing a sense of depth.

Strong Sense of Texture

Another strategy used by many painters in drawing attention back to the picture plane is to create a strong sense of surface texture. This may be achieved in countless ways, but the results can be grouped together as two general effects: a surface texture that is actual, and a surface texture that is illusionary. At times, the two effects are combined.

In Peter Doig's *Night Fishing* (Plate 19) we are offered an elusive representation of two figures in a canoe, fishing at dusk. The painting conveys a scene of great depth, created primarily by the use of aerial perspective. A diffused twilight envelops the figures and lake in a soft haze. Simultaneously, the rich, actual texture of the paint itself draws our attention to the mottled surface of the picture plane.

Grattage, a technique for creating a strong illusion of texture, is introduced in an exercise that follows.

Strong Sense of Materials and Techniques

So far our program of study has concentrated primarily on painting on flat, rectangular supports made of paper and stretched canvas. For the past hundred years numerous painters have explored the incorporation of an ever-widening variety of substances into or with their paints, while the paintings themselves have been created on supports fabricated from a diverse range of materials (artists in many non-Western societies have regularly used nonrectangular supports throughout history). In Chapter 7 we will examine *collage*, a technique in which everyday lightweight materials such as photos or fragments of newspaper are adhered to the painting's surface. (Marshall used collage elements in Figure 6.9.) Other materials added to alter the texture or density of the paint layer have included broken crockery, mud, straw, and fabric. In the painting exercise below we discuss a method of adding sand into acrylic paint.

Journal Exercise

Landmarks Remembered

Gornik painted Figure 6.22 from memory. You, too, can develop ideas for a personal iconography of places by recalling natural forms or other landscape features to which you once had a powerful attachment — a tree to climb, a hornet's nest, a water tower. Think of all the places you have lived or visited and make a list of significant landscape features you recall. Include features you remember with fear or distaste as well as those you loved. Next to each item write a few sentences or even paragraphs describing its importance and meaning for you. Note anything you recall about how the feature looked, smelled, and felt to the touch. Alongside your writing, draw a sketch from memory. Keep adding to this list whenever you remember additional landscape features (or when you encounter new ones that impress you). The list will become a resource you can refer to whenever you are painting a landscape and want to incorporate iconography that has personal resonance.

Painting Exercise

An Invented View

Artists have conveyed a seemingly inexhaustible range of moods and attitudes in paintings of places, from classical serenity to introspective contemplation to awe to irony to terror. The specific subject matter — perhaps a forest in the snow, or a fogbound harbor — may intensify an emotional reverberation in viewers.

APRIL GORNIK
Figure 6.22

April Gornik has been painting invented landscapes since the early 1980s. *Still Flood* (Figure 6.22) is the artist's imaginative recreation of a flooded landscape she saw in France. The painting recalls the dreamy atmosphere of the mid-nineteenth-century American Luminists, whose paintings likewise depict scenes of uncanny stillness bathed in quasi-mystical light, as if water and trees were generating their own light glowing from within rather than reflecting light from the sun. Gornik enhances an introspective, twilight mood of reverie by leaving the scene unpopulated, as if the viewer is solitary, and by using a subdued palette of very dark green and pale yellow.

Although the forms are accurately rendered, Gornik's sensibility is strongly abstract. The dark positive shapes of the trees and the light negative shapes between the trees combine to make a dramatic iron cross pattern that unifies the entire composition. Thus, while Gornik modulates a sense of depth using many of the spatial strategies outlined in this chapter, at the same time she creates a strong surface pattern which contradicts the spatial illusion. The shift between these two interpretations of the space of the painting yields a dynamic tension, creating a feeling of paradox and mystery.

6.22 April Gornik, *Still Flood*, 1989. Oil on linen, 74″ × 116″. Private collection. Courtesy: Edward Thorp Gallery, New York.

For this exercise you should paint an invented land-scape or dreamscape. Think of this painting as a representation of some overarching mood (such as lyrical joy or anxiety). If you wish, use features from the list you developed for the preceding journal exercise, exaggerating their physical appearance to enhance their emotional impact. In painting the landscape, utilize a combination of strategies discussed in this chapter: use some that serve to create an illusion of depth, and others that bring the viewer's attention back to the flat surface of the picture plane.

Option: Another approach to this exercise is to invent a different mood and content for a landscape based on a source photo or another artist's image. Strive to organize, simplify, and intensify the pattern of darks and lights you find in the source image. Don't attempt to simply copy the image as you find it.

Painting tip (to develop a strong value pattern): Simply copying nature (or a source image such as a photo or postcard) will not automatically result in an effective image. At the block-in stage, try organizing your composition by its value scheme — the arrangement of lights and darks — even if you expect color to play a decisive role in the formal or emotional effect of the completed painting.

Many painters follow the block-in stage by a strategy of working from dark to light. Refine the middle- and darker-valued colors first, leaving the addition of lights and highlights until the end. This strategy is based on two observations. First, in oil paint, white is usually one of the most opaque of all pigments and thus easily covers any dark color (only zinc white is semi-transparent). Second, when painted last, highlights can be made thicker, which allows them to appear to come forward, as they logically would. (In contrast, most watercolorists and those working with oil pastels apply light colors first and darker colors last, because in these media darker colors cover the other colors better.)

Painting Exercise

Painting a Nocturne Using Grattage

Create a painting of a nighttime landscape or cityscape. Incorporate the technique of *grattage* in the painting in order to create a strong sense of texture or pattern on the surface of the picture plane. After using grattage, utilize more straightforward painting techniques to "go back in" and complete the painting.

Directions: to make a grattage, an artist presses the back of a canvas (already painted in one color) on top of a textured surface or object to create an imprint. Using a palette knife or trowel, he scrapes fresh paint in a second color across the canvas. The paint stays in the "canyons" but is scraped back off the "plateaus," thus creating a reverse image of the underlying texture. (Imagine the effect that would be produced by scraping paint across a canvas pressing down on something like a waffle iron.)

The technique of grattage was pioneered by Max Ernst. In Figure 6.10, one of Ernst's grattage paintings, the patterned area conveys a compelling illusion of a textured landscape. While the mountain was created using grattage, the night sky and full moon were painted with a flat application of paint.

The technique of grattage is related to the techniques of *frottage* and *decalcomania* (also pioneered by Ernst). In producing a frottage, the artist makes an image by lightly rubbing (usually using charcoal or a pencil) across a paper positioned above an object with a relief surface. The technique of decalcomania involves pressing a sheet of paper or other material onto a wet surface of paint and then peeling it back up again. The paint will stick to the top surface only in places, creating a rich textured effect. In an offshoot of the decalcomania technique, experiment with rubbing your hand on the back of the top layer which is pressed against another sheet with wet paint.

Painting Exercise

Sand Painting

Working from memory, make a painting of an interior or landscape that you found visually compelling. Combine the use of sand as an ingredient into the paint.[10] Remember, a strong sense of texture can be an effective strategy for unifying a composition and calling attention to the picture plane.

Plan the painting so that the texture produced by incorporating sand into the paint plays a significant role in your painting's overall effect. If desired, experiment with adding other materials into the acrylic medium mixture.

In Jane Asbury's painting *Secrets* (Plate 20), the use of sand contributes to a powerful vision of the artist's subject matter. The painting itself becomes a landscape of textures and shapes reminiscent of the rock walls of canyons and buttes and the barren ground of the

American Southwest. Notice how Asbury's use of the textured sand allows her to fuse together the landscape with the strange animated figures in the foreground. The result is a melding together in which the figures echo features of the land, and the land seems very much alive!

Technique for sand and acrylic painting
Materials needed

a. Sand. Inexpensive fine white sandblasting sand should be available from a local hardware or building supply store.

b. Acrylic matte medium or gloss medium.

c. Acrylic paints in a range of colors. Using acrylic paints in jars is easiest, because the paint is more liquified to start. As an alternative, use powdered pigments (taking precautions to handle safely).

d. A supply of small containers with lids (we use rinsed-out yogurt containers); one per color.

e. A stiff support such as plywood, which works well to support the weight of the sand mixture and to avoid cracks.

Procedure

a. Fill each container with a mixture of sand and acrylic medium. Start with $\frac{2}{3}$ volume of sand to $\frac{1}{3}$ acrylic medium; add more medium for a thinner mixture.

b. Add a small amount of acrylic paint (or pigment) to color the mixture in each container, as desired.

c. Apply the colored mixture to the support in a horizontal position. Use a trowel or palette knife to spread a thick layer; use brushes for smaller details. Don't let the mixture dry on the brush.

d. Indent objects (such as combs, various old kitchen utensils) into the surface of the mixture in order to create textures. For example, press a wire screen to make a waffle-like relief.

e. Allow the artwork to dry overnight.

f. Once it is dry, use acrylic paint in washes to add more color; or you can build up additional layers and thickness. Don't add to a layer while it is still partially wet, as this can cause it to crumble. Oil paints can be applied over a dry painting, if desired.

Recommended Artists to Explore

Nicholas Poussin (1594–1665)

Claude Lorrain (1600–1682)

Jacob van Ruisdael (1628/9–1682)

Jan Vermeer (1632–1675)

Katsushika Hokusai (1760–1849)

Caspar David Friedrich (1774–1840)

James Mallord William Turner (1775–1851)

John Constable (1776–1837)

Albert Bierstadt (1830–1902)

Winslow Homer (1836–1910)

Thomas Moran (1837–1926)

Paul Cézanne (1839–1906)

Claude Monet (1840–1926)

Vincent van Gogh (1853–1890)

Pierre Bonnard (1867–1947)

Gabriele Münter (1877–1962)

Edward Hopper (1882–1967)

Tarsila do Amaral (1886–1973)

Georgia O'Keeffe (1887–1986)

René Magritte (1898–1967)

Yves Tanguy (1900–1955)

Emily Carr (1917–1945)

Jacob Lawrence (b. 1917)

Neil Welliver (b. 1929)

Yvonne Jacquette (b. 1934)

David Hockney (b. 1937)

Roger Shimomura (b. 1939)

Jennifer Bartlett (b. 1941)

Anselm Kiefer (b. 1945)

Linda Lomahaftewa (b. 1947)

Mario Martinez (b. 1953)

April Gornick (b. 1953)

Guillermo Kuitca (b. 1961)

1. April Gornik, quoted in *10 + 10* (New York: Harry N. Abrams and The Fort Worth Art Museum Association, 1989), p. 104.

2. Gaston Bachelard, *The Poetics of Space* (Boston: Beacon Press, 1969), p. 136.

3. Patricia Malarcher, "Editorial," *Surface Design Journal* (Oakland, CA: Surface Design Association, summer, 1997), p. 2.

4. While most strategies developed for the artistic representation of space have ties to the way the human eye sees depth in looking at everyday three-dimensional reality, some of the means used in looking at everyday reality cannot be employed by the visual artist working in a two-dimensional

medium. In painting on a flat surface, the artist cannot in-corporate motion parallax or binocular disparity. Motion parallax is the constant displacement in how objects line up relative to our eyes, as we move about and look around in a three-dimensional space (such as our ordinary world). Binocular disparity refers to the (slight) difference in how a three-dimensional space appears through each of our two eyes. A thorough discussion of cues for seeing depth in the real world and in a flat image is contained in Paul Messaris, *Visual Literacy: Image, Mind and Reality* (Boulder: The Westview Press, 1994), especially pp. 51–56.

5. Artist's statement in the exhibition catalogue, *New Art of the West 5* (Indianapolis: Eiteljorg Museum of American Indians and Western Art, 1996), p. 42.

6. Antecedents for linear perspective were developed by the ancient Romans and as early as the second century B.C.E. by Ptolemy, a noted astronomer and geographer who lived in Alexandria, a city located on the northern coast of Africa in present-day Egypt. Starting in the fifteenth century, artists and mathematicians in Italy "rediscovered" the principles of linear perspective and then further advanced it as a highly organized system for the representation of a unified sense of space on a flat surface. See Messaris, op. cit., pp. 53–54. A thorough treatment of the historical development of strategies for articulating pictorial space can be found in William V. Dunning, *Changing Images of Pictorial Space: A History of Spatial Illusion in Painting* (Syracuse: Syracuse University Press, 1991).

7. Linear perspective is a system of conventions, differing in some important ways from how the human eye actually sees (a full treatment of these conventions is beyond the scope of an introductory text like this one). Everyone is thoroughly familiar with how a scene represented in linear perspective appears because the normal 35 mm camera records scenes using virtually the same conventions.

8. Jean Clair, "The adventures of the optic nerve," in *Bonnard: The Late Paintings* (Washington, DC: The Phillips Collection, 1984), p. 36.

9. Neal Benezra and Olga M. Viso, *Distemper: Dissonant Themes in the Art of the 1990s* (Washington DC: Hirshhorn Museum and Sculpture Garden, 1996), p. 69.

10. The basic technique of using sand with acrylic paints and mediums was introduced to author Craig McDaniel by painter Jane Asbury.

Form and Light
Practice Subject: The Human Figure

In Chapter 5, we discussed how an artist can analyze the interplay of flat and curved shapes, called planes, which connect together to define the exterior surfaces of a form's volumes, using self-images as the practice subject. In Chapter 6, we looked at the articulation of space in painting, using scenes of exterior and interior places as the practice subject. In this chapter, we explore the articulation of form and light, while introducing several new techniques. Our practice subject is the human figure, particularly the human figure posed within a place (a setting). The human figure is a complicated and highly flexible form, capable of an endless variety of poses, and hence is visually an intriguing subject to paint. Moreover, the human figure offers a wellspring of potential cognitive meanings, and thus provides an enormous conceptual challenge to painters.

We begin with a brief introduction to the human figure as a subject in painting. Then we introduce strategies for representing the structure of human forms, incorporating visual elements discussed in previous chapters, particularly shapes and volumes, plus a consideration of new concepts such as proportion, scale, and gesture. You should bear in mind that the strategies we are introducing can be adapted to articulate the structure of virtually any physical form: nonfigurative as well as figurative, geometric or organic, actual or invented, naturally occurring or fabricated. Furthermore, these strategies can be employed alone or in combination. Next we focus on how a painting can represent *light*, including conditions of illumination and the physical qualities of light. We explore how painters use the visual elements of value (contrasts of light and dark) and color to render effects of light, and how in turn light is used to define a sense of the volumes of form and the positions of forms in space. We tie the discussion of how light functions in formal and technical terms to a consideration of psychological meanings painters can express through the manipulation of lighting effects. We continue to use the human figure as the practice subject, although again you should remember that light may be an important consideration in paintings of all kinds of subjects. In later sections of the chapter we explore a range of painting and collage techniques and discuss how these can be used to explore some of the themes the human figure has inspired in paintings.

INTRODUCTION TO THE HUMAN FIGURE AS A SUBJECT

The oldest known surviving works of art that show human images are small stone carvings of female figures made between 25,000 and 30,000 years ago, and unearthed in central Europe. Other early representations of humans include Mesolithic (Middle Stone Age) schematic paintings of humans in a wide variety of poses located on stone walls of shallow rock shelters in northern Africa and the east coast of Spain, dating from 7000 to 4000 B.C.E. While we can never fully understand these

prehistoric images, many art historians speculate that they embody beliefs our ancestors held about the meaning of human existence.

The human image has been a persistent subject in art from prehistory to present times, appearing in virtually all cultures in every corner of the world. We humans share a fascination for creating and looking at images of ourselves. Such art falls within the category known as *figurative* art, a term used for art showing figures of humans or animals. (In some books you will find *figurative* used in a broader sense to refer to any artworks which are representational rather than totally abstract. We prefer the narrower meaning.) When the people in a painting are identified, the artwork is called a *portrait*. In this chapter, we discuss both portraits and other portrayals of people.

Artists have depicted human figures in a tremendous variety of styles. The aforementioned rock paintings are highly schematic, more like a diagram or symbol for humans than a picture of actual people. Figurative paintings from ancient Egypt, such as Figure 7.1, show flat, outlined figures lined up along the same ground plane, with figures scaled in size according to their importance. Body parts are joined synthetically to show them from what were considered the most characteristic positions: head, arms, and legs are in profile, while the eye and torso are frontal. Artists of the Middle Ages in Europe often exaggerated features such as heads, and twisted and stretched proportions for emotional and dramatic impact. Artists of ancient Greece and the Italian Renaissance portrayed figures as three-dimensional forms in space; while appearing realistic, the figures' appearance was also invented and idealized — shown in what the culture considered a peak of physical perfection. Artists of northern Europe in the fifteenth century, including the Flemish painter Jan van Eyck, whose *Arnolfini Wedding Portrait* appears in Chapter 2 (Figure 2.1), painted in a style of extreme realism from the point of view of a single observer. Van Eyck's portrayal includes abundant details of clothes and facial expressions, and closely observed textures of skin and hair.

In the past hundred years, the human figure, like so many artistic subjects, has provided a motif for experimentation by artists. In the West, Cubists transformed the curving forms of humans into hard-edged, interlocking geometric patterns; Expressionists distorted bodies, applied intense, nonnaturalistic colors, and used slashing brushstrokes for dramatic, emotional effects; Surrealists put the body into physically bizarre or psychologically suggestive situations. For instance, *Family Portrait* (Figure 7.2), by the Surrealist Dorothea Tanning, shows a figure group distorted in their size relative to one another in order to emphasize the dynamics of family relationships (analogous to the use of scale to signify power relationships in Egyptian figurative art).

The range of styles used by present-day painters to depict the human figure is also vast. Philip Pearlstein's *Punch on a Ladder #3* (Figure 7.3), composed as a distinctive diamond-shaped painting, provides a contemporary example of detailed realism. Ed Paschke paints figures who appear drenched in the artificial coloration we associate with television, video, and computers (see Plate

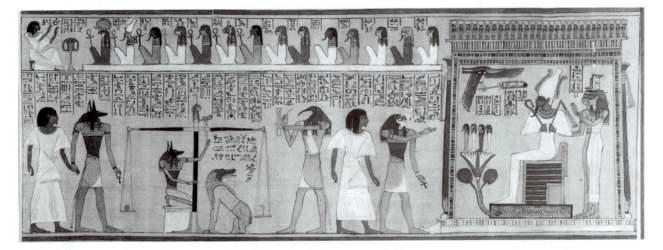

7.1 (detail) *Psychostasis* (soul-raising) *of Hu-Nefer*, from Thebes. c. 1350 B.C.E. Painted papyrus scroll, 2 ³/₄″ high. Collection: British Museum, London.

7.2 Dorothea Tanning, *Family Portrait*, 1954. Oil on canvas, 39 ³⁄₈" × 31 ⁷⁄₈". Musée National d'Art Moderne, Centre Georges Pompidou, Paris.

STRATEGIES FOR THE ARTICULATION OF FIGURATIVE FORM

The human figure poses challenges unlike any other subject. Beginning artists may be inclined to represent the figure based on a storehouse of preconceived notions, such as a tendency when rendering heads to emphasize small details of the eyes and mouth while ignoring the interplay of masses throughout the skull. Effective figurative painting is anchored in an awareness of the overall structural and visual properties of the human form, an awareness enriched by direct observation. This is one reason why so many introductory painting and drawing classes provide practice in working directly from the nude and clothed figure. Painting from life provides invaluable experience, instilling knowledge that the artist can draw on to avoid clichéd or superficial approaches, even when painting invented or remembered, naturalistic or expressive figurative compositions.

Standards for Proportions

Many artists have based their figurative art on their culture's conception of the ideal human figure. As we saw above (Figure 7.1), Egyptian artists showed figures with the head in profile and the upper torso facing frontally, positions they considered most important for displaying the respective parts of the body. The Greeks developed mathematical proportions for calculating the relative size of each part of their ideal figure, while Leonardo da Vinci's widely reproduced diagram shows a man's outstretched arms equal in length to his height. In our own era in the West, this kind of standardization of physical perfection is followed most rigidly in advertising by the fashion industry and other commercial enterprises (where today's fashion ideal is an elongated body often rendered up to eight times the height of the head). Contemporary painters tend to be more interested in bodies that depart from the cultural ideal. Sometimes a painter will develop his or her own "canon" of physical proportions, distinct from what society considers beautiful or desirable, with the result that the figurative paintings of that artist are all recognizable in part by their common body type, as if they all belonged to the same family. For example, Roy Carruthers has painted many figures with features similar to those shown in *The Rival* (Figure 7.8):

21). In *Two Kachinas* (Figure 7.4), Dan Namingha, a Tewa-Hopi from the San Juan Pueblo in New Mexico, depicts two costumed dancers in a flat, stylized composition of interlocking shapes covered with rhythmic designs.

Since the 1980s, the human figure has emerged as a significant subject in the work of many artists associated with current ideas and trends such as Postmodernism and Multiculturalism. For example, Shahzia Sikander, who was born in Pakistan and now lives in the United States, melds the disciplined techniques of classic Indian miniature painting with a personal vocabulary and involvement in current issues. In delicate, diminutive paintings such as *Apparatus of Power* (Figure 7.5), Sikander positions detailed, stylized female figures against simple, flattened backgrounds, evoking Hindu religious art while moving beyond tradition. Sometimes a figure floats, according to the artist, "to show that she is not grounded in anything other than herself."[1] Artists such as Sikander often work in the directions we are calling "Expanded Forms and Ideas" (the topic of Chapter 8).

7.3 Philip Pearlstein, *Punch on a Ladder #3,*
1996. Oil on canvas (diamond shape), 48″ × 48″.
Courtesy Robert Miller Gallery, New York.

the necks are conical; hands often have six fingers each; and the heads are disproportionately small.

Geometric Simplification

The process of planar analysis, introduced in Chapter 5, can be used to represent the body as a three-dimensional structure. As we noted in studying the subject of self-im-

ages, it is not possible to paint in total, exacting detail something as complicated as a human body (and even if it were possible, the labored process would risk draining all vitality out of the subject).

Simplifications or abstractions must be made. In one approach, surface texture, subtleties, and details are drastically reduced while the overall structure of the figure is summarized as an interconnecting series of

7.4 Dan Namingha, *Two Kachinas.* Acrylic on canvas, 72″ × 60″.

simplified geometric volumes. In Figure 7.8, Carruthers follows this approach by transforming an imagined man and woman into collections of cones and cylinders. The artist constructs these simplified volumes through the process of painting an appropriate arrangement of flat and curving planes.

Analyzing Anatomical Structure

The outermost layer of skin is supported and shaped from within by the interplay of skeleton, muscles, and layers of fat. Note, for instance, how the skin of the face crests over the ridge of the nose and brow bone in Reginald Gammon's portrait of Jack Johnson (Figure 7.6). Attention to such structural features as the movements of the joints and curvature of the spine establish a base for constructing an invented but believable scene in Brett Bigbee's *The Artist's Wife* (Figure 7.9).

For the purposes of this program of study, beginning painters are encouraged to search out what clues are observable of the underlying anatomical structure of their

subject. Study the contrast of muscles which are tense with those which are not, and observe how bony forms of the skeleton may punctuate the softer landscape of the body. Both of these pairs of oppositional qualities provide evidence of the overall dynamic gesture of a pose (observe how the distinct gestures in Bigbee's painting, Figure 7.9, show evidence of where bones and muscles push beneath the skin). More advanced painters — especially those with previous instruction in life drawing — are encouraged to seek out additional information as their artistic goals and skills mature. (See specialized publications on human anatomy for artists, as well as entries on human anatomy in general encyclopedias, or even medical texts.)

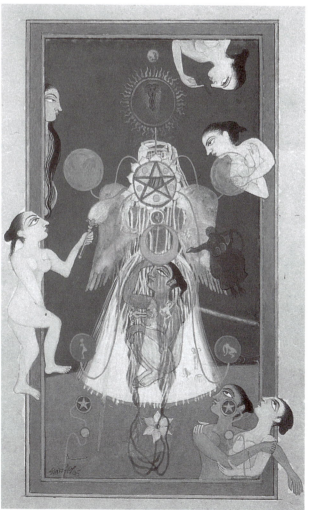

7.5 Shahzia Sikander, *Apparatus of Power,* 1995. Vegetable pigment, dry pigment, watercolor and tea water on wasli handmade paper, 9″ × 6″. Collection: Carol S. Craford.

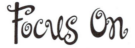

Focus On

REGINALD GAMMON AND RAYMOND SAUNDERS
Figures 7.6 and 7.7

Figure 7.6 by Reginald Gammon and Figure 7.7 by Raymond Saunders are both portraits of the boxer Jack Johnson, who in 1908 became the first black heavyweight world boxing champion. Created just five years apart, at a time of great political activism on behalf of civil rights in the United States, the two paintings are very different in style but both assert the "Black is beautiful" pride of the late Sixties and early Seventies. Gammon's portrait is a naturalistic rendering using contrasts of dark and light to model and emphasize Johnson's muscular upper torso and self-confident facial expression. Bands of color surrounding the figure suggest an almost electric energy radiating outward. Saunders made no attempt at a naturalistic likeness, and combined painting, drawing, and collage to create his image. He depicts Johnson as a flattened dark shape against a red background, emphasizing just a few features, notably the eyes and mouth. He affixed luggage tags, foreign stamps, and other collage elements to the surface, and scrawled Johnson's name in chalk across the torso. Saunders's contrasting materials and gestural marks express some of the energy of the champion.

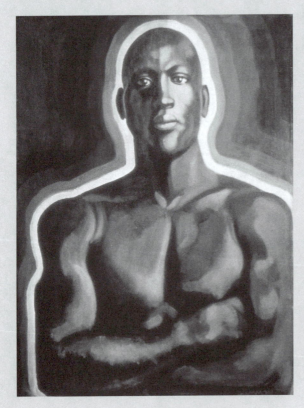

7.6 Reginald Gammon, *The Young Jack Johnson*, 1967. Acrylic on canvas, 32″ × 24″. Courtesy of the artist.

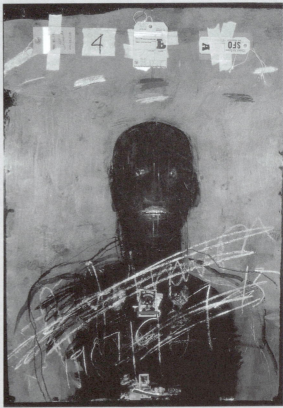

7.7 Raymond Saunders, *Jack Johnson*, 1972. Gouache, chalk, tickets, masking tape on paper, 19″ × 23″. Courtesy of the artist and Stephen Wirtz Gallery, San Francisco.

7.8 Roy Carruthers, *The Rival,* 1978. Oil on canvas, 64″ × 68″. Courtesy of the artist and the Newborn Group, New York.

7.9 Brett Bigbee, *The Artist's Wife,* 1989. Oil on canvas, 48″ × 48″. Collection: Sue Lehmann and Frederick W. Gluck.

Foreshortening

Foreshortening is the term for the condition of a form's appearance when its major axis projects in space at an angle to the picture plane. The effect is due to the combined effect of two changes in the perceived size and shape of the form. First, because the form's position is shifted so that it points at or away from the viewer — into or out of the picture plane — the form appears compacted — or shortened — from its normal height or length. Secondly, and related to the first, the relative scale of the parts of the form are altered because one end of the form is now observed diminished in size as it is seen receding into depth.

Foreshortening contributes to the articulation of three-dimensionality in the volumes depicted, and, in turn, enhances the illusion of those volumes occupying deep space. We see a dramatic example in Lorraine Shemesh's *Side Stroke* (Figure 7.10), as underwater figures swim towards and away from us along sharp diagonals.

Foreshortening can be linked to the articulation of space by linear perspective and the overlapping of forms. By mentally placing a form within an imaginary box, one can gauge the approximate convergence of the form as it recedes in space through the application of the laws of perspective. Figure 7.11 shows how to use a box to create accurate foreshortening.

7.10 Lorraine Shemesh, *Side Stroke*, 1994. Oil on canvas, 67$\frac{1}{2}$″ × 81″. Courtesy of Allan Stone Gallery, New York.

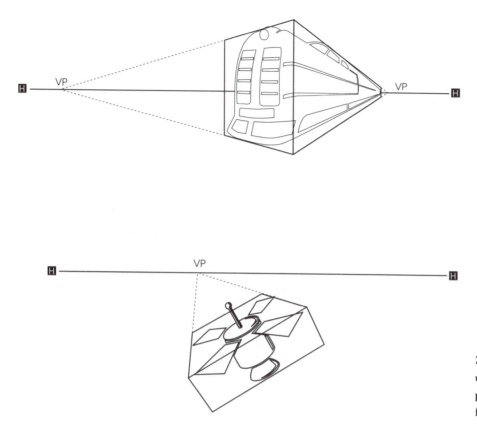

7.11 Examples showing how to use a box drawn in linear perspective to create accurate foreshortening.

To employ foreshortening, paint the parts of a figure or object which angle away from the picture plane shorter in proportion to those parts which remain parallel to the picture plane. Compare the radically foreshortened figures in Shemesh's painting (Figure 7.10) with Bigbee's figures (Figure 7.9). Observe that even in the painting by Bigbee some portions of the figures are foreshortened, such as the upper thighs of the figure on the right and the back of the figure on the left.

Painting tip: Foreshortening inevitably results in the overlapping of forms: for example, when it thrusts straight out at a viewer, a hand will overlap the wrist which overlaps the forearm, and so forth.

Painting Exercises

Painting the Structure of the Body

Option 1 (extended planar analysis):
Working from a posed model, create a painting using a complex treatment of planar analysis.

In Chapter 5, we examined how Max Beckmann painted the volumes of his own figure by simplifying the planes of his head, hands, and evening clothes (Figure 5.1). In his portrait of Johnson (Figure 7.6), Gammon used the same strategy of painting only the most structurally important planes.

Compare Emma McCagg's painting *Patrick* (Plate 22) with those by Beckmann and Gammon. McCagg's strategy involved recording many shifts of planes in order to articulate the subtlety of the human form. And whereas the planes in Beckmann's and Gammon's paintings are defined primarily by dramatic shifts in lightness and darkness, in McCagg's painting the planes are defined not only by shifts in value, but also by shifts from warm hues for the planes in light to progressively cooler hues for planes in shadow. For example, the lower figure's left leg (nearest the right edge of the painting) contains planes that shift from warm pink to brown to several shades of a cooler blue-green and blue.

For this studio exercise, work in a direct painting approach with large flat or filbert bristle brushes.

As McCagg has done to compose her painting, base the painting on one model who alternates between two separate poses, one showing a severely foreshortened view. Emphasize all the subtlety you can record about how the planes of the body reflect light and are positioned in space. Use cooler shifts of color and a reduction in value contrast to push planes back in space and away from the light source. Use the same approach to treat the planes of all props and furniture in the studio setup.

Work on the painting for at least two sessions. Allow the paint surface to dry between sessions. When you continue painting, refine the coloration of planes, allowing some of the underlying color to peek up through the new brushstrokes. To accomplish this, use a drybrush technique, as described in Chapter 3, "Materials and Techniques." Let the painting be a record of the raw energy of responding to the forms as you explore them fully.

Option 2 (planar analysis with a palette knife):

Repeat the approach of Option 1, working with a palette knife instead of paintbrushes. Let each stroke with the palette knife define a new plane. If you aren't satisfied with the shape or color (paying attention to the hue, value, and intensity), scrape off and try again. When working with a palette knife, wipe the blade clean with paper or a rag after each stroke. Mix the color you want and apply the stroke cleanly, with enough paint to cover completely. Work with paint straight from the tube.

Option 3 (expressive planar analysis):

Create a painting in which figurative subjects are constructed as volumes of interlocking planes that are distorted for expressive effects. Prior to completing the actual painting, produce a drawing in charcoal or pastels, exploring the approach you intend to take in the final painting.

An example of a simplified planar analysis done for expressive purposes is shown in David Chung's working drawing for *Mega Morning Calm* (Figure 7.12). This is a drawing Chung completed in preparation for a complex installation exloring his Korean heritage and his experiences living in cities in the United States. Note the dramatic interplay of dark and light areas which combine to create a strong impression of three-dimensional figures (both animals and people), who crowd together, completely filling the pictorial space.

7.12 David Chung, Working drawing for *Mega Morning Calm,* 1993. Mixed media installation, dimensions variable. Courtesy of the artist.

STRATEGIES FOR THE ARTICULATION OF LIGHT

Volumetric forms exist whether or not light falls on them. Similarly, space (a focus of Chapter 6) exists irrespective of any illumination. But in our daily living, where typically our vision is the means by which we explore space and the volumes within it, there must be light in order for us to see. To create a sense of three-dimensional volumes (such as human figures), a painter may strive to show them under a specific lighting condition. Since there is no such thing as a tube of light, a painter selects and applies colors of paint which will "read" as light within a specific composition. To create the appearance of illumination, the painter orchestrates a contrast: light/shadow, or light/darkness.

The quality of light in a painting — what it signifies, and how it appears — is a key means by which we recognize an artwork's period and even its painter. Baroque paintings (such as Figure 7.13) typically leave more than two-thirds of the figures and objects in deep shadow; Impressionist paintings are characterized by a shimmering light suggested by the juxtaposition of unblended strokes of bright color; expressionistic artworks (Figure 7.12) often eliminate halftones in favor of harsh contrasts of light and dark.

The representation of illumination should not come at the expense of articulating the structure of volumes. This twofold goal presents a challenge since real light seldom plays favorites. As any amateur photographer soon realizes, minor details may receive as much light as the most important form-defining aspects of a subject, and multiple or haphazardly placed sources of lighting can virtually destroy all sense of volume. As we have noted at other points in this text, a painter who works from direct observation cannot rely on simply copying things as they appear. Choices need to be made that will provide an effective balance between appearance and understanding.

Chiaroscuro (Light and Shadow)

Chiaroscuro is an Italian word meaning "light/dark." In painting, the term refers to an approach which features dramatic contrasts of light and dark values. An artist can use chiaroscuro to create the visual illusion of mass in curved, three-dimensional subjects such as a human body. An artist creates the illusion that directed lighting illuminates a figure by recording a gradual shift from light to dark across its surface. Areas are painted darker or lighter depending on how far they are from the source of light and how directly the light strikes them. The darkest values are restricted to areas in shadow. If you look at the black-and-white illustrations in this chapter in which figures and objects appear most fully three-dimensional, you can see how the illusion of volume is enhanced through value gradations alone, regardless of color. (In fact, it is difficult to combine intense color with chiaroscuro because color competes with the subtle gradations of tones; equally important, each color only achieves its greatest saturation during a single portion of its range of value.) Typically, painters using chiaroscuro begin with a ground that is toned to a mid-value neutral color.

In Europe perhaps the grandest epoch of chiaroscuro occurred in the seventeenth century, today called the Baroque period, when Rembrandt, Caravaggio, Velásquez, and many other painters created paintings with dramatic dark-and-light structures. Artemisia Gentileschi's *Judith and Maidservant with the Head of Holofernes* (Figure 7.13) provides a splendid example. A single light source — the candle depicted within the painting — theatrically picks out parts of the two women, notably their hands and forearms, spotlit diagonals which lead our eyes downward to the grisly, severed head of Holofernes at the bottom of the picture. Otherwise, Gentileschi leaves most of the women's bodies in shadow, and she paints the background space as if deep in darkness.

From the Baroque era onward in the West, chiaroscuro modeling — painting gradations of tone to indicate a rounded surface turned away from the light — became a principal strategy for painters to create an illusion

7.13 Artemisia Gentileschi, *Judith and Maidservant with the Head of Holofernes*, c. 1625. Oil on canvas, 184.2 cm × 141.6 cm × 30 cm. The Detroit Institute of Arts, gift of Mr. Leslie H. Green.

of three-dimensional volume. The gradations of value used in a systematic application of chiaroscuro are:

- highlights (the lightest values, where light strikes a surface directly, most obvious as spots of intense light when the object is glossy)
- lights
- halftones (the intermediate values between areas of light and shadow, where light strikes parallel to the surface; often shown as equivalent to the local color)
- shadow (the darkest areas of value, occurring on the parts of the object which receive the least illumination)
- reflected light (shown as subdued light bouncing back on an object from nearby surfaces)

The objects themselves may also cast shadows onto adjacent surfaces.

Directional Lighting

Chiaroscuro implies light coming from a specific source, which is depicted in the image or strongly implied outside the frame. We see its effects clearly: the sides of objects turned toward the source are bathed in light, and cast shadows are evident. In Dan McCleary's *Man and Woman in Blue Dress* (Figure 7.14), a strong light from the left picks out a few details of each figure while throwing most of each face into shadow. The light-and-shadow

7.14 Dan McCleary, *Man and Woman in Blue Dress*, 1992. Oil on canvas, 25½″ × 30½″. Courtesy of Tatistcheff Gallery, New York.

structure creates emotional drama in a pose that might otherwise seem unremarkable — by highlighting, for instance, the twist of the woman's neck away from the man's gaze.

The direction of light determines what parts of a form are in light or shadow. Moving the position of the source of light alters the distribution of darks and lights across an illuminated object. Because multiple light sources may complicate the value pattern greatly, it is easier to practice first creating the illusion of volume through chiaroscuro modeling if you use a single, directed light source.

Contre-jour (after the French term for "against the day") is a special condition in which the source of light is directly behind the form it illuminates. A figure or object seen against the light presents only its shadowed side to the viewer. Typically the illusion of volume is somewhat flattened because of the elimination of modeling. An example is provided by Alette Simmons-Jimenez's *Inside-Outside* (Figure 7.15), in which the nude female figure is a darkened silhouette against the window view of a city lit up at night.

Painting tips for modeling figures (and other volumes) using chiaroscuro and directional lighting:

1. If there are multiple sources of light in your studio, you may have trouble clearly distinguishing basic divisions of value on any volume, especially the complex volumes of the human figure. The areas of lights and darks may actually appear somewhat disordered and "patchy." To create the illusion of three-dimensionality using chiaroscuro, simplify the representation of light falling on the volumes you paint. You don't have to paint the volumes of a figure exactly as you see them. More effective representations may be produced by painting volumes as if they were illuminated by one clear directed light source. (Note: More advanced painters may try to combine aspects of the simplified illumination of a single-light source with the actual conditions available.)

2. To simplify, paint each volume with five basic divisions of value: highlight, light, halftone, shadow, and reflected light.

7.15 **Alette Simmons-Jimenez,** *Inside-Outside*, c. 1996. Oil on canvas, 60″ × 66″. Courtesy of the artist.

3. Eliminate the highlight if the surface isn't glossy.

4. Don't confuse the lights and darks. Even the lightest area of a volume in shadow should remain darker than the darkest area of that volume in light. Keeping the lights and darks distinct will enhance the illusion of three-dimensionality, and will strengthen the pattern of lights and darks created throughout the composition. (An exception to this "rule" occurs when one local color — such as a purple skirt — should appear darker even in the light than the shaded portions of another, much lighter local color.)

5. Try mixing separately the paint colors you will use for the light, halftone, and shadow areas. The halftone can be applied separately along the edge of the light and shadow. Blend slightly to eliminate a harsh line where these areas border one another, but avoid overblending.

6. Try painting the darks more thinly than the lights. Using more medium will make the colors thinner and more translucent. Many painters limit opaque impasto effects to the lights and highlights only. But put color in your darks; avoid just darkening the shadows with black.

7. Try changing value along the edges of volumes. If an area is in light, lower the value to the halftone along the edge. If the area is in shadow, raise the value up to a tone of reflected light. The area of reflected light should be painted a half step darker than the halftone areas.

Luminosity

In many periods of history and in a variety of cultures painters have used unnatural coloration for expressive purposes in painting the figure. The twentieth century witnessed an unparalleled growth in artistic experimentation, including the exploration of unusual color schemes and mixtures for flesh tones. As an example of expressive coloration, look at Paschke's painting of Abraham Lincoln (Plate 21). Notice how different the quality of light is in this painting from chiaroscuro. The painting exhibits *luminosity* — a condition when forms themselves are aglow — as if Lincoln's face is translucent and the light is shining through the skin rather than falling on it from an outside source. A similar kind of glow was exemplified in an earlier era by the illumination of a stained-glass image. When joined with Paschke's intense coloration and imagery, the glow suggests that of a computer monitor or television screen. The horizontal bands of color enhance the effect, evoking an impression of a fluctuating, electronic image.

Illusions of Texture Created through Effects of Light

Our sense of vision and sense of touch are closely linked. We see plush velvet or rough sandpaper and we recall how such surfaces feel. Since visual experience may stimulate tactile memories, a painter can imply a surface texture by creating a visual pattern. Look, for example, how Pearlstein has rendered the texture of his foreground model's hair by painting the choreographed flow of numerous strands (Figure 7.3). Another method for achieving the illusion of texture is to paint the patterns of light and shadow that characterize how a specific surface reflects light. In Figure 7.8, Carruthers achieves a range of realistic textural effects: polished leather shoes, smooth flesh, cloth suit, and silk shirt are all described through contrasts of tone. His paint surface itself is smooth. Carruthers' simulation of naturalistic textures contrasts with McCagg's approach in Plate 22, which incorporates an impastoed buildup of paint but makes no effort to simulate the different textures of the model's skin and hair. (Refer again to the discussion of actual texture and the illusion of texture in Chapter 6, "Space," p. 128.)

Journal and Sketchbook Exercise

The Symbolism of Light

Light *is* energy. As humans, we respond physically to the play of light entering us through our eyes. Our eyes are drawn to strong contrasts of light and dark; hence the bold use of chiaroscuro attracts the viewer's eye to parts of a painting the artist considers most meaningful. In a painting with an emphatic pattern of light and dark, the artist simply may be exploring the physical effects of light on colors, volumes, and textures. On the other hand, often light and dark are considered to have allegorical significance and become themes in themselves. In the myths and stories of many cultures worldwide, light has stood for divinity, goodness, and truth, while darkness has symbolized the unknown, death, and even evil. In Christian paintings, light typically represents the grace received by one who accepts the teachings of Christ. For philosophers of the eighteenth-century European Enlightenment, light symbolized reason overcoming what is hidden and irrational, a concept that is still

prevalent today in the West. But it is too simplistic to view light and darkness as polar opposites. In Buddhist thought, light and dark — yin and yang — are interdependent and inseparable. Without their contrast, we would be unable to see or understand the world. Even in the West, some artists have viewed darkness as a positive force. The concept of the Romantic Sublime, for example, was based on a faith in irrational experiences as a means to insight.

Option 1: For this journal exercise, explore some of the symbolic meanings you invest in the notions of "light" and "darkness." Draw a line down the center of a page and write "light" at the top of one column and "darkness" at the top of the other. Underneath each heading, list whatever images, concepts, and feelings come to mind that you associate with that term.

Option 2: Consider what time of day you prefer — sunrise, morning, midday, twilight, midnight, 3 A.M. Write freely describing the characteristic quality of natural or artificial lighting you associate with a favorite time of day. Explore whether and how the quality of illumination contributes to the appeal of that time of day for you. Is the appeal of the light a result of its visual, emotional, or psychological qualities, or something else?

In your sketchbook, record visual impressions of the quality of light during the time of day you explored in your journal exercise. Make more than one sketch: create versions which exaggerate the qualities you perceive. For example, if you are attracted to the appearance of fog dissipating light in the morning, make an imaginary sketch showing the effect at its maximum beauty, perhaps a scene of pedestrians emerging from a fogbound alleyway.

Painting Exercises

Painting Figures Defined by Light

Option 1: Working from a partially clothed model, paint a figure using the chiaroscuro method of modeling volumes. Each volume should be defined by five basic divisions of value: highlight (eliminate the highlight if the surface has no sheen), light, halftone, shadow, and reflected light. This approach is exemplified by Figure 7.14, by McCleary. Start by first establishing the halftones (those areas that are neither in direct light nor in shadow). Establish lights and darks tonally: add white to the halftones for light tones; add black or the complement to the halftones for dark tones. Using a soft brush, subtly blend the edges between light, halftone, shadow and so forth, but don't blend so completely as to lose the identity of each of the five divisions of value.

In order to coordinate a range of local colors, restrict the darks to a narrow range of values and do the same for the lights. To accomplish this, make the yellows and oranges most saturated in the lights, keep reds and greens most saturated in their halftones, and let blues and purples be most saturated in their shadows.

Option 2: Create a dramatic pattern of lights and darks, pushing the halftones up or down in value so that halftones on the light side of the figure belong to the light, while halftones on the shadow side of the figure belong to the dark. By suppressing the halftones, a stronger, more defined pattern of lights and darks will emerge. This treatment is exemplified in Chung's drawing (Figure 7.12) as well as by Amy Horowitz's painting, *Elevator* (Figure 7.22). (Note: Pushing the halftones up or down in value is a different approach to painting than we discussed in the section on chiaroscuro, where halftones remain between the values of light and shadow and represent a more gradual transition between them.)

Option 3: Paint a model under two directed light sources, one warm and one cool. (This can be accomplished by positioning the model by a window for a cool light, while illuminating the other side by a warm incandescent light.) As you paint, be especially *sensitive to color transitions*, especially the transition of hues from warm to cool, and the transition of values from light to dark. Even the relatively flat planes of the figure are seldom one consistent color. It may be subtle, but colors shift depending on the distance from the light source as well as the angle at which the plane faces the light. To paint this effect of color, create transitions. Using a mixture of hard and soft brushes, show a color moving from cool to warm, or from dark to light, and so forth across the flat and curved planes that combine to create the volumes of the figure.

Painting tip: Use the process of painting to record how you analyze a form illuminated by two

directed light sources. Note that the transitions representing different *temperatures* (from warm to cool) of light will not usually coincide with transitions (from dark to light) representing the different total *amounts* of light falling on different areas of the form.

Option 4: Create a painting of the figure (or figures) wearing clothing of a variety of textures (including both dull and shiny materials such as silk). Pose the figure among a grouping of objects and furniture which have a variety of textures — such as nonreflective dull wood, shiny metal, and translucent glass.

As a particular painting challenge, represent the color and lighting effects produced by *luster* — the appearance of light being reflected from a surface made from a material such as silk or metal.

Similar to how the effect of luminosity is painted, to create the effect of luster, reduce in value and saturation the colors of the form's surface which surround the highlight. In contrast, then, the highlight of a lustrous surface will appear more saturated and higher in value. If the surface is reflective (such as a shiny metal) then the highlight might also reflect surrounding colors from its surface.

Option 5: Combine any of the options listed above with the goal of creating a painting which incorporates a symbolic use of light.

EXPLORATION OF FIGURATIVE THEMES

Who am I? Who are you? Who are we as people? Such questions have served as springboards for philosophical flights of imagination for centuries. Artists have provided us with some of the more vital responses to such questions in the form of visual images, and frequently those images have been figurative.

The reasons artists have made the human figure a subject for art have varied tremendously. Painters have used the human figure to represent gods and heroes, illustrate legends and history, gratify the vanity of patrons, meditate on human nature, celebrate sensuality, invent fantasies, and express psychological states. To give just two examples: Figure 7.1 provides images of Egyptian gods, many of whom have human bodies and the heads of animals or birds; in Figure 7.2, the distortion of the figures' sizes represent power relationships in the family.

The meanings invested in figurative images have ranged from extreme idealization of humanity's physical appearance and character to an emphasis on visceral, uncosmeticized aspects of the body and scathing exposes of the troubled side of human nature. When the figure in a painting is identified as a known person, the portrait might be a physical likeness, psychological interpretation, projection of the person's social or political role, metaphorical version of some other aspect of a person's life, or some combination of these or other approaches.

We only have room in this chapter to focus on a few of the many reasons why artists have painted human figures and the cognitive content that figurative paintings can express. We will explore some additional themes in subsequent chapters.

Human Physicality

Along with providing images of the physical appearance of human bodies, figurative art may deal with major humanistic themes such as love, sexuality, childbirth, aging, illness, and death. Here, we look at some variations on themes of physicality, especially as expressed in the nude figure. The nude, a special category of figurative art, has been significant in painting in the West from the era of the Renaissance onward. As noted at the outset of this chapter, nude figures are also found as early as 7,000–4,000 B.C.E. in the rock shelter paintings of northern Africa and Spain. Among the many reasons artists have painted the nude are: to record the physical form of a specific person; to convey an idealized image of physical perfection; to express erotic feelings; to display the frailty of the flesh; and to embody an allegorical concept (for example, intending a nude figure to represent a principle such as "Truth" or "natural innocence").

The elevated status of the nude as a subject does not mean that a nude must be depicted with detached objectivity. Quite often the painted nude is naked indeed. Frequently the nude becomes an image of sensuality rendered in a pose that can range from the subtly restrained to the frankly passionate. In Hermann Albert's painting, *Nude on a White Sheet with Man* (Figure 7.16), the juxtaposition of a clothed man and partially clothed girl, the poses of the figures, lurid colors and theatrical lighting, and the male's intense stare combine to make this an explicit picture of sexual appetite. In other cases (and in a wide range of cultures), nakedness may suggest a variety of interpretations, including rapture, spirituality, anxiety, and melancholy. The physical contact between the elderly couple in Jean Rustin's *Woman Putting Her Hand in a Man's Mouth* (Figure 7.17) has sexual connotations but

7.16 Hermann Albert, *Nude on a White Sheet with Man,* 1982. Tempera on canvas, 74 $^{7}/_{16}$″ × 84$^{1}/_{4}$″. Collection: Meister, Braunschweig, Germany.

7.17 Jean Rustin, *Woman Putting Her Hand in a Man's Mouth,* 1989. Oil on canvas, 4′ 3 $^{1}/_{8}$″ × 5′3$^{3}/_{4}$″. Courtesy of the Jean Rustin Foundation, Antwerp, Belgium.

conveys the opposite of physical excitement. The man sits passively, arms dangling; the woman's expression is ambiguous, as if she is unsure what to do with her position of power over the man.

On the other hand, there are paintings where a nude is (mostly) just a nude. The two figures in *Patrick* (Plate 22) are no more the centers of interest than the checkerboard pattern of the floor or the wooden brace on the painting's left. In this painting the artist's efforts are aimed primarily at the simultaneous articulation of the picture plane and the planes that define the volumes.

Deriving Thematic Ideas for (Figurative) Painting from Photographs and Other Media Images

Using photographs (or photo illustrations from magazines) as source material is sometimes frowned upon by painters and instructors. Some warn that the photo may preempt the artist's subjective response to something seen firsthand. Others object that photos contain too much irrelevant detail. Still others point out that the photographic process reduces reality: it translates three dimensions into two, may reduce extremes of lightness and darkness observed in the "real" world, shuts out other sense impressions (such as smells and sounds), eliminates anything that continues outside the edges of the image, dictates the viewpoint, and usually shrinks the scale.

While these are reasons to be wary of the controlling influence photographic sources may have on your creative process, the bottom line should be the artwork you make and the meaning it expresses. As we have stressed throughout this text, no artist should feel constrained by ironclad rules. There is no reason to eliminate categorically all use of photos as aids, or even ingredients, in your painting. A photo can be useful in the same way as a sketch — as a starting point for your painting and as a memory aid regarding certain aspects of the subject. Some painters use photos when they wish to paint a pose that a model would have difficulty holding for an extended period.

In addition to using photos as a source upon which to base their own image-making, some painters will incorporate a photo, or photographic image from a magazine or newspaper, directly into a painting, using it as collage material. The photos or images can be affixed with acrylic gloss medium onto a gessoed support. Coat a

7.18 Holly Roberts, *Two People Watching,* 1990. Oil on silver print on board, 15″ × 28″. Courtesy of the artist and Dartmouth Street Gallery, Albuquerque, NM.

photograph only on the back; coat both sides of newspaper and magazine images. Once the collage materials are dry, the painter can apply oil (or acrylic) paints directly across them.

Other painters might use the photo itself as a support, already containing an image which the painter then alters or adds to. As an example of this approach, we illustrate Holly Roberts's *Two People Watching* (Figure 7.18). Roberts's artwork is a captivating combination of techniques, materials, and styles: selective details (such as the eyes) from the underlying photo are accentuated, while the rest of the photo is painted out — like a face in a mask embellished by lines where the artist has used sgraffito to incise the rich paint surface.

Many contemporary painters — like artists in other media — wish to explore aspects of a shared *cultural* milieu rather than limit expressions to their firsthand observations of the physical world. In this regard, photographs and other mass media images are invaluable elements in the creative process. Indeed, exploring how the media themselves interpret reality — and have become their own virtual reality — is a primary theme in the work of many of today's artists. For example, in *Bloodline: The Big Family, No. 6* (Figure 7.19), Chinese artist Zhang Xiaogang shows three people in a standardized pose used for photographic portraits. The conformity among the people's features and their expressionless faces seem to symbolize the official suppression of

7.19 Zhang Xiaogang, *Bloodline: The Big Family, No. 6*, 1995. Oil on canvas, 39$\frac{1}{3}$" × 51". Courtesy of the Soobin Art Gallery, Singapore.

individual differences that began under Mao's version of a socialist state.

Journal and Sketchbook Exercises

Exercise #1: *Physical Attractions*
Feelings about physical attraction can be a powerful motivating force for creating art. Expressions of the sensual can range from uninhibited depictions of the naked body to more or less disguised versions — for example, when an artist intends vertical forms as phallic symbols or flowers as female forms.

Think about your own feelings of physical desire and curiosity and how you might encode them in symbols. What colors, shapes, objects, and abstract designs might you use as symbols? Would you want your symbols to be easily interpreted by viewers or would you want them to be more like a secret code? Make a list and sketches of some symbols you might use, and write a paragraph exploring how open or hidden you would want their meanings to be.

Exercise #2: *Physical Actions*
Explore through both written journal entries and small, quick (but intense!) sketches the setting, emotional tenor, and kinesthetic variety of all the physical actions that you undertake in the next week. Special focus should be given to those activities — such as eating, drinking, breathing, and resting — that reveal basic similarities of the human experience and the indissoluble link of humans to other forms of life.

Make a series of very tiny, intimate painted studies based on some of the sketches produced of physical actions.

Exercise #3: *Figurative Traditions*
Research a figurative tradition unfamiliar to you, from a society other than your own. Record in your journal some impressions about how figures are represented by artists in that culture and what meanings are implied by the ways in which the human form is represented. You might explore what meanings are attached to nude figures in the tradition you selected to research. Make sketches of your own, capturing the essential visual qualities you find most compelling and characteristic from the tradition you research.

Exercise #4: *The Influence of the Media*
A recurring theme of Ed Paschke's paintings is exploring the influence of mass media: how films, news and fashion photography, computers, and television filter our view of the world. The portrait of Lincoln in Plate 21 resembles the cropped, close-up heads of actors we often see in movies, an effect even more apparent in front of the actual painting since the head is painted larger-than-life-size on a canvas with the elongated horizontal proportion of a movie screen. Paschke's representation of Lincoln is unsettling: the icon-like status of the president who penned the Emancipation Proclamation and oversaw the Union during the Civil War becomes, in Paschke's art, a mediated image, staring at us through the strident coloration of MTV.

Thumb through magazines looking for a range of images of figures: include images that look "fake" or distorted to you and others that appear "natural" and believable. Tape the original images or photocopies onto a sheet of paper. Underneath each image write freely as you interpret the qualities you find in the figures. What can distortions of the figure reveal about the contemporary human condition? Explore the figurative imagery in a variety of magazines, such as serious news magazines, fashion magazines, and magazines that report on the sport of body building.

In your sketchbook, respond to the visual characteristics of the images that you wrote (or will write) about. Don't try to reproduce images literally — use the sketching process to analyze and explore the images and to stimulate your own visual creativity. Your sketching might involve such procedures as: simplifying the value structure of an image, so that a pattern of lights and darks emerges with greater forcefulness; focusing in on a small detail of the whole image and enhancing what you find most compelling; altering the relationships between positive and negative shapes; working with oil pastels (or painting directly in your sketchbook with acrylics) to simplify or change an image's original color scheme, and, in doing so, create a different emotional effect or develop new symbolic meanings.

Painting Exercises

Exercise #1: *Glazing: A Media-Derived Image*
Using the glazing technique, create a painting that expresses an intense reaction to the media-saturated world we live in. Use imagery culled from magazines, books, or

newspapers to serve as reference material. (The subject matter of the painting should include figurative imagery as well as one or more objects or details from a setting.)

Start with an underpainting of oil paint thinned only with mineral spirits. For the underpainting use black (or another dark color such as burnt umber or ultramarine blue) mixed with white to define the value pattern of the composition. If available, use mars black and underpainting white or flake white for faster drying oil paints, or use acrylic paints.

Once the underpainting has dried, apply transparent glazes of color over the underpainting. Diluting glazes with Liquin will speed up the drying of the paint and result in a nonglossy surface. For a glossier surface, try diluting with a medium containing a drying oil, such as stand oil. (Refer to Chapter 2 for information about glazing mediums, p. 26, and glazing procedures, pp. 35–36.)

In selecting the glaze colors, use only transparent oil paints. To explore a color scheme we might associate with the glow of electronic imagery, distorted television, or MTV videos, use colors at full saturation. To change values, change the hue. For example, a glaze of yellow or orange may be used as the light area of a cheek, while a glaze of pure alizarin crimson may serve as the shadowed areas of flesh. Employ some color as transparent overlays in abstract patterns (such as stripes or zigzags), similar to the way an image on a television monitor on the blink might appear. (Refer again to Plate 21.) Don't mix glaze colors with an opaque white (if you must mix with white, use semi-transparent zinc white).

Use this exercise as an opportunity to explore the contrast of surfaces and color effects produced by glazing versus the opaque application of paint. Restrict yourself to using opaque paint on some areas of the underpainting, rather than glazing. (Observe how light passes through the surface of glazed colors and reflects back off the lower underpainting, so you actually see light as it passes through the glazes from behind. This produces a very different range of color effects than can be produced by opaque paint applications.)

PAINTING TIPS FOR GLAZING:

1. Give greater contrast to the underpainting than the way values appear in your source image/s, since glazing will tend to darken light values and lighten extremely dark values.

2. Areas that will contain lights or highlights in the completed painting should be left as the white of the gessoed canvas at the underpainting stage.

3. To paint rounded figures and objects, even at the underpainting stage blend slightly to create soft edges, rather than leaving as sharp outlines — this will help produce a stronger illusion of three-dimensional forms existing in space.

Exercise #2: Naked versus Nude

This exercise should consist of a series of three small paintings on square supports of equal size. If possible, work directly from two models. Your primary goals for the exercise are: to visually express a distinction of nudity from nakedness; and to explore how changes of scale and *cropping* (cutting off) the subject at the edges of the support can alter the visual impact of the composition.

Painting 1: Work from a pose in which nude models are analyzed with unemotional objectivity. Refer again to the cool detachment shown in the paintings by Pearlstein (Figure 7.3) and McCagg (Plate 22). Rather than cropping, reduce the scale of the figures to fit entirely inside the canvas.

Painting 2: Here the sensual implications of the poses should become more evident, both in the way you as the artist respond and in the way the models are directed to become increasingly conscious of their naked or partially naked state. For ideas look again at Figures 7.16 and 7.17 by Albert and Rustin. In positioning the models for this painting, explore how various poses and the addition of clothing accessories can influence the overall effect. Arrange the lighting so that you highlight parts of the models to which you want to draw attention. Enlarge the scale of the figures slightly, so that a small portion of each of their forms is cropped by the painting's border (as in the Rustin, Figure 7.17).

One approach to completing this exercise would be to explore an expressive use of colors. For example, what changes occur in the painting's meaning if green is used as the color of the skin?

Painting 3: Turn the square support on its end to create a diamond-shaped support with four sides of equal lengths (see Figure 7.3). Develop a composition that strongly implies its continuation into the four triangular areas that appear to be "missing," as if the diamond were cut from a larger square (rather than being made from the small square turned on its end). In this painting, enlarge the scale of the figures even more, exploring how the outer edges of the diamond can be used to create strong diagonals

cropping through portions of the figurative image. Because of the dramatic cropping, viewers are pushed to mentally "complete" the picture. As with Painting 2, select poses and clothing accessories that accentuate the "nakedness" of the models.

PAINTING TIPS FOR PAINTING FROM THE MODEL:

1. Most flesh has no consistent local color. Skin color is often warm in some areas and cool in others. For darker complexions, explore using complementary colors (usually orange and blue, or red-orange and blue-green) to mix the local skin color, then add white for cool highlights or work around the color wheel adding orange-yellow and a touch of white for mixing warm highlights. For pale Caucasian skin colors, start with cadmium red light, yellow ochre, and white. Cool, darken, and lessen the saturation by adding a touch of the complement or near complement (such as viridian), or move around the color wheel and add violet for cool shadows. To create warm highlights, mix in small amounts of yellow and white. For cool highlights just add white.

 These are just some suggestions to get you started. Don't rely on a strict formula for mixing skin tones. The color of anyone's flesh is easily altered by the colors around it and the lighting that illuminates it. More expressive approaches may call for skin colors that are far from "realistic."

2. Use progressively cooler colors to show planes of the figure that are receding from view at an angle.

3. Define the major planes of hair conceived as a volume before establishing specific textural details.

4. Paint features *and* the forms between features. Paint how one form joins another.

5. Create a visual relationship among the various parts of the figure and between the figure and the setting. Don't paint every leg and arm jutting forth haphazardly.

6. Inexperienced painters often make the head too large and the hands too small. Avoid those tendencies (unless they are being exaggerated purposefully for experimental purposes). It is more often effective — for formal and expressive reasons — to distort in the other direction, by painting the head a tad too small and the hands a tad too large. This helps create a balanced interest in the entire gesture and pose of the figure, and compensates for the natural human tendency to focus most viewing attention on the face.

7. Don't approach painting a person as only a challenge to create a pictorial illusion of a complex three-dimensional form. Remember: When you paint a figure from life, *you are painting a person — a human being as alive as anyone ever was or will be.*

EXPLORING MORE TECHNIQUES

The forms in a painting are produced by the application of techniques in the manipulation of materials. This occurs at any level of producing form: the creation of formal elements (lines, shapes, and so on), the representation of the forms of any subject matter, and the development of the overall form, called composition, of the entire painting. In this section we introduce some additional techniques that can be used to explore the articulation of form and light, and the representation of figurative subjects; these same techniques, of course, can also be employed in orchestrating any of the formal elements and in the production of paintings of any subject.

Collage

The technique of *collage* involves the addition of "nonart" materials onto (or within) the face of an artwork. Used widely by artists in the twentieth century (Pablo Picasso and Georges Braque are generally credited as the first painters to use collage), collage has proven to be a wonderfully flexible strategy. It expands the painter's formal vocabulary by allowing for the incorporation of materials with widely different textures, shapes, thicknesses, reflective properties, and coloration. Collage expands the potential for cognitive meaning, especially as a technique that seems inevitably to call into question the boundary between an artwork and reality. For example, if an artist glues portions of a newspaper onto her canvas, and then paints around and upon the newspaper, does the completed artwork still contain fragments that function as bits of "real" newspaper or are they transformed into something else as they become parts of an artwork?

Whether collage elements become changed beyond recognition or remain virtually intact and untouched, their incorporation into a painting inevitably becomes integral to the painting's meaning. For example, Raymond Saunders' utilization of collage materials results in a portrait (Figure 7.7) which, according to one interpretation, reveals its subject "as a black chimera, placed

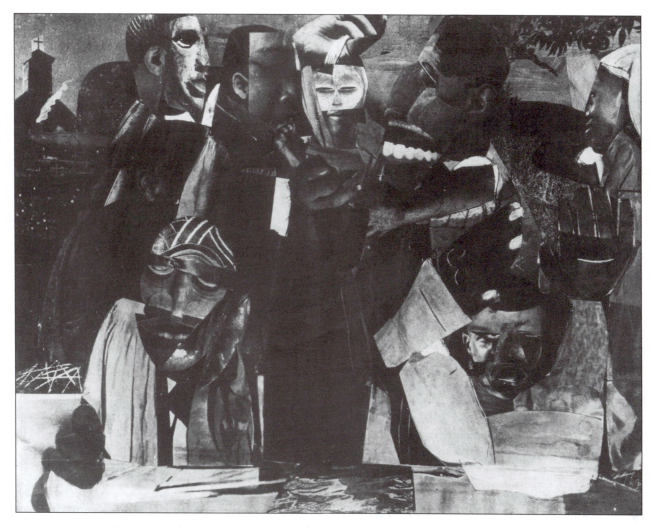

7.20 Romare Bearden, *The Prevalence of Ritual: the Baptism*, 1964. Collage on masonite, 37″ × 48¹⁄₁₆″. © Romare Bearden Foundation/Licensed by VAGA, New York.

against a red backdrop and 'identified' by airline luggage tags, crayon erasures, foreign stamps, and advertising labels."[2] Without the addition of real luggage tags, stamps, and so on, the painting would be something else entirely.

As noted earlier in the chapter, some artists utilize photographs and images cut from newspapers and magazines as collage material. Employing a range of materials, painter Romare Bearden produced an extensive series of collages depicting aspects of African American life in the middle of the twentieth century. Many of the collages, such as *The Prevalence of Ritual: The Baptism* (Figure 7.20), focus on Bearden's understanding of the importance of rituals in the lives of blacks living in the rural South. The

collaged image of the train in the upper left of the composition we illustrate symbolizes both the intrusion of new technology and the migration of southern blacks to the urban North.[3] Bearden's dramatic use of collage materials allows the artist to fracture his figures and the surrounding space in ways which echo both European Cubists as well as the art of Africa from which the Cubists themselves drew inspiration.

More Brushstroke Techniques

Some painters employ a technique of making brushstrokes that are highly ordered in their application.

Simmons-Jimenez employs a *hatching* technique in Figure 7.15, in which short, individual brushstrokes are applied parallel to one another; the hatching is visibly aligned along a diagonal that ascends from the lower left to the upper right of the canvas. An exception occurs where the artist painted the figure with brushstrokes that follow around the form (in a technique known as *cross-contour*). Other systematic applications of brushstrokes are evident in the modified pointillist technique of Chuck Close (Plate 14). Refer back to the discussion in Chapter 5 for further discussion of Close's technique.

Broken brushstrokes (sometimes referred to as *broken color*) involves the application of paint in layers so that the open spacing between strokes allows portions of underlying brushstrokes to remain visible. To utilize this technique successfully, a painter needs to anticipate or gauge the effect of subsequent colors in combination with those applied earlier. The wall in Plate 22 by McCagg is an example of broken color.

Wiping-out Technique

The wiping-out technique consists primarily of *subtracting* paint to create an image. Begin by covering the area you plan to complete in one session with a thin layer of oil paint. For Figure 6.6 (illustrated in the previous chapter), Mark Tansey, who specializes in the wiping-out technique, selected a neutral brown that evokes the sepia tone of an antique photograph. For toning the support, use a color with a value in the middle of the value range. After the surface is evenly covered, remove wet paint in order to: a) create lights and highlights; and b) produce a representation of varied textures. For the removal process, a rag dipped in a little solvent is useful for wiping out light areas. Use a clean scouring pad or steel wool to rub away even more paint. To create the look of textured surfaces, experiment with a variety of tools. Tansey uses everything from paintbrushes to carved wood to knotted string to lace, each tool producing a different texture. The goal is to create visual variety through the interaction of textures rather than colors — to discover which materials can be used to mark, wipe, scratch, imprint, or remove paint to create the illusion of texture in the image.

Illuminated areas are produced by removing paint and revealing the white gesso ground; no white paint is applied over the monochromatic paint you used for toning. Corrections can be done by repainting an area with white, allowing the white to dry, then adding the original toning color, and, while the color is still wet, proceeding

with more wiping out. Aerial perspective is created by blotting and smudging partially dried paint. Once the paint has dried, minor adjustments can be made by glazing certain areas, adding dark accents, or scratching in highlights.

Painting Exercises

Practicing Techniques

Wiping-out Technique
Experiment with a wiping-out painting technique, working from a studio setup with directed lighting, posed model(s), and props showing a range of textures — including shiny materials, shaggy surfaces, and so forth.

Practicing Different Approaches to Making Brushstrokes
As a practice exercise, paint a figurative image divided into four quadrants. In each quadrant, utilize a different technique of producing brushstrokes. In at least one quadrant, try inventing a new approach to making brushstrokes (your approach might involve the use of a new type of "paintbrush" which would deposit paint in a different way, or a new pattern for organizing the brushstrokes across an area). In the remaining quadrants, utilize any of the techniques discussed in the book so far — such as hatching and cross-contour (Figure 7.15), blended brushstrokes (Figure 7.16), broken brushstrokes (Plate 22), the flat application of paint (Figure 7.4), the modified pointillism illustrated in Plate 14, and dynamic brushstrokes (dynamic brushstrokes are introduced in Chapter 5). Observe how each technique of applying paint produces its own effect on the overall content.

Collage Figure Study
Adhere a selection of collage elements of varying thicknesses onto several painting supports. Make figure studies across the surface of the painting and collage materials. After completing the figure studies, continue working on each artwork, attempting to build formal and cognitive "bridges" which further link the collage materials within the structure of each overall composition, paying attention to such formal elements as line, shape, value, and texture. For example, can a pattern found in a collaged fragment of a newspaper advertisement be made to "flow" into a painted pattern?

MORE EXPLORATION OF FIGURATIVE MEANING

Human Relationships

When you make a painting of more than one figure, you may want your composition to express something about the psychological and emotional connection between them. You can imply the kind of relationship that exists between figures through pose, gesture, setting, lighting, and other clues. Of particular importance is the position of the bodies in relationship to one another, including whether and how they are touching, and how the bodies are turned. Look at Claire Klarewicz-Okser's *The Return #6* (Figure 7.21). What can you decipher about the relationship between the two women by their pose and gestures? One woman's hands hold and frame the other's face; their bodies are locked into a single vertical shape centered in the composition.

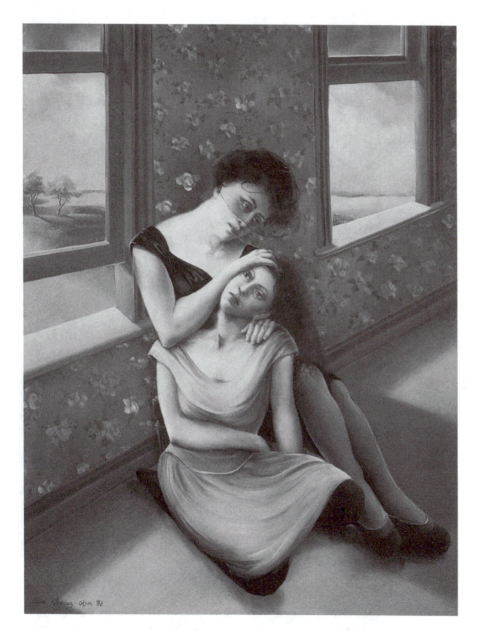

7.21 Claire Klarewicz-Okser, *The Return #6,* 1986. Oil on linen, 52″ × 40″. Courtesy of the artist.

Sometimes a painter means to suggest that the lives of figures are closely bound together (parents and children, lovers, friends, person and pet, or rivals or enemies). Other times a painter may be depicting strangers, who nevertheless interact for a brief time in some kind of content-filled relationship. For example, the figures in Amy Horowitz's painting *Elevator* (Figure 7.22) are confined together within a claustrophobic enclosure. Judging by her defensive posture and expression, the woman feels everything is much too close for comfort. A concave overhead mirror gives us a glimpse of another (perhaps the male's) point of view; in the mirror the interior stretches out of reach. The portrayed relationship of these two people may, in the artist's opinion, be emblematic and symptomatic of male/female relationships throughout society — relationships in which the female may be on guard against a more powerful male counterpart.

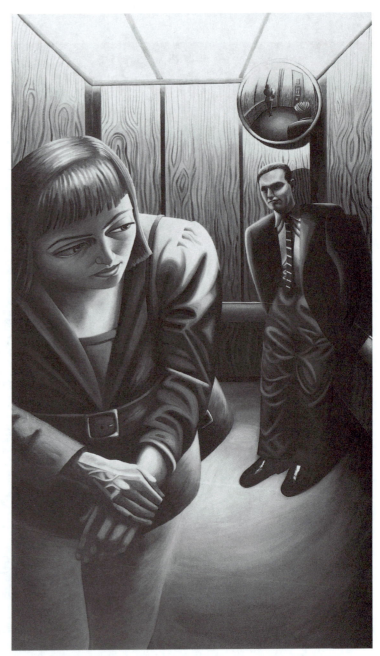

7.22 Amy Horowitz, *Elevator,* c. 1997. Oil on canvas, 72″ × 42″. Courtesy of the artist.

Journal and Sketchbook Exercise

Personal Relationships

Think about relationships you have observed between significant people in your life separately from their relationship with you — between your siblings, parents, other family members, friends, and teachers, in any combination. Select one of the relationships to concentrate on. (This will probably be simpler if you select just two people.) How complicated is their relationship? Is the emotional register constant or do their attitudes toward each other change frequently? How do they act when they are around each other? Can you remember any characteristic body language they display in each other's company? Write spontaneously describing what you think characterizes the relationship between these people. Pay particular attention to any visual memories which provide clues to their relationship, such as facial expressions, the way they stand or sit when they are talking to each other, and whether or not and how they touch each other. When you have finished, reread what you have written.

If you were going to make a painting of the people together, how would you portray them in order to convey an interpretation of their relationship? Draw sketches of possible compositions, indicating the gestures of the figures and the negative spaces between them. Pay attention to how the sketching process itself may reveal new possibilities for formal and cognitive meaning, meaning which the journal writing process may not have explored or uncovered. Part of your challenge as an artist is to discover how the visual and technical means at your disposal influence (and to some extent may even dictate) the content that an artwork embodies.

After having completed some sketches, write again in your journal, responding to the differences in meaning between the visual and written portrayals.

Painting Exercise

Family Portrait

Directions: Paint an imaginary group portrait of members of your own family, using expressive poses to explore the personalities involved and the relationships between the various figures. Avoid a simple lineup of figures in a row, like a school photograph. Look at the family portrait by

Tanning (Figure 7.2) and other group compositions throughout this chapter.

All portraits are incomplete in the sense that any person has more than one appearance and mood. In the everyday world we gather an impression of someone over time. Nevertheless, a portrait that focuses on one major aspect of a person's temperament or personality can be highly effective.

In completing this portrait of more than one person, aim to give each individual more or less equal prominence while creating a composition that is dynamic. Note how Klarewicz-Okser's image (Figure 7.21) expresses a profound connection between the two women and, furthermore, expresses a bond between the women and the architectural setting by aligning the upper figure's right arm with the diagonal thrust of the windowsills.

Painting Exercise

Reviewing Strategies and Concepts

This chapter may be thought of as the final chapter in an informal grouping of chapters which constitute the second of the book's three sections. In addition to expanding our study of painting with new strategies and concepts, the chapter should also serve as an opportunity to review all that has been presented so far, and to integrate the new strategies and concepts introduced here with those that came earlier in the development of paintings and preliminary drawings of any and all types of subject matter. We list some suggested exercises that may be followed:

1. Use strategies for creating effects of light as you make a series of sketches or small-scale paintings of the same outdoors scene at different times of day, and in different weather conditions.
2. Set up objects in still-life arrangements and sketch and paint them with the goal of discovering and enhancing contrasts of light and shadow. Experiment with unusual lighting conditions, such as lighting an arrangement with flashlights, or a single spotlight directed up at the arrangement from below.
3. Explore how changes in the treatment of light can alter the emotional mood of paintings of the self. Keep the pose constant, while you alter the arrangement and quality of the darks and lights in a series of quick self-portrait studies. Develop arrangements where the pattern of darks and lights of the positive shapes are

interconnected with the pattern of darks and lights of the negative shapes.

4. Use the techniques of glazing and/or collage to create studies of still-life arrangements. Organize the placement of collage materials or the articulation of color effects (created through glazing) to control the path and pace of a viewer's eye through the composition.

Recommended Artists to Explore

Jan van Eyck (1380–1441)

Piero della Francesca (1416–1492)

Michelangelo Buonarroti (1475–1564)

Hans Holbein the Younger (1497–1543)

Peter Paul Rubens (1577–1640)

Artemisia Gentileschi (1593–1653)

Jean-Auguste-Dominique Ingres (1780–1867)

Edgar Degas (1834–1917)

Thomas Eakins (1844–1916)

Mary Cassatt (1845–1926)

Henri Matisse (1869–1954)

Paula Modersohn-Becker (1876–1907)

Pablo Picasso (1881–1973)

Rufino Tamayo (1899–1991)

Alice Neel (1900–1984)

Wilfredo Lam (1902–1982)

Francis Bacon (1910–1992)

Romare Bearden (1911–1988)

Jacob Lawrence (b. 1917)

Lucian Freud (b. 1922)

Philip Pearlstein (b. 1924)

Nancy Spero (b. 1926)

Jean Rustin (b. 1926)

Fernando Botero (b. 1932)

Sidney Goodman (b. 1936)

Emma Amos (b. 1938)

Ed Paschke (b. 1939)

David Salle (b. 1952)

Cheri Samba (b. 1956)

Shahzia Sikander (b. 1969)

1. Quoted in *ARTnews*, Vol. 97, No. 2 (February 1998): 86.
2. Richard J. Powell, *Black Art and Culture in the 20th Century* (London and New York: Thames and Hudson, 1997), p. 126.
3. John A. Williams, "Introduction," in *The Art of Romare Bearden: The Prevalence of Ritual* (New York: Harry N. Abrams, Inc., 1972), p. 16.

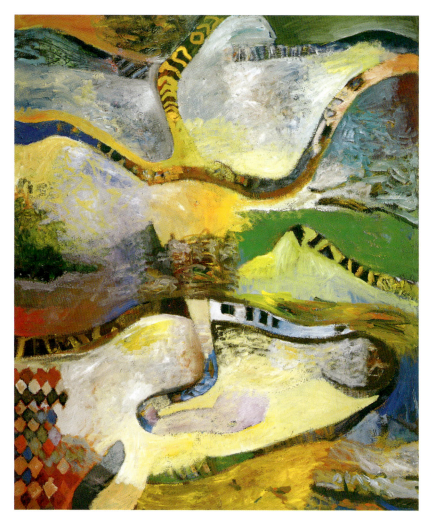

Plate 17 Mario Martinez, *Serpent Landscape II*, 1993–94. Acrylic on canvas, 60″ × 49½″. Courtesy of the artist and Jan Cicero Gallery, Chicago.

Plate 18 David Hockney, *A Visit with Christopher and Don, Santa Monica Canyon*, 1984. Oil on two canvases, 6′ × 20′. © David Hockney.

Plate 19 Peter Doig,
Night Fishing, 1993. Oil
on canvas,
200 cm. × 249 cm.
Courtesy of Victoria
Miro Gallery, London.

Plate 20 Jane Asbury, *Secrets,* 1987. Acrylic and sand on
watercolor paper laminated on a panel, 31″ × 23″. Courtesy of the
artist.

Plate 21 Ed Paschke,
Libredo, 1987. Oil on linen,
68″ × 80″. Collection of
John L. Stewart, New York.

Plate 22 Emma McCagg, *Patrick*, 1996. Oil on canvas, 94″ × 72″.
Courtesy of the artist.

Plate 23 Colette Calascione, *Two-Faced Portrait,* 1997. Oil on wood, 14″ × 12″. Courtesy of the artist.

Plate 24 Jennifer Bartlett, *Sea Wall*, 1985. Oil on canvas and constructed objects. September 12, 1985, Installation: Carpenter & Hockman Gallery, Dallas, TX.

Plate 25 Pat Steir, *The Brueghel Series (A Vanitas of Style)*, 1982–84. Oil on canvas, sixty-four panels, each panel $28\frac{1}{2}'' \times 22\frac{1}{2}''$. Courtesy of the Pat Steir Studio.

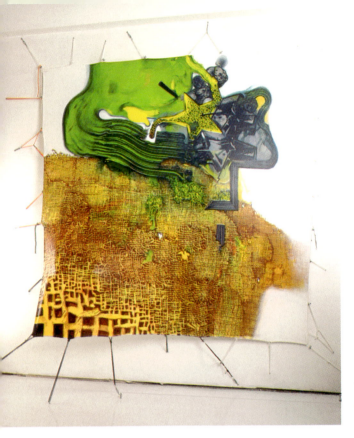

Plate 26 Fabian Marcaccio, *New Ground Management*, 1997.
Water- and oil-based paint on canvas, copper tubing and
nylon ropes, dimensions variable. Courtesy of Gorney,
Bravin + Lee, New York.

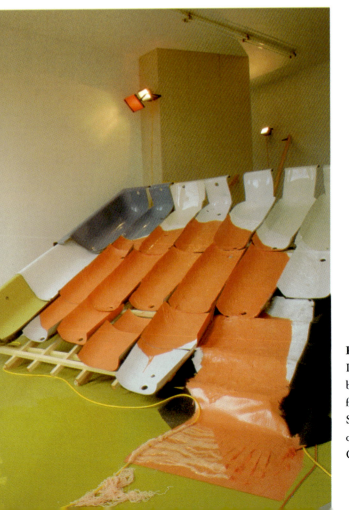

Plate 27 Jessica Stockholder, *Catcher's Hollow*, June 1993.
Installation at Witte de With, Rotterdam. Indoors: paint,
bathtubs, lumber, silicone caulking, lights and wires, colored
filter paper, transparent tape over and under paint, yarn.
Space is 26′ × 49′ × 4¼′ Outside (on neighboring rooftop):
cable antenna painted green together with a quartz light.
Courtesy of Gorney, Bravin + Lee, New York.

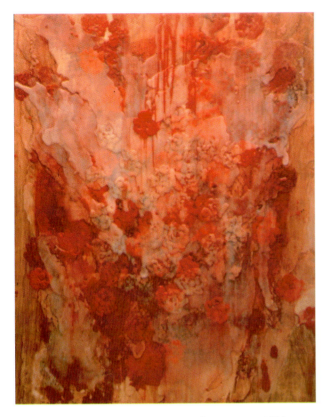

Plate 28 **Sabina Ott**, *Disappearance and Return: #17*, 1990. Oil and encaustic on mahogany panel, 60″ × 48″. Private collection.

Plate 29 **Fred Tomaselli**, *Collection*, 1992. Acetaminophen, aspirin, antacid, saccharin, wood, Sudafed, acrylic, and resin. 48″ × 48″ × 2″. Fred Tomaselli, Collection, care of the Jack Tilton Gallery, New York.

Plate 30 **Carole Caroompas**, *Before and after Frankenstein: The Woman Who Knew Too Much: Bedside Vigil*, 1992. Acrylic on canvas, 96″ × 108″. Courtesy of the artist and Mark Moore Gallery, Santa Monica, CA.

Plate 31 Arnaldo Roche-Rabell, *For the Record: The Eleventh Commandment*, 1990. Oil on canvas, 96″ × 96″. Collection: Dr. and Mrs. Alfred Cisneros, Elburn, IL.

Plate 32 Kerry James Marshall, *The Lost Boys,* 1993. Acrylic on canvas, 104″ × 120″. Collection: Principal Financial Group, Los Angeles.

Expanded Forms and Ideas

"There is no reason not to consider the world one gigantic painting."
— Robert Rauschenberg[1]

"Painters today find themselves curiously liberated. . . . Quarrels which vexed earlier artistic generations — among them those of abstraction versus figuration, or invention versus observation — seem in their dogmatic posturing to have little to do with the wealth of creative intelligence that characterises art today."
— Henry Meyric Hughes and Greg Hilty[2]

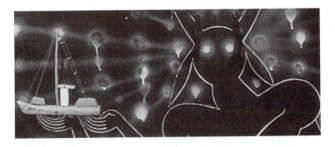

INTRODUCTION TO EXPANDED FORMS AND IDEAS

Most of the paintings you have made so far in this course of study have been *easel paintings*. The term once referred to all paintings on portable supports, which were typically placed on an easel as they were being painted. The practice of easel painting was initiated over 500 years ago in the early Renaissance in Europe. Before that, most paintings in Europe were designed for specific locations, intended to remain with the building or other place where they were created. Many paintings were made directly on walls or ceilings, and hence were immovable. In fact, painting on supports of various materials and shapes not only predates the easel painting tradition in Europe but varies widely around the world. Examples include Paleolithic cave paintings in prehistoric Europe (Figure 1.1), folded screens and scrolls in ancient China and Japan, papyrus scrolls in ancient Egypt (Figure 7.1), murals painted on walls of Roman architecture, painted wooden altarpieces in medieval Europe with opening and folding wings, painted masks of pre-Columbian societies, illuminated manuscripts in India and Asia Minor, and painted folk art in colonial America.

By the late fifteenth century many European painters turned to easel painting, using canvas or other woven fabric tightened across wooden stretchers as their preferred support, and oil paint as their favored medium. (Prior to the development of oil paint, the two favored painting media in Europe were tempera on wooden panels and fresco painting on walls.) Since that time, easel painting on flat, rectangular supports of stretched canvas has been the dominant form of painting among artists in the West, including the United States. During the latter part of the twentieth century, easel painting with oils and acrylics also achieved a measure of cultural prominence in societies around the globe, including many in Africa, South America, Asia, Australia, and India.

Not only have you been painting on flat, rectangular supports so far for most of the exercises in this book, but you have devoted much attention to the visual observation of actual objects and figures, and the translation of your perceptions into paint. We have also asked you to pay attention to the cognitive content of your paintings — the messages you want to convey — but we have not asked you to think about content in a theoretical way, as something that might be motivated by philosophy or psychology or science or ethics or other bodies of shared knowledge.

The approach we have taken to this point has been intended to help you begin learning aspects of the language of painting, including becoming familiar with various materials, techniques, visual elements, and principles of composition. Becoming fluent in the language of painting is necessary if you want to become a serious painter,

whether you continue to paint from life based on visual observation (as many excellent painters working today still endorse), or whether you become more preoccupied with invention, exploration, and symbolization of ideas. Moreover, a focus on ideas still might involve closely observed and carefully crafted representations of visual appearance, so your development of skills at observation and representation could be relevant in that way also. For example, in Figure 8.1 Kevin Wolff has used his illusionistic painting skills to create a disembodied, mirrored image of an arm and hand flashing a gang symbol — a marriage of "traditional" skill and current cognitive meaning.

Throughout the twentieth century and now leading into the twenty-first century, an explosion of fresh ideas and approaches have reshaped painting. In the United States much of the inspiration for expanding definitions of painting has come from the rich cross-fertilization of artistic traditions and ideas among the various peoples from different parts of the world who have met and mingled here. In addition, the proliferation of information technology has vastly increased knowledge of the variety of painting practices throughout history and in places far from the United States, offering even more alternatives.

In this chapter, we first explore some of what we call *expanded forms*. An expanded form painting differs from an easel painting in terms of the condition of its material presence. It might have a curved or broken surface; it might be a portion of an architectural site; it might be nongeometric; it might have multiple parts; it might have temporal, kinetic, or sculptural components; it might have monumental (or miniature) proportions; it might not embody a physical presence; it might not be painted; it might have several or all of these characteristics. For example, Janine Antoni created *Loving Care* (Figure 8.2) by painting ("mopping") a gallery floor with hair dye soaked into her own hair, thus creating an artwork which combined painting with performance.

8.1 Kevin Wolff, *Gang Signal II*, 1992. Acrylic on canvas, 40″ × 68″. Courtesy of the artist.

8.2 Janine Antoni, *Loving Care*, 1993. The artist soaked her hair in hair dye and mopped the floor with it. Performance at Anthony D'Offay Gallery, London.

Following our discussion of expanded forms, we look at what we are labeling *expanded ideas*. The ideas we will explore are some of those that have served prominently as the fuel for artistic change, redefining aspects of the practice of painting during the last few decades.

CRITERIA FOR JUDGING PAINTINGS

Some of the expanded forms and ideas that inspire artists today challenge conventional assumptions about what makes a painting valuable or "good." Before delving into these expanded directions, we ask you to pause and consider the kind of critical judgments you apply right now to evaluate paintings. In the journal and discussion exercise in this section, we ask you to take a hard look at your own assumptions about what a painting is and what makes you prefer one painting over another.

Anyone who looks at a painting is involved in passing judgment to some degree. At the most basic level, deciding whether to move on or to continue looking at a painting implies a judgment about its worth. A viewer measures a painting in terms of standards, whether these have been carefully defined or thoughtlessly presumed. Critical judgments may be assessed by a professional art

critic, an instructor, a painter gauging her own progress, a fellow art student participating in a class critique, or a member of the general public who looks at a painting and decides whether or not she thinks the painting is any good or, for that matter, is even a work of art at all.

Journal and Discussion Exercise

Criteria for Judging Paintings

Do you know what criteria you use to evaluate paintings? Do you employ a consistent set of criteria for judging the success or effectiveness of all paintings, or do you shift criteria depending on the artwork under scrutiny? Do you use different criteria for your own paintings compared to those by another artist?

1. Examine the illustrations for paintings by the following artists:
 Painting A: Max Beckmann (Figure 5.1)
 Painting B: Colette Calascione (Plate 23)
 Painting C: José Bedia (Figure 8.3)
 Painting D: Yourself, using a self-portrait or figurative painting
2. For each painting, select the three most pertinent criteria from the list below in the order you believe best approximates how you would employ them in judging the merits of each painting. Your top three criteria will not necessarily be the same for each of the four paintings.
 - excellence of form (e.g., balance, unity, harmony)
 - expression of beauty
 - creative originality
 - importance to society
 - excellence of craftsmanship

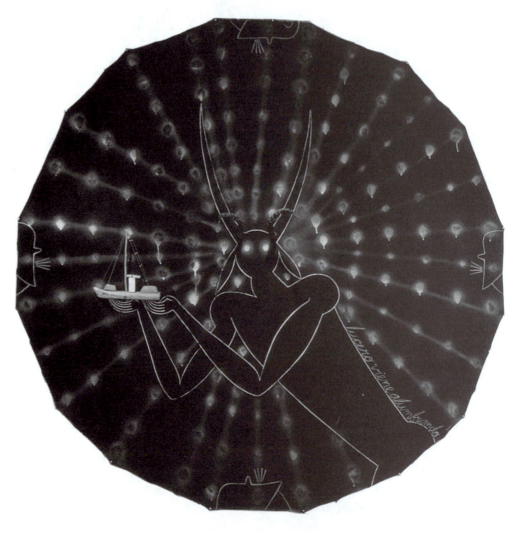

8.3 José Bedia,
Lucero viene alumbrando
(*Star Comes to Light the Way*), 1992. Acrylic on canvas and found objects, $109\frac{1}{2}'' \times 112'' \times 4''$. Irregular tondo. Collection Carlos & Rosa de la Cruz.

- labor and time involved in creating
- excellence compared to other works by that artist
- intensity of emotional expression
- capturing a realistic likeness
- accuracy in documenting history
- appeal of the subject matter
- distinctiveness of style
- conceptual content
- monetary value
- other(s)?

3. Write a paragraph in your journal exploring whatever thoughts occur to you about the process of evaluating paintings — analyzing what criteria you use, and whether or not you are consistent in your use of criteria from one painting to the next. Speculate on how you think you developed your attitudes and knowledge about your criteria for judging a painting.

4. *Discussion topic:* Passing critical judgment on a painting may involve a complex, multilayered process. In addition to measuring the success of a painting in terms of the viewer's personal criteria (the focus of steps 1, 2, and 3 above), the viewer may also wish to assess the artist's purposes and intentions for creating the painting and gauge how fully the painting succeeds in achieving these.

Locate illustrations of artworks in this text or other publications in which it seems to be especially important to take into account the artist's purposes for making the painting. Be prepared to discuss your selections in class.

EXPANDED FORMS

In Chapter 1 we asked, What is a painting? To some extent, we begged the question by turning it into the related question, What is a painting made of? In answer to this question, we identified four aspects of a painting — materials, techniques, form, and cognitive meaning — all of which contribute to a painting's overall content.

Here we return to our original question, What is a painting? Now we ask, What does a painting look like? If we base our answer on only those examples that we have illustrated in previous chapters (overlooking just a few exceptions), we might conclude that a painting is a work of art on a support that is rectangular, movable, singular (it is constructed as one cohesive unit), and

bears a visual image that is painted, handmade, and static (the image doesn't move). While most paintings being made today in the United States are rectangular, movable, and handmade, numerous painters are also experimenting with other forms of painting. We chart the development of these expanded forms for painting as the outgrowth of four developments.

First, as the twentieth century began, advanced painters in Europe and the United States were becoming less interested in emphasizing painting as an art of representation. Increasingly, painters considered their paintings to be *objects* in their own right rather than *illusions* of the painted subject matter. Over the course of the twentieth century, this shift in how a painting was *looked at* resulted in a progression of shifts in how a painting *looked*. Some artists began experimenting with unusual forms in order to remove their paintings from any association with a rectangular window and to emphasize their "objectness." A new range of options for painting opened, a range which we are calling expanded forms. As the twenty-first century begins, a painting's support and its physical structure now seem open to the widest parameters imaginable.

Secondly, widening the possibilities of painting into expanded forms is actively pursued by artists interested in challenging Eurocentric hegemony. Because easel painting was a European invention, it can be viewed as a symbol of European colonization of other cultures; for some painters, using forms borrowed from other cultures or from European history before the Renaissance is a way to show a broader appreciation of global history.

Thirdly, increasing numbers of painters living and working in the United States originate from non-European places that do not have an easel painting tradition, and have not attended art schools that teach easel painting. When these painters make expanded form paintings, they are not rebelling against easel painting because they never practiced the tradition to begin with. More likely they are building on and updating forms of painting from their cultures of origin.

Finally, a hierarchy that says certain paint media are "better" than others (for example, that oil paint is superior to watercolor) seems biased and no longer tenable. While we have focused on the use of oil paints, we want to assert that paintings can involve the use of a range of materials restricted only by one's imagination. In the contemporary period, the exploration of a broad range of materials for painting — including materials other than paint — has been undertaken for the very reason that different materials evoke different meanings. (Remember: one of the bedrock premises of this text is that materials

are one of the four basic aspects contributing to a painting's content.) Antoni's painting created on the floor with hair dye (Figure 8.2) suggests different associations than a painting made with delicate washes of ink on a silk scroll. Hair dye and ink each embody a very different physicality than, for instance, thick globs of oil paint applied onto a mattress. In Chapter 9 we even show a painting made with pharmaceuticals (Plate 29).

Breaking the Rectangle

Painters have developed a range of approaches that break free of the rectangular shape (of course, some painters were never restricted to a rectangle in the first place). Below, we describe a few among the many types of expanded forms that various artists today are working with, and offer studio exercises to give you practice in trying some of the forms. We are particularly interested in expanded forms which retain some or all of the following "painterly" qualities: color, the use of paint, and pic-

torial elements. First, we look at some of the qualities of life in the contemporary world that are reflected in this interest in expanded form paintings.

Fragmentation

One of the key characteristics of contemporary culture is *fragmentation*. In the United States and other complex societies inundated with information technology (including telephones, televisions, and computers), our daily lives are filled with a constant bombardment of images and information. In just a few minutes we might see and hear hundreds of snippets — snippets that are taken out of context and typically are unrelated to one another. (Think of clicking rapidly from one television station to another, seeing a few seconds of a movie, a flash of a news story, a bit of an infomercial.) This way of experiencing the world as a disconnected series of rapid impressions began over a hundred years ago with the rapid growth of cities and modern inventions, but the pace has accelerated enormously over the past few decades.

8.4 Hung Liu, *Raft of the Medusa,* 1992. Oil on canvas with lacquered wood and mixed media, 61″ × 96″ × 8½″. Eric and Barbara Dobkin Collection.

Today, innumerable fragments of information that do not really "belong" together compete for our attention. The resulting visual and conceptual static makes it difficult or impossible to decipher a coherent, stable meaning from the fragments.

Not surprisingly, over the past century artists have been developing art techniques that reflect this fractured way of receiving images and information in the everyday world. Particularly significant are *collage* and *assemblage*, both developed in Europe around 1912. Collage involves creating an artwork by affixing various materials, such as pieces of paper, fabric, and photographs, to a flat surface. Assemblage, the three-dimensional counterpart to collage, involves grouping an ensemble of objects and materials. Often the components are attached, using techniques such as nailing and gluing; sometimes they are merely placed near one another. Hung Liu's *Raft of the Medusa* (Figure 8.4) is an assemblage which juxtaposes an oil painting on canvas, a shelf, and wooden bowls. There are many variations of collage and assemblage, and both techniques may involve the use of paint.

In collages, assemblages, and other works composed from fragments, artists leave it to viewers to try to piece together some kind of meaning by looking for relationships among parts, versus the approach of developing a unified rectangular image and a singular meaning in paintings. (An extreme instance of a unified image and meaning in painting is conformity to the central vanishing point of linear perspective, a convention which emphasizes a single, undeviating point of view.) In some cases it is fairly easy to interpret a fragmented artwork because the artist has related the pieces through shared imagery, colors, style, and so on; in others, the meaning is a complicated puzzle because the separate components seem to come from different universes.

One example of a fragmented artwork is Elizabeth Murray's assemblage *Painter's Progress* (Figure 8.5), in which the artist has rendered a broken-up image of an artist's palette and brushes across nineteen irregularly shaped canvases. Prominent gaps give the shattered image the look of a jigsaw puzzle that does not fit perfectly together. Another example is shown in *Part Two* (Figure 8.6), one of a series of artworks by Craig McDaniel exploring aspects of tensions arising from the aging process and the battle to retain one's memory. Functioning like a rebus, the artwork combines twelve separate painted canvases. On some, visual images take the place of words within the flow of an autobiographical text. The artwork resists efforts to decipher a single, coherent meaning

8.5 Elizabeth Murray, *Painter's Progress*, 1981. Oil on canvas in nineteen parts, overall 9'8" × 7'9". The Museum of Modern Art, New York. Acquired through the Bernhill Fund and gift of Agnes Gund.

from the disparate components. Like many other contemporary artists who make fragmented works, McDaniel purposely did *not* integrate all the elements. This kind of fractured mixture of images and information is how many of us—and especially people struggling with various forms of dementia—experience at least part of our world on a daily basis.

Hybrid Forms

Closely related to fragmentation, another key characteristic of contemporary culture is its *hybrid* nature. Current thinking does not subscribe to grand categories and unified theories. Many people today oppose Western dualistic ways of thinking, which attempt to place people, objects, and events into fixed "black-and-white" categories: old versus new; public versus private; male versus female; nature versus culture. In contrast, today many people believe that meanings are not so easily defined and fixed, that categories are unstable, and their boundaries

8.6 Craig McDaniel, *Part Two,* 1999. Oil and acrylic on canvas in twelve parts, overall approximately 8′ × 10′. Installation at Jan Cicero Gallery, Chicago.

are blurred and shifting. For instance, theorists argue that "nature" and "culture" have become so inextricably mixed up that we can no longer easily separate them. Farm animals have been genetically engineered to have culturally desired characteristics; children keep "virtual pets" that have life cycles; and so on. (Of course, in some societies nature and culture have always been intertwined philosophically and spiritually.) As another example, a person might understand him- or herself as being a hybrid in terms of ethnic identity — a mixture of white, Native American, and black, let us say —and resist attempts by society to be labeled within just one category. (In Chapter 11 we look at how some artists are making paintings about their own identity defined along a variety of social variables.)

Reflecting the hybrid character of culture, more and more works of art are no longer easily defined as one type rather than another; some are hard to put a name to at all. Murray's fractured palette (Figure 8.5) is painted and has many pictorial qualities, but it projects off the

wall like a sculptural relief and almost none of its separate canvases are shaped like conventional rectangular paintings. Hung Liu's assemblage (Figure 8.4) likewise occupies a zone between two and three dimensions. Antoni's *Loving Care* (Figure 8.2) is a hybrid between painting and performance art. Many of the other artworks illustrated in this chapter are also hybrids —part painting and part something else. Some mix paint with other media while remaining basically flat; others move into space like sculpture.

Painting Exercises

Expanded Form Paintings

The following exercises share the same primary goal: to explore what a painting can look like and what it may mean once an artist allows him- or herself the freedom to

overstep the boundaries of the rectangular, static image created from familiar painting materials.

Option 1: Exploring shaped supports and nontraditional supports

Use a piece of plywood (or other suitable material) to create a shaped support for a painting. Plan a support that is nonrectangular — the shape may be representational or abstract. After drawing in the perimeter of the shape, cut carefully along the outer border of the shape with a band saw or portable jigsaw. Gesso both sides of the support. Create a painting that relates to the shape of the support. Incorporate other materials as needed. As an example, look at Jonathan Borofsky's *Running Man at 2,550,116* (Figure 8.7), which is painted on a piece of plywood cut into the shape of a figure. (Figure 8.8 shows the same artwork installed in an exhibition at the Los Angeles County Museum of Art. Note how the dynamic pose of Borofsky's painted figure, placed within the museum setting, seduces such "nonart" elements as a nearby architectural column into becoming part of the art.)

For an alternative approach, paint on an object found or procured for that purpose. Contemporary painters have employed a wide range of objects as supports — including mattresses, shopping bags, items of clothing, and pieces of furniture. The challenge is to create a painting in which the shape of the support enhances or contributes to the overall content of the artwork.

8.7 Jonathan Borofsky, *Running Man at 2,550, 116,* 1978–79. Acrylic on plywood, 89½″ × 110¼″. Courtesy of Paula Cooper Gallery, New York.

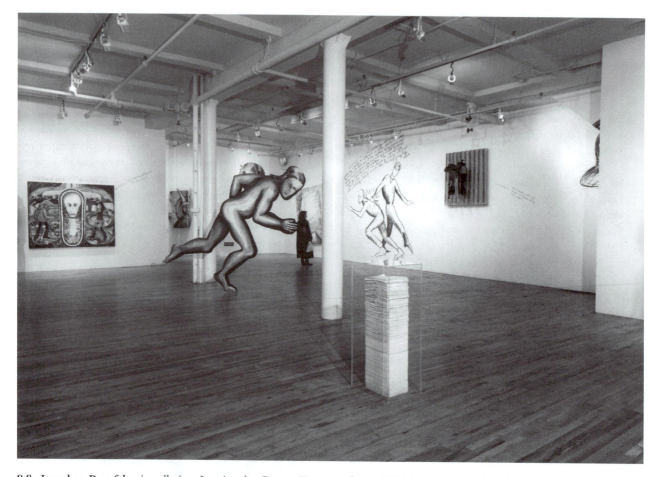

8.8 Jonathan Borofsky, installation, Los Angeles County Museum of Art, 1981. Paint and mixed media.

Option 2: Making a multiple-parts painting

Create a painting that has two or more separate "pieces." For the multiple parts of the support, shapes of plywood can be painted directly or covered with canvas. Coat the canvas with acrylic gloss medium, then press the canvas flat, adhering it to one side of the plywood; at the same time coat the reverse side of the plywood with acrylic gloss medium so the support doesn't warp. Allow the two sides to dry simultaneously. Gesso all canvas and wood surfaces you plan to paint.

Artists have explored various approaches to this challenge. Murray's nineteen-part painting (Figure 8.5) depicts a painter's palette; Jane Hammond's two-part painting *Sore Models #4* (Figure 8.9), looks like a pair of fortune teller's hands decorated with arcane symbols, including eyes, flowers, and a puppet. *A Man's Head* (Figure 8.10) is an example of a multiple-part folding screen created by Tom Judd.

As the artist explains his creative process, *"A Man's Head* did not start out as a screen. It was part of a series of painted plywood cut-outs I was working on at the time . . . I put the hinges on as an easy way to join the two main sections of wood. As I did this I noticed that, if I put the two sections at an angle, the piece would stand freely on the floor, as opposed to being mounted on the wall as it was originally conceived. Suddenly it was a screen."[3]

In conceiving and executing your own multiple-part painting or screen, create an image that actively extends into the surrounding space (as Figure 8.10 does) or creates a dynamic interplay across the space between the parts (as Figures 8.5, 8.6, and 8.9 do).

Option 3: Exploring materials and processes

Painting a. Create an assemblage mixing two- and three-dimensional media. Incorporate several found objects onto the surface of the painting, as

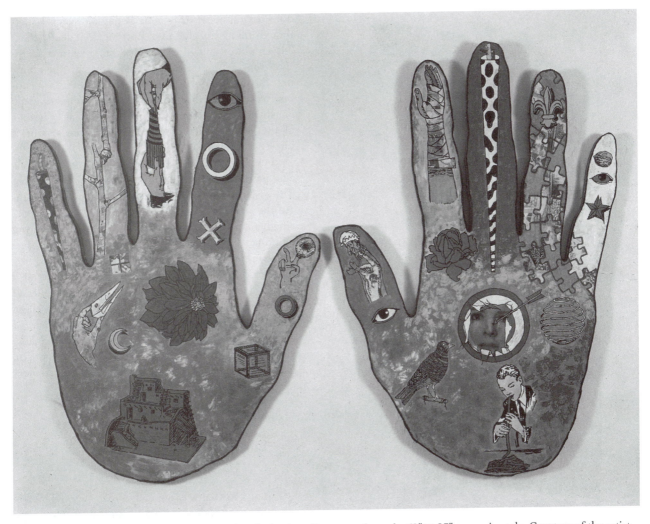

8.9 Jane Hammond, *Sore Models #4,* 1994. Oil and mixed media on wood panels, 69″ × 93″ approximately. Courtesy of the artist and Luhring Augustine.

Bedia does in attaching a small found boat above the painted hands in Figure 8.3. The range of possible examples is enormous: painters have incorporated into their artworks such materials and found objects as broken plates, roofing compound, bird cages, magnifying lenses, cement, and bullet casings. In your painting, paint across the objects, integrating their mass into the overall composition of the image. Bedia's artwork is an example of a painting created "off the stretcher," and tacked up as a loose piece of material directly against the wall. The canvas may be cut in any desired shape; for increased durability, sew a hem along the edges of the canvas and insert grommets. The painting can then be hung on nails through the grommets.

Painting b. Using acrylic gloss medium, attach a sheet of wallpaper (or map) to a canvas or plywood support. Paint an image on top of the wallpaper (or map), allowing some of the design to be visible in the final composition.

Painting c. Incorporate into the creative process techniques to apply paint that will remove your conscious control. Possibilities include: spreading paint with a squeegee, creating impressions on a canvas with a wooden board that has been covered with paint, dripping paint from holes punched in a swinging bucket. Invent new techniques that no one has ever tried before!

Painting d. Make a "painting" out of a material other than paint. Think about materials that offer a

8.10 Tom Judd, *A Man's Head*, 1985. Oil on plywood, 85″ × 44″. Courtesy of the artist.

rich range of colors, such as flower petals, autumn leaves, and fabric and yarns, or materials that have a consistency somewhat like paint, such as eyeliner, lipstick, or frosting (colored with food dyes). For inspiration, look again at Antoni's *Loving Care* (Figure 8.2) and at Plate 29, Fred Tomaselli's painting made with pills (which we discuss in Chapter 9).

Option 4: Exploring installations

An *installation* is an artwork that is composed over an entire viewing site, usually with multiple components. You could think of an installation as an assemblage that has grown large. Often designed for a specific site, an installation emphasizes the entire context of the real time and space in which it is placed; typically the viewer enters into the installation, rather than viewing it from outside. Installa-

tions do not necessarily include painted elements, although many do. Jennifer Bartlett's *Sea Wall* (Plate 24) combines a 10-foot-long painting with a sculptural representation of the same scene. In the painting, Bartlett renders simplified seaside motifs — cabins, rowboats, the sea wall — in impressionistic brushwork; in front, three-dimensional versions of the same motifs share space with the artwork's viewers.

For this option, an entire class, or teams of artists, can work collaboratively to make an installation. The synergy of working with others should accentuate the process of exploration. After a theme is decided upon, use a range of supports that can bring paintings *off the wall* and into the viewer's space. Some options are: use various found objects and furniture; create a folded screen by hinging together a sequence of old wooden doors; or paint both sides of freestanding panels that are held upright by attaching "feet" at the bottom. If possible, incorporate painted elements that hang from the ceiling. Explore how various painting techniques (e.g., applying paint in glazes; using sgraffito) can be used as an ingredient in an artwork that totally envelops the viewer.

EXPANDED IDEAS

We live in an era that is often called *postmodern*. The terrain of the postmodern is vast, and people do not agree on the meaning of the term. But many people share a general belief that one era, *modernism*, is ending, and that we are in a period of transition and change marked by widespread challenges to prevailing ideas, beliefs, values, and practices in every field of human endeavor, including art.

Modernism was not as simple or as monolithic in its ideology as its critics make it sound. But for the purposes of discussion, and because of our space limitations, we, too, will generalize in an effort to highlight some key aspects of modernism that various current theories challenge. Modernism as a general cultural condition in Western society predates modernism in art, and was based on Enlightenment values arising in the eighteenth century: a faith in the power of human reason (and a resulting privileging of rationality over emotion, intuition, and fantasy); a search for universal theories and principles that would apply to all people or all political, social, and economic structures; and a belief in progress and preference for the new over the old. Applied to art

beginning in the mid-nineteenth century, modernist values meant that artists and art historians believed that art history was unfolding in a linear, orderly way, with each new style growing logically out of a previous one; that "original" (new) styles were better than old ones; and that universal criteria for judging all art from all times and places could be identified.

In the twentieth century some influential modernist theorists became convinced that what was universal to all artworks were formal elements such as color, composition, and shape. According to this theory, known as *formalism*, while you couldn't compare, say, an African sculpture and a Greek sculpture on the basis of their narrative content or social function, you could compare them formally in terms of structure, scale, composition, and so on. Formalism became allied to the modernist desire for newness and originality, an alliance which led to the elevation of artists who were engaged in formal experimentation, supposedly creating new styles that contributed to the linear progress of art history. The term "art for art's sake" refers to art which claims to derive its value from formal qualities rather than from its intellectual, political, or social content. The heyday of formalism in the United States was in the twenty-five years after World War II — a period sometimes known as late modernism — and was the extreme version of modernism against which postmodernists are rebelling most directly.

Beginning in the 1970s, numerous artists in the United States and elsewhere became skeptical and critical of the tenets of modernism. The opponents were motivated by rapid social changes, political causes, new intellectual theories, an expanded awareness of alternative art-making traditions around the world, and the increasingly visible presence of ethnically and culturally diverse artists and art audiences. The *expanded ideas* espoused by critics of modernism challenge the notion that a painting's meaning and value can be gauged almost exclusively in terms of its formal qualities or as an expression of the artist's individuality. Today, a painting's success is gauged against a broader, more expanded (and controversial!) range of criteria, a development that in our opinion has revitalized painting.

The expanded ideas that are important to contemporary painting are multiple. Below, we discuss some of them under two broad headings: "Challenging Hierarchies" and "Painting as a Language."

Topic #1: *Challenging Hierarchies*[4]

The critique of modernism was launched by art critics and scholars in many disciplines as well as by feminists and artists of color. The latter two, who were gaining a more visible presence in the art world, believed that modernist claims to universality narrowly limited artistic choices to those practiced by primarily white male artists who traced their artistic lineage in a rigid path that was almost exclusively centered on European history. Many also argued that modernism's appetite for the new had turned art into a market-driven commodity incapable of expressing any values beyond ceaseless change for its own sake.

Challenging the Mainstream

Often committed to social causes, many women and minority artists wanted to express content that referred outward to society again, and they found both formalism and older European styles of realism inadequate to bear their messages. They began to look to non-Western societies, as well as to their own groups' poorly documented histories in the West, and to the art of "outsiders" such as self-taught artists for artistic ideas and approaches that differed from the Eurocentric "mainstream." Jean-Michel Basquiat, for instance, was inspired by urban graffiti artists and by African masks in works such as that shown in Figure 8.11. Often known as *multiculturalism*, this attitude recognizes and embraces cultural diversity, and espouses *pluralism* in art — the coexistence and equal validity of many styles, techniques, forms, and varieties of cognitive meaning.

José Bedia, born and educated in Cuba, has studied the art of indigenous cultures of the Americas, including the Yanomamo of Venezuela and Brazil, and the Dakota Sioux of North America, as well as hybrid Afro-Cuban groups. Bedia is interested in creating new mixtures out of ideas borrowed from many ethnic groups who converged in colonial settings such as Cuba. In Figure 8.3, Bedia depicts Lucero, a spirit figure from the Kongo religion, rendering the figure in a style of outline drawing adapted from the Dakota Sioux. The glowing boat Lucero holds aloft (a found object attached to the canvas) may symbolize the search for a safe haven by people who have been uprooted.

Challenging the Separation of Art and Life

With feminism, multiculturalism, and other developments contrary to formalism, there is a revived interest in art that connects with the world outside of art. The reinvestment of art with ideas and purposes drawn from reality is exemplified by such developments as paintings that make explicit social commentary, and painted artworks that serve a functional purpose.

Figure 8.12, one of Ross Bleckner's series of "Dot" or "Constellation" paintings, contains globules of white paint which at first glance appear to be simply an

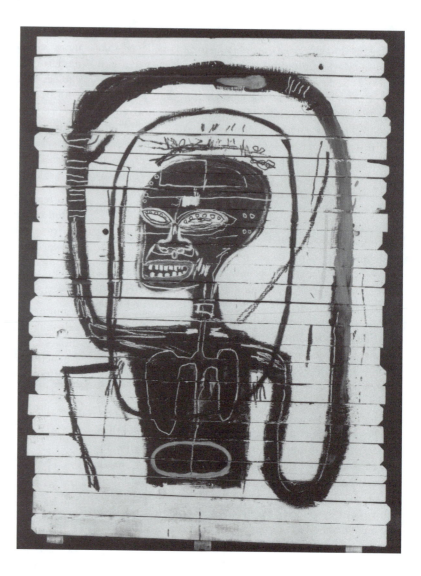

8.11 Jean-Michel Basquiat, *Flexible*, 1984.
Acrylic and oilstick on wood, 102″ × 75″.
Estate of Jean-Michel Basquiat.

exploration of pulsating optical effects. An imaginative viewer might further read them as representations of astronomical phenomena — stars or gaseous nebulae. In fact, the patterns are based on the lesions of Kaposi's sarcoma, a cancerous skin condition often accompanying cases of AIDS. With this knowledge, the viewer now might understand the surface of the painting as a metaphor for human skin, and the painting as a picture of disease, very much a real-world concern! Moreover, since depictions of intense light in paintings historically have had mystical and religious connotations, the glow takes on a spectral message, of lives turning into ghosts.

Challenging the Hierarchy of "High" and "Low" Art

Related to challenging the separation of art and life, postmodernism challenges a hierarchy which places the fine arts ("high" art) above popular and vernacular culture ("low" art). While challenging this hierarchy is not altogether new, the fusion of art and everyday culture, such as borrowing "kitsch" imagery, materials, and techniques, has become widespread in the current period. In Figure 8.13, Christian Schumann incorporates imagery derived from cartoons and commercial art along with patterns reminiscent of wallpaper designs. Ed Paschke's portrait of Lincoln discussed in Chapter 7 (Plate 21) combines the painting technique of glazing, imagery from a nineteenth-century documentary photograph, and colors from the electronic age.

Challenging Hierarchies of Society

Feminists, multiculturalists, and gay activists, among others, have utilized painting to challenge the social structure

8.12 Ross Bleckner, *Always Saying Goodbye,* 1987. Oil on linen, 48″ × 40″. Private collection. Courtesy Mary Boone Gallery, New York.

above craft—the fine arts of painting and sculpture ranked above functional activities such as glassblowing and woodworking. In the twentieth century, formalist art critics also stressed keeping different media separate. They were not supportive of mixed-media works, maintaining instead that the best artworks were those that remained "pure" in terms of a single medium. For example, they said that painting and sculpture should never be combined because (they argued) painting's essential nature is two-dimensional while sculpture is three-dimensional.

In our own period, the validity of each of these hierarchies is questioned, and traditional boundaries between various visual arts media and between the arts and crafts are increasingly blurred, leading to the kind of hybrid forms discussed previously under "Expanded Forms."

of society. In these artists' views, various structural conditions of society provide power, privilege, and prestige to some members of society at the expense of others. Colette Calascione's *Two-Faced Portrait* (Plate 23) makes a wry comment on artificial conventions of feminine beauty, representing a woman whose wig and costume are derived from the elaborate fashions of eighteenth-century France. The figure's third eye and breast test the limits of exaggeration in the service of "beauty."

Challenging Hierarchies of Media and Subject Matter

At various periods, different kinds of subject matter and different kinds of media have been considered more prestigious than others. For example, historically across the continent of Africa, the human figure was the principal subject in art, except in Islamic areas, where religious doctrine did not permit representations of humans. Within European painting from the Renaissance until late in the nineteenth century, certain subjects were ranked as more important than others—narrative painting, for instance, was deemed more important than still life. Furthermore, a traditional hierarchy valued art

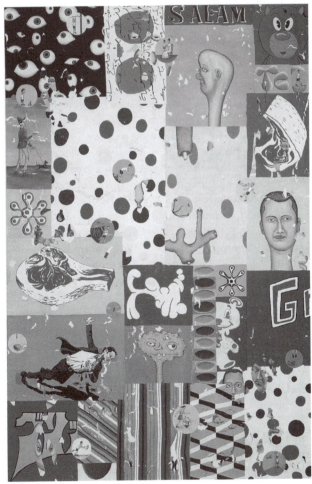

8.13 Christian Schumann, *Death of a Friend of a Friend,* 1994. Acrylic and mixed media on canvas, 72″ × 48″. Courtesy Postmasters Gallery, New York.

Challenging Hierarchies of Originality and Individuality

At the risk of oversimplification, we observe that many "modern" societies have placed a high premium on originality in art, and, additionally, the emphasis on originality has been measured primarily in terms of the accomplishments of individual artists. Originality might be defined as any significant change from an established pattern. Such change may be gauged by comparing an artist's work with predecessors or with contemporaries. It should be noted that in contrast to this trend, in many other societies there has never been a premium placed on originality; instead, a premium has been placed on maintaining and revering tradition.

In a society that privileges individualism, to be recognized as original a painter often develops a distinctive *style*, a characteristic approach to using materials, techniques, formal elements, and subject matter. By virtue of the consistency of his style, a painter's works would be recognizably like one another and unlike the work of other artists. It was believed that a fully developed style, like one's handwriting or fingerprints, was the unique imprint of an individual artist's personality and sensibility.

While favoring a consistent style began to be contradicted even during the heyday of modernism (famously by Picasso), it is only within the past few decades that a wholesale challenge of the desirability or even possibility of a unique "signature" style has occurred. Pat Steir raises the issue of originality in a spectacular way in her monumental painting, *A Vanitas of Style* (Plate 25). Steir painted each of the sixty-four gridded sections that make up the composition in a different style imitating famous painters from many periods of Western art history. In a further twist, she borrowed the underlying image from a still-life painting of flowers made by the seventeenth-century Dutch painter, Jan Brueghel.

Topic #2: Painting as a Language

Many of the artists who are labeled postmodern (a label not all of them accept) are motivated by their interest in intellectual theories. This interest can be traced partly to the Conceptual art movement of the 1960s, which emphasized the artist's thinking as the most important part of the creative process. Artists began to research theories developed in literature, linguistics, philosophy, psychology, and other disciplines, and apply them to art. We give but a brief glimpse of the rich terrain of theory by looking quickly at two intertwined analytical approaches which have been influential for artists: semiotics and deconstruction. We rely on a few examples to suggest the complexity of some painters' preoccupation with theory. Then we look at a few strategies for image making which lend themselves to a semiotic approach.

Semiotics and Deconstruction

Postmodernists reject claims to universal meaning, and assert that no set of values can apply to all situations. Nevertheless postmodernists are very interested in the question of meaning, wanting to debunk any claim to authority and to analyze how meaning is produced — how it is *constructed*, in current terminology. *Semiotics* is a branch of philosophy which studies how meaning is communicated through signs and symbols and what they represent. Semiotics understands language as a system in which meaning is communicated through the use of agreed-upon codes, such as the definitions of individual words and the conventionalized organization of words through syntax and grammar. Semiotic analysis can be applied to any coherent system that communicates through conventionalized signs (a *sign* is something which refers to, stands for, or represents something else), from literature to architecture to photography to comic strips to fashion advertising to painting.[5]

Just as the language (English) in which this text is written involves our mutual agreement about the meaning of these words, a style of painting can be understood as a language involving mutual agreement about the meaning of visual conventions. You have been learning many conventions of painting in previous chapters — for example, the Italian Renaissance convention of linear perspective, which viewers familiar with the code understand as communicating an illusion of depth, and the convention of agitated brushstrokes, which viewers learn to interpret as a sign of the artist's strong emotion (see Figure 8.11, by Basquiat). A painter may create her own conventions which a viewer "learns" in the process of viewing examples.

Painters today who are conversant with theories of postmodernism argue that these or any other conventions of painting are fundamentally arbitrary. A textured brushstroke, for example, does not contain any meaning in and of itself that viewers would necessarily understand. If we see it as emotional it is because we have learned to interpret such a brushstroke as a sign for emotionalism. Theoretically inclined painters want to expose and dismantle the underlying biases of painting and of many other kinds of sign systems. They use an approach known as *deconstruction*, which is derived from semiotics, and which seeks to undermine the authority of a system by revealing its underlying structure and by demonstrating that the meanings attached to the signs produced by the system are arbitrary.

Artists interested in semiotics and deconstruction may seek to undermine the conventions of art history; they also may deconstruct stereotypes and clichés which are communicated by other sign systems, especially the mass media and popular culture. Deconstruction strikes at the heart of the status quo by unmasking the hidden agendas underneath our most basic thought patterns.

In previous chapters we focused primarily on the cognitive meaning of a painting from the painter's point of view. In this chapter a shift occurs: the painting is now being considered as part of a process, a process in which meaning is arrived at (impermanently) as each viewer engages the painting within his or her own viewing context. The painter influences the process, but he cannot fully control the viewer's interpretation.

Discussion Exercise

Postmodernism and the Moral Code

Postmodernism presumes that the structure of society is the result of culture, not nature. Following this premise, many postmodernists argue that because it is the product of human invention — not of nature or divine intervention — society is ours to change in any way we might wish. There are no intrinsic guidelines and no absolute givens.

Because of this line of reasoning, some critics believe that postmodernism is amoral, and that cultural relativism cannot distinguish right from wrong. Although it may sound paradoxical, others would argue that postmodernism does not absolve humans of moral responsibility. To the contrary, if we make up the way the world is, then we are directly responsible and the only ones who can be held accountable.

Topics for discussion: Is an artist obligated to paint in a way that upholds a moral code? Who defines morality?

Expanded Strategies for Image Making

Having ideas to communicate is rarely an artist's sole goal. For most, an equally important goal is to create artworks that give compelling form to one's ideas. Because form is part of content — one of our book's basic premises — we find that many painters use strategies that create images and forms which embody or parallel the ideas they wish to express. The strategies we discuss below are particularly effective for exemplifying the two main expanded ideas we have been discussing — chal-

lenging hierarchies and deconstructing the conventions of painting (revealing how painting functions as a system of signs).

The strategies listed below are neither exhaustive nor exclusive: the same painting may utilize several of the strategies; painters may utilize other strategies (even historic ones) to communicate expanded ideas; and these same strategies could be used to communicate or embody entirely different ideas. Additionally, several of the strategies we list frequently overlap.

Mixing Imagery

A painter may combine imagery that does not seem consistent or cohesive within the same artwork (e.g., a painting that combines images of Santa Claus and a Greek god without providing any narrative or other thread that would seem to justify their juxtaposition). The connections among the eyeballs, steak, cartoon cat, and body organs depicted in Schumann's painting (Figure 8.13) appear arbitrary; the whole does not add up to a single, stable meaning.

Mixing Styles

Consistent with the postmodernist premise that society is cultural, not natural, follows the corollary that individual identity is socially constructed. Therefore, no link between an individual artist and a specific style is any more "authentic" than any other. In Plate 25, Steir uses an array of painting styles to create her overall image. Here Steir claims her right to explore and mix various styles just as she might experiment with different color schemes. No style is prioritized.

In Figure 8.13, Schumann has juxtaposed various styles of image making (including cartoon-like depictions of imaginary figures and naturalistic renditions of faces and objects), in addition to his juxtaposition of various subjects. By purposefully frustrating all attempts to arrive at a single, confident interpretation, the strategy of mixing styles proves, by counterexample, how painting is indeed based on conventions. Like any language, one needs to know the code. Without an established code, meaning becomes inconsistent and individual interpretations are inevitably tentative.

Artistic Collaboration (Mixing Artists)

By working as collaborators, some artists overturn the romantic conception of the supreme artist as a solitary genius, and debunk the notion that the creative process should function as an expression of individuality. Specific art projects are sometimes tackled by temporary teams of many individuals (and established artists may hire studio assistants or "farm out" work to specialists).

Appropriation

Appropriation means using something that originated with another person. In contrast to plagiarism or fakery, appropriation is done without any attempt at deception. A painter might "borrow" or recycle an image, style, or composition from another artist, time period, or culture, utilizing whatever is borrowed as if it were a sign (like a word in a language) whose meaning is altered by inserting it into a new context. Sandow Birk, for instance, appropriated the composition of Jacques-Louis David's painting *Marat Assassinated*, created in 1793, for his painting *Death of Manuel* (Figure 8.14). The recycling of the well-known pose of the dead figure imbues Birk's study of contemporary urban violence with historical signifi-

cance. The fuller message of Birk's painting would only be accessible to a viewer with knowledge of European art history. Hung Liu created the image in Figure 8.4 by appropriating a turn-of-the-century photograph of Chinese prostitutes.

Layering

A painter may overlay images together in the same pictorial space. In Chapter 6, we discussed how a painting can establish a sense of place. In today's world, traditional notions of time and space are of reduced importance. Think of information afloat in cyberspace, the flow of capital in our global economy, and social relations between nations; we cannot pinpoint a specific location

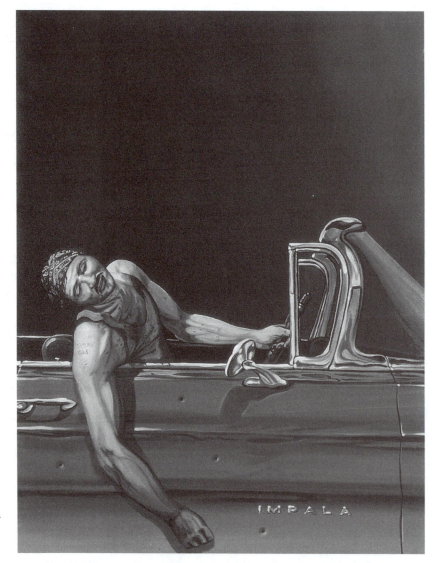

8.14 Sandow Birk, *Death of Manuel*, 1992. Oil on canvas, 33″ × 25″. Courtesy of Koplin Gallery, Los Angeles.

for these and many other important aspects of contemporary reality. To symbolize or map these fluctuating networks of meaning, a visual artist might employ a strategy of layering imagery (rather than creating a coherent image of a specific place).

Borrowing from Other Areas of Knowledge

A painter may incorporate the "language" of other systems of knowledge in order to expand the range of ideas that the artwork can reference. For example, many contemporary artists incorporate various types of maps and diagrams into their imagery. In Figure 8.1, Wolff borrows from the body language of hand signals made by members of urban gangs.

Finally, we want to point out that artists often combine several of these strategies to produce a painting with complex and changeable meaning. Although Figure 8.13 by Schumann is constructed primarily on a grid format, frequently an image in one pictorial style from one rectangle will run over the border and become layered with a nearby image done in a contrasting style. The result is a painting in which space appears fractured, unlike the coherent sense of space that we find in a painting employing linear perspective. It is instructive to compare the sense of space in Schumann's painting with that in Marc Jacobson's cityscape illustrated in Chapter 6 (Figure 6.14). Schumann's painting seems effective in its own way in capturing the emotional quality of contemporary urban living without representing the specifics of city streets or architecture.

Painting Exercises

Exploring Expanded Ideas

Option 1: Challenging hierarchies

Challenge one of the hierarchies discussed in this chapter, such as the separation of painting and "real" life, or the hierarchy of "high" and "low" art. To challenge the hierarchy, create an artwork that mixes materials and images from more than one category.

Option 2: Appropriation

Create a painting in which the composition or subject matter is appropriated from one artist while the style is appropriated from another artist. If a class undertakes this project, each artist should work from the *same* source, but combine it with a different artist's style.

After completing the painting, the group should discuss: What does it mean to have a style? and,

How has the changed style altered the content of the original painting?

Option 3: Painting a flag

Flags are in the news a lot. There have been heated controversies over the U.S. flag, for instance, involving disputes as to its proper display and what the flag itself symbolizes. We are accustomed to thinking of a flag as signifying a political entity, such as a country or state; a flag also might stand for a smaller organization. Flags often feature symbolic designs, usually geometric but sometimes with representational elements. (Think of the skull and crossbones of a pirate's flag, or the blue sky and stars on the U.S. flag.) A flag's form follows conventions: usually the flag consists of an image sewn onto cloth and attached at one side to a pole. As a category of objects, flags are understood to symbolize a concept or group.

Design and fabricate a painted flag that stands for one of the following (use paint along with other media, such as buttons, fringe, foil, or twine):

- a flag for birds that sing
- a flag for our solar system
- a flag for creativity
- a flag for your family

Option 4: Layering "languages"

One of the primary characteristics of contemporary society is the blending and blurring of lines between fields of knowledge (e.g., astrophysics, psychobiology). It is valuable to bring into the explorations an artist conducts in the privacy of the studio ideas, concerns, and patterns of thought that one is accustomed to dealing with in other contexts. For this exercise, create a painting whose content borrows or addresses the language of another nonart discipline. Layer the symbols or notations across painted imagery. Your approach may be aimed to create a specific message (see Wolff's painting, Figure 8.1) or to create a pastiche of codes of information and styles of image making (see Schumann's painting, Figure 8.13).

Select from the following list a "language" to explore:

musical notations	military codes
military insignia	foreign language (Chinese,
printer's marks	German, etc.)
shorthand	mathematical formulas
Arabic numbers	Roman numerals
chemical signs	computer keyboard
computer languages	symbols

religious symbols
corporate logos
sign language
hieroglyphics
traffic signs
crests/coats of arms
telegraph codes
punctuation (!!!!@??
&&###)

runes
money symbols (U.S. and
 foreign)
hand and arm gestures
international pictograms
abbreviations
facial expressions
symbols on maps

GROUP CRITIQUE
Expanded Ideas

In conjunction with a final critique of artworks created as a response to this chapter, discuss:

1. What is beauty? What is grotesque? Who determines their definitions?
2. Is the painting's title part of the artwork? How can the title invest a layer of meaning(s) in the painting that influences the viewer's "reading"? As part of the discussion, come up with different titles for paintings shown in the group critique, then offer a new interpretation for each different title of a particular painting.
3. Discuss which paintings shown in the critique seem the most "expanded" in their form and ideas. Students should explain their own choices for "most expanded."

Recommended Artists to Explore

Robert Rauschenberg (b. 1925)

Faith Ringgold (b. 1930)

Gerhard Richter (b. 1932)

Sam Gilliam (b. 1933)

Raymond Saunders (b. 1934)

Kay WalkingStick (b. 1935)

Judy Chicago (b. 1939)

Beverly Buchanan (b. 1940)

Elizabeth Murray (b. 1940)

Jennifer Bartlett (b. 1941)

Sigmar Polke (b. 1941)

Jonathan Borofsky (b. 1942)

Ben Jones (b. 1942)

Vernon Fisher (b. 1943)

Vitaly Komar (b. 1943) and Alexander Melamid (b. 1945)

Juan Davila (b. 1946)

Hung Liu (b. 1948)

Ross Bleckner (b. 1950)

Lari Pittman (b. 1952)

Tim Rollins (b. 1955) and K.O.S.

Gu Wenda (b. 1955)

Jessica Stockholder (b. 1959)

José Bedia (b. 1959)

Jean-Michel Basquiat (1960–1988)

Meyer Vaisman (b. 1960)

Christian Schumann (b. 1970)

1. Robert Rauschenberg quoted in Ellen Dissanayake. *What Is Art For?* (Seattle: University of Washington Press, 1988), p. 191.
2. Statement in the "Foreword" of the exhibition catalogue, *Unbound: Possibilities in Painting* (London: Hayward Gallery, The South Bank Centre, 1994), p. 5.
3. Tom Judd, artist's statement in Virginia Fabbri Buttera, *Contemporary Screens* (San Francisco: The Art Museum Association, 1986), p. 27.
4. This section has been written from a belief that operating within contemporary U.S. society and within the U.S. art world are dominant hierarchies that hold or have held a disproportionate share of power and attention. (Of course, the same state of affairs holds true within cultures throughout history; only the particulars change.) This text, intended as it is for a readership primarily composed of U.S. college students, presents many ideas (including those in this section) from the framework of prominent U.S. social and cultural paradigms. Obviously, readers who do not subscribe to, or have not been indoctrinated into, the fabric of a society dominated by the hierarchies identified would not experience any need or tension in reacting against them. For them, many of the same strategies we identify throughout this chapter may be utilized, but for different reasons, reflecting cultural attitudes to which the Western tradition is irrelevant.
5. Semiotics—the study of signs—is a theoretically complex field; our discussion offers only the most basic and simplified introduction. Readers who want to learn more can consult a specialized text, such as John Deely, *The Basics of Semiotics* (Bloomington: Indiana University Press, 1990).

Contemporary Abstraction

"Indeed, abstraction is rarely as free of the world or of content as some of its proponents assert, or as purely decorative as its enemies say."

— Mark Rosenthal[1]

INTRODUCTION TO ABSTRACTION

All paintings contain abstract elements. Even a painting that carefully depicts recognizable subject matter (a *representational* painting) is abstract in the sense that what we see when looking at the painting is not the actual subject matter but its rendering in colors and shapes of paint. Nevertheless, paintings that are abstract only in this limited sense are not ones we identify by the term *abstract painting*. Some paintings are more abstract than others, and this chapter concerns those that are more rather than less abstract.

The paintings we call abstract paintings may be abstract in many ways. Here we cite four:

First, a painting which depicts a recognizable subject is abstract to the degree that the painter emphasizes the general formal qualities of the subject and eliminates minor or individual details. Considered in this way, many paintings share significant qualities of both representation and abstraction, and are not easily labeled abstract or not. In earlier chapters, we looked at examples of paintings that combine representation with a considerable emphasis on abstraction, such as Figure 1.2 by Susan Rothenberg and Plate 17 by Mario Martinez. In similar fashion, the pioneer U.S. modernist Arthur Dove experimented with an abstraction derived from natural forms in paintings such as *Fields of Grain as Seen from Train* (Figure 9.1). To cite a recent example, Christopher

Brown's *Slip Stream — Stream of Consciousness* (Figure 9.2) incorporates recognizable subject matter: the round shapes over striped lines represent the heads of bathers in a body of water. But Brown has eliminated features such as eyes and mouths, reducing the heads to dark silhouettes. Brown's painting is both abstract and representational. Its abstractness stems from its significant reduction of mimetic detail in favor of a greater emphasis on formal qualities.

In a second manner, abstract paintings are those that are composed of abstract forms which do not derive at all from recognizable subjects. A painting of green squares and blue circles may be just that: a painting of green squares and blue circles. Art historians and artists call this form of abstract painting *nonobjective* or *nonrepresentational* painting. Some refer to this as "pure" abstraction. Piet Mondrian's *Lozenge Composition in Red, Gray, Blue, Yellow and Black* (Figure 9.3) is an example of nonobjective painting. The image does not have any recognizable subject matter outside of the painting itself; its subject matter is the colored lozenge shapes and dark lines.

A third manner in which paintings may be abstract involves giving visual form to subject matter that is not inherently visual. Examples include paintings in which the artist intends to visually express emotions, or musical sounds, or intellectual concepts. Abstractions may function as a mapping or diagramming of various processes, such as the cognitive thought processes of science. In *Yell* (Figure 9.4) by Pinkney Herbert, we see an abstraction or visual analogue for sound.

A fourth manner occurs when painters depict "images" which have established meanings as abstract signs and symbols, such as depicting numbers, words,

9.1 **Arthur Dove,** *Fields of Grain as Seen from Train*, 1931. Oil on canvas, 24″ × 34⅛″. Gift of Seymour H. Knox, 1958. Albright-Knox Art Gallery, Buffalo, NY.

9.2 **Christopher Brown,** *Slip Stream — Stream of Consciousness,* 1987. Oil on canvas, 87″ × 72″. Courtesy of the artist and Campbell-Thiebaud Gallery, San Francisco.

emblems, or logos. The circle, triangle, and square used by Richard Pousette-Dart in his triptych, *Time Is the Mind of Space, Space Is the Body of Time* (Figure 9.5), are geometric symbols that have cosmic significance in many world religions. The reverse painting on glass from the Ottoman Empire illustrated in Figure 9.6 shows swirling interlaced calligraphy that spells out holy names of Islam.

In practice, many painters combine more than one manner and purpose when they create abstract paintings. Abstractions that appear to be derived from recognizable subjects also may be intended to communicate nonvisual concepts; and seemingly nonobjective works may have social or spiritual content. Brown, for example, abstracted from his observation of actual water and bathers to make Figure 9.2, but the title *(Stream of Consciousness)* indicates that the painting also refers to reverie, a psychological state when the mind is set adrift. Mondrian (Figure 9.3) intended his nonobjective paintings to be much more than formal arrangements of shapes and colors; he saw them as providing a utopian vision of a future society based on order and harmony. As we will see in a variety of examples later in this chapter, many of today's abstract painters tend to be self-conscious and theoretical about their decision to make abstract paintings. While their paintings may appear to be straightforward abstractions from reality or "pure" nonobjective paintings, underpinning their work is strong conceptual, psychological, or political content.

9.3 Piet Mondrian,
Lozenge Composition in Red, Gray, Blue,
Yellow, and Black, c. 1924/1925. Gift of
Herbert and Nannette Rothschild,
Copyright © 1998 Board of Trustees,
National Gallery of Art, Washington.
Canvas on hardboard, diamond:
1.428×1.423 cm ($54^{1}/_{4}'' \times 56''$);
framed: $1.508 \times 1.505 \times 1.063$ cm
($59^{3}/_{8}'' \times 59^{1}/_{4}'' \times 2^{1}/_{2}''$).

9.4 Pinkney Herbert, *Yell,* 1996.
Oil on canvas, $57'' \times 56''$. Courtesy of
the artist and Ledbetter Lusk Gallery,
Memphis, TN.

9.5 Richard Pousette-Dart, *Time Is the Mind of Space, Space Is the Body of Time,* 1979–82. Acrylic on linen, 3 panels, each
$89\frac{1}{2}'' \times 62\frac{1}{2}''$. Courtesy of Estate of Richard Pousette-Dart.

9.6 Ottoman Empire,
probably Turkey or Syria,
The Holy Names: Allah,
Muhammad, Hasan, Husayn,
Fatima, c. 1910. Reverse
painting on glass with foil
backing, $15\frac{5}{8}'' \times 12\frac{5}{8}''$.
Girard Foundation
Collection at the Museum of
International Folk Art, a
Unit of the Museum of New
Mexico, Santa Fe.

A SHORT HISTORY OF ABSTRACTION IN ART

Although many people in the United States associate abstraction with modern art of the Western world, the process of visual abstraction has operated in art since prehistoric times. Among the most recognizable examples of abstraction in early art are the pyramids of ancient Egypt. Even older examples with emphatically abstract qualities are the so-called "Venus" figures — small, carved rock sculptures dating from about 25,000 years ago and found in present-day Austria — with their featureless faces, enlarged bellies, and missing feet and hands.

Numerous cultures around the globe have exhibited a long, sustained history of exploring abstraction in craft objects, artistic images, and architectural decoration. Examples include the symbolic patterns used by many Native American groups to adorn weapons, clothing, blankets, and ritual objects; the geometric, floral, and calligraphic patterns found throughout Islamic art and architecture (Figure 9.6); the angular planes and expressive distortions of African figurative sculpture; and the shallow treatment of space, highly ordered compositions, and stylized forms in Japanese prints. Avant-garde artists in Europe at the turn of the twentieth century were increasingly aware of alternatives to realism visible in art from numerous other cultures, and in many cases modeled their own experiments with abstraction on these precedents.

In Europe and the United States, it was not until the early twentieth century that some painters went so far into abstraction that they dispensed entirely with any recognizable subject matter, making the kind of artworks we label *nonobjective*. In the ninety years since Russian artist Wassily Kandinsky created what is usually considered the first nonobjective easel painting, numerous styles, movements, and individual explorations have proliferated in abstract painting. In the United States, the first internationally recognized movement involving abstraction arose in New York in the 1940s and 1950s, and most frequently is known by the name *Abstract Expressionism*. However, individual painters in the United States, including Dove (Figure 9.1), made early forays into abstraction at virtually the same time as the first European abstractionists. Moreover, abstraction has long been significant in genres outside the "high" arts of painting and sculpture, including quilting, weaving, and other "craft" mediums. Native Americans, as mentioned above, have ancient traditions of abstraction in art and craft.

The vitality of the New York art scene following World War II is attributed in part to a surge of American-born artists (including Jackson Pollock) who moved there from throughout the nation, as well as the influx of many European artists (including Mondrian) who emigrated to the United States during the period of political turmoil and war in Europe. Gifted painters arrived from other parts of the world as well, adding artistic ideas from their societies to the mixture. Yayoi Kusama, for example, arrived in New York from Japan in 1958 at age twenty-nine, with her interest in making artworks with obsessive, all-over patterns already well established in her practice (Figure 9.7). The rapid development of abstract painting was further powered by ideas from other sources — such as the affinity between abstraction and American jazz that influenced a number of artists at mid-twentieth century.

At the risk of overgeneralizing, we observe (as have many others) that many abstract paintings made by artists associated with Modernism fall into two broad categories. The first type is more deliberate and measured, often hard-edged and neatly finished, and tends to extrapolate forms and patterns from geometry or mathematics. This type of abstract painting often relies on the concept of a grid to provide a clear underlying compositional structure. The nonobjective paintings of Mondrian (Figure 9.3) are archetypal examples of this type of *"geometric" abstraction*. The geometric direction is not always perfectly ordered. Kusama's rows of collaged airmail stickers in Figure 9.7 are enlivened and given a hand-crafted, irrational quality by the way the artist overlapped and glued them in slightly irregular, rippling rows.

An alternate broad approach to abstraction is more spontaneous and intuitive, and is characterized by looser, more gestural applications of paint. This overall approach, which art historians often label *organic abstraction*, involves the personal expression of the artist's sensibility and exploration of visual form. (Although the term "organic" implies that the forms involved are derived from natural forms, this is not necessarily the case.) In this approach to abstraction, colors are often intense, edges tend to be blurred, surfaces can be highly textured, and the overall composition has a fluid, open-ended quality. In Plate 26 Fabian Marcaccio, from Argentina, provides us with a contemporary example of applying paint in a gestural manner. Because of the spontaneity involved in

9.7 Yayoi Kusama, *Airmail Stickers*, 1962. Collage on canvas, $71\frac{1}{2}'' \times 67\frac{1}{2}''$. Collection of Whitney Museum of American Art, New York. Gift of Mr. Handford Yang.

creating this kind of gestural abstraction, many viewers consider the results to be highly expressive, a "free" flowing from the individual artist's inner being. The paintings of the Abstract Expressionists belong in this camp.[2] We should note that in some cases the apparent spontaneity may belie detailed planning and careful execution.

Discussion Exercise

What Makes a Painting Abstract?

At the start of Chapter 1, we presented a Research and Discussion Exercise on the topic, "What is Realism?" (see pp. 11 and 14). In undertaking that exercise, you were asked to "strive for a more expansive understanding of visual realism." The range of representational paintings illustrated and discussed in subsequent chapters should have reinforced an impression that there are many approaches to creating a realistic artwork, and that, like so many topics we have explored in this book, realism in art is not an all-or-nothing affair.

It is time to build on that earlier exercise by asking, What makes a painting abstract? Can a painting that is highly realistic exhibit qualities that also make it powerfully abstract? Can a painting be abstract in more than one way?

Prior to a group discussion, consider how you might answer the preceding questions in terms of the following paintings illustrated in the text: Plate 14, Figure 1.5, Figure 1.6, Figure 4.14, Figure 6.1, Figure 6.20, Figure 7.14.

Sketchbook Exercises

Make sketches of abstract motifs you discover in the world around you:

1. Concentrate on the underlying structure of formal relationships, in sketching such subjects as the view down a building's stairwell or the pattern of pipes on a ceiling.
2. Enlarge small details of subjects, thereby reducing the image to an abstract arrangement of forms exploding off the picture plane. In some of these sketches, position a negative shape in the center of the picture plane, or create a composition in which there is a strong figure/ground reversal.

CONTRAST

As a key to understanding how abstract paintings are often created on a formal level, we introduce the concept of contrast. In painting, *contrast* is a relationship of opposing qualities. For example, a painting consisting simply of circles and triangles of many different sizes and colors would be a contrast of shapes and hues. To make a contrast more compelling an artist often selects one quality for emphasis, while the contrasting quality plays the role of providing variation, relief, or drama — think of a painting of dozens of green circles and one red triangle.

Although contrast can involve subject matter (such as a painting of one smiling face among a crowd of frowning expressions), most often contrast involves formal qualities, the use of materials, and/or techniques. Developing contrasts is a strategy that is integral to the organization of most abstract paintings' compositions. Why? Because contrast is key to the development of a dynamic relationship between parts and between parts and the whole. Contrast keeps the viewer's eye moving.

While the concept of contrast may, at first glance, appear to work against compositional unity, this is not necessarily the case. In fact, a rule of thumb subscribed to by many artists is that an artwork is not complete unless a contrast is asserted and then brought to a unified resolution. Much as the concept of asymmetry continues to demand balance, the concept of contrast ultimately must be contained within an overall equilibrium of competing forces.

In many paintings, contrasting elements occur on multiple levels, often serving as a recurring motif. In preceding chapters we have considered important contrasts: Chapter 6 explored the contrast of the articulation of the picture plane (flatness) with the articulation of space (depth); Chapter 7 explored the contrast of light and dark as a strategy for defining forms and establishing expressive meaning. In this chapter, we introduce a more systematic way to think about the articulation of formal contrast, keying our discussion to the development of abstract imagery.

The Articulation of Formal Contrast

While contrast is discussed most frequently in terms of a dichotomy (two qualities that seem to be at opposite ends of some scale from each other), contrast can just as certainly involve qualities that range fluidly along a spectrum. In exploring the qualities listed below, you should think of each as constituting relative directions on a continuum, not as fixed polar opposites.

At a basic level, visual elements can be related in contrasting ways, such as:

a contrast of colors —
 chromatic/achromatic
 saturated colors/neutral colors

pairs of complementary colors
dark/light
warm/cool
transparent/opaque
a contrast of shapes, planes and volumes —
geometric/organic
rounded/angular
flat/curved
large/small
many/few
foreshortened/not foreshortened
a contrast of texture and surface treatment —
rough/smooth
thick/thin
glossy/matte
a contrast of linear qualities —
straight/rounded
thick/thin
continuous/broken (implied)

At the level of compositional organization (design strategies), contrast may involve such possibilities as:

a contrast of spatial dimensions —
flatness/depth
near/far

compositional climax (Here the contrast involves the complexity of elements coalescing in one area — the compositional climax—relative to the reduced complexity in all other areas of the composition.)

movement/stasis (Implications of dynamic movement contrast with areas of rest in a composition.)

structural contrast (This can involve any contrast of the major compositional structure, such as vertical/horizontal.)

A contrast can involve multiple differences: for example, in Brown's *Slip Stream — Stream of Consciousness* (Figure 9.2), the bathers' heads stand in contrast to the surface of the water (a dark/light contrast) and in contrast to the ripples on the water (a contrast of round shapes and lines). Contrast is established by the relative quantity and quality of juxtapositions: for example, in Leslie Wayne's *Ruckus* (Figure 9.8), the puckered ribbons of paint seem all the more textured and three-dimensional because they are presented, within the format of the artwork, in contrast to other areas that are relatively flat and smooth. A contrast can involve slight variations: in Plate 27, by Sabina Ott, we see a subtle contrast of red colors — some of which are dark and saturated; others are less saturated pale pinks.

9.8 Leslie Wayne, *Ruckus*, 1995. Oil on wood, 12″ × 9″. Courtesy of Jack Shainman Gallery, New York.

Painting Exercise

Establishing Formal Contrasts

Do a series of abstract paintings in which a contrast of formal elements is established:

Series #1: Create several small-scale, nonobjective paintings in which pairs of contrasting elements work together. (For example, in Figure 9.8, a dark/light contrast is aligned with a contrast of thick and thin paint. The dark area at the top of the painting is also where the paint layer is thinnest, while the light area at the bottom coincides with the thickest application of paint.)

Series #2: Create a series of paintings of imagined landscapes in which details are simplified, and the primary visual effect depends on a strong contrast of

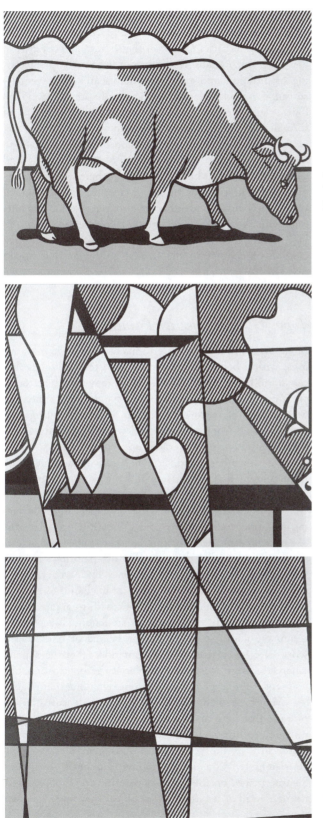

a limited number of elements. (In both Figures 9.1 and 9.2, outdoor scenes are built around a contrast of rounded shapes and parallel lines.)

Painting Exercise

Abstracting in Stages

A number of modern and contemporary artists have developed abstractions in series. This exercise offers two possible approaches.

Option #1 (systematic breakdown):
Create a series of three to five paintings in which a subject is systematically broken down into increasingly abstract treatments.

In this approach, each successive painting builds on the previous treatment by simplifying or intensifying formal relationships, while paying increasingly less attention to the natural appearance of the original subject. An example of this approach can be seen in a three-part painting created by Roy Lichtenstein, *Cow Triptych (Cow Going Abstract)* (Figure 9.9).

As you "push" the original subject towards ever greater degrees of abstraction, it should be clear that even the appearance of total nonobjectivity may have been stimulated by a subject in real life.

In thinking about how to increase the abstract quality in successive stages, examine the possibility of intensifying contrasts from the previous stage.

Option #2 (free-wheeling exploration):
Create a series of three to five paintings in which a subject (such as a still life, landscape, posed model, or architectural setting) is altered by successive approaches to an abstract treatment. Allow yourself creative freedom to take each painting off into a new direction. The following are some suggestions only: the first approach might involve painting the subject "realistically"; the second approach might involve a geometric simplification of the same subject, bathed in luminous colors; a third approach could take a gestural approach to the same subject, emphasizing the major and minor tensions as you analyze how the entire visual structure is composed; a fourth approach could reduce the same subject into visual

9.9 Roy Lichtenstein, *Cow Triptych (Cow Going Abstract)*, 1974. Oil and magna on canvas, 3 panels, 68″ × 82″ each. Private collection.

fragments which are then shuffled and recombined into a newly invented composite.

In all of these approaches, develop relationships of contrasts appropriate to the subject and the specific approach taken in each painting.

Option #3 (abstracting from another work of art): Create a series of three to five paintings in which you create your own abstract compositions inspired by the contrasts you analyze in another artist's work of art.

TOPICS OF CURRENT ABSTRACTION

Where once abstraction was a startling innovation in painting in the West, today it has a ninety-year history, and thousands of artists have painted abstract paintings. Much of the language of abstraction in painting has become a convention, making it difficult for an artist today to engage in abstraction with the same almost innocent, pioneering spirit that linked together many of the first generation of abstractionists in Europe or the Abstract Expressionists in this country. Many of the strategies that make a painting more rather than less abstract have remained relatively stable over the past ninety years, although today's abstractionists often use these strategies in a coded manner. That is, they apply to abstraction the kind of *semiotic* analysis discussed in Chapter 8.

In the remainder of this chapter, we will explore some of the issues that are at the forefront of abstract painting today in the United States, as artists use (and attempt to modify) the historical language of abstraction in order to address current concerns. Along the way, we will offer painting exercises to give you practice in making your own abstract paintings and investing them with meaning.

We introduce four fertile topics that artists are presently exploring in abstract painting. Although all are significant topics, this is not an exhaustive listing. Other topics we do not discuss—such as figurative abstraction—are equally significant. First we discuss the topic of nonobjective painting, recognizing that some painters are continuing to make paintings which do not have their basis in mimesis or even a generalized representation of reality. We consider some of the purposes motivating today's nonobjective painters. The remaining three topics

concern various meanings of paintings that dissolve boundaries between abstraction and representation. In contrast to the strict *formalism* that dominated art critical discourse during late Modernism, today the gap separating abstraction and representation seems to have narrowed if not closed entirely. (See Chapter 8, p. 173ff, for a review of the issues involved in the concept of formalism.) Indeed, many artists today don't recognize, or don't care to debate, a separation between abstraction and representation. Contemporary abstractionists — and those who think and comment about their work — reemphasize the link forged by the pioneer abstractionists between the canvas and ideas from other realms. Concurrent with the reestablishment of a link between art and life, there is a corresponding deemphasis on limiting discussion of content to the formal strategies that are in play.

Topic #1: Nonobjective Painting

Some artists today continue to make nonobjective paintings, with a belief that there are vital formal issues that remain to be explored. These artists may be interested in creating special optical impressions, or experimenting with effects of texture or shape, or incorporating patterns derived from mathematical work in fractal geometry or digital images generated on a computer.

On the other hand, a nonobjective painting could have content that alludes beyond the painting's borders. In the case of a painting by Sean Scully (Figure 9.10), "formal traits are endowed with the capacity for becoming metaphors about the world."[3] Scully emphasizes the use of geometric elements: rectangular shapes and stripes arranged in parallel designs. But his paintings are not hard-edged geometric abstractions. The artist himself would point to the "blurred" edges of his bands of color as a formal trait that endows his work with humanistic cognitive meaning. In considering a similar quality of indeterminacy about where a border begins or ends in the work of other artists, Scully contends, "there is a point where the edge seems to tremble: at the point of contact one senses the tragedy of life can be felt along that edge."[4]

Many recent nonobjective paintings feature the exploration of new or nontraditional media and supports, unusual painting techniques, and an emphasis on the materiality of the paint itself. This general strategy is consistent with a long-standing emphasis by many abstractionists on the abstract painting as an object unto itself, as well as its status as an object that takes its place

9.10 Sean Scully, *Facing East*, 1991. Oil on canvas and steel, 60″ × 72″. Courtesy of the artist.

alongside other objects in the world. In creating *Ruckus* (Figure 9.8), for example, Wayne employed a technique of scoring and partially peeling back the thick outer layer of oil paint to expose the underlying ground. The materiality of the paint as paint, rather than as the means for the creation of an illusion, is graphically evident.

We complete this discussion with a look at three artists whose work explores qualities of both painting and sculpture. Soon Bong Lee's mixed media painting *A Man and a Mouse* (Figure 9.11) incorporates intimate-sized objects that have been mounted in cubbyholes cut into its hard, outer surface. While the objects selected, such as a bent tin can and a small sculpted head, symbol-

ize past events to the artist, their arrangement in a distinct pattern emphasizes the abstract nature of the composition. In Plate 26, Marcaccio has applied paint to an "expanded form" of his own design, which hangs off the stretcher and off the wall. Jessica Stockholder's *Catcher's Hollow* (Plate 27) is a creation that blurs the boundaries between painting and sculpture. Writing about her art, curator Adrian Searle explained that her "work is built out of surfaces, cavities, holes, walls and the floor. Isn't this like painting, isn't this what painting does. . . ? . . . Jessica Stockholder brings a lot of things into the gallery and builds something we can take away with us, something like the memory of a painting."[5]

9.11 Soon Bong Lee, *A Man and a Mouse*, 1999. Mixed media, 48″ × 56″. Courtesy of Ann Nathan Gallery, Chicago.

Painting Exercises

Exploring Nonobjective Painting

The overall goals for this exercise are: first, to make a painting that is not mimetic (there is no preconceived subject matter outside of the painting), and secondly, to make a painting which emphasizes its own physicality (the painting is an object made out of specific materials).

Option 1: Using Process or Accident

Create a nonobjective abstraction using a strategy for applying or manipulating paint over which you can exert only limited control. In Chapter 8 we cited the example of Janine Antoni (Figure 8.2), who presented the process of painting with hair dye as a work of art. In this chapter, Wayne's painting (Figure 9.8) was created by building up an extremely thick layer of paint which was then partially scraped back, creating a beautiful, rippled effect.

Incorporating accidents into the creative process can be a strategy to overcome or avoid habits of rational thinking and conscious planning. We suggest two techniques to explore: decalcomania and dripping paint. *Decalcomania* begins by painting an abstract arrangement on another surface (such as a sheet of paper or wooden board). While still wet, this painted surface (the decal) is then pressed onto the surface of the painting. When the decal is peeled away, some paint remains stuck to the painting in an irregular, often unexpected pattern. When applied, the decal can be partially "streaked" across the painting for a different effect.

A technique of dripping paint usually involves paint that is relatively thin and "liquidy." Various paints work suitably, such as housepainter's enamel, latex paint, or acrylic paint in plastic containers. (Latex and acrylics have the added benefit that brushes are cleaned with water.) Dripping can be done by flinging the paint in semi-controlled arcs with a brush flooded with paint. A second method is to punch holes in the bottom of a can that is then filled with some paint; the can is swung above the painting's support on a string to create arcs that are only partially under the painter's control. Acrylic paint in plastic containers can be squeezed out in arcs.

Explore processes of your own invention. At any step in the creative process, additional paint can be added with various brush techniques, in order to enhance or alter the composition that appears to be forming with the "chance" effects.

For a challenge, try to use any of these "chance" processes to create abstractions that represent: an emotional feeling, such as radiant joy; a concept, such as freedom; or a physical quality, such as friction.

Option 2: Encaustic Painting

Create an abstraction using the ancient technique of encaustic painting (or the closely related technique of encaustic emulsion). The painting should exhibit a strong physical presence.

To prepare for an encaustic painting, wax (bleached white beeswax) is heated. While it is in its hot, liquefied state, dry powder pigments are mixed into the heated medium in order to create the desired paint colors. (Take care not to breathe any pigment dust.) Once the wax cools, the cakes can be stored in small tins until they are to be used.

To prepare for an encaustic emulsion painting, follow the same procedure as outlined for the encaustic painting, except in addition to the powder pigment, add linseed stand oil to the heated wax (in a ratio of 4 parts wax to 1 part oil).

To apply (in either technique), the prepared cakes of colored wax are reheated. A heated metal palette is used to keep the wax colors in their melted state. The wax colors are then applied to the support. A traditional support is canvas or wood panel primed with rabbitskin glue. The hot wax is applied in the desired composition. A heat lamp is used to fuse the various colors together and to adhere them to the support. A hardened encaustic painting is quite durable because beeswax is an extremely stable material. Just be careful not to let the painting get too cold or hot, as extreme temperatures endanger the wax surface.[6]

To create *Pollera* (Figure 9.12), an encaustic emulsion painting, Tom Lee started by sealing his canvas with four coats of rabbitskin glue. (Directions for preparing and using rabbitskin glue are typically provided on the container by the manufacturer.) A wash of thin brown oil paint was applied to tone the entire surface, and then allowed to dry. The dark serpentine shapes at the top were applied with black encaustic. Other elements, such as the lower dark shape, were applied with sign painter's enamel. (The long-term durability of combining enamel and encaustic is questionable, but it does make a wonderful effect.) Lee likes to apply encaustic wax over oil paint once the oil paint has been allowed to dry thoroughly. Doing this, he creates an effect in which the oil paint appears to float within a thick, translucent skin of wax.[7] Later in this chapter, we discuss an encaustic painting by Sabina Ott (Plate 28).

Option 3: Acrylic Paints and Gel Medium

Combine acrylic paints with gel medium to produce an abstract painting with a very thick surface, in which swirls of color are seen embedded deep within the painting. Because it is transparent once it dries, gel medium (a heavy-bodied, viscous medium) can be mixed with acrylic paints to produce thick glazes and heavy impasto.

As an example, look at *Only for a Day* by Clarence Morgan (Figure 9.13). Inspired by the style of modern jazz — "a style of music that is both structural and improvisational"[8] — Morgan combines acrylic paints with gel medium to produce such abstractions as Figure 9.13. To achieve an almost sculptural surface, Morgan may incise or puncture the thick layers produced with the gel medium.

As an added challenge, undertake this exercise while listening to music — aim to create a painting which translates into visual relationships key qualities which you discern in the aural structure of the music.

9.12 **Tom Lee,** *Pollera*, 1997. Oil and
encaustic on canvas, 72″ × 48″.
Courtesy of the artist.

Journal and Sketchbook Exercise

Researching Approaches to Abstraction

Research an approach to abstraction or a specific artist
who is noted for her/his use of abstraction. Respond in
your journal to what you discover to be the hallmarks of
your subject's approach. Make your own sketches creat-
ing abstract compositions employing your subject's
strategies.

Possibilities for research are broad. We suggest the
following for consideration: New York Abstract Expres-
sionism (of the 1950s); Bridget Riley or Victor Vasarely's

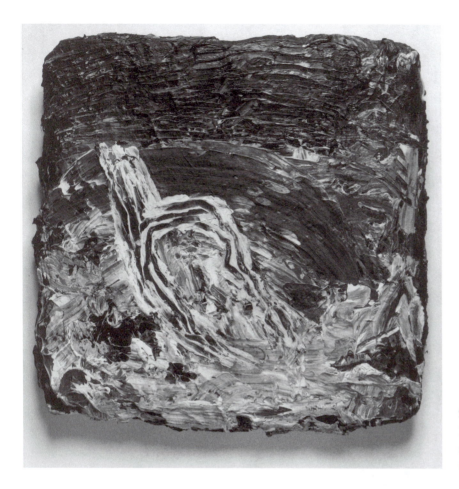

9.13 Clarence Morgan, *Only for a Day,* 1995. Acrylic and gel medium on paper, mounted on canvas, $20'' \times 21\frac{1}{2}''$. Courtesy of the artist.

approach to op art; traditional American quilt designs of the nineteenth century; abstract decorative designs on Moorish architecture.

Topic #2: *Abstracting Nature*

Over the past century human understanding of the natural world has undergone profound changes. The publication of Einstein's Special Theory of Relativity in 1905, for example, offered a startling new paradigm for physical reality, a theoretical model that defined a direct relationship between energy and matter now charted in terms of the speed of light. Advances in such diverse fields as computer engineering, space exploration, paleontology, and eco-biology have contributed to profound alterations in how we understand the world around us. These changes have impacted the way artists envision the universe and our place in it. The cumulative effect of such changes has reduced the relevance of many conven-

tions of painting, calling into question strategies like linear perspective and a viewpoint that emphasizes the solitary individual surveying physical reality from a fixed position with the unaided human eye.

What reasons would compel members of the current generation of abstract painters to become engaged anew with themes or topics rooted in the natural world? Some artists continue to want to explore the dynamic relationship between direct visual observation and the possibilities for formal abstraction. Other artists are compelled by our culture's changing relationship with nature. Among the latter, some use art to express concerns over our planet's endangered biosphere; others see nature as a touchstone for the rediscovery of shared universal meaning; and others seek in nature an avenue for escape or transcendence from an overly regulated and processed culture.

Consider *Wolf Waterfall* (Figure 9.14), a painting by Pat Steir measuring over 14 feet in height. A broad streak of oil paint cascades vertically down its center. On

#

TERRY WINTERS
Figure 9.15

Almost any disruption of the conventions of realism can enhance the abstract qualities of a painting — including such strategies as a drastic change in scale, unexpected viewpoint, or inconsistent treatment of space. Terry Winters disrupts conventional realism by basing much of his imagery on abstract treatments of biological and mineral forms blown up to eye-opening size. His painting *Soil Cap* (Figure 9.15), for example, presents a schematic view of cell-like forms that seem to be buzzing with life; one form in the upper left corner is even beginning to sprout branches that will congeal as a new cell cluster. At the stage of the process depicted in the painting, the growth resembles branches and thorns familiar to us as botanical forms.

In Winters's art, organic subject matter, sensuous paint handling, and the rich tradition of painting itself are fused seamlessly together. On one level *Soil Cap* is about biology (at the level of cell formation); on another level biology is about us (how our own bodies look at the cellular level); and, finally, the painting is about painting, echoing in its thickened forms both the geometry and linear gestures of earlier abstract painters. (Compare, for instance, the forms in Winters's painting with the grid structure in Mondrian's painting, Figure 9.3.)

9.15 Terry Winters, *Soil Cap,* 1984. Oil on linen, 101″ × 68″. Courtesy of the artist.

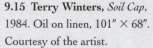

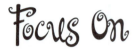

Focus On

DJALU GURRUWIWI
Figure 9.16

Djalu Gurruwiwi, an Aboriginal artist of Arnhem Land, in the northeastern area of Australia, has created an image painted on bark which may appear to a Western viewer as strictly a decorative abstraction (Figure 9.16). The initial reaction may be to admire the qualities of its rhythmic design and the engaging subtlety of its asymmetrical balance. One may be content to search for meaning strictly on the formal level of the patterned interplay of shapes, lines, and texture.

Within the context of Aboriginal culture, a bark painting resonates with much deeper, complex layers of meaning. In fact, bark paintings encode a cohesive body of knowledge, the Aboriginal worldview "developed over a period of 60,000 years of Aboriginal occupation [of the Australian continent] before white colonization."[9] Each bark painting is the product of the belief system that generated it, and simultaneously each bark painting maps specific aspects of the Aboriginal belief system.

Bol'ngu, the Thunderman represents aspects of a sacred narrative, a portion of the creation story of the Galpu clan, of which the artist is a member. According to Aboriginal beliefs, the specific features of the Australian landscape that we see are the result of events that took place in an ancient period called "Dreamtime." In the Dreamtime, Ancestral Beings (such as the Thunderman) traveled the initially featureless land and created the landmarks which are the various geographic features in existence today. The Thunderman is represented symbolically; various rivers and springs were created by the Thunderman as he passed over the landscape. Gurruwiwi's bark painting is essentially a diagram of his Aboriginal clan's worldview, a worldview that correlates the observable features of the landscape with a cosmological belief system.

9.16 Djalu Gurruwiwi, Galpu clan, Dhuwa moiety, Naypinya, northeastern Arnhem Land, *Bol'ngu, the Thunderman*, 1990. Bark painting, 191 × 67.5 cm. National Gallery of Victoria, Melbourne.

Herbert's painting *Yell* (Figure 9.4) is a dynamic image of a loud burst of noise. The artist has incorporated an abstract image of vocal chords and mouth cavity on the right side of his composition. In the portrayal of the sound being emitted, we sense that the noise wavers and changes pitch, qualities expressed by the wave-like patterns that churn in the space of the painting. The sound is obviously strong: the "mouth" recoils from its force.

Topic #3: *Abstracting the Spiritual*

Scholars believe that the earliest art of our human ancestors typically had spiritual overtones, that people made objects and images we now call "art" for use in rituals and ceremonies of worship. We know that over the millennia of recorded history many artworks have served religious purposes — to express ideas about the divine, to foster pathways to mystical experience, to function as moral education and visual preaching, and to provide objects used in religious rituals. While much of the religious art in the West (such as Michelangelo's Sistine Chapel ceiling) has been representational, art that incorporates or emphasizes abstract qualities as a means to express spirituality has also been extremely significant in cultures around the world. (Examples known to most readers are the pyramids of ancient Egypt and the pyramids of the Mayas in Mexico.)

Throughout the development of abstract painting in the past one hundred years, many artists have sought to embody, express, or inculcate a spiritual dimension through their work. They have not attempted to communicate a religious story; rather, they have believed that an abstract painting made with a spiritual intention can stimulate a generalized spiritual response from viewers. Pousette-Dart, for example, believed that a viewer could look at one of his paintings, such as the triptych we reproduce (Figure 9.5), and have a mystical experience of the supernatural or the immaterial universe.

In contrast, many new abstractionists reject any faith in the transcendental potential of abstract painting. Influenced by the theories we discussed in Chapter 8, some of these artists believe that at best a painting can only provide a coded simulation of spirituality. For example, in his painting shown in Figure 8.11, Ross Bleckner depicts light in a quasi-ironic manner: he is appropriating light in a kind of impersonation of spirituality, without faith in sacred enlightenment.

Nevertheless, there are abstract artists today who continue to make artworks that exhibit a reverence for the sacred or transcendent in nature and humanity. This urge to confront the cosmic is wonderfully exemplified by a sequence of five large-scale wall paintings installed by Dorothea Rockburne in the André Emmerich Gallery, New York, in 1994. While we could have discussed these abstractions within our previous topic of nature, they aim to take us into an exalted realm where, "grafting astrophysics to Genesis,"[10] these paintings explore the universe as a "work-in-progress." In *First Day* (Figure 9.17), one of the sequence, Rockburne utilized the surfaces of two parallel walls to create an image that appears to symbolize the manifold separations that theoretical science and religion alike attribute to that initial moment of creation: the separation of firmament from void, energy from mass, light from darkness.

Journal Exercise

Taking Measure of Your Spiritual Dimension

None of us develops our concepts of the divine entirely on our own. Religious ideas have evolved over centuries, and are transmitted through the written and spoken word, visual media, and rituals and ceremonies. As we grow educated about the ideas of different religions and think about the sacred dimensions of our own experience, we have the opportunity to select among existing spiritual beliefs and practices.

This exercise helps you to examine your spiritual beliefs and concerns, whether or not you are an active member of an organized religion. The goal is to help you explore the option of addressing spiritual themes in your own artworks. You might discover that you want to make art about themes at the heart of a specific religion—for instance, the Buddhist emphasis on the interconnection of all life forms or the Christian emphasis on resurrection. You might recognize spiritual themes in specific settings, such as a reverence for nature.

1. *The Past*: Close your eyes and go back in your memory to childhood and adolescence. Ask yourself: What were the religious and spiritual messages that I received as a child and teenager?

 Recall the words that adults, parents, teachers, and other people said to you or what you read about religion and spirituality. Allow yourself plenty of time to meditate about the messages you received.

9.17 Dorothea Rockburne, *First Day,* 1994. Lascaux Aguacryl Flashe, Berol Artstix on wall. Installation: André Emmerich Gallery, New York.

Divide a journal page vertically down the middle into two columns. Head one column "Messages." Head the other column "Sources." In the first column record all the messages as you remember them. Don't worry if some of the messages appear to contradict one another.

Now review the list of messages. As you read each one, ask: "Where did this message come from? Did others tell me this? Did I read it or see it in artworks, movies, or television? Did I develop this message on my own?"

In the column across from each message statement write down where you learned the message. If you can't remember hearing the message from any specific source, then leave the space blank. Fill in your own name if you think you came up with the message yourself.

Reread the list of messages and where they came from. Allow yourself to feel your gut reaction as you hear these messages right now. Put an exclamation mark (!) next to those messages you still hold firmly today.

2. *Today:* Close your eyes and ask yourself: What religious and spiritual beliefs have I developed or maintained as an adult?

Head one journal page "Beliefs today." Then write down the religious and spiritual messages you send yourself at this particular time in your life. Repeat messages from your list from the past, if appropriate.

Read over your list of beliefs. Think about the relationship between your religious and spiritual beliefs and your art making. Have your beliefs ever entered into your art, either in particular artworks or in

your work in general? Are you reacting against religious ideas or are you expressing religious faith? Write down your reflections and feelings about whether or not your spiritual beliefs influence you as an artist. If you hold strong spiritual beliefs which you do not draw on for artistic content, explain to yourself why you don't use this material. Can you imagine yourself exploring spirituality as artistic content in a painting?

Painting Exercise

Spirituality: A Multi-Part Painting

Create an abstract painting that explores aspects of your own spirituality. Work on a support with multiple parts — such as a triptych or a hinged folding screen.

Choose a format and imagery for your artwork that will allow you to explore more than one "side to the question." For instance, the two sides of a folding screen could depict — in abstract terms — your vision of good and evil, the here versus the hereafter, or the physical and the spiritual worlds. A three-part painting might be used to develop abstract images of Heaven, Hell, and the earthly realm. Or a two-part painting might function to embody the interconnectedness of all forms (such as the yin/yang of Taoism).

Multi-panel paintings have long been associated with the expression of spiritual beliefs and events. In the arts of China, Japan, and Korea, multi-panel screens have often been used as the support for paintings that explore transcendental feelings regarding nature. Modern painters in the West, including Max Beckmann and Francis Bacon, have explored the use of triptychs with images that blur the boundaries between the secular and the sacred.

In Pousette-Dart's triptych, *Time Is the Mind of Space, Space Is the Body of Time* (Figure 9.5), we find a sequence of abstract geometric symbols that are on the verge of decomposing or recomposing. Significantly, while the title of the painting would seem to split the artistic conception into two halves, the painting is divided into three sections. This discontinuity functions to connect all of the sections into one totality. As Robert Hobbs has explained, Pousette-Dart's art seeks to "go far enough to come into the universe of everything where nothing is separable."[11]

Topic #4: Abstraction as Commentary

As we have already suggested, today it is hard to explore abstraction without some self-consciousness. It is no longer a given that abstraction is central to advanced art. Moreover, today's practitioners are building on almost a century of previous artists' work. The language of abstraction has become conventionalized — coded with meanings that exert extraordinary influence on viewers' interpretations. For example, a gestural brushstroke is now widely understood as a sign for inner emotion; a painter might make emphatic gestural marks knowing viewers will read them as emotional expression even if there were no actual feelings generating their creation. Likewise, the use of hard edges, a grid, or other geometric forms might be employed as signs of order and rationality.

Some painters have chosen to create artworks which analyze and critique the strategies as well as the meanings invested in the historical vocabulary of abstract art. Their appropriation of past techniques and forms of abstraction is often ironic and subversive. These painters' goals may range from an exploration of how cognitive meaning itself is yet another element (like color or shape) that can be manipulated by the artist, to a search for the limits of originality as a benchmark of human creativity, to a critique of the hero worship accorded to some of the twentieth century's most famous abstract painters. While these artists may appear to be making "purely" abstract paintings, their actual concerns are political and social. They employ an abstract visual language to subtly explore issues of gender, race, economic class, advertising and consumer culture, technology, or other topics. They are attempting to reinvest abstraction with the power to serve as a metaphor for contemporary society or a tool to promote social change.

Consider, for example, the use today of stripes, which are a significant element in the historical vocabulary of abstract painting. In the hands of many abstract Minimalist painters of the 1960s, stripes were considered the ultimate marker of impersonal nonobjectivity — their rigid geometry setting them far apart from the irregularities and emotions of the everyday world. In contrast, many artists today no longer believe a painting can be so detached from the outside world or from the artist's subjectivity. As we already saw, Scully blurs the edges of his stripe paintings in part to reintroduce the notion of individual variation within a geometric structure (Figure 9.10). In her diptych, *Lovely #1 & #2* (Figure 9.18), Karin Davie appropriates the parallel wavy lines employed by Op artists[12] to create an illusion of movement. Davie endows the stripes with feminist content, using the optical

9.18 Karin Davie, *Lovely #1 & #2*, 1993. Oil on canvas, diptych, each panel 90″ × 60″. Courtesy of the artist and the Turner & Runyon Gallery, Dallas, TX.

effects to suggest a woman's buttocks undulating in motion. Gazing at the painting, we find ourselves staring at an abstracted version of female anatomy. By transforming a 1960s concern with visual perception (the heyday of Op art) into a 1990s exposé of voyeurism, Davie implicitly critiques the earlier era's naive separation of art and society.

Sabina Ott parodies the macho image of the heroic male abstract painter by "feminizing" abstraction in her encaustic and oil painting, *Disappearance and Return: #17* (Plate 28). At first glance, this may look like a highly abstract painting whose content is exclusively a formal concern with the encaustic technique, sensuous texture, and subtle gradations of rich color. However, a closer look reveals that Ott's painting hovers at the edges of representation, with clusters of half-formed roses dis-

persed across the monochromatic field. Moreover, the bright pink color has numerous connotations outside the realm of art, including blood, passion, and romance. The lacy images of roses and bright pink defiantly stake a female claim to the language of abstract painting. Ott's painting functions as a humorous comment on the pretentiousness of some past male abstract painters, who claimed moral superiority for nonobjective painting because, in their view, the formal rigor of such paintings set them apart from the vagaries of the everyday world. Ott proclaims a powerful female presence and redefinition of abstract painting's purpose and meaning.

In the West, the appropriation of past abstractionists' styles and motifs may make sense only to art world insiders who get the art historical references; outsiders might find the same paintings obscure and even

irritatingly inbred.[13] The most effective appropriationists, including in our view the artists mentioned here, do more than simply quote a borrowed historical vocabulary; they rejuvenate abstraction by creating paintings that are as visually seductive as they are subversive.

Painting Exercises

Abstracted Appropriation

Option 1: *Ironic Awareness*

Have you ever enjoyed thinking about the subtle differences between saying "I know . . . " versus "I know you know . . ." versus "I know you know I know . . ."? Appropriating an earlier style of art making can be a somewhat similar strategy. You are saying something like, "I know about the historical style called Abstract Expressionism. I know you know about Abstract Expressionism, too. So when I make a painting based on the historical language of Abstract Expressionism, you and I both know I am quoting the past and trying to put a new spin on it." To experiment with the type of strategies a purposefully self-aware artist may incorporate into the creative process, begin by planning an abstract painting that examines its own integrity. Your strategy is to build into the painting clues and devices that expose or embed complex levels of awareness. Working in the style of James Havard (Figure 9.19), create a painting that appears to function on multiple levels. First, the painting appears as a "straight" Abstract Expressionist painting. The straightforwardness of Havard's image, however, is cleverly subverted by the incorporation of trompe l'oeil devices that thwart the nonobjectivity of abstraction. Some shadows are painted and thus question: a) the spontaneity of the painting process; and b) the implied depth of the spatial field.

The challenge now is: Can you add yet *another* layer of complexity or self-awareness to the painting? Havard was appropriating Abstract Expressionism *and* adding shadows to some of the gestural brushstrokes. What can *you* add as you appropriate Havard's approach?

Option 2: *Exquisite Corpse*

A creative strategy enjoyed by some of the Surrealist artists was called "exquisite corpse." To create an exquisite corpse, a group of artists share the same support. Each artist completes one section of the total artwork and then passes it on to the next artist for his or her contribution. All previous work is hidden from view, so that each successive artist doesn't see what the other artists have already completed. Only the tiniest of hints are left exposed, so that the next artist has some guidelines regarding the placement of shapes, lines, or colors.

For this exercise, at least three artists should work together. The overall support should be divided into a grid of nine blocks, or a pattern of six or more vertical or horizontal segments. Each member of the group works on one segment at a time. Upon completion, that segment is covered (leaving only a sliver to remain on view to orient the next artist).

Artists should appropriate styles of earlier artists. The team should decide on a strategy to make sure that at least half of the blocks will be nonobjective. The resulting artwork should be a visual and cognitive surprise to everyone involved.

Painting Exercises

Expanded Form Abstraction

In Chapter 8 we discussed what we call "expanded forms" — paintings which are nonrectangular, impermanent, mobile, constructed of unusual materials, and/or which incorporate three-dimensional elements. This exercise provides two options for using expanded forms with a theme of abstraction.

Option 1: *Nonpainted Painting*

Use a nonart material that has a strong content in and of itself to create a "painting." Take advantage of the colors and physical qualities of the material you select to produce an artwork with an engaging visual presence.

Nonart materials may range from the natural (leaves, branches, pebbles, and so forth) to the cultural (postage stamps, labels, and so forth). In Chapter 4, we illustrated an *Honoring Circle* (Figure 4.14) made by Sara Bates, who arranged shells, feathers, corn kernels, and other natural materials on the floor to create her design. Earlier in this chapter we discussed Yayoi Kusama's artwork *Airmail Stickers* (Figure 9.7) and Soon Bong Lee's mixed media painting with found objects (Figure 9.11).

As another example, look at *Collection* (Plate 29) by Fred Tomaselli. Tomaselli employs a highly inventive approach to materials, using an assortment of pharmaceutical drugs as his "paint." To create *Collection*, the artist

9.19 James Havard, *Ghost Dance Shirt No. 421*, 1977. Acrylic on canvas, 35″ × 35″. Courtesy of Louis K. Meisel Gallery, New York.

arranged aspirin, antacid, saccharin, Sudafed, and other pills into clusters, encasing them in acrylic resin. Evoking constellations in a night sky, Tomaselli's abstract patterns may be a send-up of the wish to experience transcendence through abstract color and form, drugs becoming equated with paint as a potentially mind-altering substance. Additionally Tomaselli's content may involve a critique of our over-medicated society, the jewel-like presentation of the pills symbolizing the way we overvalue drugs as solutions to our problems.

Option 2: Three-Dimensional Abstraction
Utilize a format for a painting that is nonrectangular, mobile, and/or incorporates three-dimensionality in its surface. Working with this format, create an abstract artwork that explores one of the following themes:

* a sacred space or sanctuary (as an example, see Figure 4.14)
* a place in outer space (as an example, see Figure 9.17)
* a bold exploration that blurs the boundaries of painting and sculpture (as examples, see Plates 26 and 27).

GROUP CRITIQUE

At the start of the previous chapter (Chapter 8, pp. 164–165) a journal and discussion exercise asked you to consider the criteria you employ in evaluating a painting. The group critique which concludes this exploration of abstract painting is an opportune time to build on that earlier topic. The following questions should be considered in conjunction with an evaluation of the paintings produced during the study of this chapter:

> What criteria are most useful to the viewer and to the artist in evaluating an abstract painting?
>
> At this moment in time, can we assert that there are any universal meanings in art?
>
> Are there any universal meanings in your works completed for this chapter?
>
> Would adults from other cultures around the globe understand and appreciate your paintings?
>
> Is it important that art try to be universal?
>
> Can art provide an experience of transcendence?

Recommended Artists to Explore

Wassily Kandinsky (1866–1944)

Piet Mondrian (1872–1944)

Arthur Dove (1880–1946)

Joan Miró (1893–1983)

Stuart Davis (1894–1964)

Mark Rothko (1903–1970)

Willem deKooning (1904–1997)

Lee Krasner (1908–1984)

Jackson Pollock (1912–1956)

Agnes Martin (b. 1912)

Dorothea Rockburne (b. 1921)

Yayoi Kusama (b. 1929)

Robert Ryman (b. 1930)

Bridget Riley (b. 1931)

Sam Gilliam (b. 1933)

Brice Marden (b. 1938)

Mary Heilmann (b. 1940)

Pat Steir (b. 1940)

Sean Scully (b. 1945)

Jonathan Lasker (b. 1948)

Gregory Amenoff (b. 1948)

Terry Winters (b. 1949)

Clarence Morgan (b. 1950)

Christopher Brown (b. 1951)

Rosemarie Trockel (b. 1952)

Peter Halley (b. 1953)

Sabina Ott (b. 1955)

Fred Tomaselli (b. 1956)

Emmi Whitehorse (b. 1957)

Jessica Stockholder (b. 1959)

Fiona Rae (b. 1963)

Fabian Marcaccio (b. 1963)

Ellen Gallagher (b. 1965)

1. Mark Rosenthal, *Abstraction in the Twentieth Century: Total Risk, Freedom, Discipline* (New York: Guggenheim Museum, 1996), p. 11

2. Students may wish to research some of the more influential artists of American Abstract Expressionism, such as Jackson Pollock, Mark Rothko, Willem deKooning, and Lee Krasner.

3. Victoria Combalia, "Sean Scully: Against Formalism," in Ned Rifkin, *Sean Scully: Twenty Years, 1976–1995* (New York: Thames and Hudson and the High Museum of Art, 1995), p. 36.

4. Quoted in *Ibid.*, p. 36.

5. Adrian Searle, "Jessica Stockholder," in *Unbound: Possibilities in Painting* (London: The South Banke Centre, 1994), p. 96.

6. For further instructions regarding the encaustic technique, we suggest referring to the excellent discussion in Mark David Gottsegen, *The Painter's Handbook* (New York: Watson Guptill Publications, 1993), pp. 215–218.

7. Correspondence from the artist to the authors, January, 1998.

8. W. Jackson Rushing, "Clarence Morgan: Recent Abstractions," in the exhibition brochure *Clarence Morgan: Recent Abstractions* (St. Louis: Gallery 210, University of Missouri-St. Louis, 1997), n.p.

9. Judith Ryan, *Spirit in Land: Bark Paintings from Arnhem Land* (Melbourne, Australia: National Gallery of Victoria, 1990), p. 1.

10. Lilly Wei, "Dorothea Rockburne, Stargazer" (New York: *Art in America*, Oct. 1994), p. 113.

11. Robert Hobbs, "Confronting the Unknown Within," in Robert Hobbs and Joanne Kuebler, *Richard Pousette-Dart* (Indianapolis: Indianapolis Museum of Art, 1990), p. 80.

12. Op art was the name given to a style of art making, especially prevalent in the 1960s, which emphasized the exploration of special visual effects, such as optical illusions. Bridget Riley, a British artist, and the late Victor Vasarely, a Hungarian, were two noteworthy practitioners. Riley remains active as a painter.

13. A close quotation of a past artist's abstraction raises the philosophical issue whether the "new" painting is also an abstraction, or whether it is a "realistic" representation of an abstraction.

Narrative Painting

<div style="text-align:right;">10</div>

INTRODUCTION TO NARRATIVE PAINTING

We are all familiar with stories. Since earliest childhood, we have heard, told, and read stories. We have also experienced stories told through pictorial means. Most children spend time drawing, and some of their drawings are meant to tell stories; moreover, very young children examine pictures in books of various types before learning to read. In fact, in our culture learning to read is often made easier by storybooks in which illustrations accompany a verbal text. In addition, from childhood onward most of us are regular viewers and listeners of stories communicated through films, television shows, videos, songs, comic strips, computers, and ordinary conversation.

But what is a story? What makes a story a story? Words alone do not make a story. For example, a shopping list in and of itself is not a story. Similarly, a picture is not necessarily a story. A simple line drawing of a toaster on an otherwise empty piece of paper is not likely to be considered a story. What, then, are factors that distinguish a story?

Narrative Factors

A story is taking place in Paula Rego's painting, *The Family* (Figure 10.1). A man in a suit appears to be overwhelmed by a woman and a girl while a younger girl watches in front of a window. Interpreting the image by its title and the characters' clothing, we conjecture that a servant and an older daughter are struggling with the girl's father. Sexual undertones permeate the scene; it appears that the father is being forcibly undressed, while the girl and maid are smiling mysteriously. As viewers, we are curious about what is happening now and may happen next.

Rego's painting contains the traditional hallmarks of a *narrative* — a story that unfolds over time. Rego's painting implies an ongoing *sequence of events*, where time is passing and *change is occurring*. Were we to see more of the sequence, we anticipate that later events would involve *one or more of the same characters*. All of these factors — a sequence of events, change over time, consistency of character(s) — contribute to the telling of narratives in virtually any medium, including literature, movies, ballets, and paintings.

Identifying a painting as a narrative is not an all-or-nothing situation. Some paintings clearly depict a story, while others contain relatively weak narrative factors. Furthermore, while most narrative paintings include figures, not all figurative paintings are narrative, and some narratives are painted without using any figures. As we discussed in Chapter 4, the shorn locks of hair in Catherine Murphy's *Bathroom Sink* (Figure 4.8) seem to hint at a plot.

Rego's painting is an example that clearly emphasizes its narrative intent; in contrast, Richard Diebenkorn's painting, *Seated Figure with Hat* (Plate 1),

10.1 Paula Rego, *The Family*, 1988. Acrylic on canvas-backed paper, 88⁹/₁₀″ × 88⁹/₁₀″. The Saatchi Collection, London.

seems devoid of narrative content (or what is there is relatively weak). Although a viewer might conjecture that the woman is waiting for someone, the painting itself does not emphasize such an interpretation. The painting makes little if any attempt to establish a story line. Instead, the artist has focused on how shapes and colors look in relationship to one another, how they correspond to the appearance of the subject, and how they establish an expressive mood. A narrative painting may do all of these things, but it also does something else: it establishes that events are unfolding over time, events which engage the lives of a cast of characters (or a single character). As we shall explore later, the characters in a narrative are not necessarily human.

HISTORY OF NARRATIVE PAINTING

Paintings may have functioned in at least a partial story-telling capacity from the time of the Paleolithic cave paintings, some of which appear to record events of hunting. Certainly stories have been told visually in cultures throughout the world since ancient times. For instance, among the wall reliefs and paintings from ancient Egypt, some scenes depict a story or historical event involving the participation of the pharaoh. Although the compositional formats of Egyptian narrative art vary, the majority are *multi-episodic*, meaning that artists show a succession of scenes from the same story, typically depicted in a sequential manner in bands across and down a wall (as in a contemporary comic book).

Narrative art increased in importance in ancient Greece and Rome, accompanying the growth of literature in books. Visual narratives represented scenes from mythology and other stories whose iconography the educated minority was already familiar with from reading. Educated viewers could identify characters through well-known attributes and actions. Depending on the period and format (vase painting, wall painting, sculptural frieze, statuary group, or the illumination of a text), Greek narrative art either represented a story *multi-episodically*, with many figures and scenes, or as a *single scene*, rendering one specific moment from a story. The Romans refined the compositional technique of the *continuous narrative*, defined as the representation of a sequence of events in the same picture. We look more closely at multi-episodic, single scene, and continuous narratives in the section "Narrative Formats" later in this chapter.

Around the globe and throughout history we can identify countless examples of paintings that are used to express, illustrate, or insinuate narratives. Examples include small-scale paintings from Persia[2] included in written manuscripts to illustrate historical narratives and romance tales, panel paintings from India depicting incidents in the Buddha's life, and wall paintings and painted images on ceramic vessels from pre-Columbian Mesoamerica showing religious and secular narrative scenes.

In Western culture, a large proportion of paintings made from the Middle Ages until late in the nineteenth century depicted stories, or contained at least some elements we can identify as narrative. During the Middle Ages in Europe, most narrative paintings focused on stories from the Bible. Media included illustrations in manuscripts, wall and ceiling paintings (both frescoes and mosaics), woven tapestries, and paintings on wooden

10.2 Hieronymous Bosch, *Paradise*, left wing of the triptych, *The Garden of Earthly Delights*, c. 1500. Oil on wood, 86½" × 38". Museo del Prado, Madrid.

panels. Themes included the lives of Christ and the Virgin, and the lives and martyrdoms of saints. Renaissance narrative painters, from c. 1500 onward, continued to depict biblical stories while adding stories from classical mythology, literature, and history to their repertoire, along with the occasional depiction of an important recent event. For example, *Paradise* (Figure 10.2), the left panel of a sixteenth-century triptych by Hieronymous Bosch, depicts the biblical Garden of Eden.

In the West, narrative paintings of biblical, classical, literary, or historical subjects were called *history paintings*, and were viewed as the most demanding and important category of painting until well into the nineteenth century, receiving the most expensive commissions and highest critical esteem. A history painting was expected to show a significant incident taken from a well-known written text, and to glorify the exploits of people of high status, such as kings, generals, heroes, and religious figures, or characters whose actions encoded a valuable lesson in morality. This grand approach to narrative painting began to erode in the late eighteenth century, as various painters broke with tradition by depicting popular stories involving less exalted people, painted less morally uplifting stories, and even depicted recent news stories. By the late nineteenth century, a reversal had occurred: most avant-garde European painters avoided narrative subject matter in favor of still life, landscape, and portraiture—genres previously considered below history painting in status.

Through the first two-thirds of the twentieth century, many avant-garde painters in the United States and Europe avoided storytelling, instead exploring other issues such as formal abstraction and experimentation with materials and techniques. Some artists, historians, and art critics even doubted the appropriateness of a painting to express a story. They argued that paintings should focus exclusively on qualities that seemed to them to be the province of painting at its purest (such as color and paint texture). Nevertheless, throughout the twentieth century, some artists, including many Surrealists, Mexican muralists of the 1920s and '30s, and Pop artists of the 1960s and '70s, continued to develop aspects of painting's rich storytelling potential.

NARRATIVE PAINTING TODAY: WHAT AND WHY

Since around 1980, narrative painting has experienced a resurgence in the United States, accompanying a renewed belief that painting, like other art forms, should reconnect with the world outside the painting's borders. The resurrection of narrative painting has been reinforced by the fact that narrative imagery in general is highly compelling and ubiquitous in our culture, which has been permeated by television, film, and video.

The reasons painters throughout history and today have chosen to depict narratives, or partial narratives, are almost as diverse as the reasons for making art at all. Pictorial narratives have been used to express religious values, foster political or social change, legitimate authority, provide moral instruction, fantasize, entertain, document historical events, and record personal histories. The subject matter may be fictional, or historical, or some combination of invention and actual events.

Many of the broad reasons for telling visual stories are the same today as in the past, but new motivations also compel contemporary painters, such as the use of a narrative mode to communicate an intellectual theory. In addition, painters today often have new stories to tell: some painters convey autobiographical narratives drawn from personal memories; some tell stories on behalf of people ignored in the past by artists and art patrons, with messages intended to address the complicated lives we can expect to lead in the twenty-first century.

The reasons artists today make paintings with narrative components are not mutually exclusive. Many paintings reflect a combination of reasons, and we could discuss most paintings on the basis of alternative or shifting motivations. But to give you a place to begin thinking about this complicated topic, we have organized some of the reasons into three general classifications: "Framing History," "Capturing the Mood of the Times," and "Personal Memory."

Framing History

Narrative factors may illuminate or illustrate an artist's understanding of history and how today's conditions are seen in part as the result of past actions and attitudes.

Giving form to a narrative through art can be empowering for women, minorities, and other artists who need and wish to tell their own story in their own way, the types of stories which may never have been told in art before. These stories may reflect the artist's status as a member of a certain group with a shared history and common framework for understanding and relating to the present. Telling such a narrative may serve to call into question the assumptions and biases of prevailing beliefs.

Some painters retell past history, as Nancy Chunn does in *China III: Era of Division; 316 to 589 A.D.* (Figure 10.3); others document a more recent event, compelled

10.3 Nancy Chunn, *China III: Era of Division; 316 to 589 A.D.,* 1991. Oil and ink on canvas, 90" × 72". Courtesy of Ronald Feldman Fine Arts, New York.

by the idea of making a pictorial interpretation of what otherwise may be lost or misinterpreted. Frank Romero's *The Closing of Whittier Boulevard* (Figure 10.4), for instance, focuses on a dramatic moment during "violent confrontations between the police and members of the East Los Angeles Chicano community in 1970."[3] Romero's subject matter, treated in a colorful, buoyant style that seems to find humor in grim circumstances, is unlikely to have been painted by someone interested in upholding the political status quo.

Capturing the Mood of the Times

Narratives can be effective in expressing artists' feelings and understandings of our present society — a society in which traditions, purposes, and values are not clear-cut, and many casts of characters are functioning simultaneously with separate purposes and trajectories into an uncertain future. Narrative elements may reflect how an artist sees herself embedded in the context of life's events; and narrative elements may allow the artist and viewers to become more conscious of how identity is shaped by forces outside one person's immediate control. For example, Amy Horowitz's painting *Elevator* (Figure 7.22), discussed in Chapter 7, explores how a woman may find herself trapped in the role of a potential target — the woman hopes the story ends and "nothing happened."

For the purposes of discussion, we have separated the theme of "framing history" from "capturing the mood of the times." These themes may merge as an artist presents

10.4 Frank Romero, *The Closing of Whittier Boulevard*, 1984. Oil on canvas, 34″ × 56″.

events and forces from various historical moments, and, doing so, asserts the continuing influence of the past on the present. In a large painting of dazzling complexity, *Revolution* (Figure 10.5), Indonesian artist I Wayan Bendi collapses together a vast profusion of Balinese society and history, including present-day tourists and invading Dutch colonialists from the turn of the twentieth century. Through his imagery, the artist brings to light some of the tensions that characterize Indonesia.

Personal Memory

Painters may use narrative factors in order to respond to or give form to a personal memory (whether invented or real). Rego's *The Family* (Figure 10.1) incorporates details and events from the artist's own life, including her husband's extreme helplessness due to illness. Vernon Fisher's *When I Was a Kid* (Figure 10.6) is derived from the artist's recollection of childhood Easter egg hunts.

Like people in all walks of life, many artists search for a sense of purpose and meaning beyond themselves. Whether it consists of spiritual exploration, establishing

a closer connection to nature, or recognizing a kinship with other people, the act of searching for meaning might be expressed in narrative form, and these narratives may explore personal recollections. Indeed, narrative is an especially effective format for showing how life's meaning necessarily involves the passage of time. In Fisher's artwork, the artist's childhood serves as a metaphor for the artist's adult understanding of reality (there appears to be a code which one must know in order to understand events and relationships).

Journal and Sketchbook Exercises

Personal Narratives

Life Path
Think back over your life up to the present and ask yourself, "What have been the key events in my life?" Close your eyes to more clearly visualize your memories.

10.5 I Wayan Bendi, *Revolution*, **(detail)** 1991. Acrylic on canvas, 57½″ × 104¾″. Courtesy of the artist.

To begin, draw a life path, including a mark for your birth and a mark for now. Draw your path in whatever form, shape, or direction comes naturally to you — such as a straight line, jagged line, circle, or spiral. On the path, make marks for ten to twelve key life experiences. Near each mark write a word or phrase describing the experience, e.g., "first date," "my father's death," "canoe trip in Canada." Also record a few feelings (physical and emotional) you remember having at the time of the experience, and note one or two objects or images that symbolize that event for you.

When you have finished, study your life path. Select one of the experiences and then focus on a particular incident within the experience that seems to generate

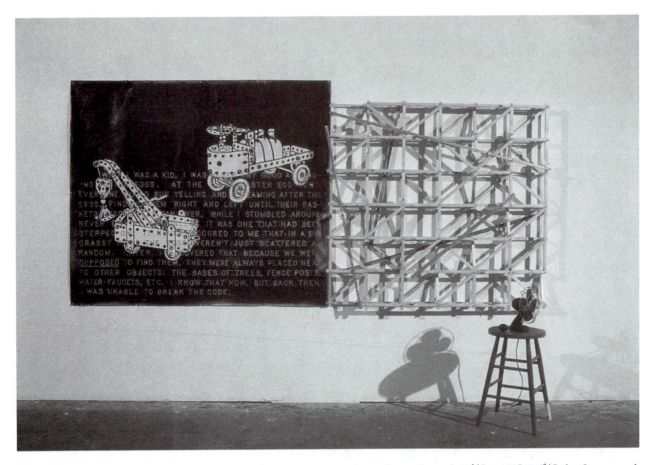

10.6 Vernon Fisher, *When I Was a Kid,* 1983. Acrylic on paper, eggs, plaster, fan, and metal, $60\frac{1}{2}'' \times 131'' \times 4\frac{3}{4}''$ plus fan on stool. Arthur and Carol Goldberg Collection, New York.

particularly powerful visual images and emotional feelings, and effectively represents the whole experience for you. In your journal, describe the incident: first, as you remember feeling at the time and secondly, as you feel about it now, recalling it in the present. Write down a description of what happened and your visual memories — what was the setting, the weather, the location, how you looked at that age.

To explore your life path through sketching, spontaneously "doodle" and sketch as you daydream over the events you recorded. Allow visual relationships to develop: follow a line to see where it leads, create shapes spontaneously and then "tie" them into what you've already sketched. Sketching should allow new content to evolve as you explore what your memories trigger visually and, vice versa, what the process of creating visual forms triggers mentally.

Life Passage Event

Recall a life passage event — a birth, a death, a romance — that affected you profoundly (most likely this

will be an event on your life path). Think about any rituals that accompanied this event, such as a religious ceremony, funeral service, or wedding. Remembering your feelings about this momentous occasion, pretend that back then someone had asked you to create an object that would be used in the ritual. Describe what kind of object you would have created — what it would have looked like and how it would have entered into the ritual.

Dream Journal

For most of us, our imagination is at its most powerful, unbridled, and inventive in our dreams. The Surrealists are probably the most famous artists who deliberately sought creative inspiration in dreams. All artists who learn to tap into this rich source can unearth stories, symbols, and imagery of compelling force.

For the next week, keep a record of your dreams each night. Keep a pen and your journal or sketchbook on your bedside table or under your pillow. If you wake up from a dream during the night, try to record as much as you can right away. Make spontaneous sketches and

jot down phrases describing vivid details and the emotional feelings you had while dreaming. In the morning look again at your sketches and reread your scribbled notes, adding whatever else you remember. If you wake up in the morning just after dreaming, lie in bed with your eyes closed replaying as much of the dream as you can. This will help fix the dream. Then open your eyes and make a sketch. Give your dream a title. Don't try to interpret your dream while you are recording it.

After you have collected a week's worth of dreams, choose one dream to explore further. Close your eyes and replay as much of the dream as comes into your mind. Hold each of the incidents in your imagination for a long moment, as if you are looking at snapshots of the dream. On another page in your journal, write your dream's title at the top of a page. Underneath list all the key visual details (people, animals, places, objects, colors, abstract forms) and incidents from the dream which stand out in your mind. Draw more thumbnail sketches of the major scenes from your dream — the process of continuing to sketch will help clarify the most compelling visual qualities, and give you practice in translating and embodying emotional nuances into visual form.

Write a paragraph telling yourself your impressions about what the message of the dream is for you. Begin, "My dream was sending me the message that . . ."

NARRATIVE PAINTING TODAY: HOW

Narrative paintings communicate a story or at least hint at part of a story. Something is happening to someone. In the preceding section we introduced examples of contemporary content and reasons for expressing that content. In this section we look at how narrative paintings are structured. First, we look at types of narrative formats, then we look at various strategies for telling stories. Keep in mind that *how* a painting communicates through its format and composition is linked with *what* the content of the painting is and *why* the content is expressed.

Narrative Formats

It is a challenge to tell a story in a painting, for at least two reasons: most paintings are physical objects that never change, and most paintings can be seen in their entirety at once. Why should these factors pose a problem for painting's capacity to tell a story?

Remember, by definition a story involves a chronologically ordered sequence of events, often including a beginning, a middle, and an end. Even in cyclical stories, events follow in a sequence. Because most paintings never change (they show "frozen" scenes), whatever a painting shows is what it always shows.[4] If a painting shows one particular event in a narrative sequence, it does not later change and show other subsequent events. This limitation was not usually serious for earlier painters because they could assume viewers already knew the stories they were representing. A painter could depict one isolated incident and rely on viewers to know where it fit into the larger narrative. Today, it is more difficult to communicate a coherent narrative in a painting because viewers do not all share the same stories. Even detailed clues may not be enough to evoke the full plot and cast of characters. (In contrast, novels, plays, films, and ballets can easily show a sequence of events unfolding over time, because these art forms themselves are capable of changing over time — the pages in the novel are turned and new words appear, the dancers and lights in the ballet change positions, and so forth.)

Because most paintings can be seen in their entirety at once, the viewer is not easily channeled into looking at one part before another in a prescribed sequence. While a novelist writing in English can presume that the words she writes will be read from left to right, the lines read from top to bottom, and the pages read in sequence, a painter must provide her own structure for looking. Even with a carefully planned composition, a painter may not be able to dictate that all viewers will consistently scan the painting in one "proper" order.

To override these limitations, and to enhance the capacity of the painting to "tell" a story, many contemporary painters employ narrative formats that have been passed down from previous generations, although they may experiment with a format or use it with a different intention. Other painters use newer formats for creating narratives, ones that enable the expression of competing points of view and inconsistent meanings, and offer partial narratives that may tease us by thwarting their narrativity.[5]

The following discussion is not meant to be an exhaustive summary of all possibilities for narrative formats in painting. Perhaps you will be inspired to devise or develop your own distinctive approach to embodying narrative factors in painted artworks.

Single Scene Narratives

In a single scene narrative, the painting depicts only one scene. The choice of which scene and how it is portrayed

is critical if viewers are to make connections between that event and past and future events.

Single scene narratives often depend on a viewer's knowledge of the overall story. Jim Denomie's *The Renegade* (Figure 10.7) makes the most sense to viewers who already possess many impressions of the basic history of the conquest of the American West, including knowledge of the enforced placement of Native Americans on reservations (symbolized in the painting by the plateau of the foreground mesa).

To strengthen the sense of a story unfolding, a single scene narrative may zero in on a dramatic highpoint in the action. Masami Teraoka's painting, *New Waves Series/Makapuu Twist* (Figure 10.8), captures a moment when a Japanese tourist pops out of the waves on a Hawaiian beach and spies a bikini-clad Caucasian woman. As the artist explains, "the crucial photo opportunity disappears, however, when [the tourist] takes a moment to think about his Japanese girlfriend," who is represented in the painting by a small oval insert in the upper left corner. We can enjoy Teraoka's painting as a playful case of a man torn between lust and loyalty, and we can examine the painting as a meeting of Eastern and Western cultures. The cultures share technologies (symbolized by the camera), and each feels a tension between new desires and past traditions.

Multi-Episodic Narratives

A multi-episodic narrative consists of at least two separate scenes or images which function together to establish a sequence, or partial sequence, of the events in a story. Consisting of three discrete images, Gabriel Laderman's *A Drunkard's Progress* (Figure 10.9) is an example.

The multi-episodic format is especially powerful for establishing a chronology of events and showing changes that occur over time. In Laderman's artwork, each image shows two figures in an interior. By showing multiple scenes, the artwork graphically reveals key events in the story. The story is told from left to right, consistent with how written language is customarily read in English. The couple appears to quarrel in the leftmost scene; in the central panel the man (a belligerent drunk) looms monstrously large while the woman looks on shocked; and in the right panel the man has passed out, reduced to a fallen shadow of himself, as the woman rests exhausted. Without all three scenes it would be difficult to comprehend the full narrative.

Multi-episodic narratives were particularly widespread as painting formats in Western Europe prior to the Renaissance, after which the development of conventions for linear perspective resulted in an emphasis on the portrayal of a single scene from one static vantage point. Although paintings were only infrequently painted as

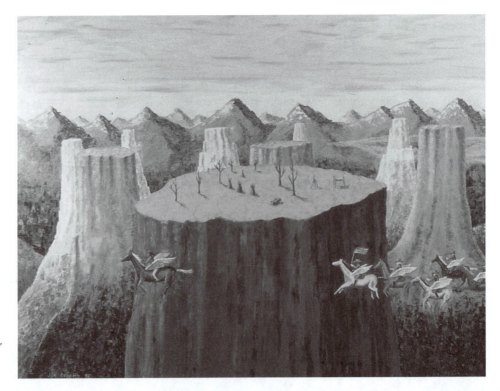

10.7 Jim Denomie, *The Renegade*, 1995. Oil on canvas, 36" × 48". Courtesy of the artist.

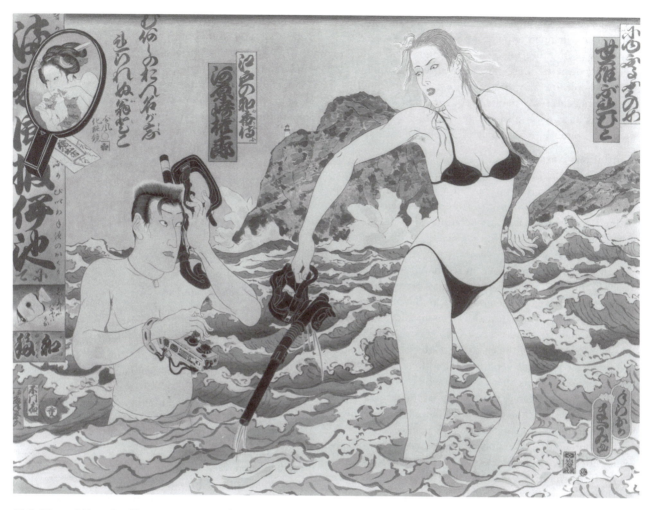

10.8 Masami Teraoka, *New Waves Series/Makapuu Twist,* 1992. Watercolor on paper, 22¼″ × 30″. Courtesy of the artist and Catherine Clark Gallery, San Francisco.

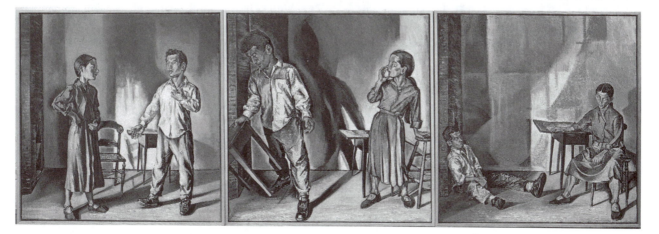

10.9 Gabriel Laderman, *A Drunkard's Progress,* 1988–91. Oil on canvas with alkyd resin, each panel 36″ × 36″. Courtesy of Tatistcheff Gallery, New York.

multi-episodic narratives from the Renaissance onward, the format remained popular for cartoons and served conceptually as the forerunner of the motion picture. In the past few decades there has been a renewal of interest in multi-episodic narrative paintings. Our example by Laderman features a painted sequence that is consistent with the narrative's chronology; in other artworks the painted sequence may be out of chronological sequence.

Continuous Narratives

A multi-episodic narrative is constructed by juxtaposing a sequence of discrete images. In a related format — often called a *continuous narrative* — separate events are embedded within the same composition. The events themselves are not simultaneous; they occur at different times, and might even involve the same cast of characters shown at different moments in a story. In Bosch's *Paradise* (Figure 10.2), three different time periods are fused within the same overall composition. In the painting's upper section, the primeval earth is shown before any large animals inhabit it (only birds can be seen flying); the middle section shows the earth, at a later stage in its development, with animals both real and fanciful; the final, lower section depicts the scene in which Adam is presented with Eve. Seen as a whole, separate periods in the biblical story about the creation of the world are shown in the continuous narrative of Bosch's painted image.

A contemporary version of a continuous narrative is exemplified by Lincoln Perry's *Picturing Will* (Figure 6.19), if we interpret that the dark-haired females appearing in separate rooms of the building all represent the same woman at different times.

Disjunctive Narratives

We use the term *disjunctive narrative* to describe paintings in which the narrative elements are disjointed, overlapping, or blurred to such a degree that all efforts to produce a clear and unambiguous reading of the narrative is thwarted. Narratives of this fragmented and incomplete type are common today, reflecting the hectic mixture of voices and sources of information clamoring for attention in today's America.

In a disjunctive narrative painting, the cast of characters may not remain consistent. A chronology cannot be established: often it is unclear whether the various events that are depicted succeed one another in any particular fashion or pattern, whether or not they are simultaneously occurring, or whether the pieces even belong to the same story or instead straddle several narratives. The artist supplies fragments, but each viewer serves as an author, often using a process of association to piece together a partial story. For example, a confusion of chronological order occurs among the framed panels within the overall composition of Jim Nutt's *Why Did He Do It?* (Figure 10.10). We cannot even be sure of the temporal relationship among all the panels in the composition.

Disjunctive narratives may employ an overlapping of imagery, especially images that differ stylistically from one another. For example, in Plate 30, Carole Caroompas mixes the distinctive textured look of wood engravings with a photo-realist style for the men's colorless heads. (Caroompas's painting is discussed in a Focus feature later in this chapter.)

Painting Exercises

Exploring Narrative Formats

Option 1: A Group Disjunctive Narrative

Select a short story or narrative poem as the basis of the artwork. Each person creates a painting using the same size small canvas; each painting focuses on a *partial glimpse* of one incident or detail from the overall story. After completion, the canvases are arranged together, but not necessarily in "proper" chronological order. (The arrangement of panels might be in a grid, such as the format employed by Dotty Attie in Figure 10.12, or another format, such as a spiral or circle, may be selected.) Panels should be arranged to create a "new" version or plot that scrambles the original text in a conceptually provocative or visually engaging way.

Prior to painting, a consensus should be reached regarding what color scheme will be used by all painters in the group.

Option 2: Update of a Narrative Painting

For this exercise, appropriate an earlier narrative painting and produce your own version. (See Chapter 8, p. 178, for a review of *appropriation* as a creative strategy.) Your transformation should entail changes of both the form and cognitive meaning of your source. Plan your painting so that its composition and narrative format contribute to the new meaning and emotional emphasis you wish to give to your painted update.

Three examples illustrated in this chapter relate to this painting project. Laderman's *A Drunkard's Progress* (Figure 10.9) makes alcoholism the downfall of the protagonist in the artist's contemporary take-off after a famous cycle of paintings (and the engravings created from them) called *The Rake's Progress*, by the eighteenth-century English painter William Hogarth. Attie's *An Eminent Painter* (Figure 10.12) transforms Copley's *Watson*

10.10 Jim Nutt, *Why Did He Do It?*, 1967. Acrylic on Plexiglas, enamel on wood frame, $60^3/_4'' \times 35^1/_2''$. Courtesy of the artist and Nolan/Eckman Gallery, New York.

JOHN SINGLETON COPLEY AND DOTTY ATTIE
Figures 10.11 and 10.12

John Singleton Copley's painting, *Watson and the Shark* (Figure 10.11), was commissioned by a wealthy London merchant, Brook Watson. In 1749 Watson, then an adolescent, was attacked by a shark while swimming in the harbor off Havana, Cuba. Watson lost a foot and damaged a leg in the incident, but a rescue boat thwarted the shark's final assault. The painting's composition is structured as a large triangle: Watson and the shark form the base while the harpoon descends from the top. Smaller triangles, such as an inverted triangle of figures reaching out to the victim, serve as variations. In order to maximize the story's suspense, Copley portrays the moment when Watson's fate appears to hang in the balance. For eighteenth-century viewers, the artist's polished technique contributed to the painting's success as a convincing record of historical truth (somewhat the way a news photograph might function today).

As an artistic response to the Copley painting, Dotty Attie's *An Eminent Painter* (Figure 10.12) appears to call everything into question. Instead of a classical, triangular composition, Attie's contemporary artwork is fashioned as a grid composed of thirty-six separate canvases. Instead of the singular moment presented by Copley, Attie shows Watson's outstretched hand and upturned face repeated across several segments. A text painted on the four corner canvases shifts the focus of the story from Watson to Copley, revealing that Copley's loyalities at the time of the Boston Tea Party were split between the American revolutionaries and the English loyalists. The final text in the lower right corner reads: "Despite his fear of the sea, Copley realized that it was at last time to pursue his studies abroad, and taking leave of his wife and children, hastily sailed for England."

(continued)

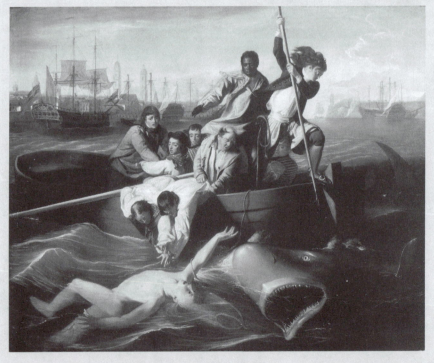

10.11 John Singleton Copley, *Watson and the Shark*, 1778. Oil on canvas, 72″ × 90¼″. Gift of Mrs. George von Lengerke Meyer. Courtesy, Museum of Fine Arts, Boston.

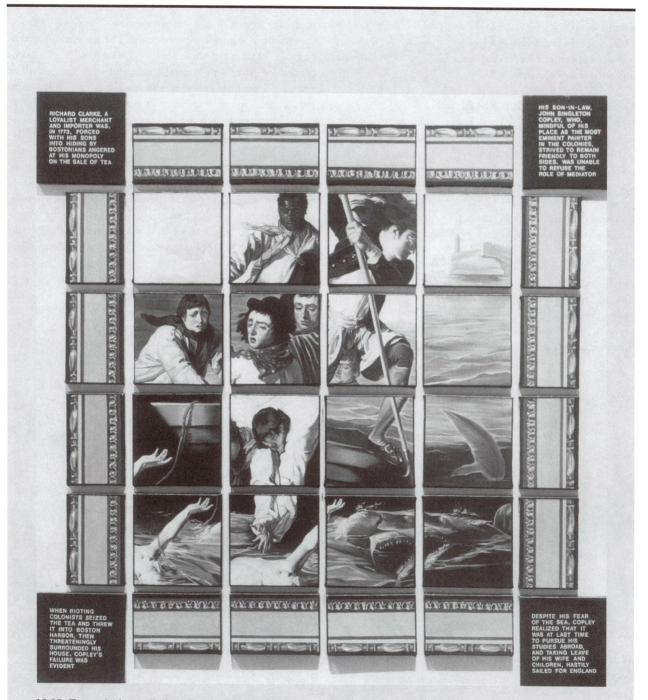

10.12 Dotty Attie, *An Eminent Painter*, 1989. Oil on canvas, 36 parts, 36″ × 36″ overall. Courtesy of the artist and P.P.O.W. Gallery, New York.

and the Shark (Figure 10.11) into a tale of political intrigue hinting that Copley himself was a traitor to the American Revolution. Robert Colescott's *George Washington Carver Crossing the Delaware* (Figure 10.13) is a ribald, tongue-in-cheek send-up of Emmanuel Leutze's famous 1850 painting, *George Washington Crossing the Delaware*, which represents a key event from U.S. history that is familiar to many citizens.

Option 3: *Reverse Painting on Plexiglas*

Use the technique of *reverse painting* to create a narrative painting. A reverse painting is a painting produced on the "reverse" side of a transparent support; the completed painting is viewed from the front side, *through* the support. When working in this technique it is important to plan ahead: because the finished painting is viewed through the support, generally the brushstrokes which are laid down first become those in the foreground.

For this project, utilize imagery from popular media (such as cartoons, comics, television shows, compact disk inserts, commercial product labels). By combining imagery from multiple sources, create a new, invented narrative of your own design. Select one of the following formats: multi-episodic, continuous, or disjunctive.

Apply the paint to the "reverse" side of a sheet of clear Plexiglas. Acrylic paints adhere very well, drying to a tight, permanent bond. The paint can be applied in a variety of ways, including lines, flat expanses of color, and blending. On a separate piece of Plexiglas, experiment with the application of paint. For example, a quantity of ultramarine blue, phthalo green, and white paint placed together on a palette knife and then applied all at once in a smooth swipe to the Plexiglas can be used to create the rippled look of ocean waves.

There are two basic options for painting lines. The first method follows this sequence: paint the lines, let them dry, then paint over them. Looking from the reverse side, the lines will appear to be in front of what was painted last. The second option is to paint an area, allow the area to dry a few minutes (but not rock hard), then scratch lines through the paint down to the Plexiglas. Next allow the area to dry completely, then paint a second (or multiple) color(s) back into the incised lines.

For blending colors: apply one color to an area of the Plexiglas. While the paint is still wet, apply a second color over the first, using a soft brush or cloth. Rub together, blending the colors. Check your progress by looking at the painting through the Plexiglas. Working

10.13 Robert Colescott,
George Washington Carver Crossing the Delaware: Page from an American History Textbook, 1975. Oil on canvas. Collection: Robert H. Orchard, St. Louis, MO.

quickly is imperative, for once the paint begins to dry successful blending becomes impossible.

In creating the reverse painting on Plexiglas in Figure 10.10, Nutt first made a drawing to define the gestures, features, and placement of figures within the composition. The artist then taped the drawing to the back of a sheet of clear Plexiglas, and proceeded to paint in the outlines of the drawing on the face-up side of the Plexiglas. He completed details next, followed by painting in the large blocks of flat color.

Once your image-in-reverse is completed, turn the Plexiglas over. The finished artwork is viewed *through* the Plexiglas sheet. For added complexity, additional painted details may be added to the front side. Small holes can be carefully drilled for attaching collage elements on the front.

Option 4: An Artist's Book — Making a Narrative

Using the format of an *artist's book* (a one-of-a-kind book created by a visual artist), create a narrative that incorporates both words and visual imagery.

From ancient times to the present, artists have been involved with the book arts, creating illustrations for works of literature as well as designing lettering, bindings, and layouts. In recent decades there has been a surge of interest in creating one-of-a-kind books, often made entirely by hand. These *artists' books* are not necessarily made of paper; the "pages" might consist of wood, fabric, canvas, leather, metal sheets, cardboard, or any other material. Artists embellish the pages with paintings, drawings, and collages, and often incorporate words within or alongside visual images.

Because a painted artist's book is viewed over time — as the pages are turned — it is an excellent format for embodying a narrative. In planning an artist's book, one question you (as the artist/author) decide is whether to create an artwork that "wants to be looked at" in a particular sequence, or whether to encourage each viewer to explore the pages freely, in a path of any order.

This project is an opportunity to explore the expanded range of meaning that is possible from the union of verbal and visual imagery. In planning your book, consider ways to allow the reader/viewer to catch glimpses of other pages by cutting openings from one page to pages that are below (possibly hiding the opening with flaps or sliding components). To make the artwork kinetic, examine how a child's "pop up" book is constructed with elements that change shape or position as the reader/viewer turns a page.

Because an artist's book typically involves a minimum of four surfaces (a front and back cover, and at least one pair of inside pages), its format is extremely flexible for providing a narrative structure. The artist can exert control over the sequence in which a viewer will experience the artwork, and this sequence can be utilized to give structure to the sequence of events and cast of characters involved. The narrative does not necessarily become fully spelled out. As Stephanie Brody Lederman explains in the quote that opens this chapter, "I do not tell a story, I tell the viewer that there *might* be a story."

For this exercise, incorporate a wide range of collage elements and mix of materials to enrich the painted surfaces of individual pages. Note how Lederman tantalizes us so we want to explore the interior of the artwork by breaking the border of her book's rectangular format in *A Bird in Hand* (Figure 10.14). Make your use of text as distinctive visually as any other component in the artwork.

Strategies for Expressing Narratives

Using Composition to "Tell" a Narrative

Narrative paintings depend on successful compositions. As we have stressed in earlier chapters, a composition traditionally aims for a balanced organization of formal elements on the picture plane. As a way of organizing the picture plane, painters often emphasize one or two geometric motifs. For example, the composition of Rego's *The Family* (Figure 10.1) consists of a series of dark and light rectangular shapes (some of them slightly askew). Turning the illustration of the painting upside down may help you to see how these rectangular shapes organize the entire surface of the painting roughly like a checkerboard.

In addition to organizing and strengthening the visual effect of the painting, a successful composition contributes to the communication of the narrative. In *The Family*, the rectangular motif occurs with greatest intensity near the painting's center. Our eyes are drawn to the skirt's checked pattern, where the plot unfolds at its highest pitch: one girl seems to be rubbing against the man. A secondary geometric motif of triangular shapes also becomes more concentrated in this same central area, where a dark triangular shape thrusts into the arch of the girl's lower back, and the other girl's shadow points toward the checked skirt. Such a concentration of forms in one particular area of a painting is sometimes called the *compositional climax*.

There are many other geometric motifs which can unify a composition; some of the more commonly used are curves, diagonals, circles, and ovals. Of course, not

10.14 Stephanie Brody Lederman, *A Bird in Hand,* 1988. Unique book, mixed media, 11″ h × 17″ w × 40″ d. Courtesy of the artist.

all compositions are based on a motif that can be identified as a simple geometrical figure, but planning a painting in this manner is a strategy to coordinate the impact of all the parts of a painting.

Using Point of View

Point of view implies the distance and angle of the viewer in relationship to a painting's subject matter. By controlling this implied physical relationship between the viewer and the painting, an artist can enhance the mood and clarify the narrative. For example, the intimate quality of Dan McCleary's *Man and Woman in Blue Dress* (Figure 7.14) depends largely on the vantage point which places us face to face with the couple.

Related to the concept of a point of view, we might also consider whether or not a narrative relationship is suggested between the viewer and the painting's subject matter. In some paintings the viewer's presence is explicitly acknowledged by the characters in the scene. The maid, father, and younger daughter in Figure 10.1 all make direct eye contact with the viewer. Because of this, the viewer is implicated as a participant or witness to the scene. In contrast, in other paintings the viewer functions like the proverbial "fly on the wall," invisible and completely ignored by the painting's cast of characters. In Horowitz's painting (Figure 7.22) we assume that the two figures are confined and alone. The sharp tension in the plot stems from the privacy of their situation.

Using Symbolism and/or Allegory to Strengthen a Narrative

Symbolism is closely linked with communicating a story in many paintings. Some symbols are consistent across many cultures, while others are consistent only within one culture. Some symbols are highly personal, their full meaning known only to the artist. Understanding a pictorial narrative may depend on the viewer's ability to decipher the specific connotations of the symbol system employed. For example, in Western paintings, the appearance of a snake usually signifies temptation or eroticism; in Far Eastern religious images, snakes can symbolize the concept of rebirth (because they shed their skin).

The fact that our society is a conglomerate of people who come from many different cultures is a challenge for painters in the United States who wish to use symbols; painters cannot assume that symbols are widely recognized. Some painters embrace a symbolic language anyway, even reveling in combining symbols from disparate times and places, so that their narrative paintings become complex puzzles that may not be entirely decipherable. Among the numerous oddly juxtaposed symbols in Caroompas's painting (Plate 30) are the combining of Elizabethan, Greek, and modern nurses' costumes, a man's head on a platter (John the Baptist?), men's severed heads held aloft (male Medusas?), and a grid of red crosses in the background (a reference to the health organization?). There is no guarantee that all viewers will recognize these apparent symbols or interpret them in the same way, let alone figure out why Caroompas chose to bring them together in one painting.

An *allegory* is a narrative that uses events from one story to symbolize and examine another, deeper story. Frequently an allegory is intended to establish moral value. In addition to serving as a spoof of a famous history painting, Colescott's *George Washington Carver Crossing the Delaware* (Figure 10.13) serves its own allegorical purpose, examining the struggle for American Independence in terms of the prolonged struggle by African Americans for recognition in our national history. Even the outrageously stereotyped features and gestures in Colescott's painting play a serious role. Just as a fiction writer may need to explore characters' perspectives which are anathema to his own, Colescott — an African American himself — has caricatured prejudice by imagining his subject from a bigot's perspective.

Using the Representation of Movement

A narrative is embedded within a chronological framework. In order to emphasize the passage of time, a painter might depict movement or change. The streaming lines of mounted soldiers in Chunn's painting (Figure 10.3) portray the paths of invading armies through ancient China. The icon-like lines of soldiers function to represent an entire column of soldiers as well as an individual soldier moving along a path. Illustrated in Chapter 1, Giacomo Balla's painting of a dog (Figure 1.7) shows movement through space and time by showing multiple "exposures" of the leash and dog's legs.

Combining Images with Text

Increasingly, artists add words as a counterpoint to visual imagery. A text can add another layer of meaning, reinforcing or contradicting the pictorial narrative. Familiar words might take on a new twist by being placed in the context of a painting. Moreover, the way the words are formed — their shape, size, placement, and design — adds visual richness to the surface of a painting. While these practices may seem to be contemporary innovations, they echo such precedents as illuminated manuscripts in medieval Europe and Chinese ink paintings combining an image with calligraphic text.

In Figure 10.6, Fisher combines various materials (wood, plaster, metal), objects (eggs and a fan on a stool), painted imagery (depicting metal toys), and an autobiographical text that reads in part: "When I was a kid I was never any good at finding Easter eggs . . . It never occurred to me that in a big grassy field the eggs weren't scattered at random . . . they were always placed next to other objects . . . I know that now, but back then, I was unable to break the code." Together these words, images, materials, and objects create the ambience of a childhood seen in hindsight through the eyes of an adult — its setting, props, and naïveté. The images and objects do not "illustrate" Fisher's text; they coexist and intermingle, like ingredients in a recipe.

Painting Exercises

Painted Stories — Single Scene Narratives

Option 1: Updated or Invented Fairy Tale or Folk Tale
Select a fable, folk tale, or children's fairy tale to use as the basis for a narrative painting; alternatively, invent a new narrative involving a fanciful cast of characters.

This painting should utilize strategies which we have discussed as ways to enhance the narrative. Plan your composition to help "tell" the narrative, using a repeated geometric motif and area of compositional climax to focus the viewer's attention. Employ, as appropriate,

DEBORAH OROPALLO AND CAROLE CAROOMPAS
Figure 10.15 and Plate 30

In some recent paintings, Deborah Oropallo has derived images from well-known children's stories. "Little Red Riding Hood" is a fairy tale intended to entertain and educate children. Oropallo's painting, *The Wolf* (Figure 10.15), shows Little Red Riding Hood and the wolf side by side in a pose that undermines the familiar plot of seduction and betrayal. A bull's-eye is superimposed on the wolf, suggesting a radical shift has occurred in the balance of power. In Oropallo's feminist version, Red stands in a confident pose (her stance echoing that of powerful men in historical portraits), while the male wolf becomes a target. Oropallo's painted variation seems to say that the lessons the original fairy tale aimed to teach us — lessons about courage, survival, violence, and redemption — do not hold their old certainty and must be adapted to the changing circumstances of the present.

Oropallo utilizes compositional elements and techniques of paint application to strengthen narrative factors in the painting. Shadow images of Red and the wolf ripple out on either side, and narrow vertical stripes further blur the images. The representation of time passing and change occurring is further enhanced by the artist's use of rollers and squeegees to smear the paint. Oropallo uses oil glazing techniques and effects of chiaroscuro to impart a mysterious mood. The multiple positions of the figures seem to imply that even the meaning of the story is undergoing revision, that various interpretations are now possible with each shift in the subject matter's alignment and the viewer's perspective. (Perhaps each viewer is a marksman, shooting holes in the story!)

Carole Caroompas's painting, *Before and After Frankenstein: The Woman Who Knew Too Much: Bedside Vigil* (Plate 30), includes a multitude of figurative and abstract elements, all densely packed within an inconsistent, unsettling sense of space. The title relates the painting to the story contained in Mary Shelley's well-known novel *Frankenstein*. This paint-

ing is one in a series of twelve paintings Caroompas completed on the theme of "the woman who knew too much." Here the theme appears to involve a grisly dream of female revenge and an overturning of stereotyped views of women as placid caregivers. In response to the painting's flamboyant mixture of details, we might ask ourselves: How is the effect of this painting similar to the proliferation of information and lack of coherent direction and unified purpose that characterize much of contemporary life?

10.15. Deborah Oropallo, *The Wolf,* 1993. Oil on canvas, 86″ × 64″. Collection: Anne MacDonald, Tiburon, CA.

such devices as symbolism and the representation of physical movement.

Begin by making *a lot* of sketches. With each version, try to vary the position and angle of the viewpoint. Explore variations in which the viewer becomes a recognized aspect of the story, and others in which the viewer remains invisible to the characters in the painting.

Select one version from all your sketches to work into a finished painting. Choose the format and version which you think most effectively captures — through visual means — the emotional tone of a dramatic moment in the narrative. Be prepared to discuss and defend in a critique why you selected this particular format for your painting.

If your narrative involves one or more animals as characters, utilize this project as an opportunity to experiment with ways to achieve a strong illusion of painted texture (fur, wet nose, claws, and so forth).

Option 2: *Using Sgraffito and Impasto to Express a Dramatic Moment*

Create a painting that emphasizes a particularly dramatic, emotion-filled moment in a narrative. The choice of narrative can involve a religious story, a myth you are familiar with, or an emotional episode from your own life story.

Use this painting exercise as an opportunity to explore more fully the painting techniques of sgraffito and impasto (see pages 34–35 for an introduction to these techniques). Sgraffito involves incising lines in the paint surface. The incised lines reveal an underneath layer of paint, thus producing a contrast in color. Because sgraffito involves scoring or marking *into* a lower layer of paint, its use makes a particularly vivid contrast when used in combination with impasto, which involves the thick buildup of a painting's surface texture.

For the Record: The Eleventh Commandment (Plate 31) is one of a series of self-portraits by Arnaldo Roche-Rabell exploring his Puerto Rican cultural heritage. A viewer who does not have knowledge of the artist's life story would have limited access to the narrative implications contained in the painting (for example, mirrors held by the painted figure refer to mirrors owned by the artist's mother). Plate 31 is a masterful example of the use of sgraffito and impasto to create a large-scale artwork with almost overwhelming physical presence.[6]

To work in a style similar to Roche-Rabell, plan your basic composition first, including the general placement of shapes and colors. To create a quick-drying, sturdy underneath layer, paint the colors you plan to scratch down to with acrylic paints in the positions called for by your composition. Use colors that are high in value at strong saturation, such as yellows, oranges, and yellow greens. Once the first layer has dried, overpaint with a thicker layer of dark oil paint (use dark browns, blues, blacks, or purples). Experiment with various tools — such as a palette knife, old spoons, and the ends of paint brushes — to scratch lines and bands of varying width back into the oil paint. In Plate 31, Roche-Rabell has created the dramatic forms of the central figure and the surrounding ferns using a similar sgraffito technique. The larger, brilliant orange streak across the bottom of the composition appears to have been created by removing the upper layer of paint with a broad instrument, such as a palette knife turned on its edge.

After you have developed your painting with sgraffito, paint further details and model wet-into-wet, or wait until the earlier paint has dried.

Journal and Discussion Exercise

What is Time?

Our culture is undergoing profound changes in how we understand the concept of time. We are increasingly knowledgeable about the vast scale of astronomical time, but our daily lives seem to zip by in the speeded-up timeframe of the electronic age. Painters at the beginning of the twenty-first century can select from a wide range of strategies to explore how time may be embodied or represented in a narrative. We can borrow strategies of earlier artists or utilize the flashbacks, flashforwards, and jumpcuts of contemporary television, novels, and movies.

Read and respond in your journal to the following statements, in preparation for sharing your thoughts in class:

- Time is like the gears of a machine; time proceeds in a linear sequence, a strict and unalterable chronology of equally spaced "nows."
- Time is a recurring cycle. The seasons repeat; history repeats itself.
- The future, present, and past are endlessly occurring all together; all time is simultaneous.
- Narrative time is not indifferent time: the ticking of the clock goes slower or faster in time with the ticking of our (emotional) heartbeats.

- Some paintings depict a timeless moment. Other paintings depict a split second. Compare the representation of time in Peter Doig's *Night Fishing* (Plate 19) with Teraoka's *New Waves Series/Makapuu Twist* (Figure 10.8).

Painting Exercises

Expanded Form Narrative Paintings

Option 1: A Mural-Sized Rebus

Using individual supports (such as small sheets of cardboard or wood panels), paint a series of words that tell (or insinuate) a story. Substitute a painted visual image that stands for some of the words in the tale.

A more complicated but intriguing challenge is to use visual images to substitute for words which, in turn, function as metaphors or symbols in the narrative. (See Craig McDaniel's rebus, Figure 8.6.)

Option 2: A Three-dimensional Narrative Painting

Paint images on sheets of paper which are affixed to all the interior walls of a large box (a cardboard box approximately 30″ × 30″ × 30″ would be excellent). The imagery constructs the setting of a narrative. The "viewer" of the artwork enters into the story, literally, by poking her or his head up through an oval hole cut in the bottom panel. The viewer then becomes a character in the painted narrative. A hole at the top allows ambient light (or a flashlight) to illuminate the artwork.

Recommended Artists to Explore

Sandro Botticelli (1444–1510)

Hieronymous Bosch (c. 1450–1516)

Titian (c. 1490–1576)

Pieter Bruegel the Elder (c. 1525–1569)

Michelangelo Merisi da Caravaggio (1571–1610)

Peter Paul Rubens (1577–1640)

William Hogarth (1697–1764)

Angelica Kauffman (1741–1807)

Jacques-Louis David (1748–1825)

Eugène Delacroix (1798–1863)

Gustave Courbet (1819–1877)

Grant Wood (1892–1942)

Jacob Lawrence (b. 1917)

Robert Colescott (b. 1925)

Paula Rego (b. 1935)

Masami Teraoka (b. 1936)

Dotty Attie (b. 1938)

Jim Nutt (b. 1938)

Frank Romero (b. 1941)

Odd Nerdrum (b. 1944)

Carole Caroompas (b. 1946)

Sandro Chia (b. 1946)

Eric Fischl (b. 1948)

Mark Tansey (b. 1949)

Deborah Oropallo (b. 1954)

Arnaldo Roche-Rabell (b. 1955)

Kara Walker (b. 1969)

1. Unpublished artist's statement, sent to the authors in November, 1997.
2. Persia was renamed Iran in 1935.
3. Jacquelyn Days Serwer, "Frank Romero," in *American Kaleidoscope: Themes and Perspectives in Recent Art* (Washington, DC: National Museum of American Art, Smithsonian Institution, 1996), p. 88.
4. These statements about paintings and time are general conditions; exceptions in the West are easily found. A kinetic painting, for instance, might show an image that changes over time. In other cultures, the frozen image seen all at once is not necessarily the norm. For example, a Chinese scroll painting is seen in segments selected by the viewer who unrolls the scroll.
5. In describing some formats as "newer" we refer only to a change of emphasis and practice from the immediate past. Even the latest modes of art seem inevitably to echo earlier practices. It can be argued that Paleolithic cave paintings are our earliest known examples of visual images layered together in site-specific installations.
6. According to Kathryn Hixson, in other paintings that are not self-portraits, Roche-Rabell employs his own distinctive frottage technique: he wraps "his models with canvas, and applies paint to the enshrouded body in a peculiar ritualized art-making that is a material enactment of the passionate struggle to communicate feeling with paint." See Kathryn Hixson, "AVA 10: 1991," in *Awards in the Visual Arts: X* (Winston-Salem, NC: Southeastern Center for Contemporary Art, 1991), p. 18.

Society and Issues

"Obviously, art does not do the same thing, epoch after epoch, merely changing its style; its function varies enormously from one society to another. Art has always interacted with the social environment; it is never neutral. It may either reflect, reinforce, transform, or repudiate, but it is always in some kind of necessary relation to the social structure."
— Suzi Gablik[1]

INTRODUCTION TO ART ABOUT SOCIETY AND ISSUES

Simply stated, this chapter is about paintings with a purpose. Right away you may ask: Don't *all* paintings have a purpose? Of course, the answer is yes, all art is made for a reason, or a combination of reasons, which may range from the fairly frivolous (to decorate a living room) to the utterly serious (to worship God). From the earliest civilizations, humans have made art to fulfill many purposes, among them to work magic, express strong feelings, preserve human likenesses, record history, tell stories, fulfill a desire for beauty, proclaim religious beliefs, and symbolize social values. Oftentimes an artwork will fulfill several purposes at once. In this chapter we turn our attention to paintings whose primary purpose is to convey explicit messages about social issues and problems.

History shows us that many of the purposes of art have been directed at society. Nevertheless, for a brief period during late Modernism, in the middle of the twentieth century, it appeared as if some people wanted to strip art of all its purposes except that of providing an aesthetic experience — art for art's sake — and sometimes that of providing the artist a means to "find" him- or herself — art as an expression of individual psychology. As we have argued before in this book, today the narrow view known as *formalism* has lost its persuasiveness, and many artists want to reconnect the content of their art with the larger world outside the studio. Key questions of our time for artists are: What are the purposes of art? Does the artist have roles in addition to aesthetic expression or a personal search for the self?

In this chapter, we introduce you to social commentary as one possible artistic purpose. We turn our attention to a line of current thought which holds that the overriding purpose of art today should be to provide pointed visual commentary about where society has been and where it is heading. According to this viewpoint, our world is beset by ominous perils — war, violence, poverty, racism, sexism, disease, environmental pollution — and artists have a responsibility to bear witness to the traumas of our age and to call for social and political remedies. So-called *political* or *activist* paintings deal with current social problems and often argue for social change. Such works may be narrative, thus relating to the paintings discussed in Chapter 10, which use memory, myth, literature, and history as sources of imagery. Or painters may use other approaches and subject matter to convey political content.

Art with a social message is not new. Until the modern era many artworks in the West implicitly or explicitly supported the reigning belief systems of church and state authorities and the wealthy aristocrats who once were the patrons of almost all art. The pyramids in Egypt, for instance, which required vast resources and labor to construct, were a visual symbol of the enormous power and prestige of the pharaoh. The dramatic religious paintings of the Counter-Reformation were intended to increase the power of the Catholic Church by winning converts; the innumerable Baroque portraits of European monarchs in grand poses asserted the absolute authority of kings.

What changed in the modern era was the type of social messages that art expressed. Following the vast social changes accompanying the American and French Revolutions in the late eighteenth century, the social messages of art began to involve critiques of those in power and the institutions which supported them rather than endorsements of official values. An early social critic was Francisco Goya in Spain, who made numerous paintings and prints satirizing contemporary morals and depicting the horrors of modern warfare. Goya's famous painting *The Third of May, 1808* (Figure 11.1) commemorates a popular uprising against Napoleon's invasion of Spain. For perhaps the first time in Western history, an artist showed ordinary citizens rather than generals as the "heroes" of a war. Twentieth-century artists who explicitly addressed social problems in their art included: German Expressionists during and after World War I, who satirized corrupt politicians and capitalists; Mexican muralists between the world wars, whose public artworks supported the goals of the Mexican Revolution; and Social Realists of the same era in the United States, who focused on examples of social injustice.

Today an important influence on social and political art is the emergence of voices from the margins of society: people of color and other historically disempowered groups in Europe and the United States; and activist artists from Asia, Africa, and Latin America. *Multiculturalism* — the recognition that contemporary societies are a diverse mix of ethnic, racial, economic, and sexual subcultures — challenges the whole notion of a single, dominant "mainstream" approach to artistic form and content. (See Chapter 8, for further discussion of multiculturalism.)

The forms of today's issue-based art are as varied as the available media and styles of art. Many socially concerned artists are exploring newer media and forms such

11.1 Francisco Goya, *The Third of May, 1808*, 1814. Oil on canvas, approx. 8'8" × 11'3". Collection: Museo del Prado, Madrid.

as photography, video, performance art, and installation art. Among other attractions, newer media do not carry a long history of association with the mainstream Western tradition which many activist artists are critiquing. But an equally vital group of artists use painting, sculpture, and drawing to create meaningful works about current issues.

In this chapter you will explore social and political issues as content for your paintings. Even if you do not believe that ultimately you will want to continue making issue-based paintings, we urge you to undertake the exercises with an open mind. At the least you will gain an understanding of some of the motivations and approaches of artists who are engaging in a social critique. Hopefully you will also begin to understand that on a fundamental level there is no such thing as politically neutral art. *All* artists are products of social and cultural contexts, and their art necessarily reflects the ideology they have learned, whether or not they are conscious of that relationship. As unique and individualistic as you may believe yourself to be, you live your life within interconnected spheres of political, economic, and social forces and the networks of power that bind those forces together. How you behave, think, and feel is partly (some would say completely) determined by these intrapersonal structures.

Journal and Discussion Exercise

Roles of the Artist

The United States is faced with enormous social and economic challenges, even as many citizens thrive within a network of unparalleled global opportunities. Is it irresponsible for an individual painter to ignore society's serious problems when making art? Are paintings that are politically, socially, environmentally, and economically aware somehow "better" than those that are not? Conversely, is it productive or worthwhile to insert politics into art? Should we take "political" artists seriously if they do not work for social changes in the issues they supposedly care about in ways other than making art?

Think about yourself. Do you find you have an interest in working toward social, political, and economic change in our society? Are your political beliefs well-formed and fundamental to how you view yourself? If your political beliefs are strong but you don't use them consciously in your paintings, ask yourself why you don't try to use social content? Do you work for social change in ways other than making art?

In preparation for a group discussion, write freely speculating on what you think the role/s of the artist should be regarding the socioeconomic challenges facing the world. Don't worry about being "politically correct." Record whatever opinions and feelings arise spontaneously.

Topics for Group Discussion

Social commentary is by no means the only purpose available to you as an artist today. Other time-honored purposes, many of which we have touched on in previous chapters, are also being revived and reexamined, including telling stories, conveying spiritual values, sparking the power of the imagination, exploring technique and form, and providing experiences of beauty and joy. The class as a whole should discuss and debate what the role or roles of the painter should be: to serve as history's witness? to promote social justice? to produce objects of beauty according to aesthetic tradition? to craft visual objects consistent with exacting technical standards? to function as a prophet (revealing the truth as one sees it)? to explore one's own inner being?

In considering the roles of the painter, do you see a changed emphasis from the roles painters played in previous generations?

Is it necessary that all painters play the same role? Is there room in the culture to support a variety of roles for painters?

How is being a painter similar to and different from being a writer in our society? Consider the variety of roles that writers may assume: as lyric poet, newspaper reporter, personal letter writer, essayist, political speech writer, author of training manuals, and so forth.

Option: Research and report back to the group what a variety of artists, writers, critics, and politicians past and present have expressed regarding the roles of the artist.

TIPS FOR PAINTING WITH PURPOSE

1. Paint intensely. Aim to make your painting powerful *right from the start*. Be as assertive as you can from the very first brushstroke. Don't expect to captivate your viewers' attention with a painting that doesn't captivate your own attention *while you are in the process of creating it.*

2. Be bold with your approach to painting. Be willing to explore your most deeply felt ideas and convictions. In order to learn something new (about painting and about yourself) have courage in trying something new.

3. Don't skimp on paint. Unless there is really a strong artistic reason to, don't paint too thinly. You will

SUE COE
Figure 11.2

Sue Coe is one of the most committed activist artists of our era, wholeheartedly viewing art as an agent of social change rather than an end in itself. Although she sometimes exhibits her work in galleries and museums, more often she makes work for reproduction in magazines and newspapers, wanting to address the largest possible audience. A product of a working-class upbringing in London, Coe has lived in the United States since 1974. Her drawings, prints, and paintings provide a blistering indictment of capitalism, sexism, racism, militarism, and violence in all forms.

Coe is a stellar model of a socially dedicated artist who makes work about issues she has researched thoroughly. For example, she visited slaughterhouses for six years with her sketchbook to witness how animals are butchered, so that her visual exposés of the meat industry (a frequent target) blaze with authentic fury. *The End of the Empire* (Figure 11.2) contrasts the bucolic image many hold of the life of animals on farms with the conditions that actually prevail on a factory farm designed to raise as many animals as quickly as possible. The artwork displays typical elements of Coe's style: a blend of caricature, expressionistic distortions, and realistic details; a moody palette of extreme darks and lights; a crowded composition, so that we must decipher elements slowly; and slightly misaligned perspectives for the edges of walls and buildings, producing a subtly surreal effect.

11.2 Sue Coe, *The End of the Empire*, 1990 (*Porkopolis #106*). Watercolor and graphite on white Strathmore Bristol Board, 58″ × 72 ³/₄″. Courtesy Galerie St. Etienne, New York.

only shortchange your potential for making strong images.

4. *Be committed* to your content. Throughout this chapter, you are challenged to work with a range of issues and painting formats. We believe this will be a valuable learning experience. It must be emphasized, however, that if you are to develop fully as a painter working with the kind of social issues discussed in this chapter, you will ultimately need to commit yourself to your topic. Strong art with a social message is not made to be politically correct; it is made because an artist is driven by conviction and a sense of purpose. This commitment may call for additional research. While certainly your best paintings may appear as if they came straight from your gut or from your heart, you will have more to communicate if you have made it your business to *know what you are painting about*. Make your content your own.

DEFINING YOUR ISSUE, YOUR AUDIENCE, YOUR GOALS, YOUR EFFECT

To function effectively as an issue-oriented artist you should define your issue and then delve as deeply as possible into the issue and its ramifications. Avoid being superficial and revisiting clichéd observations.

The issue you wish to communicate in your art may not seem topical — other artists may not be focusing on the issue; critics and curators may not be drawing attention to it. But you can still make it the focus of your art. Your paintings will be more powerful if you define content that is important to you.

Having selected an issue, you will communicate something about your topic to those who comprise your viewing audience. Rather than conceiving your potential audience as the entire undifferentiated mass of the public, it may be useful to consider defining your audience in more limited terms. Doing so, you may be able to gauge with greater accuracy the effect your painting will have. Indeed, this is how most contemporary artists function, whether or not they acknowledge it. One painter might make a work with art world insiders as the expected audience; another uses an expensive frame to attract well-to-do collectors; another creates a public mural to be seen mainly by workers in a factory; some painters paint only for the enjoyment of family or friends.

In some of the exercises that follow, we explore how a different understanding of your audience will likely cause you (or allow you) to produce a very different painting. You may even need to strategize how to get your intended audience's attention in the first place, before you can expect to communicate successfully anything at all.

Related to defining an issue and an audience, you are also challenged to define the goals and effects you aim to achieve through your painting. There are many possible goals for painting, even within the spectrum of paintings that address contemporary issues. These goals include the artistic documentation of a current state of affairs, the consciousness-raising of your audience, an expression of moral outrage, and a call or blueprint for action (such as political action).

Painting Exercise

Framing the News

Create a painting that documents a current event dealing with an issue you have strong feelings or opinions about.

Base your painting on a photographic image of the event published in a newspaper or magazine. Carefully select a close-up detail to enlarge as your painting. Choose the detail to focus attention on one particular relationship within the overall event; controlling what is seen is one strategy for maximizing your control over a viewer's interpretation.

Option 1: Make a painted enlargement (in black, white, and shades of gray) of the detail shown in your original source image. For added emotional effect, increase the contrast of values. Lighten all light grays to near white, and darken the middle and dark grays to near black.

As an example of a painting using a strategy similar to Option 1, we illustrate Hugo X. Bastidas's *Move Along* (Figure 11.3). The painting focuses on a homeless man next to a police officer's boots. Because of its low viewpoint, the painting encourages viewers to empathize with the person lying on the street. Our view of the scene is restricted to the vulnerable position of the downtrodden. The artist's use of heightened value contrast makes the scene appear ominous and stark.

Option 2: Create a monochromatic (one color) enlargement of the entire image. Choosing color for its emotional effect is another strategy for increasing your control of the viewer's interpretation. Once the monochromatic painting is completed and dry, use a

11.3 Hugo X. Bastidas, *Move Along,* c. 1994. Oil on canvas, 24″ × 36″. Private collection. Courtesy Nohra Haime Gallery, New York.

11.4 Bernard Williams, *Story of Jean Baptist du Sable,* 1999. Acrylic on canvas, 72″ × 78″. Courtesy of the artist and Jan Cicero Gallery, Chicago.

complementary color as a glaze to call further attention to or heighten the disparity between portions of the painting. (Review the sections on glazing in Chapter 2, pp. 35–36.)

TOPICS OF ISSUE-BASED ART

The topics that politically motivated artists address in their work are as varied as the headlines of newspapers and the themes of history books. Below, we introduce five topics that appear frequently in paintings today. But be aware that artists also make paintings about social issues we do not discuss. Moreover, our category divisions are somewhat artificial: most activist artists, including those discussed in this chapter, see social issues as a complex interaction of many factors, and many painters address a range of issues in a single artwork.

Topic #1: Group Identity — When the Personal Is Political

In Chapter 5, you made paintings based on your self-image, including your physical appearance and your emotions. In Chapter 10, you used your autobiography as one source for making narrative paintings. In this section we ask you to broaden your sights to consider who you are in a social sense — how you define yourself in relationship to larger groups.

"Identity" is one of the buzzwords of the contemporary art world. When people say that an artwork is about *identity* they usually mean that the artist is expressing what it means to be a member of a certain group defined by demographic, physical, or cultural characteristics such as national origin, religion, race, gender, or physical disability. People with widely contrasting values, beliefs, and behaviors inhabit this planet. One of the ways in which we define ourselves is by assessing our similarities and differences from other people. Sometimes we find these differences appealing and instructive. At other times, differences puzzle, offend, or disturb us, perhaps because they challenge our deeply held notions of the correct or "best" way to behave.

In an ongoing sequence of paintings, Bernard Williams explores the overlooked history of African Americans in the settlement of the United States. By presenting a heterogenous array of figures, text, and symbols within frieze-like compositions, Williams reveals that there is no monolithic historical truth, no single best

viewpoint for giving form to our collective past. His *Story of Jean Baptist du Sable* (Figure 11.4), for example, involves a black man whom the artist credits as the original founder of Chicago, the artist's hometown.

While some artists may devote their work to a single theme of identity, others try to address the hybrid aspects of "belonging" to several groups. Howardena Pindell's *Autobiography: Water/Ancestors, Middle Passage/Family Ghosts* (Figure 11.5) is from a series of artworks entitled "Autobiography." This visually rich and complex

11.5 Howardena Pindell, *Autobiography: Water/Ancestors, Middle Passage/Family Ghosts,* 1988. Acrylic, tempera, cattle markers, oil stick, paper, polymer photo-transfer, and vinyl tape on sewn canvas, 118″ × 71″. Collection: Wadsworth Atheneum, Hartford, CT. Ella Gallup Sumner and Mary Catlin Sumner Collection Fund.

Focus On

KEN CHU AND PHYLLIS BRAMSON
Figures 11.6 and 11.7

In Figures 11.6 and 11.7, Ken Chu and Phyllis Bramson explore the role of fantasy and stereotypes in constructing social identities. Chu examines forces that define the artist's multicultural identity; Bramson explores factors that constrain and define female sexuality. In creating their artwork, each artist has fractured the rectangle of traditional two-dimensional paintings. Both works incorporate a number of distinct components, all gathered together within an unusually shaped arrangement. Chu has cut shapes out of foamcore, painting them in bold colors. Bramson has produced a "bouquet" of smaller paintings (some found, some painted by her), many in their own separate ornate frames, to which she has added sculptural elements such as a spray of metal branches.

11.6 Ken Chu, *I Need Some More Hair Products*, 1988. Acrylic on foamcore, 21″ × 25″ × 5″. Collection: Arthur and Leah Ollman, San Diego, CA.

Chu uses humor to comment about the relationships between mainstream and ethnic identities. Framed as if inside a television set, an Asian-American teenager combs his hair before a mirror, imagining himself transformed into the clichéd blond, white "American" male of a Hollywood movie. Additional clichéd images of mainstream America (a surfboard, a bowling pin) surround this central scene, while a few similarly clichéd symbols for "Asian-ness" raise the issue of ethnic identity. Bramson's strategy likewise is to juxtapose clashing stereotypes, such as the central geisha figure (an exotic image of Japanese female allure for Westerners) and a small oval image of a bare female derrière (a parody of the female nude so prominently displayed in Western painting). Taken as a whole, Bramson's work appears to expose ways in which female sexuality is culturally encoded and socially determined. At the same time, her painting can be viewed as a celebration of female identity, with its embrace of "female" motifs such as flowers, beadwork, and lush ornamentation.

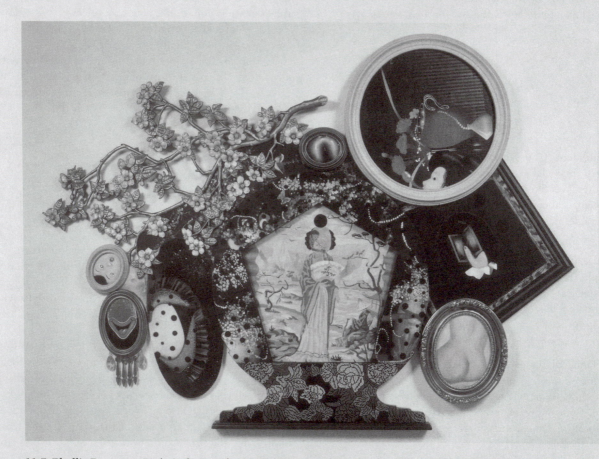

11.7 Phyllis Bramson, *Little Goody Two Shoes*, 1996. Mixed media and oil on canvas, 49″ × 69″. Courtesy of the artist and Carl Hammer Gallery, Chicago.

mixed-media painting incorporates a wide range of styles and images, including a tracing of the artist's body which has been sewn into the center, and a white silhouette of a boat form at the lower left which symbolizes a slave ship. The diversity of materials included in the creation of the artwork reinforces Pindell's understanding that her "autobiography" is the result of the complex interaction of many factors throughout history. Her heritage "is a grand mixture of African, Seminole, French, English, German, Christian, and Jewish; she has traveled in Africa, Asia, Europe, the Soviet Union, Latin America, and the Caribbean, and has lived in Japan and India."[2]

Issues that activist artists concerned with identity have called attention to include gender and racial stereotyping in the mass media, race relations, sexual harrassment and violence against women, ageism, and unequal access to economic opportunities (including opportunities in the art world). In this section we do not claim to offer more than a first glance at a complicated, varied area.

Journal Exercise

Group Identity

We all identify ourselves with various groups. Moreover, society may label us as members of certain groups whether we like it or not. Characteristics within the following categories are some of the ways in which our society defines people:

gender	religion
sexual orientation	race/ethnicity
physical appearance	nationality
species	health/disability
family/clan	region
age	class
occupation	education

Think about each of these categories and how important or unimportant each is both to your self-image and to how others view you. Do you believe other people identify you more in terms of some of these categories than others? Do certain categories matter more to you in your self-assessment?

Pick out *four* of these categories: two that are very important factors in defining your identity and any two others. The two others could be of high importance or

they could simply be identity categories you would like to contemplate.

Write the name of each category you selected at the top of a page. Write a few words or phrases describing how you fit into the category. For example, *region* might be something like "the Midwest" or "the suburbs of New York City." Next write at least a paragraph exploring why you selected that particular category. Are you clear how you fit into a category or are your thoughts about your identity within the category confused? Are you surprised you selected a category? Repeat this writing for each of the four categories.

Next think about the four categories in relation to your art making. Do any of these aspects of your identity ever inspire subject matter or affect other qualities of your creative work? In what ways?

Is any identity category so central in your life that it affects everything you do, including your art? Does any category inhibit you as a painter by restricting the subject matter you think you can select? Write down some of your reflections about the relationship of the four aspects of your identity to your painting.

If you believe your painting does not currently reflect any of these identity characteristics, write about why you don't express these aspects of your identity in your work and whether you wish you ever did.

Painting Exercise

Group Artwork on Stereotypes

The goals for this project are twofold: to create an artwork that challenges viewers to think about what it means to be stereotyped; and to experience working collaboratively, as a member of a team of artists who complete a multi-part painting that "holds together" visually.

The class divides into small teams of three or four artists. Each team selects one group identity as the focus for its project. For suggested "categories" of group identity, refer to the exercise above, "Group Identity." Or your team may define its own category of group identity. It isn't necessary that any of the artists in the team "belong" to the group identity that is selected for exploration.

Team members brainstorm to create a list of common stereotypes associated with the selected identity

group, such as how members of the group are portrayed in movies, on television, by strangers, or by members of the group themselves. *Stereotypes* are prejudiced viewpoints, based on an assumption that all members of a group are similar in some way. Stereotypes often refer to physical appearance, attitudes, beliefs, or behavior. Stereotypes do not all have to seem negative. A general assumption may sound positive but still be a stereotype if it is attributed to someone simply on the basis of their race or sex or nationality. Examples would be generalizations such as, "All Asians are good at math," and "All women are nurturing." Some stereotypes on a group's list may even contradict one another.

After developing the list of group stereotypes, each artist in the team individually executes a small-scale painting that represents an aspect of one of the stereotypes on the list. Try to avoid a literal illustration of the stereotype; instead, think how to show the stereotype symbolically or metaphorically. Upon completion, the team works together to design an overall configuration in which the small-scale paintings are combined. The multiple parts should be incorporated into an overall configuration. Found objects or other painted elements may be used to create a more visually and conceptually unified artwork.

Individual components can be created out of materials that can be cut or made into distinctive shapes. Gessoed pieces of cardboard, foamcore, or plywood are versatile possibilities. Alternatively, small picture frames purchased at yard sales or flea markets can be used to decorate individual canvases, both rectangular and oval. Individual components can be arranged and then attached together on a plywood backing (see Figures 11.6 and 11.7).

Ideas for Group Critique

Evaluate as a class how each team's artwork succeeds formally — how effective and engaging the overall configuration is, and how the individual components contribute to the visual impact of the whole. Equally important, the class should discuss the cognitive meaning conveyed by each assemblage. Is it possible to decode the stereotypes that are depicted in individual components of the overall artwork? What is the effect of having negative and positive stereotypes of a group combined into one artwork? Do contradictory stereotypes cancel each other out, or are some stronger than others? Do any of the assemblages convey how it *feels* to be stereotyped? What limitations and dangers reside in a "positive" stereotype?

Discussion Exercise

Breaking Stereotypes

In advance of the discussion each member of the class selects an identity group with which she or he is intimately familiar. (For variety, select a different group than the one you worked on as a team for the painting exercise on stereotypes above.) Each person assembles from mass media resources an image and data bank documenting the prevalence of stereotypical views of the identity group. To assemble the data bank you might collect magazine illustrations, ads and stories in newspapers, and keep a log of television shows with brief descriptions of characters and events portrayed. Each person then lists five observations from direct personal experience that *break* these commonly held stereotypes about that identity group.

Discussion topics: How are stereotypes formed? What role do the mass media play in the construction and dissemination of stereotypes? How can personal experiences and observations contradict commonly held stereotypes? How would you go about making an artwork that reverses stereotypes?

Faith Ringgold's *Dancing on the George Washington Bridge* (Figure 11.8), and Jaune Quick-to-See Smith's *Trade (gifts for trading land with white people)* (Plate 11) are examples of artworks which serve to challenge or break stereotypes. Figure 11.8 is a "painted story quilt," Ringgold's name for an artwork combining acrylic paint on canvas along with pieces of dyed and decorated fabric. This particular story quilt confronts stereotypes which define women as powerless and belittle their contributions to society as relatively insignificant. In order to symbolize her vision, Ringgold shows a group of women literally dancing on one of the large bridges that lead into New York City. The artist explained that she aimed "to create an image of women as powerful and creative and able to stand up to a bridge."[3] To make her vision rich with associations, Ringgold added a pieced fabric border around her painting. The border is linked visually with the interior image by the repetition of squares in a gridded composition that echoes the grid of the bridge's structure.

In Plate 11, Quick-to-See Smith has collaged together images and information about Indians and their treatment from a variety of mass media sources, along with a collection of baseball hats, tobacco containers, and

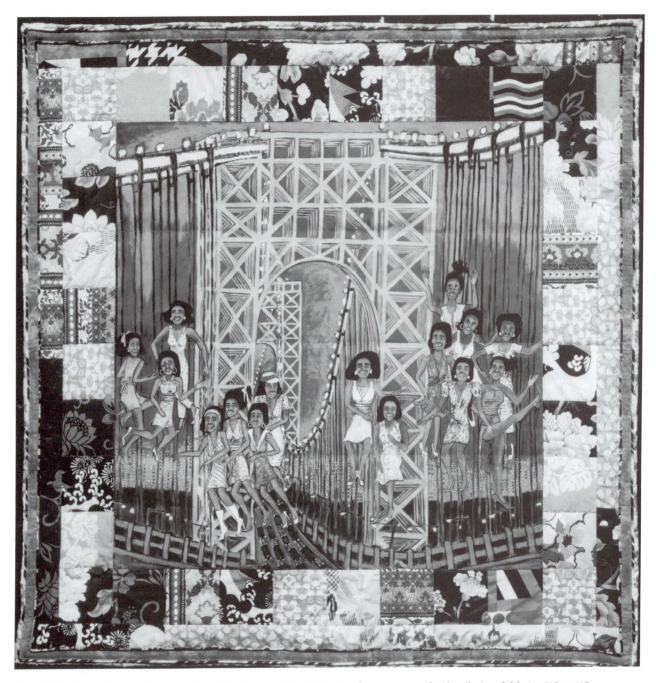

11.8 Faith Ringgold, *Dancing on the George Washington Bridge*, 1988. Acrylic on canvas, dyed and pieced fabric, 68″ × 68″. Collection of Roy Eaton. Photo courtesy of the artist.

souvenir dolls that utilize Native Americans as mascots or corporate logos. *Trade (gifts for trading land with white people)* evokes the experience of being a contemporary Native American, inevitably influenced by Western culture but also profoundly shaped by Indian ideas and history. Focusing on how Native American cultures have fared in the process of colonization, Quick-to-See Smith's art is both sarcastic and poignant. Within the rich mix of material incorporated into Plate 11, we find stereotyped images of Indians and Indian history found

in American popular culture juxtaposed with images and symbols of surviving and evolving traditions.

Painting Exercise

Breaking Stereotypes

Experiment with how a selection of images can be used in a painting as an interconnecting set of symbols. These symbols should illuminate the contrast between stereotypical views of a group and views that challenge those stereotypes. While the approaches to this project may vary widely, you may wish to refer back to the use of symbolism in the paintings by Ringgold (Fig. 11.8) and Quick-to-See Smith (Plate 11), just discussed.

Establish a composition in which the symbols you depict in paint or include as found objects are repeated in a pattern for added visual and cognitive emphasis. As examples, see Ringgold's use of the grid as a pattern, and Quick-to-See Smith's patchwork-like rectangles of paint interspersed with collaged images and newspaper fragments. You could try adding a border around the painting incorporating some of the symbols.

Topic #2: Health

On local, national and international levels, health issues are of rising concern. Increasing health care costs and problems of adequate access to medical care link individual health concerns to larger social and economic debates. Some artists have turned towards a strategy of showing ways in which an individual's health is affected by power relationships among different groups. The most visible health issue addressed in recent art in the United States has been the AIDS epidemic, partly due to the high number of well-publicized cases among people in the art world. In the late 1980s and early 1990s, many artists expressed concern that the federal government did not earmark sufficient funding for research into possible cures for AIDS because the disease — at that time — was perceived as a gay crisis, and the contraction of the disease was (erroneously) perceived as a consequence of homosexuality. Thus, art about AIDS often intersects with art about sexual identity. Other health issues increasingly addressed in art are those closely identified with women, such as breast cancer, eating disorders, pregnancy, and childbirth.

Journal and Sketchbook Exercise

Illness and Death

Let your mind go back to occasions when illness and death have touched you closely — when a significant person in your life, or a pet, or a public figure you admire suffered a serious illness or injury, or the person or animal died. Make a list of everyone important to you who has died or gone through a life-threatening experience. Next to the name write a phrase identifying what happened. ("Best friend Kathy — killed by a hit-and-run driver"; "Roger — lung cancer"; etc.) Include your own name if you have experienced a serious illness or injury.

Look over your list and select one name on which to focus special attention. Let your memories of this person's (or animal's) injury, illness, or death flood over you. Recall what your relationship with the person was like when he or she was healthy. Follow the history of the illness or death from beginning to end, meditating on the gamut of your emotions during this period. Remember how your body felt. Where in your body did you feel the pain of the experience? Tune in to how you are feeling now as you remember this particular time.

When you are ready, write down your memories of the incident you have been meditating about. Don't try to control the direction of your writing. Whenever you need to, stop writing and recall more memories before proceeding.

Next, imagine that you are going to create a painting in which you use one body part to express what this experience of death or illness meant to you emotionally. Which body part would you use and why? Would you show the whole body, highlighting the symbolic part, or would you show the part as a detached fragment? Would you assemble multiple renditions of the body part or use just one version? How would you alter or embellish the body part to express your emotional content?

Draw several sketches of how you visualize the appearance of your body part artwork. With each successive sketch, try to develop a more compelling visual statement that strongly communicates the content you think is most memorable.

Are there aspects of your understanding of illness and death that relate how you and/or the ill or dying person is identified as a member of a group? For example, if your grandfather has developed Alzheimer's disease, how can you relate his individual situation to that of others who also have a diminished ability to remember? How does our culture respond to a loss of memory?

Focus On

HOLLIS SIGLER
Figures 11.9 and 11.10

Figures 11.9 and 11.10 show two paintings by Hollis Sigler from a series entitled *The Breast Cancer Journal*. The individual oil and oil pastel paintings throughout the series reveal the complex shifts of feelings and thoughts experienced by the artist in response to her own breast cancer (first diagnosed in 1985 and then in 1992 diagnosed as having metastasized to her bones). In this pair, the alter ego in Sigler's images finds herself moving from fatigue and despondency to joy and spiritual awakening.

Like others in the series, these two works incorporate texts in a painted wooden frame around a

11.9 Hollis Sigler, *There Are Not Many Rest Stops on This Trip* (from *The Breast Cancer Journal*), 1994. Oil pastel on paper with painted wood frame, 29½″ × 34½″. Courtesy of the artist and the Susan Cummins Gallery, Mill Valley, CA.

central image painted in a style of deceiving simplicity. Some texts in the series offer poetic or philosophical observations; others relate the grim picture painted by statistics: "Breast cancer is the leading cause of death for women between the ages of 35 and 54: 46,000 women with breast cancer will die this year."[4]

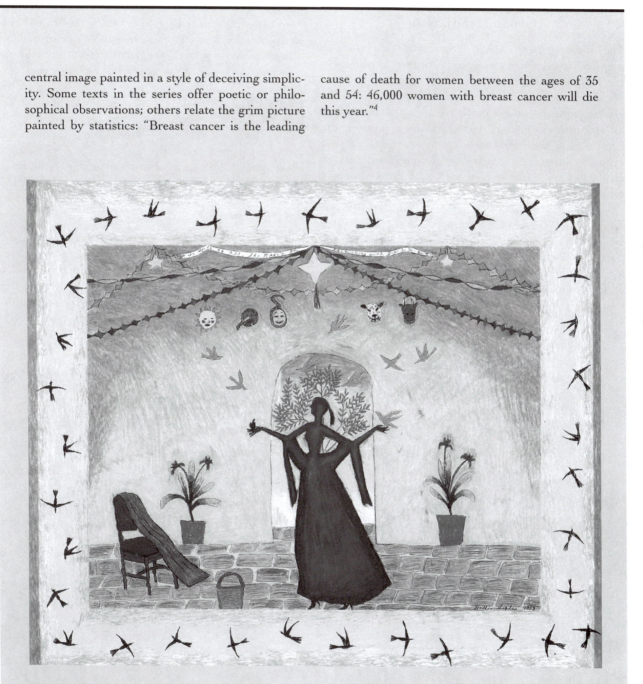

11.10 Hollis Sigler, *In Spite of All She Rises in the Morning with Joy in Her Heart* (from *The Breast Cancer Journal*), 1993. Oil pastel on paper with painted wood frame, $29\frac{1}{2}'' \times 34\frac{1}{2}''$. Margaret Johnson & Ray Ottenberg Collection, Washington, D.C.

Painting Exercise

Expanded Form Project on a Group Health Issue

Plan and execute an expanded form artwork focusing on a health issue from the perspective of that issue's importance to a *group* of people.

By creating your artwork as an expanded form, you challenge the dominance of the rectangular format for an oil painting. Doing so, you have an opportunity to explore how the visual form and presentation of your artwork can serve as a metaphor for your content, which challenges the status quo of the health issue you have selected.

Options to consider in creating your artwork are: Should your artwork hang flat on the wall? What other ways can you consider for its presentation (for example, leaning against the wall, hanging across the corner of two walls, lying flat on the floor)? What additional level of meaning would be gained by exploring the physical relationship between your painting's installation and its viewers?

As an introduction to this painting exercise, look at *Emetic Fields*, by Ida Applebroog (Figure 11.11). Her artwork is composed of eight separate panels, each oil on canvas, arranged in three major sections. The sections are distinguished by color, shape, scale, and subject. The left section, with a muted green doctor standing against a dark maroon background, is mirrored by the right section, showing a similarly colored image of a middle-aged woman, who appears to be based on Queen Elizabeth. Words incised on the right panel define the overall theme, ironically repeating that the (male) doctor is the "real person," while the female is only the patient (even if she is a queen!). Applebroog is challenging the hierarchical structure of our medical profession, dominated by male doctors. As a result of this structure, some patients (especially female patients) may feel powerless.

Painting tip: The technique of sgraffito can be effective for adding text to your artwork. First, paint an area the color you want the words to be. After this area has dried, paint another color over that area. Let this area dry partially (so the paint does not "run") and then use an instrument (such as the end of a brush handle) to

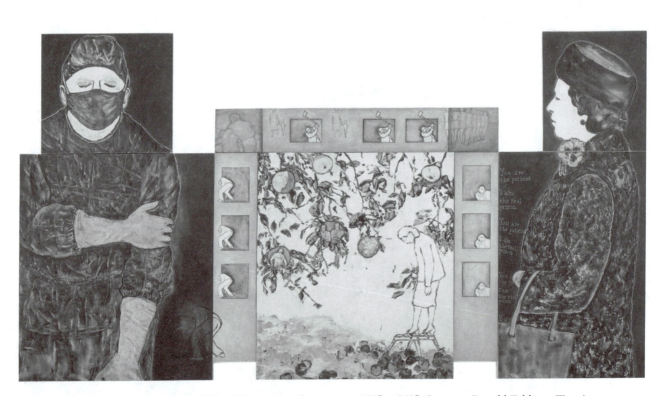

11.11 Ida Applebroog, *Emetic Fields*, 1989. Eight panels, oil on canvas, 108″ × 202″. Courtesy Ronald Feldman Fine Arts, New York.

incise the letters into the top layer. The text appears as you scratch through to the lower color.

Topic #3: Conflict and Violence

As we witness the close of one century and the start of a new one, issues of conflict and violence of varying dimensions command attention in almost all parts of the world and sectors of society. A significant number of contemporary artists have shaped their work as tools for exploring conflict, including international war, ethnic conflict, the threat of nuclear terrorism, crime, violence in the media, rape, and physical and mental abuse within various social relationships. An entire volume could be written on the treatment of issues of conflict and violence in contemporary painting. While earlier generations of artists were likely to create images that glorified conflict or documented its effects from a heroic individual's vantage point, contemporary artists are more likely to explore underlying social, cultural and institutional forces that engender conflict and violence.

Research and Painting Exercise

Root Causes of Conflict

Create a painted artwork that gives visual form to your response to an issue of conflict.

Begin by identifying the issue you want to focus on. You may need to undertake some research in order to clarify your knowledge of the major factors involved, and to identify imagery or symbols that represent the forces that are central to your theme.

While your approach does not need to duplicate that taken by Janice Hartwell (Figure 11.12), we suggest that as a learning experience you design a way to incorporate kinetic elements within your painting. Try to imagine inventive ways to embody the changing nature of various forces that govern relationships between institutions and people, as well as the relationship of these forces to actual locations in time and space. Explore an option for constructing your imagery that does not involve linear perspective or a literal illustration of a violent encounter. You might use a map as the underlying structure of your artwork, as Hartwell does, or consider inventing your own large diagram that identifies the factors you determine as the root causes for the conflict under examination.

This exercise is an opportunity to expand your range of how you conceive and compose a painting into a new mode of image making, one involving movable elements. There are numerous strategies for creating movable elements in a painting. One decision involves whether to allow the viewer total or partial control over the movements (as Hartwell allows in Figure 11.12). If the painting's support is rigid, then hooks can be attached which allow parts of the artwork to be repositioned onto any one of the hooks. A painting that incorporates certain metals in its support would allow for the repositioning of magnetized parts. (For increased durability, use acrylic paint for parts to be handled by viewers.)

Painting Exercise

Information Sign Painting

Many issue-oriented artists devise strategies to have their work seen outside the context of art world institutions. Ilona Granet, for example, began her career by attaching her work to billboards and buildings in New York City. She gained notoriety by displaying painted signs that offer rules for "proper" street etiquette, such as *Curb Your Animal Instinct* (Figure 11.13). Granet's tongue-in-cheek artwork breaks stereotypes of behavior in direct but complex ways, offering an exaggerated view of a bestial male restrained from sexually harassing the passing woman. Freed from the fear of sexual assault, the woman walks with pride and confidence. Note how Granet has created the dynamic quality of the darkened silhouettes. A powerful visual tension is established by the relationship of such elements as the outstretched fingers of the "beast" and the backward curling fingers of the female.

For this studio exercise, paint an information sign in which you convey a strong message about an issue of violence (examples include political terrorism, the international arms race, gang warfare, and domestic abuse). Select a topic about which you harbor strong feelings or opinions. Your approach can range from the witty to the deadly serious, but — like all effective signage — the image should be attention-grabbing and capable of being understood quickly by a passing viewer. You should think about using widely understood symbols to convey your message.

In creating your sign painting, select a limited palette of bold colors to help focus dramatic attention on your message. If time permits, first paint your image in a

JANICE HARTWELL
Figure 11.12

An intriguing subset of painters have occasionally incorporated maps into their images at least back to the sixteenth century.[5] Contemporary artists seem especially attracted to the visual and conceptual richness of maps, finding them to be effective visual formats for condensing information and abstracting relationships in geographic terms. For an artist, maplike imagery can create a visual perspective that takes in "the bigger picture." In this regard, it is instructive to compare and contrast a map with a representational painting done from the singular vantage point of linear perspective.

The large painting by Janice Hartwell illustrated in Figure 11.12 uses a map of the world to critique the relationship between the economic motives behind maintaining a large arms industry and the worldwide difficulty of resolving conflicts without resorting to war. In order to establish the intertwined and fluctuating relationship between money and weapons, Hartwell gives viewers the option of removing and rearranging a variety of icons that can be attached by Velcro strips on their back sides at any point upon the painting's mapped surface. In this way, the artwork becomes both kinetic (movable) and interactive.

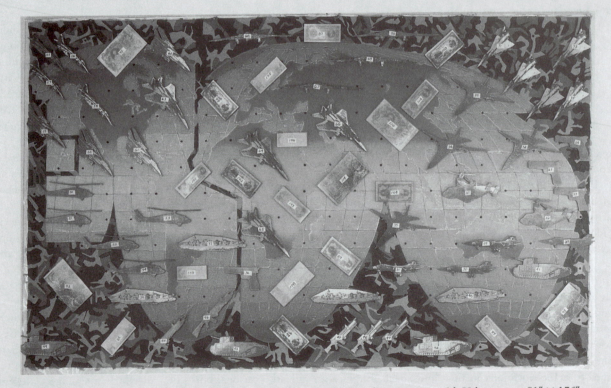

11.12 Janice Hartwell, *Love of Conflict — The Economics Lesson,* 1990. Acrylic on canvas with Velcro parts, 81″ × 136″. Courtesy of the artist.

palette in which the colors you select have a high contrast in values, and then paint another version in which the colors change in hue but are close or even identical in value. (The latter version should produce an effect of vibrating colors.) You may wish to employ a shape for your sign painting that is nonrectangular; many signs in actual use, for example, are diamonds or other distinctive geometric shapes.

KERRY JAMES MARSHALL
Plate 32

Kerry James Marshall's painting, *The Lost Boys* (Plate 32), is the large-scale centerpiece of a series memorializing African-American children who are victims of violence. Marshall shows that for some children—especially the urban poor—notions of childhood as a time of carefree play are a fantasy. He makes his social commentary in part through irony and contrast, and relies strongly on symbols to carry his messages. Rendered in dark indigo paint, the "lost boys" contrast with a cherubic orange kewpie doll in the foreground, an idealized image of privileged white childhood. The boys hold toys (a plastic gun, the wheel of a child's race car) which in this context remind us how guns and cars function in their adult versions as instruments of power and potential destruction. Other symbols contribute to the theme. For example, the tree recalls the tree of knowledge in the Garden of Eden, but the "serpent" encircling the trunk is a police line from a crime scene. The apples on the tree contain bullets, symbolic threats contrasting with the toys of childhood. White gates framing the scene suggest both the fences of a suburban childhood and the pearly gates of heaven. Marshall's deliberately naïve style (flat, simplified figures in a shallow space) resembles folk art, among other art historical sources—another contradiction because his theme of violence reverses the joyfulness frequently associated with folk art. Patches of expressionistic brushwork in the background contrast with Marshall's sharp linear rendering elsewhere, adding to the message of chaos lurking beneath a surface appearance of control and "normalcy."

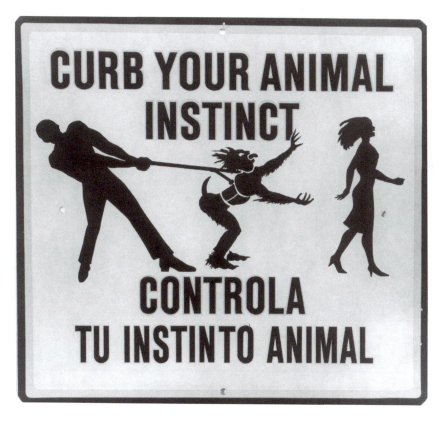

11.13 Ilona Granet,
Curb your Animal Instinct, 1986.
Enamel on metal silkscreen, 24" × 26".
Courtesy of the artist and P.P.O.W.
Gallery, New York.

Focus On

ROGER BROWN AND R. B. KITAJ
Figures 11.14 and 11.15

Roger Brown's distinctive painting style emphasizes a strong sense of pattern and depicts landscapes populated with silhouetted figures. In *Freedom of Religion* (Figure 11.14), Brown comments on what he sees as a dangerous erosion of the fundamental separation between church and state guaranteed by the First Amendment. Brown's image provides a caustic look at how social forces demanding freedom are in conflict with ones seeking control.

While not evident in the black-and-white illustration in our text, the tension between religious freedom and state control is dramatically heightened in Brown's painting by the contrast of comple-

mentary colors. A saturated flame-red cloud formation linking the burning structure of the church with the (heavenly) sky is set against the darker green earth upon which the tanks are lined. Brown's use of generic silhouetted figures and the repeated image of tanks underscores his artistic interpretation of how this particular history is destined to repeat itself.

The issue of free and unfettered communication is addressed in a quite different manner by R. B. Kitaj in *Against Slander* (Figure 11.15). Within the square format of his composition, the artist reveals how individuals are locked within the complex web

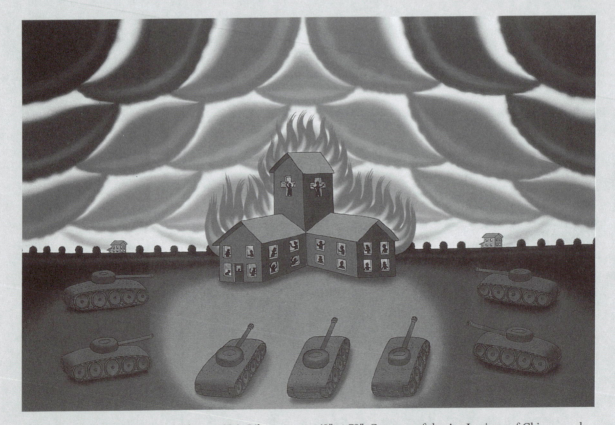

11.14 Roger Brown, *Freedom of Religion*, 1994. Oil on canvas, 48″ × 72″. Courtesy of the Art Institute of Chicago and the Brown family.

of purposeful cruelty and mistrust which sets slander in motion. In turn and in time everyone plays all the roles: victim, witness, perpetrator. The dynamism of the web and its forces is traced by the series of parallel diagonals which run upward on slanting 45-degree angles throughout the picture plane. On a smaller scale, a similar fretwork of lines defines planes of various body and facial features.

11.15 R. B. Kitaj, *Against Slander*, 1990–91. Oil on canvas, 60″ × 60″. Courtesy of Marlborough Gallery, New York.

Topic #4: Censorship and the First Amendment

Not surprisingly, when artists make art as a form of social protest, governments and other powerful groups may respond by *censorship* — by attempts to put restrictions on the content of art. In the United States, an enormous amount of public discussion and activity has been generated in the past two decades by the issues of censorship and government funding of the arts. Debates have raged in the mass media and the halls of Congress. A handful of the thousands of projects funded by the National Endowment for the Arts (NEA) and state arts councils have been singled out by some critics as obscene, or degraded, and held up as evidence that taxpayers' money is being misused. Artworks which have been criticized include ones that show homosexuality in a positive light and others that use religious or patriotic symbols, especially the American flag, in unconventional ways. Attempts have been made to put restrictions on the content of arts projects eligible for government funding, to cut back government arts funding, and even to eliminate the NEA's budget altogether. NEA supporters say these efforts amount to censorship and pose a serious threat to the First Amendment, which guarantees the right of all citizens to free expression.

For this exercise, cast your inhibitions to the wind and make a list of every topic you feel too embarrassed, afraid, or guilty to imagine yourself ever making art about. Don't hold back anything. Assure yourself that you will not show this list to anyone. When you have finished the exercise you will destroy the list and whatever else you write.

When you have completed the list, pick out one topic on which to focus. Think about why this subject matter causes you embarrassment or fear. Recall some of the experiences you have had in your life involving this area. Allow emotions and images about your taboo topic to flood over you.

Reminding yourself that whatever you write will remain your secret, write out everything you are thinking and feeling about the taboo topic. Be completely honest and provide as much vivid detail as you can. Pay particular attention to the emotions the topic arouses in you and to sights, smells, sounds, tastes, and tactile impressions you associate with the topic.

Now explore your worst fears about using this charged material in your art. Are you afraid of what other people might say? Are you afraid of revealing too much about yourself? Are you afraid of losing control of your emotions? Write honestly, telling yourself what is preventing you from artistically exploring this topic.

Journal Exercise

Taboo Topics (a List to Burn)

In discussing censorship, commentators usually focus on instances in which an institution or person bans someone's open expression. Also of importance to consider is the possibility that for a variety of reasons (both internal and external) artists may censor themselves. We consider this type of self-imposed inhibition in the following writing exercise.

All painters have knowledge of vast quantities of subject matter they do not use in their art. Perhaps they find certain topics uninteresting or unsuited to their style and medium. Or it may not have occurred to them to consider a certain topic as artistic subject matter. In other cases, painters may avoid topics because they find them embarrassing, or socially or politically unacceptable, or too troubling emotionally. Moreover, painters may feel inhibited because they know viewers often read images as autobiographical and as keys to the artist's psyche, as if images reveal hidden psychological traits.

Discussion Exercise

Censorship

This discussion should follow the completion of the exercise, "Taboo Topics." No one should be made to discuss any specific writing that he or she is not comfortable sharing with the group, but, hopefully, everyone will share some general thoughts on the topic.

Topics for Discussion

Are all subjects acceptable for art? Are some unacceptable? For example, do you believe that there are icons or symbols so sacred to some societies or religions (such as the Christian cross and the U.S. flag) that no artist should be permitted to use them in their art in an ironic or disparaging way? Is there any iconography in your own life that it would bother you to see ridiculed or criticized in someone else's artwork?

Think about the list you created in the journal exercise, "Taboo Topics," in relation to the issue of

censorship. Would you support an outright ban on any of your own taboo topics? If another artist made images dealing with one of your taboo topics, would you avoid looking at them? How would you judge another artist for using charged content? Is it important to protect the right to free speech (as guaranteed by the First Amendment) even if that means some people will be offended by the content of certain artworks? Are there subjects outside the limits of free expression?

Painting Exercise

A Humorous Look at a Taboo Topic

As a follow-up to our study of censorship as an issue that affects artists as well as society as a whole, create a painting in which you take a humorous look at a "taboo" topic.

Humor in painting comes in many forms. The range of strategies, styles, and emotions employed includes aggressive sarcasm, joyful silliness, playful cartoons, and dreamlike witty fantasies. You may decide to focus on a subject that you find inherently funny, or you may prefer to focus on a subject that is serious but you wish to approach in a humorous manner. Remember, humor can range from lighthearted comedy to biting sarcasm. Refer again to the paintings by Brown (Figure 11.14) and Granet (Figure 11.13), in which each uses a cartoon-like painting style to inject dark humor into a thorny issue with grave moral overtones.

Topic #5: Imperiled Ecology and the Future of the Planet

Nature as we know it faces widespread threats. Deforestation, a hole in the ozone layer, global warming, the depletion of fossil fuels, and the endangered status of various species of plants and animals are but a few of the conditions of our imperiled biosphere. Since as a species we humans are dependent on the broad network of life forms and the earth's supply of natural resources, many experts warn that whatever harms the rest of nature will ultimately harm humans as well.

Instead of depicting nature either as a remote place of pristine beauty or as a threat to civilization and a wilderness to be tamed, today's artists sometimes represent the landscape as something which needs protection from the threats of human encroachment. In Dana Cibulski's *Green Spaces (Homage to Olmsted)* (Figure 11.16) we see one artist's vision of the future of urbanization: nature in the wild has vanished, and all that remains are city parks surrounded by a dense forest of skyscrapers. Cibulski's use of pastel colors for the

11.16 Dana Cibulski, *Green Spaces (Homage to Olmsted)*, 1992. Pastel and acrylic on wood, 66″ × 86″. Private collection. Courtesy of Sandler Hudson Gallery, Atlanta, GA.

buildings makes the image appear ambiguous, as if overcrowding could be softened by cheerful design. (Landscape architect Frederick Law Olmsted designed Central Park in New York City.)

Journal and Sketchbook Exercise

Prophecies for the Year 3000

Artistic innovators often experiment with media, forms, and techniques, manipulating traditional media in unorthodox ways or utilizing unexpected materials and compositions. Artists also have the power to invent new subject matter — strange figures, objects, and settings as well as situations that defy earthly logic. In a work of art a cow can sprout wings and fly, and cities inhabited by giant insects can exist on distant planets.

This journal and sketchbook exercise gives you practice in using your imagination regarding futuristic subject matter.

Visualize the part of the world where you live now — its geography and climate, its architectural features, and the people and creatures that inhabit the region. Give yourself plenty of time to visualize a range of details. Then, once you have a clear vision of your home region as it now appears, let your imagination time-travel a thousand years into the future, to Earth in the year 3000. What do you imagine your region will look like? What kinds of plants will exist? What will the climate be? What kind of structures and communities will be standing? What creatures will inhabit them and what personal and social relations will transpire among them? What strange new powers will creatures possess? What if any art will they be making? Will the future be dreadful or wonderful? As one example of an apocalyptic vision of the future, look at Figure 11.17, an illustration of Frank Moore's *Wizard*, and Figure 11.18, a detail of the painting.

At the top of a page in your journal write, "My prophecies for the year 3000." Underneath write at least fifteen statements making claims about your region of the world a thousand years hence. Your prophecies can deal with any subject or combination of subjects you wish: the visual appearance of the physical setting; new creatures; new technology; rules of reality that defy current logic; bizarre events; exotic behavior; incredible beliefs. Give yourself permission to be wildly extravagant and outrageous in your claims for the future.

When you have finished, reread your list of prophecies. Now imagine that you are going to make a fantastic object that represents an artifact from this future world. What kind of artifact do you want to make — a tool, an

11.17 Frank Moore, *Wizard*, 1994. Oil on canvas, pharmaceuticals cast in lucite encased in aluminum frame, 68″ × 95½″. Private collection. Courtesy of Sperone Westwater, New York.

article of clothing, a weapon, a container, a piece of jewelry, a vehicle, some type of furniture? Try to imagine an artifact that relates to at least one of the prophecies on your list. How would your artifact from the future look? What would be its materials, shape, size, color, and design? What function would it serve and how would it work?

Write a description of your futuristic artifact. Include as many visual details as you can invent. Make a drawn or painted sketch of the object. In your sketch-book, create a more complete image of how you might envision the world in the year 3000. Don't be limited to illustrating only ideas you have already developed in your journal writing; use the sketching process itself as a different mode of creating, giving you access to a different range of ideas as the developing sketch takes on a life of its own. As always, aim to make every sketch as stimulating to look at as possible. *Tip:* Don't just concentrate on the positive shapes; strive to have the negative shapes just as intriguing visually.

11.18 Detail of Frank Moore, *Wizard* (Figure 11.17).

11.19 Alexis Rockman, *Human Ancestors*, 1997. Envirotex, envirotex pigments, carved styrofoam, acrylic paint, plasticene, spray paint, oil stick, oil paint on wood; 70″ × 60″ × 3½″. Courtesy of Gorney, Bravin + Lee, New York.

Option: Create a companion piece to your imaginary artifact from the year 3000. This time cast your imagination back to the dawn of human existence. In your mind's eye design an object that our earliest human ancestors might have used. Try to imagine an object that serves a function related to your artifact from the future. Don't be concerned whether or not archaeologists have actually discovered prehistoric artifacts similar to yours. Give free rein to your imagination. Write a description of your prehistoric artifact in your journal, providing details about its materials, size, shape, color, design, and function. Draw a sketch. To spark your imagination, look at Alexis Rockman's *Human Ancestors* (Figure 11.19), which paints a facetious picture of evolution from our human point of view.

Suggestion: What was it like for you to fantasize about the year 3000? Was it exciting, difficult, unpleasant, delightful, frightening? Was it hard or easy to envision an artifact from the future (and the past)? Write some of your reactions to this exercise. Then speculate on whether you think fantasy — the imagination of unreal people, places, situations, and events — is a direction you want to cultivate for developing artistic content.

Painting Exercises

Prophecies for the Year 3000

Option 1: Create a series of paintings of individual artifacts you imagine would be in use in society in the year 3000.

Each painting should focus directly on one artifact (look at Vija Celmins' treatment of an electric heater in Plate 12). How each artifact functions becomes something of a mystery to viewers because the object is shown outside of its (imagined) social or technological context.

To counteract the placement of the artifacts in a painting devoid of other clues as to their function, select a painting technique that somehow characterizes qualities which you imagine will be prominent in society in the year 3000. For example, an energetic, forceful use of a palette knife to apply paint in short, thick strokes of color might enhance the feeling that, in your view, society of the year 3000 will be frenetic, with all inhabitants moving at superhuman speed. (*Tip*: Wipe the blade of the palette knife clean on tissue paper before picking up a different color. Or, experiment with charging the palette knife with two colors at once, and applying both simultaneously.)

Option 2: Create a painting of a landscape depicted from an unusual perspective that embodies aspects of your vision for the year 3000. As an example, look again at Figure 11.17, Moore's painting *Wizard*, which shows a large expanse of earth seen from an aerial viewpoint. To exaggerate the sense of depth, incorporate the use of glazes for the deeper background. Emphasize foreground details with the direct application of opaque highlights.

In planning this painting, carefully select a color scheme that enhances your vision of the futuristic qualities you want to communicate. Perhaps such a color scheme would involve colors that are *not* in harmonious relationship to each other according to the schemes presented in Chapter 3. A useful planning strategy is to create a color palette grid of the colors you plan to emphasize prior to working on the actual painting (see pp. 48–49 for a review of the concept of a color palette grid).

SUMMARY CRITIQUE

The following are suggestions for ideas to discuss during a summary group critique of the paintings created for this chapter. Before beginning, you should write in your journal exploring your own opinions and feelings about the kinds of standards you want to use when you encounter socially committed art. Don't stop to analyze whether your responses are consistent or fair. Let out all your strongest reactions, even if they sound contradictory.

Discussion Topic: Standards of Quality

It is a matter of considerable debate today whether art's primary purpose should be to provide an aesthetic experience. Some of the artists discussed in this chapter would argue otherwise, saying art's mission should be to provide a visual catalyst for engagement with the public issues of our era. Nevertheless, fair questions to ask of socially engaged art are: To what extent and how does the art rise above documentation, illustration, and propaganda? Is a work successful — indeed, is it "art" at all — if it fails to hold our attention visually, no matter how we feel about its message? If a painting conveys a strong ethical message about a serious social or political issue, can we use standards of craft or technique to judge it? Are value judgments about the aesthetic quality of "political" art as important as understanding and responding to its message?

As you explore what may be seen by some as potentially controversial content for your paintings, beware of

letting the message overwhelm the medium. If you believe art's highest purpose is to serve a worthy cause, you may fall into the trap of concluding that art's social purpose is not only necessary but (and here's the trap) *sufficient* for ensuring its public meaningfulness. The way around this trap is to realize that, even among paintings that aim for noble ends, some succeed more than others in terms of their effect on viewers. Some socially committed art does not rise above the level of heavy-handed preaching and propaganda — dogmatic slogans expressed in visual form but without effective visual interest. Other artists express powerfully felt social content in visually compelling forms that hold the eye and mind (the roots of those forms are not necessarily in traditional European painting). Thus we must still turn our attention to how paintings operate in terms of the integrated relationship of materials, technique, form, and cognitive meaning to analyze the relative success of each.

Outside Feedback

As a strategy for generating ideas about the effectiveness of the paintings completed during this chapter, the class should arrange to have visitors from outside the class (perhaps a class of students from another discipline) come in and share their responses. Because the work done in this chapter is aimed to generate a dialogue with others regarding nonart issues, it is especially useful to receive this kind of feedback. The visitors should be asked to evaluate the artworks on the basis of:

- Which works most effectively capture the viewer's attention? How?
- Which works most effectively communicate ideas about the issue being explored? Does a work have the power to change one's ideas and attitudes or convince a viewer to take specific action? Why?
- Which works are most memorable in terms of their effectiveness as *works of art* (and then, as a follow-up question, the visitors should respond to how they define "art")?

The responses of outside visitors should stimulate additional thoughts for discussion that the painting class can pursue on its own.

Recommended Artists to Explore

Francisco Goya (1746–1828)

Honoré Daumier (1808–1879)

Käthe Kollwitz (1876–1945)

José Clemente Orozco (1883–1949)

Max Beckmann (1884–1950)

Diego Rivera (1886–1957)

George Grosz (1893–1959)

Ben Shahn (1898–1969)

Leon Golub (b. 1922)

Nancy Spero (b. 1926)

Ida Applebroog (b. 1929)

Faith Ringgold (b. 1930)

Ilya Kabakov (b. 1933)

Jaune Quick-to-See-Smith (b. 1940)

Roger Brown (1941–1997)

Luis Cruz Azaceta (b. 1942)

Howardena Pindell (b. 1943)

Jorg Immendorff (b. 1945)

Hollis Sigler (b. 1948)

Hung Liu (b. 1948)

Sue Coe (b. 1951)

Ken Chu (b. 1953)

Hachivi Edgar Heap of Birds (b. 1954)

Juan Sanchez (b. 1954)

David Wojnarowicz (1954–1992)

Kerry James Marshall (b. 1955)

Chéri Samba (b. 1956)

Glenn Ligon (b. 1960)

Manuel Ocampo (b. 1965)

1. Suzi Gablik, *Has Modernism Failed?* (New York: Thames and Hudson, 1984), p. 51.
2. Lucy Lippard, *Mixed Blessings: New Art in a Multicultural America* (New York: Pantheon Books, 1990), p. 39.
3. Faith Ringgold, quoted in *Contemporary Art and Multicultural Education*, edited by Susan Cahan and Zoya Kocur (New York: The New Museum of Contemporary Art, 1996), p. 89.
4. Excerpt from the text on the frame of Hollis Sigler's artwork, *There Are Not Many Rest Stops on This Trip*, Figure 11.9.
5. See, for example, Hans Holbein's 1533 oil painting, *The Ambassadors* (London, National Gallery of Art), or splendid seventeenth-century examples by Johannes Vermeer, such as *Artist in His Studio* (Vienna, Kunsthistorisches Museum).

Glossary

abstract painting: a painting that features a heightened degree of abstraction.

allegory: a narrative that uses events from one story to symbolize and examine another, deeper story, frequently one intended to establish moral values.

artist's book: a one-of-a-kind book created by a visual artist, often incorporating both words and images.

assemblage: an artwork featuring an ensemble of objects and materials — the three-dimensional counterpart to collage.

asymmetry (or asymmetrical balance): a balanced distribution of visual weight throughout a composition, without an exact mirroring of forms between the left and right halves of a painting.

atmospheric (or aerial) perspective: the (perceived or simulated) effect of forms in the distance becoming grayer in color, with a softening of edges and a decrease in value contrast.

balance: the condition when the visual weights of all elements in a composition are equally distributed.

blended brushstrokes: brushstrokes which are blended carefully, so that the final surface has a smooth appearance.

blocking-in: the process of starting a painting by painting a simplified structure of the larger shapes of the composition.

broken brushstrokes (broken color): a technique of applying paint in layers so that the open spacing between strokes allows portions of underlying brushstrokes to remain visible.

broken color: an effect when paint is applied lightly, with a drybrush effect, over a dried layer of paint, allowing some of the underneath color to show through.

censorship: attempts to put restrictions on the content of art.

chiaroscuro: an approach to painting which features dramatic contrasts of light and dark values.

collage: a technique involving the addition of nonart materials onto the surface of the artwork (also the artwork that results from the technique). Also, an artwork developed by affixing various materials, such as pieces of paper, fabric, and photographs, to a flat surface (or the process of creating such an artwork).

composition: the overall visual organization of an artwork.

compositional climax: a heightened concentration of forms in one particular area of a painting.

continuous narrative: a painting (or other two-dimensional artwork) representing a sequence of events within the same continuous space or setting.

contrast: a relationship of opposing qualities in painting.

contre-jour: a condition in which the source of light is directly behind the form it illuminates.

cross-contour: a technique in which brushstrokes (or drawn marks) are applied in patterns that follow the surface of the forms they represent.

decalcomania: a painting technique in which one surface (the "decal") is painted and then pressed, while still wet, against the painting; when the decal is peeled away, some paint remains stuck to the painting in a pattern, often with unexpected qualities.

deconstruction: a process which reveals the underlying structure of a system, thereby demonstrating that the meanings attached to the signs produced by the system are arbitrary.

directional lighting: light coming from a specific source.

disjunctive narrative: our term for a painting in which the narrative elements are disjointed, overlapping, or blurred to such a degree that all efforts to produce a clear and unambiguous reading of the narrative is thwarted.

dynamic brushstrokes: brushstrokes which preserve the distinctness of separate marks.

easel painting: a small to medium-size painting on a portable support, rectangular (or sometimes oval) in shape.

expanded form painting: our term for a painting which has a nonrectangular, and/or nonportable, and/or nonflat support, often featuring the use of nonfamiliar art materials.

expanded idea: our term for any idea that has served prominently as the fuel for artistic change, redefining aspects of the practice of painting during the last few decades.

exquisite corpse: an artwork created when a group of artists share the same support. Each artist completes one section of the total artwork and then passes it on to the next artist for his or her contribution. The catch is that all but a small section of the previous work is hidden from view, so that each successive artist doesn't see what the other artists have already completed.

eye level: the imagined plane that would be extended in all directions looking straight out horizontally.

figurative art: art showing figures of humans or animals.

figure–ground shift: the condition when negative shapes in the background of a painting vie with one or more positive shapes in the foreground for the viewer's attention.

focal points: key details found throughout a picture.

foreshortening: the condition of a form's appearance when its major axis projects in space at an angle to the picture plane.

formalism: a set of ideas, reaching prominence in the twentieth century, founded on the philosophy that what was universal to all artworks were formal elements such as color, composition, and shape.

framing: the process of selecting what aspects of the subject to include within an artwork's borders.

geometric abstraction: abstraction involving forms (usually with hard edges) derived directly or indirectly from geometry or mathematics.

gesture: the movement or position of an individual part of the body.

gesture drawings (gesture paintings): the technique of responding spontaneously with marks or brushstrokes to the whole sweep of the dynamic qualities of a subject's form and movement.

grattage: a painting technique in which an artist presses a canvas (already painted in one color) on top of a textured surface or object to create an imprint.

hatching: a technique in which short, individual brushstrokes (or drawn marks) are applied parallel to one another.

history painting: a narrative painting of a biblical, classical, literary, or historical subject, usually taken from a well-known written text.

horizon line: the line (whether actual or imagined) where the extended plane at eye level would intersect the ground plane.

iconography: the subjective, symbolic meanings of subject matter.

identity: what it means to be a member of a certain group defined by demographic, physical, or cultural characteristics such as national origin, religion, race, gender, or physical disability.

implied line: a line that is not fully present but is completed in the viewer's mind.

installation: an artwork that is composed over an entire viewing site, usually with multiple components and often incorporating the site itself into the art.

interior: in painting, a scene showing the inside of a room, building, or other enclosure.

isometric perspective: a system of conventions for representing depth on a flat surface — forms in the distance are represented as smaller in scale, but parallel lines do not converge.

landscape painting: a painting of an outdoor scene.

linear perspective: a system of conventions for representing the illusion of depth on a flat surface from a single point of view; a key characteristic is that parallel lines and planes in the subject matter are represented as if they converge.

luminosity: the condition of light when a glow seems to be generated from within an object or surface, in contrast to a nonluminous surface, which appears lit from outside by light falling on it from an external source. Also, a condition when forms themselves are aglow, as if they are translucent and light is shining through them rather than falling on them from an outside source.

luster: the appearance of light being reflected from a surface made from a material such as silk or metal.

modernism: starting in the late eighteenth century, a general cultural condition in Western society, including a faith in the power of human reason; a search for universal theories and principles; and a belief in progress and preference for the new over the old. In a more restricted sense, beginning in the mid-nineteenth century, modernism was applied to an integrated set of beliefs about art and culture: art history was unfolding in a linear, orderly way, with each new style growing logically out of a previous one; "original" (new) styles were better than old ones; and universal criteria for judging all art from all times and places could be identified.

multi-episodic: a narrative painting (or other two-dimensional artwork) showing a succession of scenes from the same story, typically depicted in a sequential manner.

multiculturalism: the awareness that many different kinds of people coexist in the world and that each individual is a complex mixture of attributes, beliefs, interests, and behaviors derived from numerous sources. Also, the recognition and embracing of cultural diversity.

narrative: a story that unfolds over time.

narrative painting: a painting that represents a moment or moments of an actual or implied narrative.

negative shapes (also called **negative spaces):** shapes in between, around, or behind the positive shapes.

nonobjective or **nonrepresentational painting:** a painting with no recognizable subject matter outside of the formal elements.

organic abstraction: a looser-style abstraction involving the personal expression of the artist's sensibility and exploration of visual form. (Note: although the term "organic" implies that the forms involved are derived from natural forms, this is not necessarily the case.)

picture plane: the upper flat surface of the support to which paint is applied.

plane: any flat or curved surface that is tilted into space and that can combine with other planes to define a volume.

plein air painting: a painting created outdoors.

pluralism: in art — the coexistence and equal validity of many styles, techniques, forms, and varieties of cognitive content.

pointillism: a method for applying paint in small dabs ("points") of pure color, which can create optical mixtures in the eye when seen from several feet away.

political or **activist art:** art dealing with current social issues and problems and often arguing for social change.

portrait: an image of an identifiable person.

pose: the arrangement of the entire body.

positive shapes: shapes in the foreground, or shapes of represented things.

postmodernism: the condition of the current period of transition and change marked by widespread challenges to prevailing ideas, beliefs, values, and practices in every field of human endeavor, including art.

representational painting: a painting that depicts recognizable subject matter. Also, a painting that shows aspects of the way things look, or could look, in the physical world.

reverse painting: a painting produced on the "reverse" side of a transparent support, the completed painting is viewed from the front side, through the support; also, the technique of producing such a painting.

rhythm: the actual or implied repetition of related formal elements.

self-portraits: images made by artists to represent themselves.

semiotics: a branch of philosophy which studies how meaning is communicated through signs and symbols and what they represent.

sgraffito: a technique of incising lines in a paint surface.

shape: in painting, any area of the picture plane that is differentiated from other areas.

sign: something that refers to, stands for, or represents something else.

single scene narrative: a painting (or other two-dimensional artwork) rendering one specific moment from a narrative.

stereotypes: prejudiced viewpoints, based on an assumption that all members of a group are similar in some way.

still life: a painting depicting an arrangement of immobile objects, which may be organic or inorganic.

style: a characteristic approach to using materials, techniques, formal elements, and subject matter.

symmetry (or symmetrical balance): when the forms on the left and right halves of a composition are exact, or nearly exact, mirror images of each other.

vanishing point: a point on the horizon line where a set of parallel lines or planes would seem to converge, if extended.

visual elements (also called **formal elements):** the basic ingredients used to make a work of art, including line, shape, color, value, texture, and space.

viewfinder: a device that allows only a limited view, used to analyze options for framing a painting subject; typically an artist will use a viewfinder with the same proportions as the surface of the support.

viewpoint: the (real or imaginary) position — including the distance, angle, and height — of the artist's view in relationship to the subject matter.

volume: a form occupying three-dimensional space.

wiping-out technique: a technique that consists primarily of subtracting paint to create an image.

Photo Credits

Figure 1-1 Copyright © Jerome Chatin/Liaison Agency.

Figure 1-2 Copyright © 1998 Board of Trustees, National Gallery of Art, Washington.

Figure 1-3 Rosa Bonheur, *The Horse Fair,* 1853. Oil on canvas, 94 $\frac{1}{4}$" × 16'7$\frac{1}{2}$". The Metropolitan Museum of Art, Gift of Cornelius Vanderbilt, 1887. (87.25)

Figure 1-4 Courtesy of the artist and the Hosfelt Gallery.

Figure 1-5 Denver Art Museum Collection.

Figure 1-6 Courtesy of the artist and the National Gallery of Australia. Photo copyright © National Gallery of Australia. Not to be reproduced without permission.

Figure 1-7 Courtesy of Albright-Knox Art Gallery, Buffalo, New York.

Figure 1-8 Private Collection.

Figure 2-1 By courtesy of the Trustees of the National Gallery, London.

Figures 2-2 – 2-6 Photographs by Doug Bolt.

Figure 2-7 Courtesy of the artist.

Figure 2-8 Courtesy of the artist.

Figure 2-9 Courtesy of the artist.

Figure 2-10 Photograph by Doug Bolt.

Figure 3-1 Courtesy of Michael Rosenfeld Gallery.

Figures 3-2, 3.3 Diagrams by Yanya Yang.

Figure 4-1 Copyright © 1998 Board of Trustees, National Gallery of Art, Washington.

Figure 4-2 Courtesy of Mrs. Richard Diebenkorn.

Figure 4-3 Courtesy of the artist and The Metropolitan Museum of Art, Gift of Mr. & Mrs. Eugene M. Schwartz, 1980. (1980.84)

Figure 4-4 Courtesy of the artist.

Figure 4-5 Courtesy of the artist and Charles Cowles Gallery.

Figure 4-6 Courtesy of the artist and Charles Cowles Gallery.

Figure 4-7 Courtesy of San Diego Museum of Art (Gift of Anne R. and Amy Putnam).

Figure 4-8 Copyright © 1994 Catherine Murphy. Photo courtesy of Lennon, Weinberg Gallery, New York.

Figure 4-9 Rachel Ruysch, *Flower Still Life,* by permission of The Toledo Museum of Art. Purchased with funds from the Libbey Endowment, Gift of Edward Drummond. 1956.57.

Figure 4-10 Ma Quan, *Flowers and Butterflies,* first half of the 18th century. Ink and color on paper, 27.9 cm × 248.9 cm. The Metropolitan Museum of Art, Ex. coll. A. W. Bahr, Purchase, Fletcher Fund, 1947. (47.18.116)

Figure 4-11 Copyright © 1985 by Lisa Milroy and Waddington Galleries, London. Collection, Tate Gallery, London.

Figure 4-12 Copyright © 1979 Miriam Schapiro. Courtesy of Steinbaum Krauss Gallery, New York.

Figure 4-13 Photo by M. Lee Fatherree.

Figure 4-14 Photo copyright Eiteljorg Museum of American Indians and Western Art. Photo by Wilbur Montgomery.

Figure 4-15 Courtesy of the artist.

Figure 10-12 Courtesy of the artist and P.P.O.W. Gallery, New York.

Figure 10-13 Courtesy of the artist and Phyllis Kind Gallery, New York.

Figure 10-14 Courtesy of the artist. Photo: Nicholas Walster.

Figure 10-15 Courtesy of the artist and Stephen Wirtz Gallery, San Francisco.

Figure 11-1 Courtesy of Museo del Prado.

Figure 11-2 Sue Coe, *The End of the Empire*, 1990. Copyright © 1990 Sue Coe. Courtesy Galerie St. Etienne, New York. Photo by James Dee.

Figure 11-3 Private Collection. Courtesy Nohra Haime Gallery.

Figure 11-4 Courtesy of the artist and Jan Cicero Gallery, Chicago.

Figure 11-5 Courtesy of Wadsworth Atheneum.

Figure 11-6 Courtesy of the artist and Arthur and Leah Ollman Collection, San Diego, CA.

Figure 11-7 Courtesy of the artist and Carl Hammer Gallery.

Figure 11-8 Copyright © 1988 Faith Ringgold.

Figure 11-9 Courtesy of the artist and the Susan Cumming Gallery, Mill Valley, CA.

Figure 11-10 Margaret Johnson & Ray Ottenberg Collection, Washington, DC. Courtesy of the artist.

Figure 11-11 Courtesy Ronald Feldman Fine Arts, New York. Photo: Jennifer Cotter.

Figure 11-12 Courtesy of the artist.

Figure 11-13 Courtesy of the artist and P.P.O.W. Gallery, New York. Photo: Adam Reich.

Figure 11-14 Courtesy of the Art Institute of Chicago and the Brown family. Photographer: William H. Bengtson.

Figure 11-15 R. B. Kitaj, courtesy, Marborough Gallery, New York.

Figure 11-16 Courtesy of Sandler Hudson Gallery, Atlanta, Georgia. Private Collection. Photo: Frank Hunter.

Figure 11-17 Courtesy Sperone Westwater, New York.

Figure 11-18 Courtesy of Sperone Westwater, New York.

Figure 11-19 Courtesy of Gorney, Bravin + Lee, New York.

Plate 1 Copyright © 1998 Board of Trustees, National Gallery of Art, Washington.

Plate 3 Courtesy of Michael Rosenfeld Gallery.

Plate 5 Courtesy of the artist and June Kelly Gallery. Photo: D. James Dee.

Plate-6 Diagram by Yanya Yang.

Plate 7 Diagram by Yanya Yang.

Plate 8 Courtesy of the artist.

Plate 10 The Edward R. Broida Trust, Palm Beach, Florida. Courtesy of the McKee Gallery, New York.

Plate 11 Courtesy of Steinbaum Krauss Gallery, New York, and The Chrysler Museum, Norfolk, VA.

Plate 12 Courtesy of the McKee Gallery, New York.

Plate 13 Banco de Mexico, Fiduciario en el Fideicomiso Relativo a Los Museos Diego Rivera Frida Kahlo.

Plate 14 Photo by John Back. Courtesy of Pace Wildenstein.

Plate 15 Photo by John Back. Courtesy of Pace Wildenstein.

Plate 16 Courtesy of the artist.

Plate 17 Courtesy of the artist.

Plate 18 Copyright © David Hockney.

Plate 19 Courtesy of the artist and Victoria Miro Gallery, London.

Plate 20 Courtesy of Jane D. Asbury, the artist.

Plate 21 Courtesy of the artist and Maya Polsky Gallery, Chicago.

Plate 22 Courtesy of the artist.

Plate 23 Courtesy of the artist.

Plate 24 Courtesy of the artist.

Plate 25 Courtesy of the Pat Steir Studio.

Plate 26 Courtesy of Gorney, Bravin + Lee, New York.

Plate 27 Courtesy of Gorney, Bravin + Lee, New York.

Plate 28 Courtesy of the artist and Mark Moore Gallery.

Plate 29 Courtesy of the artist and the Jack Tilton Gallery, New York.

Plate 30 Courtesy of the artist and Mark Moore Gallery, Santa Monica, CA.

Plate 31 Collection of Dr. and Mrs. Alfred Cisneros, Elburn, Illinois. Photo courtesy of George Adams Gallery, New York.

Plate 32 Courtesy of the artist.

Index

Page numbers in italics refer to paintings and drawings. Color plates are identified by Plate number.